Finding
Frances
Hodgkins

MARY KISLER

Finding Frances Hodgkins

MASSEY UNIVERSITY PRESS

Contents

Introduction

In 2013, as Senior Curator, Mackelvie Collection, International Art at Auckland Art Gallery Toi o Tāmaki, I took on the task of updating an unpublished catalogue raisonné of the works of New Zealand expatriate artist Frances Hodgkins begun by former Auckland Art Gallery director Rodney Wilson. A book (or website, as in Hodgkins' case) that hopes to capture all the works of an artist with up-to-date information is a challenge at any time. With this one, it became apparent early on that there were a number of works without titles, or of unnamed places; it was also striking just how different from each other so many of Hodgkins' paintings are, in part because she was constantly on the move. Faced with trying to sort out just how her painting style and subject matter evolved as a result of her gypsy lifestyle, I decided to follow in her footsteps.

Naïvely, I felt I was reasonably equipped to trace her journeys, having travelled on and off for 30 years and lived in a remote community far from the pressures of urban life. In the 1970s and 1980s I'd spent several summers living on a remote farm on the Greek island of Paros in the Cyclades with my husband, David, and young son, Marcus. We rented a dowry house, a small cluster of rooms around a courtyard traditionally given to each daughter of a family so that they would always maintain a link to the family land. Ours belonged to an elderly woman in the village of Naoussa, while the farm itself was some five kilometres away at Langari, where we shared the simple but deeply satisfying life of three generations of the family, with its seasonal cycles of hardship, harvest and ritual celebration.

We had a large bedroom furnished with rough wooden beds on which were rudimentary mattresses stuffed with straw, and across a courtyard was a primitive kitchen attached to a barn where the family's hard-working donkey and mule spent their nights, and where swarms of flies hovered and buzzed during the day. We drew water, made drinkable by the addition of a chunk of lime, from the nearby well. Another well down the rocky path to the bay was good only for washing ourselves and our clothes after a day swimming at 'our' beach, a small cove beneath a tiny whitewashed church, where the Madonna had taken over the role of a much more archaic goddess, guarding the nearby well in a walled orchard of figs.

As we were gathered more and more into the family, our Greek improving out of sheer necessity, we helped with various tasks on the farm, walking behind the mule pulling an iron plough and gathering potatoes from the newly turned earth. We loaded them into large olive-oil tins that had been turned into buckets with the aid of a rough piece of wood fixed across the top as a handle. Nothing was ever wasted. We spent one day planting a field of onions, bending until exhausted — long before our Greek family straightened their backs. David and a friend were also roped into the wheat harvest. We were paid with wedding wine (a rosé far more palatable than the everyday retsina), chunks of τυρί, a hard white goat's cheese that grated like Parmigiano, and, before our departure the second year, a platter of the roasted corpses of their beautiful white doves, which was the best they could give us. We wept silent tears after the family had left, as we had loved the doves' swooping flight to and from the white-plastered dovecot on one side of the barn.

One day Marcus endured an agonising three-hour donkey ride (sitting behind the saddle on the animal's rough rump) into the centre of the island, where we pushed our way through shoulder-high wheat to a tiny church, its whitewashed walls catching the late-afternoon sun. Its interior was simplicity itself: a barrel-vaulted roof; black-and-white tiles on the floor; and a primitive altar behind a simple curtain, standing in for the more ornate iconostatis in larger Greek chuches, on which hung a picture of the

CLOCKWISE FROM TOP LEFT Paros, Greece, in the 1970s: Marcus and me at Mycenae; the kitchen at Langari; our 'family' on the farm at Langari: from left, Panayiota, Stelliane, Eleni, Aristides and Leila; Aristides arriving with the news of the birth of his son.

Virgin Mary. The cloth was covered with stamped tin and silver votives of breasts, including torsos of Victorian women in bustles with their upper bodies exposed, for the church is dedicated to breastfeeding mothers.

I assumed we were there with Leila and her two lovely daughters to give prayers of thanks, but instead we swept the church floor clear of dust, leaves and the odd dead spider, trimmed the wicks of the oil lamps and placed new candles in their holders before crossing ourselves silently and making the long trek home again. I came to love the simple rituals that interwove faith, community, land and sea, but in our time on the island we also saw how politics could divide a community. It was an early insight into what Frances Hodgkins found in some of the villages in Morocco, France and Spain during her constant journeying between 1901 and 1939.

When I finally went to university in the 1980s I wanted to study Greek, as I was still writing to our family on Paros, but the subject wasn't available so I chose Italian and art history instead. Since then I've been fortunate to spend a considerable time in Italy, but always doing Italian, Renaissance and baroque research, absorbed by the beauty of the art and architecture of Florence, Venice and Rome. I remain a social art historian, believing that art is inevitably linked to the society and locale in which it was created, if only we are able to understand it. I am equally curious about how and why artists create in the way they do, whether painting in a traditional manner on canvas or church wall, or playing the magician with the digital tools we have available today. But my journey in search of Frances Hodgkins and the places in which she worked was more than that. As a modernist she was committed to the quotidian rather than the grand statement, and I wanted to discover how she transformed 'the everyday' into something that was often lyrical, even rapturous, and ultimately timeless.

From early on in my work on updating the Hodgkins catalogue it become obvious that many of her paintings were specific to place. But the question was: where exactly? Many titles had been given to paintings long after they were done, by dealers and auctioneers, and I sensed that they weren't all correct. Accordingly, in 2015 I set off searching for

Frances Hodgkins. Like her, I didn't always travel alone, and was grateful for the company of friends who volunteered to help: my ex-neighbour Mary Gee, who was with me for my first 10 days on the French Riviera; Chloe Steer, a long-time friend and selfless volunteer who has worked on the project from the start; and Catherine Hammond, senior librarian at Auckland Art Gallery. Catherine organised visits for the two of us to libraries and archives in Paris and London, and gamely allowed me to drive her around Pembrokeshire in Wales. Without them, and others I met on the way, this project would never have progressed.

I was unable to achieve everything I wanted on my first trip, so I led a tour back to France and Spain in 2016 in the hope of tidying up loose ends, and returned again in 2018. You never can discover everything, but you can die trying . . .

I have structured this book around the routes I took, rather than tracking each place Hodgkins stayed in or the exact chronology of her travels. She visited Martigues five times, for example, but I went there only twice, and while she sometimes stayed in one place for weeks or months, I might have had only a day or, as was the case in parts of England, several hours.

My journey began in Mantua in northern Italy with Mary, moved across the southern coast of France and into Spain, where I was accompanied in part by fellow Hodgkins aficionado Antoni Ribas Tur as well as Chloe, then on to Paris and England. There the journey stretched along the coast from St Ives as far as Brighton and up to London, where I said goodbye to Chloe and took up the search with Catherine. We spent a week in the archives of Tate Britain and other repositories like the British Council, then took the train to Cardiff — Catherine to attend a library conference and I to view the Hodgkins paintings in the city's public gallery. We travelled on to Pembrokeshire, then back to London, before I struck off for Wales, returning to London via Manchester, Birmingham and Liverpool. And then we returned to Paris.

Brittany is the only region Hodgkins frequented that I have failed to

visit. I tried in both 2015 and 2016, but it would have taken an eight-hour journey to get there, whether by train or by flying from the south of France, and even the train from Paris can take six hours. With the likelihood of only an overnight stay, it proved impossible. Fortunately, Hodgkins was much keener on including the names of the Breton towns where she stayed in the titles of her works, and these along with information from websites, her own photographs and the invaluable postcards collated by Professor Roger Collins of the hotels and environs in which she lodged, have given me a sense of her responses to these places.

Apart from when she went to Paris, almost all Hodgkins' visits to France were for teaching purposes, and the coastal towns of Brittany were popular resorts for tourists and artists alike. There the mild summer weather made it easy to work en plein air, accommodation and restaurants were plentiful, and travel between towns and villages appears to have caused few difficulties. There was also the benefit of stormy skyscapes when the autumn months began to advance.

With images of all Hodgkins' known works stored on my iPad, my hope was to stand in the places Hodgkins stood, to look at the same views, to breathe the sea air and smell the wild herbs and resinous forests so as to greater understand the conscious decisions she made when translating these things onto paper or canvas. My travels have allowed me to comprehend more clearly the way villages, their inhabitants, their everyday objects — buildings, pottery, shrines, even tree stumps — became the motifs that linked her works to a specific time and place. The sketches created in each place became a visual memory bank on which Hodgkins could draw when an oil painting or gouache needed 'that special something' to tie a composition together. I have garnered a much wider appreciation of the richness and diversity of her work, which remained vital and everchanging until the end of her life.

So this is a memoir of my own journeying, the wonderful friends and colleagues who have dipped in and out of particular places with me, and the adventures and misadventures we experienced on the way.

Wherever possible, I have also included in the text parts of Hodgkins' letters, which are remarkable in themselves for the way they show her ability to paint pictures in words. Hodgkins' spelling was notoriously erratic, so in some cases I have made small corrections to facilitate reading; otherwise her original spelling and creative use of punctuation remain. I see the text as a kind of partner with the catalogue that focuses on works included in the exhibition *Frances Hodgkins: European Journeys*, allowing me to take you, the reader, with me on my travels.

Frances Hodgkins was born in 1869 in Dunedin, a city built on the proceeds of gold and the wealthiest in New Zealand at the time. Her father, William Hodgkins, was a solicitor, but his work seems to have taken second place to his love of art. Growing up in England, he had been particularly drawn to the landscapes of John Constable and William Turner, the former famous for depictions of the bucolic rural landscapes of Suffolk, the latter for his remarkable capture of the effects of weather — mist, storms, brilliant skies — that spoke of the sublime and untamed natural world. William Hodgkins found both in Central Otago, and would spend his weekends with his daughters, Isabel and Frances, capturing these effects in watercolour. His wife, Rachel, had always believed that Frances had more talent musically and would make her living in this field, but she hadn't considered her younger daughter's independent streak. And what her family failed to see was patently apparent to others.

Two decades after Frances Hodgkins' death in Dorset, England, in 1947, a recording was made of those who remembered her in Dunedin. In her family's eyes, Isabel was both the beauty of the family and the inheritor of her father's talent. Yet according to a former neighbour, Elsie Royce (now Mrs Morah), Frances often had a pencil in her hand, sitting down one day at the Royces' long table to make a copy of a painting of a cat and kittens hanging over the mantelpiece. She asked if they had any paints in the house, and these were duly supplied. When Elsie's mother saw what Frances had

done, she said, 'Someday that girl will be an artist.' Elsie Royce went on: 'She wasn't dominated, but she was thought nothing much of by her own family . . . Frances was rather shortish and exactly like the photographs you see of her. I don't think you would have called her good-looking but she was a very bright talkative sort of person and I think in a way that she felt a bit of an inferiority complex when she was young . . . only because she didn't get much encouragement you see from her own family.'

After spending time in Australia, the Sienese painter Girolamo Nerli set himself up as a teacher in Dunedin in 1893, and Hodgkins joined his painting class. Nerli wasn't the most dedicated of teachers, preferring to spend his time in the hotel after setting his students the subject for the day, but he evidently provided them with stimulating descriptions of the changes that were taking place in the studios of Europe. He belonged to a group of painters known as the Macchiaioli or mark makers, whose deliberate avoidance of the smooth glazes and high finishes promoted by the traditional academies of Italy, France and England served as a precursor of impressionism. They did, however, retain some of the darker tones of the Academy, something Hodgkins would turn away from in her own work. Partly this may have stemmed from her preference for watercolour at the time, and the translucent effects that could be achieved by painting wet on wet — that is, saturating the paper first and then floating the pigments onto the damp surface. It took great control to get the effect needed, and already in some of her Otago watercolours she had started experimenting with shorter dabs of colour on dry paper as a contrast to her washes.

Hodgkins was 24 when she started in Nerli's classes, and the results proved very rewarding. Both her family and Dunedin society at large began to take her seriously, and in 1895 and 1896 she took the two courses that allowed her to sit the examinations set in South Kensington, England, that would qualify her to teach. She passed with excellent grades, and began to visualise a future in which she could make her living through art. But Nerli had done more than prepare her for a career — he had given her a sense that there was a bohemian society on the other side of the

world where she would be less constrained by the conservative mores of colonial New Zealand. This, however, would have to wait.

William Hodgkins died in 1898, leaving his family far less well-off than they had expected, so Hodgkins set herself up as a teacher. She developed a love of painting people, as well as landscapes, and although she did some formal watercolour portraits when commissioned to do so, she preferred painting domestic scenes. She also spent time on the Otago Peninsula painting Māori women and children, whom she persuaded to sit for her in exchange for a few pennies. Although she would have been unaware of it, she was developing a practice that would remain with her for the rest of her career, and her painting became fresh and more individualistic as a result.

Hodgkins had her eyes on Europe, resisting expectations that she would take care of her mother. After visiting Wellington, she returned to Dunedin to teach for a year, then on 6 February 1901 boarded the *Moana*, bound for England via Australia.

Her intention was to stay in Europe for a couple of years to acquire further skills before returning to New Zealand permanently. In fact she only ever made two trips home to New Zealand, the first at the end of 1904, when she set up a studio in Bowen Street in Wellington. Her engagement to an English journalist and writer, Thomas Wilby, whom she and her friend and fellow New Zealand artist Dorothy Kate Richmond had met on the boat home, was announced in the newspapers at the end of the year. Wilby had disembarked in Cairo, but had sent Frances a scarab with a wittily illustrated letter describing its function within ancient Egyptian culture. Romance blossomed, and after the announcement of their engagement, he wrote a letter to Mrs Hodgkins from New York, laying out his intentions:

'It is difficult to know exactly what to say in this preliminary letter. You of course know my intentions with regard to Frances. She has, in a weak moment, promised to make me the happiest of men in his wife and his mother-in-law. The business side of the matter I have already communicated in part to Frances & to Miss Richmond. I would have liked very much to come over to New Zealand this year, but the difficulty of

Frances Hodgkins photographed in 1904, Wellington, around the time of her engagement.

E. H. McCormick Papers, E. H. McCormick Research Library, Auckland Art Gallery Toi o Tāmaki, gift of Linda Gill, 2015. Photo by Langfier Ltd, London.

getting away is insurmountable. Finally the obstacles were removed by Frances' proposal to meet me in Europe. Of course I fully realise that if the marriage is to take place it should be in New Zealand in your presence. But even if the marriage takes place in Europe, Frances would be desirous of returning to N.Z. for a short time as I understand, though I don't see how I could ever let her go from me once we were man & wife. I should feel the separation too keenly. But perhaps the difficulty could be overcome by my sailing for New Zealand with her in 1906.

'However this is anticipating things, is it not? I am endeavouring just now to make arrangements by which I can settle down in London or in Paris, as it is in one of these cities I should like to make my home with Frances.

'I feel that you must naturally be very anxious about Frances & that you imagine that she is taking me very much on trust in the absence of anything more tangible than my love for her. I have no relatives, so-called, only friends who have an intimate knowledge of me & to whom I could refer you, because I feel it is only right that Frances should know something about me from an outside source. But Frances & I know each other in a way that no relatives could add to. I know her whole life & nature through my own heart. Very sincerely yours, T W B Wilby.'

It's difficult to know what went wrong, but at some point in 1905 the engagement was broken off, and Hodgkins spent a very unhappy year in Wellington before her mother relieved her of her familial obligations and allowed her to return to Europe. Wilby went on to marry someone else, and came to world attention in 1911 as the first man (along with his driver Jack Haney) to cross Canada by motorcar. He published his account of the journey three years later. When, in later life, Hodgkins' friend Douglas Glass quizzed her about why she hadn't married, she refrained from explaining, saying that if she did she would be forced to lie. He didn't push her any further, so the real cause for the separation may never be known.

Hodgkins' last visit home at the end of 1912 allowed her to enjoy the Australasian summer, have sell-out shows in Melbourne and Sydney, and

catch up with family and friends before she arrived in Wellington in time for Christmas. This time there was never any doubt that she was there only temporarily and that her future lay on the other side of the world.

Determined to make her name as a professional artist on the European stage, Hodgkins had embarked on an itinerant life that ceased only during the two world wars, when travel to her favourite places in France, North Africa, Holland and Spain was no longer possible. On average, she moved six times a year between 1901 and her death in 1947, often returning to locations she favoured, initially because the climate, accommodation and desired subject matter suited her students, but in later years because a familiar place was a kind of homecoming. After receiving a contract with St George's Gallery in London in 1929, she no longer needed students to make ends meet, but those who had become friends often travelled to whichever location she was in anyway.

Although described initially as an impressionist, Hodgkins' studies of colour and light transformed into colour and form — the landscape, the traditional cubic buildings, the pruned olive and cork trees simplified as if they were part of a child's drawing. These became the focus alongside the expanses of view and changes of light so key to the Mediterranean landscape. It was only in the late 1930s that she finally came to terms with the English countryside with its soft greens and dappled masses, though she preferred the bare branches of winter — forms and motifs that she transferred into sculptural objects in the landscape. And ultimately it was England itself that became her focus and her delight. Two years before she died, she wrote to her friend and dealer Eardley Knollys: 'My Muse has returned to me. I found her waiting for me on the doorstep faithful wench, which goes to show how futile it is to travel over Mountains in search of material when it lies at your own pavement, for the seeing. I am weary after quite a stupendous onset, but much less weary than if I had not achieved it.'

01

Caudebec-en-Caux

FRANCE

odgkins' first taste of the western communes of France was in Caudebec-en-Caux in 1901, when she joined Norman Garstin's art class at the end of June, staying on until early September. As arranged in London, Dorothy Kate Richmond was already there, Hodgkins noting in a letter to her mother how her friend was 'winning all hearts by her sweetness & beauty, it is a kind of link with Wellington having her here, we talk about our respective nieces . . .' They were to become seasoned, like-minded travelling companions, with an ability to tease or defend their own corner to balance out any excesses of enthusiasm.

In the same letter Hodgkins described how their group, which numbered 12 to start with, had to be 'spread over the town in detachments'. On a normal working day, 'We rise betimes and are out by 6.30, work till midday then back to dejeuner, a comprehensive meal consisting of many courses mostly vegetables & very under done meat, puddings never and copious libations of cider. This is a great cider district and the inhabitants get gloriously drunk, after dejeuner we rest till 3, when we all meet in a large room & have afternoon tea and criticise each other's work, then out again for evening effects & at 8.30 we have another huge meal which lasts till 10 o'clock & we end the evening with a stroll & so to bed.

'I wish you could see my room, very small room very large mahogany bedstead small table which serves as both dressing table & wash stand, a pie dish & milk jug to wash in and a looking glass whose face is cracked in three places. In my best French I asked for a chest of drawers or failing that for some pegs. The Landlord looked at me blankly, ruminated aloud with hand on brow then disappeared and after some time reappeared staggering with two other men under a huge side board, it now fills up all the available space in my room and is better than nothing.

'For all these luxuries we pay 5 frcs a day equal to 30/- a week in English money. Baths are unheard of and are looked upon as one of the many idiosyncrasies of the Britisher abroad. You can get them if you like to pay a franc each time but ones weekly washing bill would soon run up at that rate. Miss Richmond has a rubber bath and I manage to keep

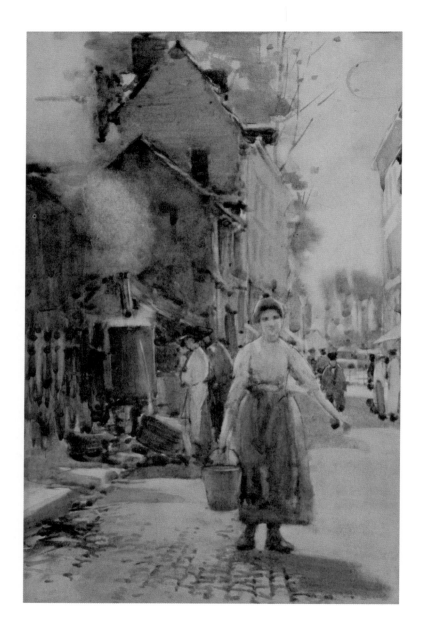

Fig. 1 *Making Cider, Caudebec, Normandy,* c.1901, watercolour on paper. *Private collection.*

fairly cleanly . . . Miss Richmond and I are never tired of congratulating ourselves on our good luck in coming abroad with such delightful people as the Garstins. She is such a nice woman, very practical and clever and manages her husband's business for him. She knows nothing at all about painting & never knows her husband's sketches from one of ours.'[2]

In *Making Cider, Caudebec, Normandy* (c.1901) (Fig. 1), Hodgkins depicted the large copper vat in which the apples were boiled in preparation for the cider, watched closely by the apple pickers at the edge of the road. The compositional structure of the work is similar to many from this time, with a close attention to buildings lining the street, leading the eye into deep space, while a young woman, bent slightly sideways by the weight of her bucket, walks towards us across the cobbles. Steam rises up from the chimney pipe above the copper, which Hodgkins depicted by sponging off the pigment after it had been applied. The pale-blue sky and the girl's deep shadow give a sense of the heat of the day.

At the beginning of September 1901 Hodgkins set off for Paris with Molly Sale, one of the students who had joined the group, which had grown to almost 40 by the end of August. Hodgkins planned to find some cheap rooms in the Latin quarter before Molly went back to London, while she went on a cycling tour with another student, and a friend of the Garstins, Maud Nickalls, while the good weather lasted. Once teaching was over they were to be joined en route by the Garstins and Dorothy Richmond, who had headed further south but who would organise her return trip so that they met up at some point.

Hodgkins was planning to stay in Normandy, but first she had to acquire a second-hand bicycle, a relatively easy task in Paris, where she hoped to pick one up for around £6. She had sold some of her sketches, so was better off than she had imagined; the £20 she'd earned would keep her for two months if she was frugal. One of her sales was to another student, the widowed Mrs Ashington, who was to accompany her to the Italian Riviera the following year. Hodgkins had a facility for friendship, and a number of women she met at this time remained friends for many

years. But at times she was assailed by homesickness, for which Richmond insisted the only remedy was whisky and a hot bottle: '[T]he latter I have the moral courage to refuse. I have still the remains of Wilsons "very best" in my flask to this day, it is much better policy when travelling to drink other people's whisky, when available.'[3]

One Sunday she and Nickalls rode their bikes out to Jumièges to see the ruins of the abbey. Hodgkins loved the decayed walls of the church rising upwards, but was far less flattering about many of the local churches, whose structures, she felt, had been subsumed beneath far too much decoration. She was, however, much taken with the way religious festivals were celebrated: 'The R.C. churches are all so tawdry and the beauty of the buildings so spoilt by these fripperies, banners & hideous saints covered with ribbons & flowers. We had a great church fete here last week, the feast of the Assumption, one of the three great R.C. feast days of the year. For several days before there were great preparations all the saints in the church were taken down & cleaned & garnished with new ribbons & fresh flowers the night before. I saw a wheelbarrow with no less than 3 saints sitting bolt upright & looking very clean & frivolous so covered were they with flowers & ribbons. The next day commenced with much bell ringing and after High Mass there was a grand procession through the old town headed by the priests in their gorgeous vestments proceeded by acolytes and after them came a number of young girls in their snowy communion dresses looking so spotless & pure against the background of grim old houses. A quaint custom is that all persons who are called Marie should receive a gift from the Church, the gifts generally take the form of flowers and cakes with "Vive Marie" written on these in icing. It is certainly a most picturesque religion.

'You would love the Calvarys and the Pietas along the roads. The Pietas are generally little railed in monuments of a recumbent figure of the dead Christ rudely modelled and sometimes colored. It is very beautiful country all round this neighbourhood and the peasants are a real joy. I would like to buy a few and take them out with me as properties. Some of

CYCLISTS'
TOURING CLUB.
47, *VICTORIA ST., WESTMINSTER,*
LONDON, S.W.

SPECIAL CUSTOMS TICKET.
(Not Available for Austria.)

1902 1902

This ticket is available
only during the year
Cette carte n'est valable
que pendant l'année

Diese Karte ist gültig
nur für das Jahr
Questa tessera è vale-
vole solo durante
l'anno

Membership No. / No. du membre / Mitgliedsnummer / Numero del socio	5...... / 01.
Name / Nom et prénom / Vor- und Zuname / Nome e prenomi	Miss. / F. M. Hodgkins
Address / Domicile / Adresse / Indirizzo	Bank of New S. Wales 64 Old Broad Street E.C.
Kind of Machine / Genre du Vélocipède / Art des Fahrrades / Genere del Velocipede	Bicyclette
Name of Make / Marque de Fabrique / Marke / Marca di Fabbrica	Diamant
No. on Frame or Hubs / No. de Fabrique / Fabriksnummer / Numero di Fabbrica	X I

E W Shipton

Signature of Member Frances Hodgkins.

Secretary.

ABOVE Frances Hodgkins' Cyclists' Touring Club Special Customs Ticket, 1902.
E.H. McCormick Papers, E. H. McCormick Research Library, Auckland Art Gallery Toi o Tāmaki, gift of Linda Gill, 2015.

RIGHT Frances Hodgkins (far right) with two of her pupils at St-Valery-sur-Somme, 1912.
E.H.McCormick Papers, E. H. McCormick Research Library, Auckland Art Gallery Toi o Tāmaki, gift of Linda Gill, 2015.

the old men wear such beautiful blue corduroy bags that make me ache to paint them, it is a great sight to see them on Market day (every Saturday) the whole town is covered with little canvas booths and with the different goods displayed and the babel of noise that goes on, each stallholder crying up their own particular wares.

'It is useless trying to paint a market scene, we have all tried and then sadly turned our backs on its fascinations. We found we always come home so cross & irritable after a morning spent in the market that Mr Garstin mildly suggested that we should cease wrestling with it. I think French people are most charming, they are so smiling and gracious and wherever we go we always meet with the greatest civility and kindness, they are certainly very dirty and have many nasty little tricks, but for all that they are a very lovable people with the most charming manners in the world.'[4]

Hodgkins' comments were prescient — as in life, so in art — for her future career as a modernist included the reduction of forms to their simplest structure, and during the 1920s she gradually moved away from indoor scenes and out into the landscape, taking her favoured pots and jars and flowers with her. Equally, she stayed away from churches, while continuing to be fascinated by the rituals that took people's beliefs into the streets and to wayside shrines, or on church processions.

When Hodgkins and Sale got to Paris they found accommodation at 21 avenue de la Grande Armée, a couple of blocks from the Arc de Triomphe. The city was quiet and relatively empty for the summer vacation. Despite their best efforts to be frugal, she and Sale spent double what they had intended. Hodgkins described to her sister Isabel a visit they made to the opera: 'Molly & I took seats in the 10th tier & at 7 o'clock found ourselves tucked away under the roof. Such a place, I never saw anything as gorgeous in all my life. It was Wagner's Tannhauser with one of the leading orchestras in Europe. Nearly all the parts were taken by

musical celebrities, there was something so weird & uncanny sitting so high up and listening to this grand volume of sound coming from below and seeing little fore-shortened pinhead figures acting on the stage.

'There is something wicked about Wagner's music I think which seemed heightened by the gorgeous staging & magnificent surroundings, it was not over till 12 o'clock and as we were too tired to wrestle with our bus we took a cab home and drove thro' Paris at midnight which was as brilliantly lit up then as earlier in the evening. You can have no idea of the beauty of Paris. There is a white glamour about it which is dazzling, the wide open streets & the almost silent traffic on the wooden pavements. The buildings are truly magnificent & everything is built with a view to beautifying the city. There is not an ugly spot to be seen.'⁵

Yet, in spite of its charms, Hodgkins felt out of kilter with the city, perhaps because she felt her shabby clothes stood out amid so much elegance. It was also an awkward time to be there, with so many of the galleries and theatres closed for the holidays.

02

Les
Andelys
and
Dinan

FRANCE

odgkins' next destination was Les Andelys, a very pretty village beside the river Seine in Normandy in northern France, which is dominated by a remarkable twelfth-century castle sitting on the top of the precipitous mountain that overlooks the area. Hodgkins stayed for a few weeks, where unlike in Caudebec she managed to complete some rapid sketches in the market, including one of a group of men looking over a group of calves for sale. Markets were difficult subjects, because people were there to work, not to pose for itinerant artists, so she had to become adept in putting down her impressions with a few considered strokes, backed up by dabs and dashes, much in the Macchiaioli style of painting that she had learned from Nerli in Dunedin.

She had more success when she went to Dinan, in Brittany, in July 1902, possibly because she sketched in the architecture rapidly, leaving it to be finished later, and concentrated instead on the figures. *In the Meat Market, Dinan* (1902) (Fig. 2) depicts a boater-hatted meat vendor presumably weighing out the customer's purchase and wrapping it while the woman stands, hand on hips. She looks like a woman who knows her business, leaning slightly to one side in concentration as she oversees the process. In the foreground, a girl of around 10 is shown walking into the picture from the artist's right, a pose that became a favourite of the time. Balancing a flat basket on her hip, she is dressed in a simple white summer shift, with a plait that falls down her back.

From this time on, many of Hodgkins' market scenes focused on the interactions of a small number of people, whereas the white-capped women in the background, as seen here, are simply 'staffage' — there to fill the scene like the chorus in a play. A greater attention to human reaction is also seen in a work done in the fish market, with one woman furtively observing the quality of the purchase being made by the customer beside her, the old lady behind the trestle table merely sitting, hands in lap, rather than attempting to bargain with the buyer, as if she senses that the woman is merely passing the time of day.

The little town, its cobbled centre lined with half-timbered houses, was

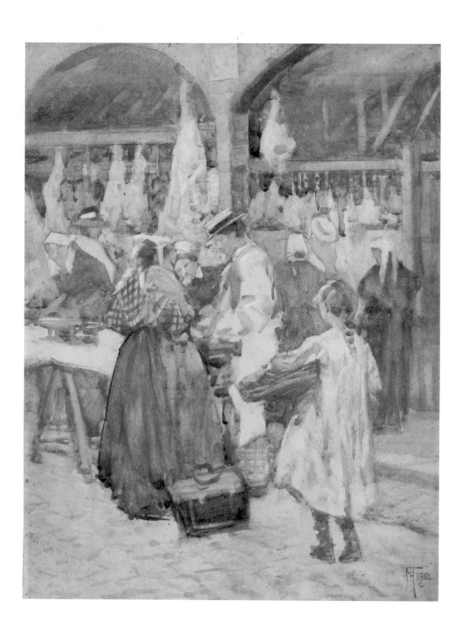

Fig. 2 *In the Meat Market, Dinan*, 1902, watercolour on paper. *Private collection.*

charm itself. Hodgkins informed her mother after she had moved on to northern Italy: 'We have had a very happy fortnight in spite of struggling with pictures & elements — we were a jolly little party — Mr Garstin, the Col, & Mr Legge & we three — ours was the only sitting room & they spent their evening round our log fires. If it was fine & not too cold we used to walk on the Ramparts. The Prof. was always so gay & amusing & the other two men were travellers & had lots of tales. What a queer little world, getting to know people so well & then saying goodbye — it is the way of life but a sad way I think. Mr Garstin went off today — such a miserable depressing sort of a day & he will have a beastly crossing I am afraid. We saw him off at the station & saw him safely into the train with all his belongings. He is much too absent minded to be allowed to travel alone. I wish you could have known him, it has been a great privilege to have had his friendship. I think of Spenser's "very gentle parfict knight" he was so courteous & kindly to everyone, & so witty & charming.'[1]

From early on Hodgkins had developed a preference for French food, although she was shocked by the amount people ate. She wrote to her mother from rue de l'Apport, Dinan, in the summer of 1902: 'I expect you get deadly weary of your own cooking — never mind wait till I get home & I shall make you wonderful French messes out of nothing at all & cook you vegetables a la Français. French cooking may make you very ill but at least it can never be dull. A good chef boasts he can create an appetite "under the ribs of death" he certainly is a man of many sauces — you may not like them all but you cannot help admiring his originality. French people are so fat & oily looking — they eat far too much. They have a huge gorge at midday which must reduce them to a state of torpor for the rest of the day. It certainly has that effect on us for at least an hour afterwards & we are only pulled together & primed for working again by afternoon tea at 3.30.'[2]

03

Tangier and Tétouan

MOROCCO

When Hodgkins set off across the Straits of Gibraltar to Morocco in 1902, you sense her delight at discovering a society that was a little wilder, a little rougher around the edges, than the well-honed and manicured towns and villages of France, with their complicated stone or half-timber buildings that she had so admired when she first arrived in Europe, and to which she was to return many times in the next decade.

On her arrival in Tangier she wrote to Dorothy Kate Richmond: 'There is a decided piquancy about the manner of one's arrival in Morocco which has its charm. One is practically hurled into Tangier & the passage of oneself & ones baggage thro' the Customs is more like the process of passing a sheet thro' a mangle than anything I have ever seen — however once we came thro' alright, the baby, birdcage, bundles & all & here we are in this wondrous land of delight — Heavens! How beautiful it is!'[1]

She was travelling with the widowed Mrs Ashington, whom she had met in Caudebec the previous year, an amenable companion who could afford slightly grander rooms than Hodgkins. Tangier — not least the smells, noise and chaos of the souk — was an assault on the senses, and the pair rapidly decided that the commercial hotel, which had been recommended by an aristocratic friend of Mrs Ashington's, would not suffice if they were to get any sleep. 'We are shaken out of our beds at gunfire in the morning. It is fired from a battery just below us & what with the Ramadaming all day & feasting all night it is hardly the place for two peacefully inclined artists to be.'[2] Through a contact of Alfred East, an Orientalist painter who was in Tangier at the time, they moved to Villa Valentina, a more substantial hotel situated on the road to Fez, on a rise nearer to the sea and with gardens behind it. On a grander scale, it was run by a kindly German woman and still within walking distance of the centre of town.

Now that they had somewhere restful to lay their heads, the city itself began to work its charms. 'The shops are the quaintest places,' Hodgkins wrote to Richmond. 'The oddest little untidy sort of cupboards with an

inscrutable Moor sitting, either tucked up on a shelf, or squatting on the floor. We haven't bought anything yet, much too frightened of being taken in. Mrs A. prays pathetically that she may not cheat the natives — I pray that the natives may not cheat me. Bad, or cracked coin as it is called abounds & everyone rings their change in a knowing manner. Being almost tone deaf I find it a difficult performance. Yesterday we stood in front of a small shop & watched a Moor cooking the most delicious looking pancakey sort of cakes in an earthen pot of boiling oil. I daresay we had that hungry resentful look on our faces that that annoying child at Dinan used to have when she glued her ugly little nose to the patisserie window when we were inside eating our rhum cakes "un petit gateau" . . . anyway the Moor offered us one each & we eat it — delicious — like toasted manna & we said so in English & smacked our lips in Arabic & he understood perfectly & now we are friends for life.'[3]

They set to work, where possible making sketches in the souk, in spite of being constantly pestered, before taking Alfred East's advice and taking portrait subjects into doorways or corridors so that they could work in peace. The situation improved when they took on the services of Absolom, one of the servant boys of a missionary doctor they had met: 'thoroughly trustworthy & good looking to boot & we are to pay him a franc a day. Yesterday we had a model — a ducky little Arab girl who we captured & painted in an aloe grove just behind the Soko — rather prickly but private & peaceful. First hour she was flattered, second, bored & finally she went off after an unseemly haggle over payment. We paid her the same as our Dinan models & plied her with chocolate. She is coming back tomorrow however so she evidently likes it.'[4]

They had also met up with David and Ethel Theomin, old friends of the family from her Dunedin days, who were travelling through Europe acquiring objets d'art for their new home, Olveston. Hodgkins was delighted when David paid her £15 in advance for a watercolour. She braved the main souk again, painting the orange sellers, their wares, along with red onions, spreading like a carpet on the ground in front

Frances Hodgkins painting a young model in Tangier, Morocco, in 1903. *E. H. McCormick Archive of Frances Hodgkins Photographs, E. H. McCormick Research Library, Auckland Art Gallery Toi o Tāmaki.*

of them, the high arched Bab el-Fah, the main gate into the medina, in the background (*The Orange Sellers, 1903*, Fig. 3). Hodgkins and Mrs Ashington were also swept up by the local English-speaking community, which included Ion Perdicaris, a Greek-American who in 1904 was to get caught up in the local conflict that Hodgkins began to follow with close interest.[5] Morocco was at that time the only independent country in North Africa, but the sultan was weak, obsessed with collecting grand pianos rather than ruling wisely. Various warlords tried to assert control, and there was constant fighting. Mathilde Bedford, the niece of the American consul, described how the Western diplomats felt it better to band together in such a chaotic environment, choosing to live outside the city walls for security reasons: 'Morocco, at that time, had no roads, not even a carriage or wheel of any kind, so we went everywhere, even at night to dinners and dances, on horses and donkeys, and if it rained, I was carried in a sedan chair on the shoulders of four Jews. No Moor would carry "a dog of a Christian", so the Jews kindly helped us out.'[6]

Hodgkins reflected the bias of the English-speaking community when she wrote to reassure her mother: 'I don't want you to feel alarmed or anxious about my being here — it is perfectly safe in Tangier & a long a way from the disturbed district where they are fighting. There are always more or less inter tribal rows going on in the interior & this particular one is over the appearance of a young fanatical Pretender to the throne who claims to be a descendant of Mahomet & therefore elect of God. The present Sultan is in rather bad odour with some of the tribes owing to his European tendencies & his strong leaning to progress & reform generally — hence the trouble but he is a strong young man & is showing himself equal to the occasion. He has done a lot of rather foolish things, which have displeased his people. Played tennis & ridden a bicycle in English dress & drunk whisky with dogs of Christians which as you may imagine no good mohammedan much less a Sultan, should do. No one knows how it will all pan out but all agree that it will be a bad day for Morocco if the Sultan gets killed & the Pretender reigns in his stead. There has been

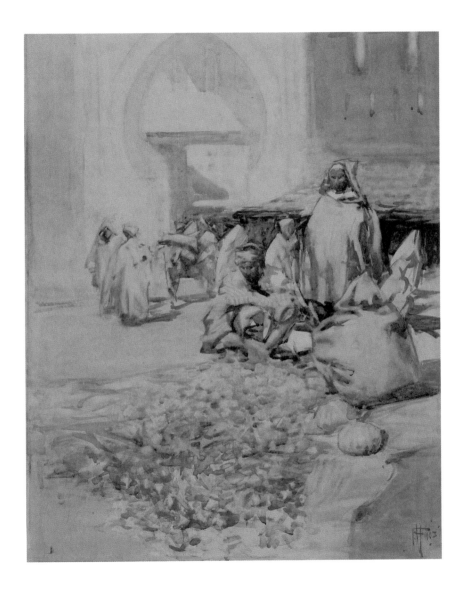

Fig. 3 *The Orange Sellers*, 1903, watercolour and gouache on paper. *Olveston collection.*

some pretty sharp fighting at Fez but all this part of the country is quiet & normal. Fez is 150 miles south nearly a week's journey over very rough country. Be quite sure at the slightest sign of uneasiness I shall make tracks — I have no desire to risk my skin — I am much too big a coward.'[7]

She was more forthcoming in a letter to Richmond, describing the inter-tribal fighting they had witnessed along the shore from their hotel. It had resulted in a few deaths, and some women being captured and placed in *The Times* correspondent's garden for safety. After the rebels were routed, the soldiers started looting, and towards evening 'they rollicked home across the sands, driving asses, goats, cattle, chickens, (no I forgot, you can't drive chickens) any way they were laden with plunder, and all next day, in the market, you could have bought a first rate donkey for 2 pextas and for a few dollars you could have stocked a chicken run, and started a flourishing milk walk. We could hear the guns, and see the smoke of the burning village, from our rooms.'

Much taken with the Basha's soldiers, Hodgkins continued: 'The dignity of these men is beautiful to see. This time they all passed our hotel, and we looked down on them from the balcony. It was supposed to be two days campaign, and they were supposed to fight two hours march from Tangiers, the enemy having retired to the hills: however the rain came down in sheets before they had got very far and whether it damped both their ardour and their gun-powder, no one seems to know, any how back they marched to Tangier in the morning and there were great tales of surrender, and peace making and sacrifices made by the enemy, and now thank goodness all is quiet, and things go on in their serene and normal manner, and we are painting peacefully in the market once more.'[8]

Having read as much as she could about the political situation, Hodgkins sent the titles of a couple of books on the subject to Dorothy Richmond in case she was interested. She spoke of her growing fascination with the Moslem faith, finding an excellent source of information in 'an old Colonel here who is more than half a Mohamedan, and spends his time pottering round among the people, for whom he has an intense

admiration and I fancy he reads his Koran a great deal oftener than his Bible — the old sinner — any way he's my great stand-by and the source of all my information, reliable and otherwise.'9

One of their fellow guests was the Austro-Hungarian legate, Victor, Count Folliot de Crenneville-Poutet, and his 23-year-old daughter, Hermine. The legation was across the road but the Count preferred the comforts of Villa Valentina, and it is apparent from Hodgkins' letters that they struck up a friendship, although Hodgkins identifies him only by his title rather than his name. At dinner he would pore over the Spanish papers for news of the conflict, muttering 'Lies, lies, lies' under his breath. Equally she and Mrs Ashington relied on the information provided by their now much-loved guide, Absolom, who no doubt evened out the bias presented in the Western press.

Not everything was grim, however. Count Viktor seems to have dominated proceedings at Villa Valentina, Hodgkins describing him as 'a man of many parts and a personage, speaks ten languages, makes an awful noise, says rude things, does kind things, plays ping-pong and the piano till all hours of the night, can't sleep at night, and tries to prevent any one else doing so, has a very pretty daughter, and apparently has tons of money . . . judging from the late hour at which he goes to his legation and the early hour at which he returns, he can't have much to do . . . he is a great sport.'10 When he gave a ball only Mrs Ashington was able to attend as Hodgkins didn't possess a ball gown, but the next evening while he played whist with some of the guests she entertained herself by going through his print collection: 'such beauties — Rembrandts, Albert Durers, Bartolozzis, and ever so many others. I just knew enough to know they were jolly good — they were all muddled together in an untidy collection in a drawer, and I couldn't resist tidying them up for him; it seemed like old times with my father's sketches and I did enjoy it. It was a chatty sort of evening, and the Count told long stories as he trumped.'11

Hodgkins also had a small exhibition of her watercolours at the home of Ion Perdicaris and his wife, Ellen, although she was unable to invite the

Count as he didn't like Ellen Varley, perhaps because she had divorced her English husband. The dislike was mutual, Hodgkins confiding to Richmond that 'he & Mrs Perdicaris are enemies — having heard what each said about the other it wld have been impolitic to throw them together in one small room with out an ambulance'.[12] Perdicaris later said he would like to buy one of Hodgkins' paintings, but by then they had been bundled up and sent out to New Zealand.

The couple were very kind to Hodgkins, and after noticing that she never came to any of the dances they invited her to a party at Aidonia, their country place in the mountains. '[A] long cavalcade of us set out on mules headed by a radiantly beautiful soldier & after him Mrs Perdicaris looking like the Queen of Sheba on a black satin Barb . . . We turned into a long drive running thro' an orderly sort of wilderness of olives & aloes & golden genesta & palmettos & mauve masses of starry periwinkle. There was a sumptuous lunch ready for us in the cool verandah overlooking the sea, & I don't know which appealed to my senses most the turkey on the table or the peacocks on the terrace. They strutted insolently up & down opening & shutting their tails with the click of a fan & looking superb in the blazing sun.

'The house is a regular eagle's nest built high on a rock with Gibraltar & Tarifa on their northern horizon & nothing human in sight but a little Spanish smuggling village tucked almost out of sight at their feet . . . After lunch we wandered round the garden. There was a temple to Vesta arranged classically over the garden pump & a Moorish mosque concealed the mysteries of the tool house & further on in a hallowed spot there was a thatched mausoleum sacred to the memory of a dead St Bernard. It was all very interesting & instructive & I come home full of information about the cork oak and the puff adder . . . They say it is never really safe to picnic in the bush without either of these two remedies at hand.'[13]

Although Hodgkins continued to mention the Count, she made no other reference to his daughter, who was proved by history to be a much more interesting individual. Despite her aristocratic Viennese

upbringing, Hermine demonstrated a strong socialist streak from an early age, possibly encouraged by her English grandmother, whom she adored. She later joined and then left the Communist Party in Germany, but never quite shucked off her nickname as the Red Countess. Fluent in a number of languages, she became a well-known writer, translating Russian, French and English texts, including work by Upton Sinclair, John Galsworthy and Harold Nicolson into German. She divorced young (having probably married to escape her forceful and exacting parents), and remarried a Jewish translator, Stefan Klein. Her autobiography describes her life at Villa Valentina, although sadly doesn't mention Hodgkins, focusing instead on her horseback rides into the countryside, causing considerable concern to her father as well as the Arab guide who was meant to be accompanying her.[14]

Hodgkins wanted to visit the coastal city of Tétouan, but didn't feel she could afford the cost of travelling there. The problem was solved when a missionary doctor offered to provide camping equipment for her and Mrs Ashington to use on the way, leaving them to cover the cost of the hire of mules, muleteers and an overseer. She wrote to Dorothy Richmond: 'We swam out of Tangier like large brown swans thro' a sea of yellow sand — into an open valley & up into the hills . . . we were very jolly and the sensation of travelling in Morocco thro' country which a few weeks before had been impassable on account of the rebellion was quite enough to keep one alert & interested no matter how tired.

'When we reached the fôndak at 5 it was blowing too hard to put up our tents so we decided to sleep in one of the little rooms which they let to travellers. The fôndak is perched high up on a ridge of the Ape Mnts a spur of the Atlas & which terminate at Tangier in one of the grand old Pillars of Hercules. It is built more for the convenience of mules & cattle than for English tourists & is rather more in the style of an old scriptural Khan than a modern boarding house. [Sketch of a fôndak] It is a hollow

square, the walls forming arched mangers for the cattle & on one side up a tiny narrow staircase are two attics about 10 ft. square, white-washed, bare & tolerably clean.

'While the men were cooking our dinner, we performed our ablutions on the roof, not being any elders about the impropriety didn't seem so great & then having scraped off some of the dust we sat huddled up in rugs & waited for the full moon to rise over Africa. Up she came a ball of gold & lit up the deep mysterious wind-swept gorge at our feet and the vastness & loneliness beyond. The yard below was full of cattle & mules all keeping a cheerful sort of munching hoofy sound which never ceased all night. A brown ghost came out of the attic door & clapped hands & in two minutes we were sitting Moorish fashion round a brown earthenware pot smelling as no pot has ever smelt before or can again. No need to say Bismillah our hungry souls said it for us. There was one prayer for the tender little chicken that had travelled alive with us all day, then our better feelings were smothered & we fished voraciously for drum sticks & wings with our own forks & sopped up the gravy in a way you would have particularly disliked . . .

'At a point where you first catch sight of Tetuan weary wayfarers have erected a cairn of stones each traveller casting a stone on it — then you lose sight of it & don't see it again till you find yourself riding up to its walls thro' a long valley with magnificent rocky hills on either side. The compactness of these old walled towns is delightful, no straggling villages & outskirts, everything snug & trim within the walls and at night when the bugles ring out at 10 o'clock there is a comfortable sort of good night All's well sound about it & you know the gates are closed & all is safe from brigands & jackals & other fearsome prowlers of these dark & lawless nights.'[15]

Their arrival in Tétouan was marked by the necessary introduction to the tiny English-speaking community, which in this case seems to have consisted of a vice-consul who was extremely grateful for some English visitors to relieve his isolation. They settled into their accommodation,

and at the first opportunity set themselves up to sketch in the market, where they immediately drew a crowd away from a local snake charmer. Absolom, who had accompanied them, felt unable to shoo the crowd away, this not being his city, so they were eventually forced to retire to the side streets where they could work unencumbered.

Hodgkins described the town to Richmond: 'I wish we could have come here in the first place . . . I have broken the onion & orange spell & have struck out in a new line and am painting wonderful little shops aglow with color under the shadow of vine pergolas supported by long spidery props, the whole emphatically repeated in clear purple on the pavement. It is really very Japanesy & Mortimer Mempes figures flit about in filabs of radiant hue — the little junior moors all wear bright colors — the soberer browns & blues are reserved for their dads — the royal shereefian green is a favorite color & catches the eye with an imperious insistance — it turns everything upside down in a picture & has to be dealt with warily but it is a gorgeous color & I have populated two of my pictures with little green gnomes.

'The whiteness & pearliness of the town simply defies you — you cant get it pure & brilliant enough & the shadows drive one silly — you race after them, pause one frenzied moment to decide on a blue mauve yellow or green shadow — when up & over the wall & away & the wretched things gone for that day at least & you are gazing at a glaring blank wall & wondering why on earth you ever started to sketch it. Cubes & domes are the general outline of things & the intoxicated pergola props take off the stiffness of things & help out compositions & foregrounds in a wonderful way.'[16]

Hodgkins probably didn't realise that she had discovered one of the keys to what she referred to as the 'modern problem' — the stripping away of extraneous detail to focus on pure form, which for her was always suffused with colour and light. The long spidery props were to find their way into her market scenes for several years, their diagonals, painted with a wet brush that dragged out the colour as it moved across the paper, leaving

shadows of pigment either side, adding a dynamism to compositions that previously had focused on the verticality of architecture.

For a brief period she relished the exposure to Tétouan's exoticism, especially the women in the Jewish and Spanish communities, who were amenable to being depicted, but the indigenous community was definitely off-limits. A visit to a harem only confirmed Hodgkins' suspicions that the country would never move forward until women had access to education to overcome their ignorance and isolation from the world. But the town was not entirely safe. Skirmishes between the Berber tribesmen in the locality meant that the road back to Tangier kept being closed. This caused Hodgkins and Mrs Ashington some anxiety, even if lulls in the fighting allowed them to escape the confines of the city and see something of the magnificent countryside. Eventually they determined they must leave if they could.

Count Viktor wrote to say he was hoping to come fishing in their vicinity and so could act as their chaperone back to Tangier. There was good news, too, from Dorothy Richmond: Hodgkins' work had hung beside that of Stanhope Forbes in an exhibition in Newlyn in Cornwall. The need to leave, however, became ever more pressing. It became clear that travelling back to Tangier by road was too risky but, fortunately, they were able to make the journey by sea. They arrived back to find their old companions in a state of anxiety about them. Hodgkins made light of it, noting flippantly: 'We found everybody anxiously looking out for us thinking we were coming by road so our tame arrival by boat fell very flat indeed. As we had been waiting for the count to offer himself up as a sacrifice, so he had been waiting for us to do the same. Now no one is allowed to go so his visit has fallen thro'.' Twenty-four hours later, Hodgkins and Mrs Ashington were on the boat to Gibraltar, and their visit to Morocco had come to an end.[17]

Hodgkins was more forthcoming about the danger they had been in when she recalled the experience in an interview with the *Sydney Morning Herald* in 1913: 'I look back upon my visit to Morocco as the real starting

point of all my work . . . My friend and I went to Tetuan, an ancient city across the Atlas Mountains. We travelled with a caravan of Jewish merchants, Arabs, and a couple of missionaries. At night we formed a camp of the animals, just as they did in the Old Testament, and we slept in a small primitive room with our Arab guards sleeping at our door. Our supper was spread on the flat roof of the little building, and there we sat and watched the moon rising up over Africa.

'The next day we reached Tetuan, and only just in time. For the following day we learned that the road had been cut by brigands, and it was not safe for us to be beyond the walls of the town. So for two months we stayed in the little city and knew nothing of the world beyond. Our chief excitement each day was seeing fresh heads being placed upon the walls!

'At the end of two months word came from the Legation that we must leave Africa. So we stole across to the sea, about 20 miles away, and there we sat for hours until a passing tramp steamer picked us up and carried us back to Europe. We did not feel that alarm you might imagine, for we were steeped in the spirit of danger which pervaded the country, and, anyhow, we had to take the sporting chance. I took a large number of sketches back to London, which were quickly sold, for Morocco was very much in the public eye at that time, and very little painting had been done there.'[18]

She was thrilled when one of her Moroccan works, *Fatima*, was hung on the line at the Royal Academy that year. The Academy was seen by the modernists as a bastion of conservatism, but its shows attracted large crowds and it was an important way of getting an artist's work noticed.

I was amused at Hodgkins' reference in one of her letters to the Pillars of Hercules, having visited these vast coastal caves in 1976 when travelling across North Africa in a camper van. We all carried lanterns inside the caves, and I was forced to keep up quite a pace to avoid our guide, who insisted on pinching my bottom every few metres. But we loved Tangier,

with its crowds and sounds and smells just as Hodgkins had described them, although she had had the luxury of experiencing the city when it was packed with animals rather than motorcars.

We had parked our van in a spectacular, overgrown campsite high above the sea, lush with tumbling orange and red nasturtiums and other familiar plants that made me homesick for New Zealand, entertaining the other campers when David opened the sliding door on the side of the van and it sailed off down the field . . . By the time we left, the door had been fixed and the van embellished with a couple of beautiful woven rugs, bought after we were enticed into a shop piled high with richly coloured wares redolent with the smell of sheep or goat wool and overlaid with a hint of dung. We sat around drinking sweet mint tea, gradually agreeing to a price for our purchases, so that even if the van continued to fall to pieces in each place we stopped during the next six months, its interior looked considerably more elegant than that of any other vehicle we were to come across.

Before we left England, we had visited Berwick Church in Sussex, famous for the mural cycle painted on its walls in 1941 by artists Vanessa Bell, her son Quentin Bell, and Duncan Grant. On leaving, I had bought Marcus a commemorative pencil from the souvenirs on sale at the door. When we left Tangier and headed to Fez and Meknes, we took a little side trip to the ruined Roman/Berber city of Volubilis, driving through early spring fields of pale-green broad beans stretching away into the distance. A little boy no more than six or seven years of age approached us on our arrival and offered to be our guide. His English was very good, and after we had visited the ruins he took us through the streets, pointing out what was being sold in the dark little shops on each side.

When we returned to our van I offered the boy some money, but he had spied the Berwick pencil on the front seat and asked if he might have that instead, and some sheets of paper. Even now, Marcus talks resentfully of the pencil I made him give away, but I have always been secretly delighted that we were able to leave a little bit of Bloomsbury in Morocco.

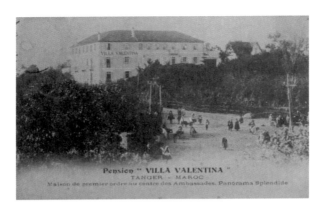

Pension " VILLA VALENTINA "
TANGER - MAROC
Maison de premier ordre au centre des Ambassades. Panorama Splendide

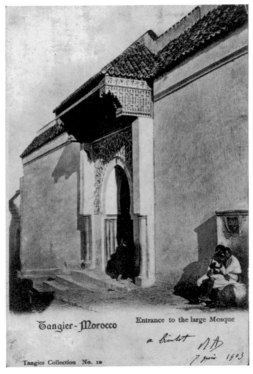

Tangier-Morocco

Entrance to the large Mosque

Tangier Collection No. 10

ABOVE The Villa Valentina in Tangier, where Hodgkins stayed.

BELOW A 1903 postcard showing the entrance to a mosque, Tangier, as Hodgkins would have seen it. *E. H. McCormick Archive of Frances Hodgkins Photographs, E. H. McCormick Research Library, Auckland Art Gallery Toi o Tāmaki.*

04

Mantua

ITALY

My old friend and former neighbour, Mary Gee, had very kindly agreed to accompany me on my first week or so in Italy and France. She has half a château in Avejan, where she spends her summers, and is far more au fait with all things French than I will ever be. We arranged to meet at a writers' residence near Mantua in Lombardy, Italy, that had become a second home for the owner after his original palazzo, where Mary had stayed in the past, had been destroyed in one of Italy's many earthquakes.

The taxi from the station in Mantua took me across a flat plain, through fields of young soft-green wheat waving gently in the spring breeze. As we drew near, I was surprised when the driver swept past the grand if faded baroque villa nearest the road, and came to rest outside a two-storey capanna or barn behind it. A small flock of goats immediately surrounded the car, nibbling on anything not tucked out of sight. After being greeted warmly by our host, I was taken up to the room that Mary and I were to share. It was large and airy, with two narrow beds on one side, and piles of enormous, ancient leather-bound books stacked awkwardly among chests and other paraphernalia. We were evidently to sleep among some of the items, still liberally coated with plaster dust, that had been rescued from the ruined palazzo.

When Mary arrived the next morning her eyes widened slightly when she saw our eccentric sleeping arrangements, but by then I had succumbed to the place's charms. Lunch and dinner each day were prepared communally, and eaten underneath a huge elm tree every evening was hung with candles suspended in jars. Our host was a remarkable plantsman, and in one of the dilapidated buildings that littered the yard he had a vast array of plants and cuttings in terracotta pots, all waiting the day when he would once more have a home of his own.

By this time I had gleaned that some of the guests were there to write, some to compose music, and others to learn Italian from the laid-back, blonde-haired German/Italian woman who masterminded the cooking when she wasn't relaxing in a hammock outside. Mary and I borrowed a

couple of ancient bikes from the stack lined up in a barn, and set off to cycle along the narrow lanes and paths to Mantua itself. I hadn't ridden a bike for many years and I was relieved not to tumble into a ditch or, worse still, knock someone else off the path. Thanks to the scrap of leather that purported to be the bicycle saddle, I was barely able to stand by the time we returned, but I was then inveigled into helping our host trim the hooves of the goats. I can safely say I have never had a male goat's head cradled in my lap in quite that way before. When their grooming was finished, a group of us herded them across the field, bathed in late-afternoon sunlight, then through the trees to their two-storey wood-and-wire mesh enclosure for the night.

Sadly, after three days we had to depart, for research awaited us and there was nothing for it but to take the train to Genoa en route for France. I had booked us into a modest hotel across the road from the Genoa railway station in a similar but perhaps slightly grander residence than Hodgkins had stayed in on her first trip to the Italian Riviera with Dorothy Kate Richmond in 1901. They had experienced a frustrating visit to Rapallo and San Remo, which they found overrun with English tourists, paling in comparison with the recent delights of the markets and everyday rhythms of Arles. At the market Hodgkins had been highly tempted by the pottery with its pretty local decoration but she had learned her lesson in Caudebec, where she had bought masses before realising she couldn't carry her purchases and they were too fragile to ship home. In later life she drew and painted pottery instead, and it was only when she settled in Corfe before the Second World War that she could finally acquire a few pieces of her own.

She described to her sister their final dinner in Arles: 'a most interesting meal, with an entirely fresh experience in the gastronomic line. We were feeling a little depressed and in need of a fillip to our faded appetites so we consulted our garcon who strongly recommended

"escargots" "tres bon et tres delicieux". We ordered accordingly & waited expectingly — it came in the guise of a delicious brown gravy over something we know not what. We were handed wiry two forked prongs which might have warned us and we fell to expecting a treat. Imagine our feelings when we exposed to view a large dish of snails. I ordered them away peremptorily and Miss R. ordered them back equally peremptorily and I sat still, quite petrified with horror while she tickled it out of its shell with the prong thing — and eat it — and her face was white & set with a sickly look while I told her if she spat it out in front of the table d'hote I should leave the room.

'So she swallowed . . . French cooking is villainous and I am longing for a decently cooked dinner and for a day beginning with curly bacon and ending with a pudding fit for a Christian to eat. They eat all sorts of small birds, larks, wrens, sparrows and sometimes I have actually seen goldfinches for sale in the market, to say nothing of thrushes & blackbirds. The consequence is there are not nearly so many singing birds in the woods.'[1]

05
San Remo
ITALY

In November 1901 Hodgkins and Dorothy Richmond moved to San Remo in Liguria in northwestern Italy, not far from the French border. They stayed in Villa Solaro, which belonged to an American artist. They were there for only a fortnight, but they were recovering from colds and so appreciated the 'home comforts, olive wood fires, hot baths, good plain English cooking and plenty of books & magazines'. Hodgkins described her hostess's studio to her mother: 'a perfectly delicious place, top light, oaken furniture, old masters, Eastern Rugs . . . with a window opening onto a sunny loggia with marble steps down to the garden'.

Miss Astley, a young woman whom Richmond had got to know in England, had joined them for watercolour classes in Arles before moving on to San Remo. Her weak lungs meant she had to winter over in the south in the villa she had taken with a companion, and she invited Hodgkins to stay so that she could continue her classes. Hodgkins told her mother that Miss Astley was meant to spend 22 hours out of 24 out of doors: 'She sleeps out side and only comes in for the 2 hours before & after sunset. It is a very wonderful treatment and how widely opposed to the old methods of treating tubercular troubles. For my own part fresh air is a very nice thing but it wants to be taken judiciously and I used to think sometimes when sitting out under the stars, dressed as for an Arctic expedition that it would be infinitely more comfortable with my feet on the fender before a blazing fire. To be truthful, I only spent 2 or 3 evenings outside on account of my cold, but it was quite enough to persuade me that a wood fire with a novel in doors was more to my taste than starlight & poetry outside.

'We went for several beautiful drives and one day we climbed the hill behind San Remo and followed an old mule track thro' the olive woods which are planted terrace-wide along the hill sides till we came to an old deserted town mouldering mysteriously between two ridges of the hills. It was weird to come on it suddenly from a bend in the track, its windowless walls staring at us like deep eyeless sockets and a crazy old campanile or bell tower toppling over in the last stage of decrepitude, &

over all a pathetic silence broken only by the cheerful tinkle of the goat bells. This is only one of the many small towns that were ruined by the big earthquake somewhere in the early seventies the people deserted then & never returned. Fancy in my wanderings one day on the hill I found a ngaio tree. I could hardly believe my eyes & was glad when Miss R. bore me out & verified our old N.Z. friend.

'. . . The Italians as far as I have seen them are picturesque but not to be compared to the Normans or our friends in Arles, whose beauty has quite spoilt us I am afraid for other types. The Italian are a small vizened toil worn looking lot — they are so desperately poor — poor souls, ground down by heavy taxation to support army & navy — food is dear in consequence & if it wasn't for their beautiful climate life would be an intolerable struggle for many of them. When the olive crops are good all goes well but when they fail there is much hunger & distress, begging is an "industry" & besets you on all hands, you have simply to harden your heart, tighten your purse strings & pass on. You walk up a mountain mule track & you meet an old peasant singing lightheartedly, driving her goat or donkey, she sees you — instantly her face changes, lengthens into an expression of unspeakable misery, & she whines out a pathetic appeal mixed with blessings from all the Saints, and which she turns with much volubility into the blackest curses if you give her nothing.'[1]

Miss Astley encouraged the two friends to find accommodation in the town so that they could stay on for part of the winter, but Hodgkins found the large English population irritating and so they determined to move on to Rapallo, south of Genoa. Both she and Richmond were travelling with their bicycles, which they rode out on day trips in search of suitable subjects until Hodgkins' bike got badly mangled on the train ride between San Remo and Rapallo, and they had to stop in Genoa for repairs. They took lodgings in a 'small & very clean German Inn, more polyglot than strictly German — for the Innkeeper welcomed us in fluent Teutonic, the chamber maid showed us to our rooms in the most graceful Italian and the waiter obsequiously served us in very excellent French, and to complete this

incongruous mixture of nations an Asiatic flavour was given to us by our table companion who was a genuine & very refined pigtailed Chinaman.'[2]

Hodgkins reported her impressions of the city: 'The old town is a network of tall narrow streets, badly lighted, badly paved, unsavoury & very picturesque. The newer part is less interesting but vastly more sanitary, electric trams & light & broad streets with modern building large & ugly . . . One street we thought very beautiful, old Renaissance palaces, a succession of them, lining the long street on both sides. Stately old houses, with beautiful portals and the painting on their faded façades wearing that look of ineffable beauty that only old age and the sun of many centuries gives to marble — it made one think of all the days when the Guelphs and the Gibellines warred eternally with each other and the old town was split up in party factions.'

The street she was describing was via Garibaldi, which today is a world heritage site, its palazzi now public museums. Even then the palazzi had open days, and Hodgkins lamented the fact that they weren't there at the right time to feast on the Rubens, van Dycks, Titians and so on that lined the walls.

She described their travel arrangements, with Richmond doing 'all the ticket-taking & registering & I am generally told off to sit on our luggage and see that no one molests it, and keep a tally of accounts which we generally square up in the train'.[3] They hadn't booked any accommodation, and found they had to spend some time hunting for a place they could afford, 'a modest looking little Inn, quite unpretentious but very clean looking — it looked more in our line so we ventured in and we were so impressed by the kindliness & hospitality of the padrona and his wife and liking our rooms so much we decided at once to stay where we were & send for our luggage. They do us for 5.50 — & we are really very comfortable indeed. We have two bedrooms opening on to a sitting room the use of which they have given us. The food is quite good, tho' plain & there is plenty of it.

'Today is our first wet day and we are indoors both writing, our feet on delicious hot Scaldinos (charcoal stoves) such cheap luxuries as fires,

hot plates, baths etc are unknown in France & Italy. At first they only gave us one Scaldino between us, but I found that Miss R's feet were so much ahem! larger than mine that I came off very badly indeed as regards heat so I petitioned for another and now we have ceased quarrelling and have one apiece. I shall bring one out with me for my studio.'

Hodgkins preferred smaller villages to the urban sprawl that was already starting to crowd the Italian Riviera, finding compensation in the local working people, not least the lacemakers, who worked on their doorsteps, where the light was better for such close work and, while the weather remained fine, it was pleasant so long as they were out of the wind.

She also discovered what she described as a disreputable but picturesque family of gypsies living in a bright-green caravan on the outskirts of town. She persuaded them to sit for her, communicating 'with the aid of a few Italian terminations tacked on to a solid ground work of pure Saxon and all I know of French and a few Teutonic roots, flung in for flavour — this language with the additional aid of my 10 fingers and a corresponding number of copper coins will see you thro' in any country. The father gipsy had a wooden leg, the father's friend has one eye but the donkey, the two eldest daughters of the house and the sons are beautiful and it is them I am painting lighting a fire while the blue smoke curls across the green caravan and a bright jumble of color in which donkey and all their bright colored clothes help to join a harmonious whole.'[4]

Only Italian was spoken at their accommodation, and this forced her to try to learn more of the language, helped by lessons from Richmond, who was reasonably fluent. They met up with a German gentleman, also staying there for his health, who expressed interest in their work, and Hodgkins was amazed to find that Richmond seemed to be fluent in that language as well. Then bad weather set in, and they were forced to spend the next fortnight indoors, which proved trying to their patience as well as their tempers.

On 22 December she managed to venture out between showers, watched closely by an Italian artist: '— you never saw such excitement

he applauded every stroke & got so worked up I thought he would have a fit, & whenever I put on color he didn't approve of he ground his teeth & snapped his fingers with disgust — finally I entered into the spirit of it & feeling I was on my mettle I turned out quite a smartish thing. He acted as an excellent bodyguard & kept all the small boys off, threatening them in violent language whenever they attempted to approach — he was a nice old man, & we had a little polite conversation in French after he had calmed down a bit — & with many compliments we said goodbye.'[5]

Finally the bad weather drove the two women back to San Remo in time for New Year's Eve. Miss Astley's health had declined, so they stayed in a hotel rather than at the villa, before moving westwards again to Oneglia, thinking that this was where they had glimpsed 'a wildly beautiful town with wonderful grey roofs & crumbling mouldy old houses, set on the hill side among olive woods' from their train window.[6] Only when they had gone out into the countryside on their bicycles did they discover that the place they were searching for was Porto Maurizio, a pretty little town tumbling down from a church at the highest point to the sea before spreading out along a broad white beach.

Hodgkins boasted to her sister that she had done more than 50 sketches since coming to the Riviera, most of which she intended for the New Zealand market.[7] Those watercolours identified from this period are either market scenes or views of boats tied up in the harbour, their calm waters reflecting the buildings rising beyond it. San Remo and its neighbouring towns have long been famous for flower growing, and the markets would have been ablaze with colour at the right time of year. In the winter months the markets mostly sold plants in terracotta pots, and cut flowers were also there in abundance from late spring onwards.

Richmond and Hodgkins had made friends with a Signorina Stella, 'a young girl, half Italian half English, who lives in a romantic old villa with her companion on the top of a very steep hill at the back of Oneglia, the olives stretching right down to the sea being her property. She is good looking in a dark rather haughty way, rather like her own slim well bred

hound which follows her about. We had tea with her today, or rather we had tea & she had coffee and cigarettes, & we thoroughly enjoyed ourselves — she came for us in a dandy little mule-cart & drove us up to her rather dilapidated but very artistic house — situated at the very top of a steep conical hill — round which the road winds.'[8]

The kind signorina promised Hodgkins the free use of her peasant women as models, allowing her some financial savings. When another acquaintance, a Miss Welton, whom they had met through Miss Astley, left them after spending a few days in their company in the hope of receiving lessons, they fleeced her of a number of articles before she left: 'tin of cocoa, ditto tea, ditto bull's eyes, hot water bottle (cost her 17/6 bought it for 2/6) all her literature, novels, papers etc cobalt (all she had) a priceless tube of rose madder and her methylated spirits. She said she had never fallen among such thieves & considered herself lucky to have escaped with her skin.'[9] Finally, when bad weather and the threat of smallpox made life unsettling, Hodgkins and Richmond decided it was time to return to England, making plans to go to Penzance and then back to France in the coming summer, before finally returning to New Zealand.

Both were waylaid for 10 days after they were inoculated — Hodgkins doesn't say for what. When they finally set off they were alarmed to hear from some English women who had been staying at the Cargill pensione in Rome of the dangers of train travel, and that it wasn't uncommon for ladies on night trains to be chloroformed and robbed. Hodgkins assured her sister after her return to Penzance: '[W]e determined to take all precautions & if necessary fight for life dearly, so accordingly towards evening we arranged a deadly sort of mantrap of string & hat boxes & umbrellas & having strapped up the door securely we lay down to sleep & had no sooner composed ourselves when the guard came round for the tickets & wanted to know in good strenuous French what we meant by tying up the door — so we had to knock down our barricades & we spent a sleepless & interminable night — waiting for the burglar who never came — Towards dawn a phantom guard appeared & told us we wld stop

for coffee at the next station — and red-eyed, sleepy & dishevelled we crept out & drank in gloomy silence the most delicious cup of coffee that ever warmed the heart of man.'[10]

She was distraught when she discovered that the watercolours she had sent back to New Zealand had been sold for far below what she had anticipated. She should, she conceded, have thought to give clearer instructions as to what she expected, but she couldn't help adding: 'Those market scenes are more the outcome of great mental strain, with nerves at a tension & eyes bewildered with an ever moving crowd & ones senses all alert & linx eyed for effects & relations one thing to another. This all sounds so peevish & cross & ungrateful — perhaps I am a little tired and overwrought.'[11]

For some reason, perhaps because the gods decided that it might be good to have a contrast to our Mantuan abode, Mary and I were upgraded to the much grander hotel next door to the place I had booked in Genoa: bathrobes and slippers in a gold bag were even laid out for our delectation on our beds. Little did I know that this was to be one of the great hotel highlights of the next three months.

The following morning, we travelled from Genoa to Ventimiglia, where we had to change trains. It was only when we were waiting to depart that we realised we hadn't validated our tickets. With four minutes until the train left, I was out the door, down the stairs, through the underpass and up the stairs into the station, where I rammed the tickets into the machine until it made the appropriate stamping noise, down the stairs, through the underpass, up the stairs and back onto the train just as it was about to leave. This gave a group of Africans a great deal of amusement. Needless to say, there wasn't a ticket inspector on the train, but when we stopped at the first station on French soil a gun-toting squad of police gave the poor Africans a going-over until they were able to prove that they were bona fide. Two nights later, in Nice, the army came sweeping through the port while we were eating our fish soup. Welcome to France!

06

Nice
FRANCE

The web page for our accommodation in Nice had shown a charming room, but the reality on our arrival proved to be different. We had to ring the bell to gain entrance to the hotel, and it was locked again smartly behind us before we were taken up to our room. The streets in the poorer end of town are layered with the dirt of ages, and our room's sloping white-tiled floor became smudged with black as soon as we entered, while the beds threatened to roll us out across it in our sleep. In the tiny blue-tiled bathroom a collection of defunct pipes jutted through the wall, suggesting an unimaginable but more complex former life. Somewhere along the way I had managed to crush my hand against my suitcase and it had turned an alarming blue-black. Had Mary not been feeling unwell, I would have suggested we move.

There was nowhere to hang anything (not even a towel), so after washing some underwear in the minuscule basin I tried draping them off the door handle and the edge of the terrible pop-art reproduction of a pair of bloated red lips which the owners evidently felt gave them the right to name the 'Art' Hotel as they did. These attempts did nothing for the overall ambience, so I decided it might be more practical to stretch my twisted travelling clothesline between the shutter hooks overlooking the alley out back.

I had used this technique frequently when studying in Florence in the 1990s, in spite of alarming the frightfully civilised members of the Circolo Unione on the floor below my hotel, who could not have anticipated that my netherwear would tumble onto their neat terrace with its traditional clipped box plants and smart garden furniture. Nice proved no different. When my bra plummeted onto a set of dangerous-looking electricity wires crudely wrapped in black plastic, I was forced to lean perilously out the window to recover the offending garment. Mary, barely suppressing her laughter, promised to grab my feet if I seemed to be leaning too far.

Mary had spent quite a lot of time in Nice over the years, and it was lovely to have a guide who knew her way around. We spurned the bus and climbed the steep hill, where the houses became grander the higher we

went, to the Matisse museum. Matisse lived in and around Nice for much of his later life, capturing views of the sparkling Mediterranean through curtained, shutter-framed windows. He revelled in the Riviera's white-sand shores, not just for swimming but also for canoeing.

We passed a vast cream hotel, its façade covered with tiers of narrow black art-nouveau railings. It was named after Queen Victoria, who had once been its most famous resident, which explained why the surrounding streets were named Regina, Edward, Queen, and so on, and why the broad sidewalk beside the sea is called Promenade des Anglais. Alongside these nineteenth-century English hangovers, parts of Nice retain elements of Italian influence, and the Matisse museum is no exception. Its rich Pompeian-red walls and deep-cream sills make it look as if it has floated to the top of the Cimiez Hill from the Bay of Naples. It sits on one side of what was once a manicured park, at one end of which is the magnificent ancient Franciscan monastery of Our Lady of Cimiez, its gardens looking down to the old harbour.

Both Matisse and Raoul Dufy are buried in the cemetery there, so it seemed a fitting place for a moment of reflection before entering the museum itself. On my first visit, the park bordered by the monastery and the museum had a utilitarian edge. Children played in the dirt, a rudimentary café sold toasted cheese sandwiches and ice creams, and young lovers, their chastity protected by two layers of denim, were entwined under the sparse olive trees. More recently, it has been pruned, cleaned and tidied, and is very pleasant.

The forecourt of the Matisse museum is more elegant, with neatly clipped bushes in tubs, and inside the rooms are spacious and light-filled, a balm to the soul. The collection isn't huge, but it was an excellent starting point for thinking about Hodgkins' favourite motifs. Here were the same tree forms she would have seen at the Matisse exhibition in Paris on her way to St Tropez in 1931, as well as his use of calligraphic strokes and impasto surfaces. A display of Matisse's photographs demonstrated his own love of ceramics and jugs, and a further resonance could be seen in

his works from the 1940s, when he started piling still lifes on chairs, just as modernists like Cézanne, Van Gogh and Hodgkins had done before him.

In an innovative painting done in St Tropez after she had seen his work in Paris, Hodgkins not only used a particularly rich red favoured by Matisse, but also introduced flat planes of colour in certain parts of the painting (*Red Jug*, c.1931, Fig. 12, see page 102). I was also delighted to note the links to Polynesian tivaevae in Matisse's later cutouts after he travelled to Tahiti in Gauguin's footsteps in 1930, in particular the perforated leaves of *Monstera deliciosa*.

Further down Cimiez Hill is the equally lovely Chagall museum, a contemporary building purpose-built to house his paintings, with rooms interwoven with pools of water bouncing light up the pale stone walls.

In Hodgkins' day the old port in Nice would have echoed to the shouts of fishermen, the tang of fish and damp nets, and the serenade of rangy cats eager for the odd fish head or tail. Now the streets nearest the sea are lined with restaurants, which on balmy summer nights are full of diners luxuriating in the pleasure of eating out of doors. You can select the venue you want by observing the quality of the food on people's plates, and nobody seemed to mind our inquisitive gaze.

Tucked in among the eateries are specialty shops, such as Alviari, its olive oil sold in beautifully designed and wrapped tins. In the 1920s a good simple olive oil may have sufficed, but today you can buy oils infused with lemon, truffles and other aromatics, and containers range from huge tins that would keep a hotel going for a year down to narrow tins like perfume bottles fitted with a nozzle — perfect for a picnic or a souvenir and just the right size to tuck into a suitcase. I bought two, one to sustain me over the next three months, and another to take to friends of Mary's in St Raphael, where we were to stay when we moved on to St Tropez.

07

St Paul
du Var/
St-Paul-
de-Vence

FRANCE

Mary had valiantly offered to be my chauffeur, as I didn't trust myself driving on the right-hand side of the road, so on the Monday morning we hiked to the office from which I had hired a car online. Fiats are deceptive, being narrow at the driver's eye height but much broader in the beam, a configuration that was to prove nerve-wracking on the narrow, winding roads with their rough stone walls hovering near the kerb. In the hills above Nice a cluster of villages — Vence, St Jeannet, St-Paul-de-Vence (also known as St Paul du Var, after the river that flows below the town, and the département in which the town is situated), La Gaude and Pastorale — cling to the hillsides, the snow-capped Pyrénées looming in the distance. In summer the narrow-terraced hillsides surrounding the villages are laden with olives, vines, almonds, oranges and vegetables, and fig trees hang over the pale creamy-yellow walls, often tantalisingly out of reach.

Hodgkins stayed in several of these villages in the mid and late 1920s, and each in its own way proved vital to new directions in her art. St Jeannet and Pastorale are probably little changed since she was there in 1930, but in St Paul, where she stayed from mid-November 1923 to the end of June the following year, the tourist trade has more than made its mark, partly thanks to the beau monde reputation the village developed in the 1950s, when artists, writers and film stars summered there. Paul Signac, the pointillist painter who moved from using the short brushstrokes of the impressionists to creating canvases solely comprised of dots or points, is often held responsible for the change after he bought a house in St Paul and invited friends to stay. Even so, there is still great charm in a lovely stone-walled village, not least on a bright summer's day.

Having left the car in a parking building burrowed into the hillside, we climbed up and entered the old town on foot. The steep road crosses a bridge over a gully, passing a large shop on the right that specialises in the types of embroidered cloths, napkins and curtains that are found in many places around the Mediterranean, particularly Italy and France. The Provençal people specialise in scallop-edged, cut-work and tambour

CLOCKWISE FROM TOP LEFT La Gaude; the donjon where Hodgkins lived when she first got to St Paul; a view of St Paul from the hill opposite.

CLOCKWISE FROM TOP La Place, St Paul; the Matisse chapel; inside the Colombe d'Or restaurant (photo by Fran Davies).

embroidery, often using a meander pattern that looks back to earlier Greek influences. Traditional Provençal fabrics with their stripes and sprigs became very popular in furnishings when Napoleon ruled Italy briefly at the beginning of the nineteenth century. Many homes continue to use these types of curtains and tablewear, although the traditional costume, which also incorporates embroideries, is now worn only on special occasions.[1]

The road then leads into a pretty tree-lined square, embellished on one side by Colombe d'Or, the restaurant made famous in the 1940s and 1950s by artists such as Picasso, Braque, Signac and Dufy, as well as film stars like Jean-Paul Belmondo and other members of the artistic glitterati. The restaurant had humble beginnings, opening as Chez Robinson only five years before Hodgkins arrived. It was run by a local farmer, Paul Roux, and his wife Baptistine. Impoverished artists paid for their meals with their wares, and a sign over the door still reads 'Ici on loge à cheval, à pied ou en peinture' (Here we host those on horseback, on foot or with paintings). Roux's generosity proved to be astute, and today the whitewashed walls of the Colombe d'Or display works by Picasso, Braque, Miro, Chagall (he lived here from 1966 to 1985 and is buried in the local cemetery) and others. Its many-paned windows open out onto a beautiful tree-shaded courtyard, where the tables are set among sculptures.

Across the square is a second restaurant and the customary stone lavoir for washing: it's no longer in use but an important reminder of women's communal work through the ages. Alongside these nods to tradition, in the historic centre of St Paul there are discreet, elegant art galleries which in the tourist season could easily be overlooked, overwhelmed by the garish colours of tourist scarves, violent daubs by would-be artists and the clashing glazes plastered across hideous contemporary ceramics for sale in tiny shops that line the streets. The ceramics look as if they have been extruded from some factory in the hinterland, but equally may have been created in studios nearby — I fear the former. Strip those away, and the stones, the vertiginous lanes winding through overhanging

buildings, the arches that suddenly reveal glimpses of the valley beyond the village walls remain the same.

The month before she came to St Paul, Hodgkins had seven works included in the 1923 Salon d'Automne in Paris: an oil painting of some gypsies, a still life, two watercolours of the flower market in Nice, and three figure studies. As a result, she would have begun her stay in St Paul feeling that she was once again making her mark on France. Her journey from Cagnes on the outskirts of Nice was made more pleasant by the newly installed electric tram that passed below the village on its way to Vence. Extremely convenient for visitors, it was of equal importance to the local farmers, who could now get their fruit and vegetables to the market in fresh condition. And in late summer the air would have been heady with the smell of lavender, which along with other flowers was used in the making of perfume.[2] With the growth of motoring, the need for the tram diminished, and it stopped running in 1932.

The village is ancient, and by the fourteenth century had become wealthy, serving as a county town for all the surrounding villages. Its protective walls were extended and strengthened in the mid-fifteenth century by King Frances I to withstand the more sophisticated weaponry of the day. Parts of the walls have weathered or tumbled into the valley below, but you can still walk around the ramparts, provided you have a head for heights and stout boots.

As befits St Paul's defensive past, there is a tall donjon or prison tower attached to what is now the town hall, since converted into lodgings. It was here that Hodgkins rented two small rooms, one as a studio and the other for sleeping. Although the rooms were somewhat cramped, she felt at first that the sunshine made everything seem possible at a time when wintry Britain was shivering in the cold. She had one meal a day at the inn, and prepared the other two herself, partly because the exchange rate was poor, but then she noted: 'I always have to wear a hair shirt & am inured to economy.'[3]

The walls of the donjon were a metre and a half thick, but they failed

to keep out the winter chill when it arrived, and if she wanted a gentle reminder of the building's past life the room next to hers still had iron rings and chains attached to the walls, though it was in the process of being converted into a lavatory. She found it all rather spooky at night when she was alone in the building, and she kept the fire burning brightly to keep away any sad ghosts who might wander the corridors. Gradually, the romance faded, and it would take the arrival of spring for her to succumb once more to the area's charms. She had a small exhibition in London just before Christmas, but it was overshadowed by a Van Gogh show at the Leicester Galleries. One reviewer in the *Morning Post* called her a disciple of his, which she hotly refuted, although she said they shared two things — poverty and a touch of ecstasy.[4]

Today the paths in St Paul are paved with large oval pebbles set sideways into cement and laid in the shape of the girasole or sunflower. An aesthetic pleasure, they are also practical, for without their raised surfaces the lanes would be treacherous. Cobbles set in patterns are a Provençal tradition, but as they weren't laid in St Paul until the 1950s, Hodgkins would have had to have been extremely careful on icy winter mornings. In summer the openings set in the walls allow wafting breezes to cool the baked stones, but she may well have silently cursed them in the winter. Finally the arctic temperatures forced her to move to a building on the sunnier side of the village at the highest point of St Paul. This entailed climbing a large number of stairs to get to her room.

She managed to retain her sense of humour when writing to her mother: 'The wall paper rather like a striped bandbox & makes you feel like a faded old last year Hat. The bed with 10 heavy crochet counter panes & canopy a cupboard wh is locked and an ancient oil stove with a leg missing & a scanty wick. <u>But</u> the view — <u>and</u> the sun they make up the list of blessings. I can't think of any other blessing at the moment unless it be that I don't squint. A little old Demoiselle is the landlady — has no teeth & talks a patois but we get along somehow.'[5]

Hodgkins' inspiration for her painting at this time was drawn from

examples of modernism she had seen in Paris in the first decade of the twentieth century, particularly Picasso's and Braque's introduction of cubism. This was possibly reinforced by more recent discussions in Manchester with her friend Karl Hagedorn, an artist who had studied in Paris before the First World War and who had retained a cubist style in his work.

The watercolour landscapes traced to this period show her setting up her easel or board (to which she pinned paper as a protection against sudden gusts of wind) at suitable vantage points. One work looks back at the village from above the chapel of St Claire outside the walls near the olive-oil mill (*St Paul du Var*, Fig. 4). From there you can look across to the stone walls of St Paul and the geometric buildings rising above it, ending with the tall, square bell tower of the church. However, she has elevated the hills in the distance so that they rise up, creating an undulating contrast with the tightly packed vertical houses. Hodgkins included one minimal palm and a couple of pruned trees, bare in the winter sunshine. Today, exotic palms tower above the cypresses, but St Paul itself remains much as she painted it.[6]

As well as watercolours, she produced a set of more experimental oil paintings, building up her forms with faceted planes which she then painted in gradated light to dark tones. In *Three French Children* (1924) (Fig. 5) the faces are sculptural, yet they retain individuality, the older girl to the left gazing out, her face pensive, while the boy to the right looks away out of the canvas in three-quarter pose. Between them sits a much younger child, her rosy face gazing tentatively at the artist, her torso turned as she clutches her sister's hand.

Hodgkins used the same palette of pinks, blues and emerald green in *Gloxinia* (1924) and *Child in a Pram* (Fig. 6), on which she worked later in Manchester. This latter composition proved so frustrating that she threw it away, and only her friend and student Hannah Ritchie's foresight saw it quietly removed and hidden away for posterity.[7] Her pièce de résistance from this stay in St Paul was *Red Cockerel* (Fig. 7),

ABOVE **Fig. 5** *Three French Children* (also known as *French Children*), 1924, oil on canvas. *Private collection.*

BELOW **Fig. 4** *St Paul du Var*, 1924, watercolour over pencil on paper. *Private collection.*

ABOVE **Fig. 7** *Red Cockerel*,
1924, oil on canvas.
*Dunedin Public Art Gallery,
purchased with funds from
the Dunedin Public Art Gallery
Society, 1957.*

BELOW **Fig. 6** *Child in
a Pram*, c.1925, oil on
canvas. *Auckland Art Gallery
Toi o Tāmaki, purchased 1956.*

again almost certainly painted on her return to England. She retained this pattern of working for the rest of her career, starting on one vein of painting in response to a place, then gradually paring back as she drew on her accumulated sketches and memories of place. In *Red Cockerel* she created a more complex and abstract composition, with the hanging bird, its feet bound, against a frieze of chevrons and rectangles, and two smaller abstracted partridges merging on the left. While the same pinks used in the series are highlighted in the background, she has eradicated any complicated brushwork around the edges so that the objects seem to float in space, like a Dutch or Spanish still life. A great deal of thought has gone into the composition, and she remained delighted with the end product when she chanced across it again in later life.

Professor Roger Collins of Dunedin spent much of his spare time in a busy academic life researching Hodgkins' travels in France, moving from village to village and acquiring a treasure trove of postcards of the hotels she stayed in and the local sights she may have seen. He kindly sent me a photocopy of the autobiography of the French chef and cookery book writer Xavier Marcel (commonly known as Marcel Boulestin), who had moved to London in 1906, opening a modern interior design shop in Belgravia at the end of 1911 that sold wares sourced from French producers. Some of his aristocratic clients were also supporters of the Omega Workshop set up by Roger Fry, Duncan Grant and Vanessa Bell, with assistance from other 'Bloomsberries'. After the First World War it was impossible to get the quality materials Boulestin needed for his fabrics and paper lampshades, and the business closed. It had never made a profit, and he relied on his editing and publishing to make ends meet.

In 1923 he published *Simple French Cooking for English Homes,* which revolutionised British understanding of French food. It had a delightful cover, bright yellow, with two cows one above the other, the top one facing left, the lower reversed. Across the top cow's belly was the word *Simple;*

French Cooking was set in the gap between; and *for English Homes* ran across the belly of the lower cow. He opened his eponymous first restaurant off Covent Garden in 1926. Hodgkins certainly met Boulestin, but we can't be certain when.

His autobiography, first published in 1936, contained a number of portraits of him. The artists, who were also friends, included Leonetto Cappiello, a French-Italian painter, better known for his poster designs, who first knew Marcel in Paris (1899); the extremely witty caricaturist Max Beerbohm, who created Boulestin's portrait sketch in Dieppe in 1905; the artist, designer and illustrator Jean-Émile Laboureur (1919); and the French painter Marcel Gromaire (1925). There is also a bullet-headed sketch by Frances Hodgkins (Fig. 8), which Boulestin dates as London, 1924. Hodgkins was in the south of France for all of 1924 as far as we know, unless she made a brief visit to London of which there is no record. Only her signature appears on the sketch, but both the style of drawing and its modelling, using heavy shading to capture Boulestin's fleshy features, suggest a slightly later date than the Spanish sketches done in Cassis and Martigues in 1921, for example, without cubist overtones. It also fits better with some of her remarkable charcoal and pencil portraits produced in France and England in the second half of the 1920s. There is no reference to Boulestin's name in the known letters of Hodgkins, and as Boulestin's autobiography wasn't published until 1936 it is possible that he was mistaken about either the place or the time of the sketch.

Hodgkins referred to the presence of a renowned cook in St Paul at the end of 1923, at the time of a visit to the village by the Duke of Connaught to one of his relations who was renting Paul Signac's house for the winter. She described the relative's retinue as stretching 'over the hill side — Scotch nurse, governesses, chauffeurs & various rather jolly kiddies by a previous husband, Nelson the cheap editionman who left her wealth. She is rather a beauty. When the Duke came to visit them he was given a lunch cooked by a French artist who is also a chef of a high degree. I wonder how he enjoyed it?'[8]

Fig. 8 Sketch of Marcel Boulestin. London (?), 1924. *Reproduced in X M Boulestin, Myself, My Two Countries ..., Cassell, London, 1936, p. 278.*

Could this have been Marcel Boulestin? Could he have taken time off from his busy life in London to come to the south of France and cook for the Duke of Connaught, whom he may have met through his aristocratic patrons in London? Or did he cross paths with Hodgkins when he started making food recordings to be broadcast on the BBC, starting with recipes from southern France in 1924? Hodgkins' letters are tantalisingly silent on the matter. Boulestin also knew the English artist Walter Sickert, and he went on to spend time in Manchester, so there are a number of places where they might have met.

Although Hodgkins' time in St Paul proved lucrative — she wrote of having sold black-and-white drawings for £35 — she may have decided that it was too difficult to persuade students of the joys of a chilly village clinging to a rocky outcrop. Instead, in February she held a sketching class in Nice, providing her students with the opportunity to paint the flower markets again, as well as the fishing boats with their red sails.

As the weather improved she wandered into the woods above St Paul, where suitable subjects were readily found for both her own work and that of a second group of students who joined her in May. Then at the end of June 1924 Hodgkins packed up and moved north to the Hôtel Belle Vue, Montreuil-sur-Mer, near Calais, a region where she had taught on a number of occasions before the outbreak of the First World War. It was no doubt easier to lure pupils across the English Channel to the broad shelly beaches and promenades of Normandy than to convince them of the rural, stony charms of villages in the south of France, but also her friend and fellow New Zealander Maud Burge was staying there, and Hodgkins would have been pleased to have her company.

H aving walked the ramparts and absorbed the atmosphere of St Paul, Mary and I walked up the hill to the Maeght Foundation. Mary waited outside, as she'd been before and the tickets were extremely expensive. Modern in style, the building consists of sections

of narrow pink brick interspersed with white concrete, and it feels more Spanish than French. Its roof has two upturned freestanding curves, as if two nuns were about to take flight. It was created by the owners, Aimé and Marguerite Maeght, in collaboration with Catalonian architect Josep Lluís Sert, in 1964. The Maeghts were serious collectors, and works by artists such as Chagall, Braque and Léger are among those featured in one of the largest modernist art collections in Europe.

Sinuous stone walls provide protected spaces for sculptures, offset by a shallow turquoise pool reflecting the surrounding pines and clouds scudding by overhead. The carefully groomed gardens stand in sharp contrast to the views of wilderness beyond. Today part of the building is given over to temporary shows — Jörg Immendorff's work was on display when I was there — but the grounds and sculptures are the real drawcard for anyone in search of modernism. There are no Hodgkins, of course, as she lived too soon and had too small a reputation in France to have a presence there.

Mary and I were in need of lunch after we had wandered through St Paul. You have to book months in advance to secure a table at Colombe d'Or, and there is a security man on the gate to ensure that those without reservations do not enter, so we headed across to the newer side of St-Paul-de-Vence, finding a working-men's café where, in spite of Mary's trepidation, we shared the most delicious salade niçoise in a large elegant bowl. Working men are no fools when it comes to good food, in Europe at least.

We then made our way along the road to Matisse's Chapel of the Rosary, one of his last great projects. Situated inside a working convent, it is a remarkable and serene experience. While not all the Stations of the Cross are equally successful, the towering figure of St Dominic is both magnificent and gentle. In the chapel we sat with the other visitors listening to a young Filipino woman talk of the history of the project and give an impassioned description of Matisse's intention. At a certain time of day, the light moves through the blue, yellow and green plant motifs

in the window panes, transporting diffused colour across the floor and past the slab of carved creamy stone that is the modernist altar, before gradually shimmering up the tiles on the opposite wall. Only then do these opalescent wall tiles come into their own, the reflected blues and yellows making delicate hints of pink and lilac dance in turn — an epiphany for those fortunate enough to witness it. Matisse, as the futurists had predicted, was painting with light.

08

St Jeannet

FRANCE

At the end of 1929, with the support and encouragement of Arthur Howell at St George's Gallery in London, Frances Hodgkins headed south once more, staying with two friends at La Pastorale until a combination of deep snows and isolation drove her across the valley to St Jeannet. She needed to be on her own to work, but she also longed for warmth and company, and the empty house was uninviting once her hosts had departed. She took two rooms at Chez Madame Villa, one serving as a studio and the other as a bedroom. A number of French artists had remained in St Jeannet over the winter, and she enjoyed meeting them at lunchtime at what she described as the crazy old inn, although in the evenings she fended for herself. Howell was requesting watercolours, of necessity painted out of doors, but Hodgkins found it almost impossible to meet his demands.

The village of St Jeannet wraps around one side of a massive baou, the cliff towering over the cluster of buildings like a gigantic protective mother. Its sheer surfaces are broken at intervals by shafts that might almost be man-made, and the cliff is also criss-crossed by ledges on which resolute, scrappy bushes have a tenuous hold, providing shelter for animals and birds. A rough path winds partway up, its surface made uncertain by loose rocks and other debris. Today the baou is a rock-climbing paradise, and intrepid adventurers scale the enormity of its heights like lizards or hang-glide off the top (*The Summit [St Jeannet]*, Fig. 9).

The location gave Hodgkins the stimulus she needed to branch out in yet another new direction. The soft, diffused light had a direct effect on her palette, which she translated into colour in her letters. She wrote to Arthur Howell, who was in the process of becoming her dealer, of the lift in spirits the landscape had given her. 'I have been in this astounding place for 10 days — it is such a staggering change from London fog & gloom that I am getting down to it only now. Really it is so lovely up on this misty mountain where the air is like wine and the wine like champagne. All is lovely all is peaceful not even the faintest whiff of a neighbour to spoil the absolute charm of the place. There is work enough for a life time.

Fig. 9 *The Summit [St Jeannet]*, c.1929–30, watercolour on paper. *Private collection.*

So far I have done nothing but look. Faces, figures, landscapes, panoramas and the Basses Alpes waiting to be painted but let me tell you that in my humility I have not lifted eyes higher than the red earth & the broken earthen ware pots strewn about making such ripping shapes turning in the pure clear light.

'You may hear them clink as you un-roll the Water Colours I am sending along to you by this same post. They are first fruits and an earnest of better to come. One is bound to work off a certain amount of "pep" but whatever I send you and however it is I know you will tell me honest Injun what you think about it. I have shown rare sense coming here and my chances of good work in a land of good & plenty were never greater than they are today — thanks again to you I hope I shall [do] good and my dream come true.'[1]

Hodgkins was anxious about Howell's responses to her work, fearing that the lilacs and pinks, heightened by blues and greys, might not be to his taste. In one letter she wrote: '[T]he three watercolours I have sent you are not exactly what I hoped to send — you may consider them too elaborate & too "searched" with the "atmosphere" over done . . . I made them in view of painting oils from them.'[2]

His response must have been a tentative approval, for she wrote back in a more confident tone: 'The nice qualities that you say you like in them such as poise, balance — colour etc are largely the result of slow & deliberate workmanship: Those symphonic schemes are not done in 5 minutes!'[3] She advised him to put them aside for a while, convinced that her new handling of watercolour and gouache was the right direction in which to move. Sure enough, Howell was gradually won over by these watercolours, not least when the resulting show gained very positive reviews.

Hodgkins was immensely encouraged when she received formal notice that St George's Gallery wished to finalise an agreement to show her work. The contract wasn't lucrative but it kept the wolf from the door, and more importantly it gave her a real sense of having found her place within contemporary English art. When Howell sent her a cheque, there was nowhere to cash it locally, so she was forced to post it back to England

to her friend (the future art dealer) Lucy Wertheim, asking her to cash it on her behalf and allowing her to settle arrears with her landlord.

For most of the time she was in St Jeannet, Hodgkins spoke only French, which found its way into her letters. She spent time with Maurice Garnier, a French experimental artist who created garden sculptures from stones, wood and other found objects 'in a style "un peu mystique, un peu precieuse"'.[4] He was working on a commission for the Marquise de Brantes in Vence, who kindly sent a car for Hodgkins so she could view the project. A photograph from an unknown source in Eric McCormick's *Late Attachment: Frances Hodgkins and Maurice Garnier* shows the Marquise and Garnier seated on an outdoor bench against a high wall, suggesting it was taken in warmer weather than Hodgkins experienced during her first weeks in St Jeannet. The Marquise is a determined flapper, complete with a dark ribbon tied around her forehead and long beads cascading from her neck. Garnier, tall, thin, and wearing a bow tie above a loose-fitting tweed suit, looks more like an off-duty army officer than an artist, although he was likely more casually clad when at work. Another photograph shows one of Garnier's wall pieces, not unlike a modernist take on the multi-breasted fertility goddess Artemis of Ephesus.[5] He and Hodgkins became firm friends; he admired her work while she in turn wrote to Lucy Wertheim and Arthur Howell endeavouring to secure Garnier an exhibition in London.

From various vantage points in St Jeannet the vista stretches all the way to the coast, and the eye is constantly drawn to the rocky mass towering above the village, or across the valley toward St Paul du Var and up again to the hills in the distance. In this environment, a renewed focus on deep landscape entered Hodgkins' creative vocabulary, the height and distance allowing a tapestried effect in her landscapes while creating certain resonances with the charcoal drawings she had produced in Martigues and Cassis in 1921. How different this must have seemed from the bush-clad New Zealand landscape of her youth. Tucked among the rocky outcrops and winding lanes lay the tiered groves of olives and

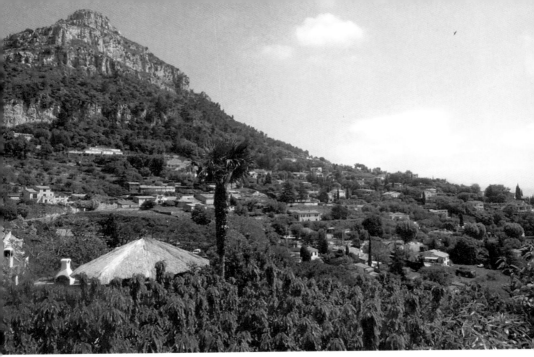

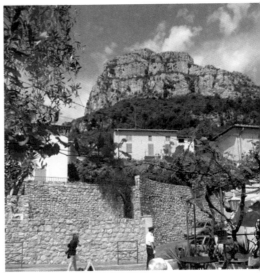

CLOCKWISE FROM TOP Scenes from St Jeannet: The view of the baou from the valley; the view of the baou from outside a café; a street scene.

grapes, and the patchwork fields lined with walls built from the rocks cleared from the ground to grow vegetables or graze a few sheep, goats or cows. This was a quintessential Mediterranean view.

Although slightly larger today, the village remains unspoiled, protected no doubt by the very narrow road that allows only one resident's car to pass at a time, so there is much stopping and reversing while pedestrians try to squeeze into doorways without destroying the lines of terracotta pots of flowers placed on the vestigial footpaths. The road winds its way to the seventeenth-century parish church of Saint John the Baptist, in front of which is one of the few broad spaces in the village. Overall, the buildings are tall and narrow, and their Provençal form became a signature motif in many of Hodgkins' paintings in the south of France. A narrow lane passing under an ancient stone arch leads past one side of the church to a lookout point, the hillside plunging down into the valley below. My admiration for stonemasons who constructed buildings like this that cling to the mountainsides over centuries knows no bounds.

Mary and I found a large display of faded black-and-white photographs which gave us a sense of how the village looked in Hodgkins' day, and which we could translate into colour with the help of her watercolours. Later in my trip I realised that she may well have recalled St Jeannet's clipped winter trees and sets of stone steps and arched doorways when she went to Ibiza in 1932.

Mary and I walked up the middle of the road towards the village rather than taking the very steep steps. Revived by a coffee at the café/bar at the entrance to the village, where the ground has been cut away to make a pleasant, tree-shaded terrace for sitting and contemplating the view, we then climbed halfway up the baou, picking our way tentatively among the loose rocks and scrubby brush on the roughly defined hillside path. Everything was bathed in the soft diffused light which Hodgkins so

adeptly translated into colour on paper, and from every vantage point we had the sense of the great valley falling away from us.

On our descent, we stood in polite silence as a group of locals laid a wreath at the war memorial in Place Sainte-Barbe, near the café where we had been drinking earlier. The mayor made a dignified and heartfelt speech to commemorate the day Germany was forced out of France, urging us all to remember the injustices of previous wars and never to take peace for granted. It brought home to us how much Hodgkins' and indeed most Europeans' lives were circumscribed by war as well as economic depression. When the little crowd had dispersed, we wandered for a time through the narrow streets, then drove the short distance to La Gaude in search of La Pastorale, where Hodgkins had stayed prior to Christmas 1929 with two of her friends.

They invited her to remain in charge of the house after they left, though in the company of a maidservant, three cats and 'the seas', so it must have faced south down the valley to the coast. Hodkgins rather dreaded spending Christmas Day on her own, so she wrote to Lucy Wertheim that she might go down the mountain as far as Vence to stay with friends, unless one of them came to see Christmas through at La Pastorale, in which case they would celebrate with a bottle and a chicken. In mid-December she wrote again, describing how the place inspired her, being a friendly country in sight of Italian snows. She hoped to paint the lovely peasant women and children and the old crones bearing heavy faggots on their backs.

Hodgkins' unnamed friend did indeed join her, but inclement weather limited any celebration, and she noted wryly to Wertheim that they had been forced to dine on leeks and eggs washed down with the red wine of St Jeannet, and to play the gramophone to keep up their spirits.[6] The one oil painting from her time at La Pastorale (Fig. 10) chills the bone: tall grey stone buildings loom over two streams spurting out beneath arches before merging to tumble down a weir in the foreground, suggesting the building might once have been a mill. Caught in the centre of this

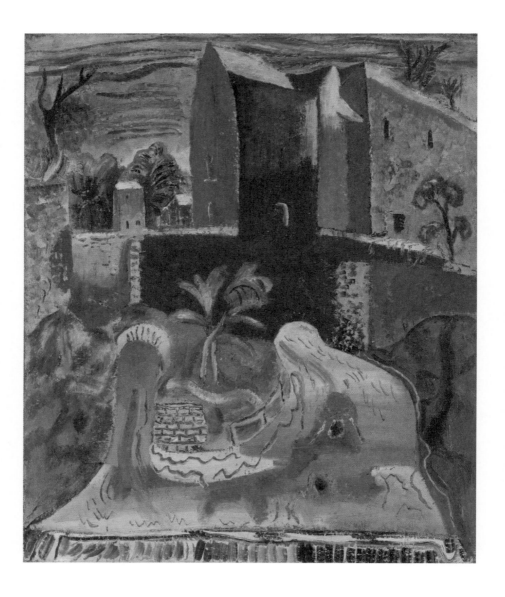

Fig. 10 *Pastorale*, c.1929–30, oil on canvas. *Auckland Art Gallery Toi o Tāmaki, purchased 1982.*

watery frame is what looks to be a palm, possibly a product of Hodgkins' imagination rather than a tree in situ, although palms grow in abundance down on the coast.

L inda Gill, the editor of Frances Hodgkins' letters, has recently located what she thinks may have been the site of La Pastorale, but the buildings, like so many in the area, have been so adapted over the years that it is hard to recognise what might have been there in the 1920s. When Mary and I drove across to La Gaude, once again leaving the car below the village, I saw a building in a similar architectural style in rue des Moulins. The pointed arches underneath it were visible only if you ignored the signs that said 'Private Property, Entry Forbidden' and climbed a stone wall protecting passers-by from tumbling into the garden below. A very stout and formidable woman, her ample bosom wrapped in a canvas apron, promptly appeared at the door of the house and glowered at me, so I thought it wise to descend once more, but I had teetered on the wall long enough to get the photograph I needed.

Wanting to find out more, we went into the bar and enquired of the barman, who waved us in the direction of a restaurant and its grumpy owner, anxious about the important guests he had to serve. When we were finally permitted to ask about the possible location of La Pastorale he replied that he would ask someone more intelligent, and took us to meet the mayor we had observed in St Jeannet, who was now eating lunch outside in the sunshine. Although he was unable to assist us, one of his fellow diners, another Mary, who spoke excellent English, promised to see what she could discover. By the time we had made our way back down the mountain and fought our way along the frantically busy road towards Nice, remembering to stop and refill the car with petrol before handing it back, we were exhausted, and it took a drink in the late-afternoon sun to revive our spirits.

09

Antibes
FRANCE

W'd had quite enough of cars and narrow, winding village roads, so the following morning Mary and I braved the throngs at the Nice railway station to take the train to Antibes. Every country seems to have its own automatic ticketing machines, and in Nice these appear to have been designed by the same person who builds gambling machines at casinos, with rotating wheels that made us think of Russian roulette, for if you don't pay attention you discover you've bought a ticket for Marseilles instead of Antibes.

Stations epitomise change, or they would if the trains eventuated. When they don't you sit and wait, and there is time to observe the human interactions on the scruffy forecourt. We felt saddened by the weary glances of the Africans who seemed to be eternally waiting for something: the possibility of employment, some form of more permanent shelter, or just a decent meal. Outside the station café a bedraggled European woman approached one table after another, her eyes widening each time she pleaded for money, as if her supplicating gaze would turn attention from her wafer-thin body, needle-scarred arms and matted hair. She looked about 50 but could have been a decade either side. Where do these forlorn waifs go when they are too tired to beg anymore? It was a relief when the graffiti-bedecked train arrived, and we clambered aboard.

Antibes is a brief ride from Nice, and once there the pervading poverty of the poorer parts of the Riviera fades. It was pleasant walking through the narrow, well-attended streets with their smart shops selling wares ill-suited to those lugging suitcases onto third-class trains rather than having goods delivered to their palatial abodes. In among them are more modest grocery shops, with wooden trays of vegetables piled up at the front door to tempt passing trade. We sat in the sun for a coffee, marvelling at the façade of the café opposite, with its faded pink rococo swags, shells and flowers more suited to a merry-go-round than to a purveyor of the 'Café' and 'Pimms' picked out in deep maroon.

We then headed to the market, where Hodgkins had painted. It's famous for its traditional Provençal vegetables, cheeses and flowers, and

the air was heady with the scents of the ground spices laid out in trays on trestle tables, like an artist's paintbox, alongside different salts from the region, ranging from whites to greys and pinks. Then there were tempting displays of rustic hand-painted Provençal pottery, almost always fatal to the eye and purse. Over the years I have lugged home pieces of varying sizes wrapped in items of clothing, but on this occasion I resisted temptation and followed Hodgkins' precedent, leaving any purchases until near the end of my trip.

Hodgkins travelled by train from Avignon to Antibes in November 1906, accompanied by Miss Hill, whom she had first met in Penzance, and whom she assured her mother was 'very nice, elderly, grey haired not unlike Miss Richmond to look at & quite willing to go wherever it suits my brush'.[1] They sat opposite a couple who hadn't eaten since leaving Paris, and shared their boiled eggs and bread rolls with them. The woman was fascinated by Hodgkins' hei tiki, a gift from her sister Isabel and her husband Will which she wore constantly. It transpired that their carriage companions, although fresh from Rangoon, had been to Dunedin the year before, and Hodgkins was indignant when the woman asked whether she was an Old Identity or a New Iniquity. She was definitely the former.

In her letter to her mother Hodgkins refers to Antibes as 'a nice little 1 horse place and I think I shall find all that I want here — the little harbour is full of picturesque craft & there are lots of nice brown faced people about. It is unfashionable and very very quiet although connected by train with Cannes; no tourists come this way, nor motors, nor millionaires consequently prices are low, not of course as low as I wld like them, they never are, but still it is cheap for the Riviera. We are comfortable here & the food is good and plentiful. The hotel is kept by a plump merry-faced old widow from Alsace, & her son, a comparative infant & his pretty wife & baby live with her.

'The staff consists of a small boy in long swallowtails who does the waiting, a large sized chef and Eugénie the femme de chamber all smiles & blessing & curtseys. As far as amicability can take anyone it has taken

CLOCKWISE FROM TOP LEFT Antibes scenes: A local café; Mary Gee peruses the spice display in the market; the Picasso Museum; inside the fort.

Eugénie. The first morning she brought me my coffee while I was yet à la pantaloons. The coffee all but dropped & her eyes went up "Blessed Virgin what small feet, what shoes! Ma foi but you should hang them up on a nail!" & next morning when she took the same shoes off to be cleaned I could hear her murmuring endearments over them.'[2]

Walking across the finger of land reaching out to the sea, you come to the Musée Picasso, which for more than 400 years was the château of the Grimaldi family. It then became the town hall, before being restored. Its great bastion bears evidence of being battered by time and sea-salty winds, whereas the restored walls of the château rising above it are beautifully rendered, each corner crisply faced. The tower would once have been an invaluable lookout for raiding ships. Picasso lived in the château for a brief period, and when it was turned into what was to be the first ever Picasso museum he donated some of his works to begin the collection. It was a delight seeing some of my favourite paintings, including *Joie de vivre* (1946) with its frieze of dancing fauns, and *The Goat* (1945), a simple cubist sketch in which the form of the animal seems to have been drawn without lifting his hand from the paper.

In 1907 Hodgkins was thrilled to discover she had won first prize for a watercolour, *Place Massena, Antibes*, in the exhibition *Australasian Women at Home & Abroad* held at Rumpelmayer's in St James Street, off Piccadilly in London. She would have loved the location of the exhibition, having developed a soft spot for another branch of the famous café closer to hand. She wrote to her mother: 'Yesterday was cold & windy so we took a day off & went by train to Cannes. I wanted to cash a cheque & when this was done Miss Hill took me to the famous Rumpelmayer's to have a cup of chocolate. Such chocolate — best described as a sensation . . . Madame Rumpelmayer, if such she was, sat seated behind a desk while her handmaidens handed round cups of chocolate in eggshell china cups to pretty ladies.'[3] In spite of the prize, *Place Massena, Antibes* didn't sell, so

Hodgkins sent it out to an exhibition in Melbourne later in 1907, and it disappeared from sight. It may well be hanging in a private collection to this day.

Although my visit to Antibes was marred by discovering that I had dropped my sunglasses on the train, I compensated by eating a very simple lunch of egg and avocado salad dressed with delicious local olive oil and just a squeeze of lemon juice, accompanied by a chilled glass of wine and some crusty white bread. That was far more to my taste than Hodgkins' hot chocolate at Rumpelmayer's, no matter how divine. I asked twice about my glasses at the lost luggage office when we returned to the Nice railway station, but I knew in my heart that with so much poverty about the chance of them being handed in was extremely unlikely. The following morning, after what proved to be a surprisingly reasonable breakfast at our hotel, we hauled our suitcases up to the station and moved on to St Raphael, where we were met by Mary's friends with whom we would stay for the night. They relieved us of our suitcases, and we dashed across the station and boarded the bus to St Tropez with minutes to spare.

10

St Tropez

FRANCE

The road to St Tropez skirts around the gulf close to the water's edge. Today almost the whole way is built up, crammed with traffic and young people hauling their windsurfing boards across the road to the sea. At each stop locals joined our bus, many heading to the market in St Tropez. We were highly amused when the driver stopped after a certain distance so that the smokers (more than half the passengers, as it turned out) could leap out and sit on a wall while they had a gasper. Once satisfied, they got back on board and we sailed off again towards our destination.

It was unexpectedly quiet in St Tropez: most of the glitterati were at the Cannes Film Festival and many tourists are not prepared to travel by bus, preferring to stay only at those places serviced by a railway station or airport. We strolled in the direction of the market, passing the little Musée de l'Annonciade, housed in a former church of that name, which Mary complained was *never* open. This was a disappointment, as the museum has a delightful collection of modernist works, Paul Signac having done much for what in 1892 was a very quiet fishing village. His presence attracted other artists, including Henri Matisse, Francis Picabia, André Derain, Pierre Bonnard and Albert Marquet, whose impressionist and fauve works help to fill the walls of the musée. We walked on to St Tropez's large central square with its ubiquitous frilly border of pollarded plane trees, whose shade gives a sense of restful ease.

Hodgkins, accompanied by one of her students, had first stopped in St Tropez briefly at the end of 1920, after a long and arduous journey. As always, her letters to friends and family painted an amusing picture of their travails, which included temporarily losing their luggage in Paris after a long ferry journey to get there; they had failed to keep hold of their baggage tags. Once that was sorted they hauled themselves onto an overheated train and headed south, before waking with cracking headaches at dawn.

When she complained about how awful the night had been, a Frenchman in the same compartment commented, "'I don't know why

14. St-TROPEZ (Var) – Vue générale prise de la Citadelle - RM

5128. — Le Port de St-TROPEZ

ABOVE A postcard of St Tropez as it would have been when Hodgkins stayed there.
E. H. McCormick Research Library, Auckland Art Gallery Toi o Tāmaki, gift of Roger Collins, 2017.

BELOW A postcard of the port, St Tropez, in the same era. *E. H. McCormick Research Library,*
Auckland Art Gallery Toi o Tāmaki, gift of Roger Collins, 2017.

Mademoiselle complains since she has slept like an infant all night". It was not true. So much for rapprochement. The French are in the worst of humours with us. They complain bitterly of our high priced coal. They certainly use too much of it in heating their trains . . . We saw hardly any of the devastated region running from Boulogne to Paris — here & there ruined houses but nothing very ruinously bad. As we got further South the colder it grew & we ran into floods, deluge of rain & when we were finally dumped at our station you couldn't see where the sea ended & the floods began. It was Sunday afternoon at 5 o'c. No one in sight. We asked for a porter — the ticket lady said It is not indeed sad that our only porter is so ill? We said we thought it much sadder that two English ladies had to carry their own luggage. At last a boy with a Murillo face found a donkey & removed our luggage across from one platform to another. An hour's wait. A little folding of the hands in sleep — for me at least, on the grass green couch in the waiting room, then on again thro' the rising floods, by a sort of tram & then another tram, rain coming down like a shower bath thro' the top, at last nearly dead & wishing we were tipped out into deep puddles & complete darkness at 9.45 we reached St Tropez.

'A six course dinner solaced us — much wine — & bed for about 2 whole days. Awoke with horrible colds, a sort of plague which is plunging round & round the house, as soon as you get well you get worse again. I believe it is plague . . . St Tropez being off the track and unfashionable, is comparatively cheap. We are being done extremely well for less than 2 gns per week including wine. The exchange is still high, well over double normal. My pupil pays me £1 a week & two more will do the same after Xmas, so I am all right.'

In spite of her wry comments the sun came out and she was able to produce some bold charcoal sketches of the ploughed fields and pruned olive trees behind the village before moving on to Cassis. Hodgkins was a keen observer of local mores, and she was horrified at the way male children were treated in comparison to girls, not least because so many men had died during the war. A little boy staying at the hotel in St

Tropez had fallen into the harbour and had been roundly slapped for it. Hodgkins described the event in great indignation, for at a time 'when the Republic is in need of all its little citizens I thought it unduly severe. His father is a consumptive architect entrusted with the building of 15 churches in the devasted regions. Think of it. Better be drowned than disfigure poor beautiful France with horrible little churches — assuming he was as bad an architect as he was artist.'[1]

She doesn't give a name to the hotel from this first stay in St Tropez, possibly because she already knew she would be moving on. A photograph of the time shows the unpaved quai, where fishing nets were piled high or laid out to dry and fishing boats were hauled up beneath rough stone houses, almost all without render.

Hodgkins returned to St Tropez in April 1931 after spending some time in Martigues. She wrote to her friend Dorothy Selby: 'St Tropez is very attractive but to be avoided in July-August when it is more of a <u>disease</u> from all I hear — Margate at its worst. Already the Hotels are packed. Such types. The young & goodlooking approaching as near Nudism as they dare — wh is pretty near. Lucky for me I have re-found an old friend & her husband who have a villa here — with a jolly garden next door to Signac's villa. She is very keen on painting in an amateur way & arranges & collects still life & flowers for me wh we do in the cool garden. I spend most of my day up there. On Sundays we take lunch & spend the day in the Cork Forests — very shady & cool & select — not a soul in sight. So the heat is supportable. Mosquitoes not too devouring — yet.

'What do you plan for your holiday? Is Barling joining on with you this year? Sep. should be very jolly here & the worst of the crowd thinned out. But perhaps too hot for you. There is always a sea breeze. I intend stopping on as I am doing good work & life down here is simpler & cheaper than elsewhere & that is an item with me.'[2] Her friends were the artist Maud Burge and her husband, George, and Hodgkins was rather delighted when George promptly took up watercolours, thinking him possibly more skilled than his wife.

I wonder what Hodgkins would have thought had she lived long enough to see St Tropez's mid-century transformation after Brigitte Bardot made it famous. Still, it remains a place dedicated to the sea, its vessels merely smarter than the simple wooden fishing boats she was familiar with. When Hodgkins first arrived there from Martigues the weather wasn't good enough to paint out of doors, so she produced a number of ink drawings which she sent off to Arthur Howell, promising watercolours as soon as the storms abated and the sun came out. A month later she sent off two batches of the desired works, now much gayer in colour, hoping that he would be pleased with them.

Dorothy Selby had sent her the latest news and reviews from England, and in her reply Hodgkins captured the ennui that can creep over you in a Mediterranean summer: 'Barling would love this place in summer. The gay cafés & the colour & movement. It is a wicked little spot while the hot weather lasts. One sits in a café, watches — talks — scandal — surmises. I think I am the only one in St Tropez who really works <u>hard</u>!'[3]

Throughout this time, Hodgkins kept a keen eye on the political situation in Europe, aware of the marked effect this was having on incomes and investments. The Burges had been forced to sell their Hampshire home and their cars after their portfolio of stocks and shares lost much of its value, and by renting the villa in St Tropez they could live more cheaply while also avoiding paying income tax.

Hodgkins was extremely alarmed to discover that the financial crisis had driven Arthur Howell to close St George's, although he had taken good care of her interests by organising a contract with the Lefevre Gallery, with whom she was to show for the rest of her career. Lefevre's, which had opened in King Street in St James's, London, in 1926, was at the forefront in selling French impressionist and modern art in England at the time, so it's an indication of Hodgkins' growing status that it was prepared to take her on. Even so, she wrote to Howell to express her sorrow, having felt the security of being one of the 'St George's family', and noted that she had eight canvases which she couldn't wait to show

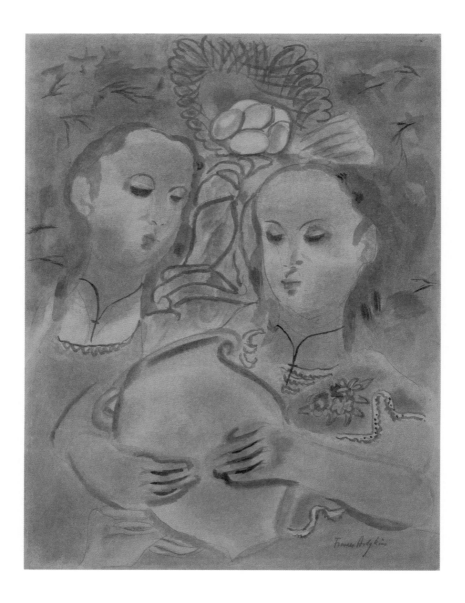

Fig. 11 *Girls with a Jug*, c.1931, watercolour on paper. *Auckland Art Gallery Toi o Tāmaki, purchased 1961.*

him on her return, even though he might no longer be able to exhibit them.

Just as her earliest visit had seen her move in bold new directions in her drawings, so her stay in St Tropez was to produce an entirely new range of paintings, which nonetheless carried echoes of her earlier forms. One of the exhibition watercolours produced during this period in the south (as opposed to the more rapid sketches that she used as starting points in later paintings) was *Girls with a Jug* (Fig. 11), previously thought to have been done in Ibiza, but more likely a response to her time spent in St Tropez in 1931. (Ibizan girls were still wearing traditional costume when she was there from 1932 to 1933.) It shows two girls almost merging with a large ceramic water or oil jug, a frilly pedestal dish wittily supporting a tilted dish of eggs between them. The girls have crucifixes around their necks, giving the work the kind of devotional mood also seen in one of her most sophisticated and complex paintings, *Spanish Shrine* (Fig. 51, see page 261), which she painted over several years after staying in Ibiza.

As it was, her St Tropez paintings took a while to reach the public. *Red Jug* (Fig. 12) was included in the eleventh exhibition of the Seven & Five Society at the Leicester Galleries in 1932; *Cut Melons* (Fig. 13) was shown at Zwemmer's, London, the same year; and a small selection appeared in the Seven & Five Society exhibition at the Leicester Galleries in February 1933. This included *Two Plates* (Fig. 14) and *Evening* (Fig. 15). Each in its way has proved vital in dating other works, because Hodgkins invariably worked through particular motifs, sometimes retaining them for long periods, and discarding them only when they no longer served as aides-memoire to a particular landscape.

The cool and shady cork forests that she mentioned in her St Tropez letters appear in two watercolours, *Red Earth* and *Landscape, South of France*, as well as a number of oil paintings in which they are reduced to single trees, standing like sentinels in the landscape and easily identified by their stripped bark. The trunk beneath is a soft, wounded pink when first exposed, fading to a duller colour once the bark starts to regrow. This

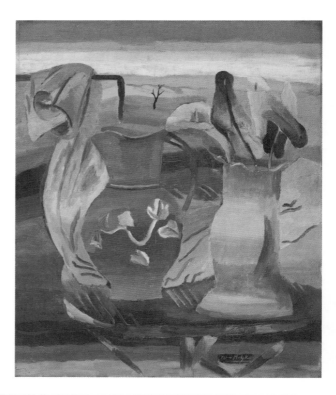

ABOVE Fig. 12
Red Jug, c.1931, oil on canvas. *Auckland Art Gallery Toi o Tāmaki, purchased 1982.*

BELOW Fig. 13
Cut Melons, c.1931, oil on cardboard. *Museum of New Zealand Te Papa Tongarewa, purchased with Special Projects in the Arts funds, 1980.*

ABOVE **Fig. 14** *Two Plates*, c.1931, watercolour and pencil on paper. *Museum of New Zealand Te Papa Tongarewa, purchased with Harold Beauchamp Collection funds, 1970.*

BELOW **Fig. 15** *Evening*, c.1931–32, oil on canvas. *Private collection.*

CLOCKWISE FROM TOP La Hune, the home of Paul Signac in St Tropez; a side view of Signac's house; the tower of the Church of Our Lady of the Assumption.

motif stands apart from the crooked Y-shaped 'twigs' Hodgkins used to suggest pruned olive trees from the late 1920s until she returned from Spain in 1936. One gouache, only recently identified in Hertfordshire County Council's collection, *Still Life with Vase and Eggs* (Fig. 16), shows an elegant jar with a folding lip, the main body swelling out beneath a slender neck before curving in to a pedestal base. While it rests on the folded cloth that she used to animate both surface and object in paintings of this time, here it is overshadowed by a larger piece of cloth spilling stiffly out of the neck of the vase like a matador's cape, accompanied by a tight spray of pink and white flowers.

A single-stemmed cup and a cluster of eggs rest at its base, and silhouetted against a washed sky are two trees that stand on the horizon either side, one with the twisted shape of a cork tree, the other less clearly defined. Animated, sculptural twists of fabric weave their way through oil paintings such as *Red Jug, Green Urn* (Fig. 17) and *Spanish Still Life and Landscape*, winding around what appears to be a residual pergola or rising up of their own accord, adding a dynamism to the composition.

However, the titles of Hodgkins' oil paintings can't be relied on as verification of the location, not least because some were not finished until she had been to Ibiza in 1932–33. In the background of *Spanish Still Life and Landscape*, for example, there is a group of tall buildings, structurally similar to those in *Pastorale*, which we know developed from her stay at La Gaude in 1930. They appear in quite a number of her paintings, including *Evening*, creating what she called that 'white note' that draws the eye into deep space, in the same way as Constable before her had added a dab of red among his greens and browns.

After Mary and I had wandered round the market St Tropez, we set off up the hill to find La Hune, the large house acquired by Paul Signac in 1897. He transformed it into the pink gem it is today, with its frieze of glossy deep-green edging tiles meandering across and

Fig. 16 *Still Life with Vase and Eggs [Flowers and Spanish Pottery?]*, c.1931, gouache on paper.
Formerly Hertfordshire County Council collection.

Fig. 17 *Green Urn*, c.1931, oil on canvas. *Private collection.*

above each of the windows on the upper floor and arching over the simple door on the street front. He built a vast studio at one end, faced with a very large lunette window that takes up much of the first floor and gives spectacular views of the hinterland leading up to the Alpes Maritimes. The Avenue Paul Signac now bears his name, in recognition of the economic boom that came as a result of his presence. The house abuts the narrow pavement, which may not have been sealed when he first moved in. Across the road, the land slopes steeply upward towards ridged pine trees before dropping down towards the sea.

Identifying the Burges' house next door, where Hodgkins had stayed, was another matter. The one immediately to La Hune's left looked likely, but had been built only recently, according to a local man of whom we enquired, and now there was another building hard up against its back boundary. A steep lane leads back towards the village immediately after you pass La Hune, and the house the Burges rented could have been any of these; but in the absence of any signs of the pretty garden where Hodgkins and Maude Burge painted we finally had to admit defeat. However, to compensate for our frustration, we discovered on our way back to the port later in the day that the door of the Musée de l'Annonciade was ajar. We had about 20 minutes before the little ferry that we were taking across the harbour to St Raphael departed, so we dashed indoors and were not disappointed.

Hodgkins returned to St Tropez for the last time during a brief holiday in March 1939. She stayed with her friend Ree Gorer at the Hôtel Sube, which had been her accommodation on earlier visits, and discovered that she had missed Dorothy Selby by just a few days. She wanted to know whether Dorothy had sailed across to St Tropez from Le Beauvallon, a hotel located on the other side of the bay. The hotel is one of the great belle-époque palaces on the Riviera, and was wildly expensive even then; it was certainly way above Hodgkins' budget. Mary and I hoped

that she at least called in for a cocktail in its enormous salons, even if she could not afford to stay.

In the 1930s the vast hotel stood back from the sea surrounded by dense trees, a setting far scruffier than the manicured views you find online today. But luxurious accommodation can't protect you from the elements, and Selby was unlucky to strike the 'seering shrivelling black Provençal wind' that has no respect for rich or poor, and Hodgkins assumed she had found it difficult to draw. She herself had managed just a few drawings. With Mussolini not far away across the border, the threat of war made her feel very insecure — a feeling that was to linger when she returned to England.

Hodgkins had disembarked in Marseilles briefly on 30 March 1901, having spent much of her first journey to Europe bedridden with a severe dose of suspected cholera contracted when she went ashore in Colombo early that month.[1] She was to suffer from stomach troubles for much of her life until she finally had an operation for a duodenal ulcer in 1941.

Imagine, then, her first experience of an exciting, bustling, noisy, Mediterranean seaport. She wrote to her mother after they had sailed again: 'I feel so thankful I was well enough to go ashore . . . I wouldn't have missed it for worlds . . . Marseilles is the most beautiful old town imaginable. I thought I had never seen anything so picturesque as it looked as we approached it in the early morning under a sky of true Mediterranean blue, blue-green water, white quays, colored craft of all nations and the red-tiled flat roofed houses. I began to understand the witchery an old continental town must have for artists . . . We prowled around the streets mostly in the old quarter of town. I loved the steep, uneven, badly paved streets plentifully strewn with every kind of rubbish and the quaint, dingy, discolored buildings with emerald green latticed shutters and dark haired women hanging over the balconies and the orange stalls making vivid blots of color at the street corners. Some day I must go back to Marseilles and paint.'[2]

In spite of the brevity of her stay, a watercolour, *Gateway on the Riviera* (c.1901) (Fig. 18), suggests that Hodgkins managed to capture the colour and energy of the city. An ochre-coloured arch towers over a group of women, baskets in hand, either on the way to market or returning up the hill with their purchases to the pastel-coloured buildings that can be seen beyond. When I showed a reproduction to a group of locals at Hôtel Peron in Marseilles, they insisted that it was a view of Le Panier, the old quarter, that had captured Hodgkins' imagination. Each person vied to identify which arch it might be, while also warning me that it might be hard to locate because after being hammered by bombs in the Second World War much of the foreshore had been rebuilt.

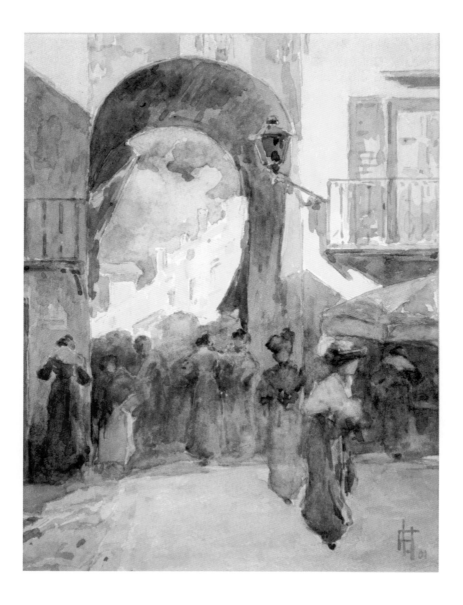

Fig. 18 *Gateway on the Riviera*, c.1901, watercolour on paper. *MTG Hawke's Bay, gifted by the New Zealand Government, collection of Hawke's Bay Museums Trust, Ruawharo Tā-ū-rangi, 89/22/1.*

62 MARSEILLE. — *Le Vieux Port.* — LL.

46 MARSEILLE. — *Le Cours Belzunce.* — ND Phot

ABOVE A postcard showing what Hodgkins would have seen as she entered Le Vieux Port, Marseilles, in 1901. *E. H. McCormick Research Library, Auckland Art Gallery Toi o Tāmaki, gift of Roger Collins, 2017.*

BELOW A postcard showing Cours Belzunce, one of Marseilles' main streets, in the same era. *E. H. McCormick Research Library, Auckland Art Gallery Toi o Tāmaki, gift of Roger Collins, 2017.*

I first visited Marseilles in 1975 when the buildings were caked with grime and soot, and the city had a seedy, slightly malevolent air that spoke of poverty and a maritime population that shifted and swayed according to the ships in port. Its raw edges suggested it had still not fully recovered from the depradations of war. Today it shimmers — literally in the case of Norman Foster's stainless-steel pavilion that casts reflective shadows over the innermost part of the port, where jubilant figures can dance with their mirror images in the steel above.

Further along the waterfront the delicate orientalist traceries of the new Museum of European and Mediterranean Civilisations (MuCEM) complex cast rippling effects in the water when the light is right, belying their remarkable strength. One side of the roof is linked by a steel walkway to the ancient Fort Saint-Jean that guards the entry to the harbour, while another stretches to Le Panier with its tiny church of St Laurent and architect Pierre Puget's La Vieille Charité on the right.[3] Restored to its original delicate-pink stone, the building wraps around his famous unfinished church in the centre of the courtyard, its ovoid dome rising above a space used today for art exhibitions. It shouldn't be missed.

Mary and I had arrived by train, and after struggling through the swarm of people coming in and out of the station took the easy way out and caught a cab to the Hôtel Peron. I had booked us in many months earlier, lured by the photographs on the website. With its white exterior and turquoise shutters the hotel is both charming and eccentric, its former grandeur now a little faded. An ancient collie dog spends its days lying in the foyer under a sign that says in French 'Don't touch me please, I'm 10 years old'. In other words, the poor devil has had enough of being assaulted and will eat the hand of the next person who tries. The stairs (of which there are many) are lined with plaster plant-life friezes in murky, acidic hues of emerald green, orange and bilious yellow. The first landing is shared with two cages, one with finches and the other canaries, amidst piles of abandoned magazines.

Our bedroom had a tiny bathroom with diamond-shaped black tiles

relieved by a border in white; a rather fine figure of the Buddha seated in the lotus position was set into the linoleum on the floor, a lotus flower beside him. Above the apple-green hip bath was a ceramic plaque that looked like a dish delivered from the famous Restaurant Peron across the road and inadvertently attached to the wall.

The hotel is run by three generations of women: the charming granddaughter Christine, who was kindness itself; her mother, who was in her seventies and seemed to spend her days in a back room attending to various washing and drying machines; and the matriarch, who, according to my très charmant driver Laurent, was still going strong in her nineties. I suspected she had slight but charming dementia, as she wandered around asking gently what we wanted and then came back a couple of minutes later to ask again. Laurent said that quite famous people have stayed here in the past (before the fading set in, presumably) because the family are souls of discretion. Guests were perhaps also drawn by their cliff-edge restaurant, which has boasted a Michelin star since 2015. It has a model of a bear above the awning facing the street, its hollowed-out stomach containing a fish on a spit.

Mary and I arrived on a Tuesday, when most museums are closed, so we explored the old port and climbed up to the twelfth-century Romanesque fishermen's church of St Laurent, which appears to be mainly overlooked by tourists. Having been damaged in the past, its creamy stone interior has a contemporary, minimal feel, its simplicity watched over by a very early wooden madonna known as Nôtre-Dame de Massalia (the Greek and Roman name for Marseilles). Later we enjoyed an early dinner (bourride — quite delicious) at a funny little restaurant that resembled a tram cantilevered above the sea wall, with a spectacular view of the coast.

Sadly, the next day Mary departed for Avejan, and I was alone. But I had no time to feel sorry for myself, as I was called away for a two-day diversion to Italy to progress the Auckland Art Gallery's bid for the Corsini exhibition, which was eventually held in 2017. Having to switch from battered French to Italian was a relief on one level, but the agents,

CLOCKWISE FROM TOP LEFT Marseilles scenes: The ceramic bath tiles of the Hôtel Peron; a stormy evening from my hotel balcony; the MuCEM museum; Fort Jean, past which Hodgkins would have sailed when she entered Marseilles harbour in 1901.

countesses and curator I met all spoke such rapid-fire Italian that I returned to Marseilles wondering just what I had agreed to.

Back in the Hôtel Peron I was directed to my new room on the second floor, which gave an even more expansive view of the sea. There was yet another marine frieze above the bed; the new bathroom, though tiny, had Matisse-inspired aquamarine tiles grouted in red; and French doors opened on to a Juliet balcony facing the sea. I was moving on to Cassis the next day, and following the advice of Madame Christine set off on what was to prove an hour-long search for the Cassis bus stop so I could be certain of being on time.

Remembering Hodgkins' recipe for exhaustion, and desperate for some shelter from the mistral that was now howling up the hill, I went into a café, planning on cheering my spirits with the tapas advertised on the board outside. As these were not forthcoming (I was 10 minutes early) I ordered crêpe carbonara. When it arrived, smothered in cheese sauce, my liver quailed. As I sat forlornly, grateful for my glass of rosé, a white plastic chair flew up the road in mid-air, narrowly missing several cars. The temperature had plummeted, and I wasn't suitably dressed, so I caught the number 54 bus back to the hotel, intent on getting an early night.

Any plans I had for an early night were abandoned when a violent noise erupted outside my window. I staggered out of bed and headed for the balcony to discover a posse of wedding cars roaring along Corniche Kennedy, led by a bedecked car crammed with the bride and her assorted assistants, whose role it was to assist with her 430 kilograms of tulle. The horns of the attendants' cars were responsible for the ear-piercing cacophony; the young men, possibly imagining that they were involved in a blood sport of some kind, hung out of the windows, shouting. Luckily, as the evening progressed, more sedate weddings followed, and I finally got some rest.

12

Cassis

FRANCE

The next morning the ever-generous Madame Christine gave me €2 for the bus to Castellane, not far from Cassis, as she said the driver wouldn't take a note. In fact, the bus went only as far as the Aubagne rail station, so once again I bought a ticket at the machine (I was now fully conversant with its vagaries) before lugging my suitcase up and over the railway line to the correct platform, located with the help of a young couple who obviously thought I was demented to be travelling on my own.

Without the assistance of porters to help people on and off trains with trunks and valises, as happened in Hodgkins' day, catching French trains is something of a challenge. Inevitably the steps are precipitous, the doors narrow and the carriage floor almost above head height, so I would never have managed to board this particular train without the kindness of strangers. Seeing my dilemma, a lovely Algerian man leaned down and hoisted me and my suitcase aboard as the train pulled out of the station. He beamed at me when I thanked him, and I tottered down the aisle before collapsing into my seat. Yet again I forgot to composter the ticket but it didn't seem to matter.

Cassis, once a Roman settlement, takes its name from Carsicus Portus or 'crowned port', after the great hooded rock known colloquially as the Couronne de Charlemagne or Crown of Charlemagne. Hodgkins was fascinated by this landmark, including it in two of her bold black chalk drawings in 1920–21, but I was unaware of this when I descended from the train, as the Couronne was far off behind me, and I only spotted it on my return trip to the station three days later. The station turned out to be quite a distance from the port, and with no bus in the offing I reluctantly took a taxi, thinking that at least the driver would deposit me at the shop where I was to collect the key for the apartment I had booked for my three-day stay. It was a Sunday, so cost a fortune, but I had little alternative.

The shop was closed when I arrived, so I lurked outside in a narrow strip of shade until a very pretty young woman appeared, carrying brilliantly coloured raffia that she later made into flowers and beachside motifs with

which to embellish the sunhats and beach bags she sold in her little shop. Much as I had enjoyed Marseilles, it was a relief to be out of a large city, and I could tell at a glance that I could walk the length and breadth of Cassis within half an hour. The young woman's husband duly appeared, and insisted on driving me the hundred metres to the apartment, where he gave me a guided tour. He was particularly pleased when I complimented him on the pretty tiled bathroom he had built himself.

Like so many people living on a shoestring, the couple couldn't afford the mortgage, so they decided to move in with maman and rent the apartment out. I think I was probably the first guest of the season, as the apartment was dusty, but, ever prepared, I whipped out my cleaning cloth and set to. I had brought the cloth all the way from New Zealand (tragic, I know) because the €40 I would have had to spend on a cleaner at the end of my stay could be better used buying a fish dinner in the port.

Determined that I would spend my first evening 'at home' watching the sunset, I then set off to find a supermarket. This proved difficult at first, as many of the shops were closed on a Sunday, but then a local directed me to a terrific deli that sold pre-cooked food, light-years away from the packaged horror that gets sold in most supermarkets around the world. Armed with some cheese, baked aubergines and peppers in a tomato sauce packed in a tinfoil oven dish, some crusty bread and a bottle of vin de pays, I was well contented. I didn't have the money to buy the more expensive white wine from Château de Fontcreuse for which Cassis is famous, and I had yet to find a cash machine to remedy the situation.

Returning to my new abode I settled down on my very own terrace. As the evening set in, I thought how influential the evening light of the Côte d'Azur became to Hodgkins, for a delicious hazy pinkness spread across the sky, and at a certain point the sea turned a magical liquid golden colour.

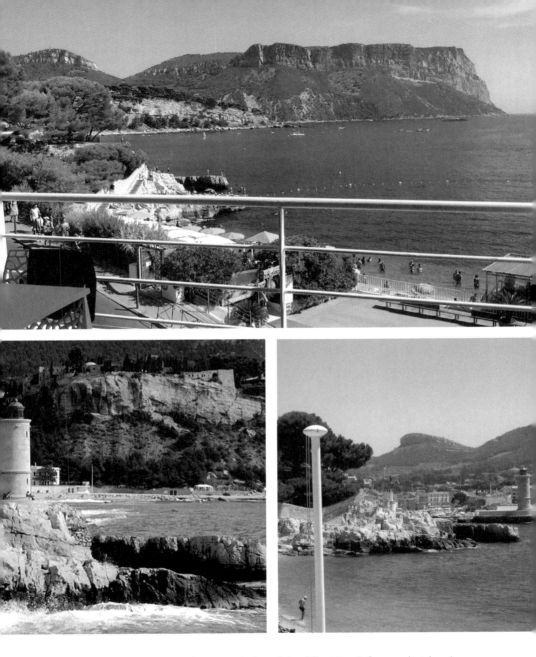

CLOCKWISE FROM TOP Cassis scenes: A view of the cliffs at Cassis from my hotel; a view of the Crown of Charlemagne, which Hodgkins sketched from the same vantage point (Fig.20, page 123); Cassis harbour's rocks and lighthouse.

On her first visit to Cassis in late December 1920, Hodgkins, having moved on from St Tropez with two students in tow, produced some powerful landscape sketches that accurately capture the cliffs and crags that wrap around this little fishing port (*Cassis, 1920*, Fig. 19). For two days I walked the length and breadth of the bays, finding the exact vantage point on Plage de l'Arène in Bestouan, the beach on the opposite side of the port, from which she drew the great crag of Couronne de Charlemagne. She had obviously set herself up on the track (today a sealed road) above the bay that looks back towards Cassis and the pharo or lighthouse built at the end of the breakwater to guide the fishing boats back to safe harbour, although she replaces the sturdy lighthouse with a slender column that resembles the tall chimney of the mine nearby (*Landscape Cassis*, Fig. 20).

I also took one of the little boats that winds in and out of the limestone calanques, as the local inlets are called, their white cliffs enclosing deep turquoise-blue water. Impressive by land, these are magnificent by sea. In one, divers can enter a deep underwater cave lined with ancient drawings of animals and wildlife. The skipper of the boat provided a brochure in English that explained the local history. The calanques are described as 'creeks', but their waters are deep, providing sheltered moorings for pleasure craft, while the cliffs, which are lined with deeply chiselled troughs, are an irresistible place for naked sunbathing in summer. That was not the case in Hodgkins' day, when the limestone was worked by Spanish miners, whom she sketched with their wives in the cafés at night.

The letter Hodgkins wrote to Rachel Hodgkins doesn't mention the hotel where she was staying — perhaps she knew the letter wouldn't get to her before she moved on. But she knew her mother would be interested that she had just missed Winston Churchill, then a cabinet minister, and his beautiful wife, though she doubted they would have stayed somewhere as basic as her lodgings.[1] She had also missed her friends Cedric Morris and Arthur Lett-Haines, who may have prompted her going to Cassis in the first place.

However, there was 'the ubiquitous New Zealand here — a pretty & very nice girl': almost certainly Jean Campbell, a former nurse in India, who had cared for a Colonel Peter Teed of the Bengal Lancers.[2] Teed was separated from his Catholic French wife, who had refused him a divorce, and he and Campbell fell in love, moving south to the Château de Fontcreuse. The château is situated further up the valley, away from the port, and in the 1950s would become a well-known vineyard, producing one of France's listed white wines. Hodgkins gave little away about her meeting with the couple in her correspondence, but she produced an ink drawing of them, he in evening dress, she bent smiling over some sort of needlework (*Miss Jean Campbell and Colonel Peter Teed at Chateau Fontcreuse, Cassis-sur-Mer*, Fig. 21).

Wearing a monocle, Teed is engrossed in his newspaper, a glass of red wine at hand. Most importantly, the work is signed and inscribed 'Cassis, 1.1.1921', and so Teed, Campbell and Hodgkins had either spent New Year's Eve together or Hodgkins dined with them on the first day of the new year. This work is now in the collection of a relative of Jean Campbell in Auckland who visited Fontcreuse to collect some of her aunt's possessions and family memorabilia after her death. She also brought back two paintings thought to be by Duncan Grant, one of the château itself (*Château Fontcreuse*, Fig. 22), and the other a loosely painted frieze of dancing birds.

And although there is no mention of a return visit to Cassis in Hodgkins' letters, go back she did. A photograph now in the Alexander Turnbull Library shows the artist and Jean Campbell seated among the craggy rocks of the calanques. Hodgkins is cast in strong shadow, which, with the clear sky, suggests that this photograph was taken in summer, rather than in the softer light of a winter's day. Wearing a rather unflattering hat, Hodgkins appears grumpy; even then she hated having her photograph taken. Both women are smoking, and an open valise to one side probably contained their painting equipment, for Campbell herself attested to their forays in search of painting subjects.[3]

ABOVE **Fig. 21.** *Miss Jean Campbell and Colonel Peter Teed at the Chateau Fontcreuse, Cassis-sur-Mer*, 1921, ink and wash on Rowneys Clifton Card. *Private collection.*

BELOW Frances Hodgkins (left) and Jean Campbell at Cassis. *Photograph courtesy of Mr O. P. Gabites.*

Fig. 22 Attrib. Duncan Grant, *Château Fontcreuse*, 1930s, oil on canvas. *Originally owned by Peter Teed and Jean Campbell, now private collection.*

Peter Teed and Jean Campbell were to become very friendly with Duncan Grant, Vanessa Bell and her extended family and friends in the latter part of the 1920s. Teed had first met Duncan Grant's aunt Daisy McNeill in India, and it was she who later introduced Vanessa to Teed and Château de Fontcreuse. Bell and Grant had been hunting for somewhere to rent as a summer home, and they persuaded Teed to let them have La Bergère, a derelict shepherd's cottage in the grounds, on a 10-year lease. Bell paid for its restoration, and the cottage proved a light that drew many creative moths to its flame.

Bell and Grant's daughter, Angelica Bell, recalled travelling there as a child in early spring before the cottage had been restored. She had a clear memory of waking up on the train and seeing her first olive tree, and how 'the squiggle of naked vine on the red earth against a clear and glittering sky brought back with a rush the smell of drains in the narrow streets, the powerful voices, the strength and vitality of the people'.[4] She looked at Peter Teed and Jean Campbell with the perceptive yet innocent eyes of a child, describing the former as having eyes that were 'small and dark, rolling in yellowish whites, and his large, bulbous nose pitted, so I believed, with gunpowder; his smile was enchanting, his French accent Churchillian'.[5]

Jean, who was lame, was most often to be found in the kitchen, 'the door of which opened off the terrace, stirring a steaming lake of cherries or quetsches to be made into jam. She also made jars of brandied cherries, offered to her guests after lunch in the cool, dark sitting-room, producing a euphoria cured by a siesta.'[6]

Vanessa Bell compared Peter Teed to an impoverished lord of the manor who got on well with locals and knew all the best tradespeople. She described Teed as having a very lined, ugly face, and captured his British accent perfectly: 'Damn picturesque place, Marseilles,' he would bark, 'when you get the hang of it.'[7] As a keen mechanic, he was often found in overalls, with oil-stained hands, rather than the dress suit in which Hodgkins depicted him. All the more reason to suggest they were celebrating New Year's Eve together.

CLOCKWISE FROM TOP Cassis scenes: View of the port from the breakwater; Château de Fontcreuse; a charming street garden.

Fortunately, the drains had been sorted by the time I visited Cassis, but the pleasure of warm air spiced with the resinous pines and the fragrance of rosemary and thyme were just as evocative. When I wandered back through the village in the late afternoon, I was impressed by the beautiful 'pot' gardens that home owners had created on the footpaths, containing a great many more flowers than we had seen in St Jeannet, where the climate is much cooler. You felt as if the locals vied with each other, the prize going to the gardener who had also hung little white pots of herbs on the outside wooden shutters (did these come down in the evening or simply swing indoors?). In defiance of its pot-bound roots, a young tree had already reached the first floor of the building, and to set it off a handsome white cow skull, replete with horns, took pride of place in the centre of the window.

13

Martigues
FRANCE

Thirty-seven kilometres to the west of Marseilles, Martigues is gritty and honest, yet it has a great degree of charm. At the beginning of the century the port consisted of a series of narrow islets in the lagoon, backed by huge salt pans on the banks of a vast lake known as l'étang de Berre, which is linked to the sea by the Caronte channel. Salt production was a major industry, along with fishing. Gradually some of the five fingers of land were linked until they formed Jonquières, L'Île Brescon and Ferrières.

I stayed at Jonquières, but Hodgkins' Hôtel Moderne was on Ferrière, five minutes' walk away. The centre of Martigues remains a real fishing village, which was all there was when Hodgkins stayed there. The impression of historical continuity is disturbed only by the hinterland of oil refineries that you pass when you drive in, the first of which had been built by the time Hodgkins made her last visit here in 1931. Put that behind you, and the port itself could be somewhere in North Africa, but with lagoons and Venetian colour thrown in.

I had booked into yet another Art Hotel, but this time it came up trumps. The charming young Moroccan man behind the desk showed me up to my room, and I nodded and agreed with him that it was 'très belle' before collapsing with laughter once he'd made his way downstairs. I had been given their main honeymoon room, entirely white except for a couple of red cushions on the bed. There was a white wooden chandelier above the bed and an ornate, white-mirrored armoire on one side. Facing the foot of the bed to one side was a large white bath in which I could have landed with one bounce of the mattress springs. Two red guttered candles stood on a dish, and a scattering of red paper rose petals remained on the floor, forcing me to check the armoire in case a dishevelled bride, veil askew, had been left behind. Fortunately, it was empty, awaiting the crushed contents of my suitcase.

Once I had regained my composure, I went downstairs and enquired as to where I should eat that evening. My host recommended his Algerian friend's tiny restaurant across the way. I stowed that information and,

clutching antibiotics for bronchitis which had been exacerbated by the wind, set off to walk around the streets of the old port. The mistral was howling by this stage, so after stopping at a local patisserie for supplies (like so many of these civilised shops in Europe it sold salads and charcuterie as well) I retired for a few hours to rest my lungs.

As so often happens after a day of the mistral, the next morning was crisp and clear, and it was extremely pleasant to be out walking. I set out for the local museum attached to the Hôtel de Ville (town hall) archives, a brand new 'Lego' building in blue-and-white cubes settled in a curve facing the water. It takes 15 minutes to get there on foot, or you can catch a blue matchbox-shaped ferry that stops briefly to take you from one island to another. It can swing in a circle in seconds, is free, and saves walking to the mouth of each islet to the bridges that link each island.

I had got it into my head that there might be some archival material on Hodgkins, or at least the Hôtel Moderne where she stayed each time she came. I was put in the capable hands of Madame P and her young sidekick Maud, the former's minimal English vocabulary a match for my schoolgirl French. The other movable feast was Madame P's monumental bosom, hardly contained within her low-cut and very tight striped T-shirt. Every time she crossed her arms two gigantic moons of flesh rose up towards her neck, trembled violently, then subsided until the next time. She was magnificent in every way.

Maud (a great young woman; hair very short with dyed blonde tips) turned up trumps, staying on after 5 p.m. when others were poking their heads into the office to say 'Bon weekend!' As we brought up image after image of Hodgkins' paintings on the internet, Maud became intensely curious about her. We looked at a vast amount of material, including a cheeky comment from Hodgkins the first time she visited in 1921, when she mocked its nickname as the Venice of the South, describing it as a dirty little fishing village.[1]

True, like all fishing villages it would have smelt of fish, but she should have been used to that from her studio in St Ives, where pilchards and

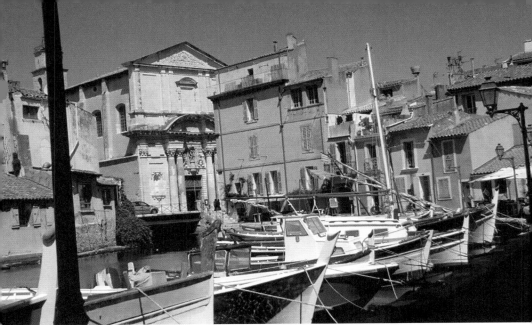

CLOCKWISE FROM TOP Martigues scenes: A view of Le Miroir aux Oiseaux, with the Church of the Annonciade in the background; the little blue ferry that spins from one jetty to another; the Hôtel Moderne, where Hodgkins stayed on her visits in the 1920s.

other fish of the day were sorted after the boats had been pulled up on the sand. Perhaps the air was particularly tangy, as Martigues' other main industry at the time derived from the aforementioned vast salt pans clinging to the inner shore of the bay. Happily, I was able to demonstrate that Hodgkins absolutely fell in love with the place, which is why she came back four times. How we come to rue what we write in haste . . .

Maud pointed out the location of the Hôtel Moderne, which still stands at the back of the town's square and is now a solicitor's office. We combed through hotel lists (alas, you only got your signature recorded if you were there for six months), as well as photographs and postcards of the hotel, which was quite grand compared to some of the others she stayed in, perhaps because she had to accommodate her students as well. We also went through documents about the buildings in one of the watercolours, *Venetian Lagoon* (Fig. 23), the title of which has often confused writers. Maud thought one of the buildings might be the large hall used for the registration of fishermen, now demolished, but she later changed her mind and confirms my belief that the painting shows part of the canal near the restaurant Le Miroir, and what we see in the corner is the baroque façade of the Church of the Annonciade. I wondered if Hodgkins had taken her students to the museum dedicated to the work of local artist Félix Ziem which had opened in 1908. Raoul Dufy also worked in Martigues a number of times, as did Braque and Derain. On one of her winter visits, Hodgkins noted that Augustus John remained in residence, accommodating what she wryly described as his retinue of wives, sweethearts and slaves in his villa.[2]

After meandering through some of the narrow streets, I found the exact spot where Hodgkins had painted *Venetian Lagoon*, its vantage point providing shelter from winds coming off the sea. After years of being forced to paint portraits, it was an interpretation of the landscape and its forms that Hodgkins was seeking. She simplified the scene, eliminating the iron lamp posts, and focused instead on an inner corner of the Miroir aux Oiseaux. You sense that there was none of the beautifying that is

visible today, when many of the houses have window boxes and climbing plants. While admiring one of these I became aware of a large tabby cat glaring balefully at me through the window, envying me my freedom, no doubt. Hodgkins adopted feline waifs and strays at every opportunity, and in many of her preferred locations there were always fish scraps with which to feed them.

When Hodgkins set out for the south of France in 1920, she was joined by three students from her St Ives classes. They spent winter nights in the cafés painting the Spanish workers, praising their bearing and beauty: 'You come away feeling you have spent an evening in the company of princes.'[3] Her letters also make it clear that one of the pleasures of returning to a location was being recognised by the locals. She visited Martigues four times, and she was always welcomed back — a reason why any of us returns to a place we find sympathique. And it must have helped that along with French she could speak reasonable Spanish, having had lessons for two hours every afternoon from a fellow passenger on her voyage from New Zealand back to England in 1906.

As recommended, I ate for two evenings at Restaurant Le Saphir — the tiny establishment several steps from the hotel which opened onto a little square at the front, while the narrow kitchen could be accessed from the street at the back. It was run by another delightful Algerian, Walid, who worked 16 hours a day with no assistance. After I asked for couscous he took me into the kitchen and showed me the huge pot in which it was being cooked, but said it would be even better the following evening, ensuring my return visit. He will never get rich: every child who comes in the door gets given bowls of sweets, or paper cocktail umbrellas, or tinsel darts, or all three at once. During the day, in a scene that is repeated in many of the smaller villages across Europe, a group of men, either retired or unemployed, avail themselves of the outside seating, tiny drinks in hand, whiling away the afternoon trying to impress one another with

stories from the past or analysing the evolving plot of some favourite soap opera on television.

On my last evening in Martigues I decided to treat myself, and went to Le Miroir on Maud's recommendation. I have much to thank her for. I'd walked past at 11 a.m. when the staff were eating an early lunch in the sunshine before the mistral started to howl once more, and was immediately taken by the food on offer. I was probably early by local standards, but I had to be off in the morning, and besides I wanted to get an outside table so I could look at the fishing boats and the gaily coloured houses.

First, I enjoyed a tiny dish of green-olive tapenade, and then settled for a rabbit terrine, served with champignons and onions on toast and two pickled cherries. This was followed by a type of open ravioli set in a deep bowl, in the middle of which was a piece of fish in a fairly wet sauce; it was finished off by a large sprig of fennel leaf and two wildflowers for decoration. Little dots of pesto sat on the inner rim of the bowl. It was absolutely delicious, made more so by a second glass of very dry rosé. I usually never take photographs of food, but the whole meal was so prettily presented that I couldn't resist capturing my reward for being on the move so long.

Later, when I walked back along the sea front to the hotel, I noticed a carousel sitting idle in the early-evening sun. Hodgkins was rather fond of these merry-go-rounds, painting them on a couple of occasions, and I was interested to read that the horses on early versions were often made by ships' carvers taking time out from working on bowsprits.

Martigues was important to Hodgkins, hence her constant return. She wrote to Lucy Wertheim in February 1928 that even though some might think her wayward, any artist worth their weight had to be. 'Au fond — deep in my work — I am steadfast & steady as a rock — I have changed & evolved & experimented . . . my present work is consistent — I shall sink or swim by it — I think swim . . .'[4]

14

Avignon

FRANCE

On my first research trip I had originally planned to travel inland to the historic city of Avignon, where Hodgkins had stayed in 1906, but it was impossible to fit in. I finally managed to visit on my third trip to Europe in 2018. Much to my delight, I found its centre relatively unchanged since Hodgkins was there. As always, her letters tell us much about her time in the city. She took with her the necessary painting equipment, but this time she also carried a newly acquired camera.

In her earlier visits to France and Holland she sometimes relied on professional postcards and photographs as aides-memoire, a gridded scene of a Dutch market place now in the Turnbull Library in Wellington attesting to their use. She almost certainly resorted to such compositions when the weather was too foul to work out of doors and indoor models were not available. She had given the purchase of the camera much consideration, describing to her mother how she felt that her art required all the extraneous help she could get. The young salesman had assured her that every artist of standing had one, although when he informed her that one woman had her negatives secretly enlarged and then painted over them she heartily disapproved, feeling it was a form of cheating.

The letter to her mother continues: 'We departed [from Paris] early one morning with a large basket full of provender to eat by the wayside. The so-called Express was nevertheless a slow one & took all day about getting to Avignon . . . [The Hôtel Luxembourg] is an old old house built in the days of the Popes . . . & we are tucked away in two nice rooms right in the middle of the house & no sound or murmur of the outside world reaches us. The rooms open on to a sunny courtyard . . . They do us for 5 francs a day & we are well fed on plain food & an abundance of fruit & vegetables. It really seems as though it were the fountain head of all fruits of the earth so rich is the supply in the market: melons seem to gush out of the ground & lie in heaped up piles of ripeness & grapes in riotous Bacchanalian profusion make you giddy as the wine they are destined for.'[1]

Hodgkins was travelling with Miss Hill, the older companion whom

she had first met in Penzance in 1902. 'Poor Miss Hill is very lame with varicose veins & scarcely stirs out. She has a cheerful bright nature though & finds plenty of amusement in working up her morning's sketches into very appalling pictures & every evening she has a nice new picture to look at. She paints strictly by formula & mixes her paints with a mixture she calls "soup" & which stands for the atmosphere of the day — yellow soup for a sunny day, grey soup for a grey day. By this ingenious dodge she claims never to "go wrong" & it certainly never fails to produce exactly the same effect in every picture but to me at least the effect of the "effect" is not so pleasing. But the great point is that her painting makes her happy & in this she is more successful than I.'[2]

Avignon provided her with much inspiration, as can be seen in a masterly watercolour on a large scale owned by a Hodgkins devotee, *La Place, Avignon* (1906) (Fig. 25). The owner's family had always regarded this work as their 'Parisian painting', but when I caught my first glimpse of its brilliant cerulean sky reflecting light on a partly obscured yellow-ochre wall, on a visit to Adelaide in 2016, I sensed that this had to be a work painted in the south of France. That tiny fragment held a similar intensity of light to that much smaller watercolour of Le Panier in Marseilles, painted when Hodgkins first set foot on European soil in 1901. With that initial clue, the owner, Auckland Art Gallery librarian Catherine Hammond and I started searching for other indicators.

Hodgkins' lodgings were adjacent to the magnificent creamy-grey stone complex known as the Palace of the Popes, which got its name from the schism that occurred in the Catholic Church on and off for much of the fourteenth century. Today it is beautifully restored, and a representation of its original internal decoration can be viewed on iPads, but I imagine that it was in a state of romantic decline at the beginning of the twentieth century. Adjacent to the site is one of Avignon's main squares, Place de l'Horloge, which in 1906 was a busy thoroughfare, with horse-drawn cabs lined up on

OPPOSITE **Fig. 25** *La Place, Avignon*, 1906, watercolour on paper. *Private collection.*

the periphery ready to collect new passengers or allow others to descend. To paint her preferred view, Hodgkins set up her easel under the shade of the large plane trees that still line the square today. On the left-hand side of the scene is a tram with a sign attached to the front. We couldn't make out the sign clearly, but AVI seemed to fit the first three letters, and this was our first clue that the watercolour had been painted in Avignon.

Then I noticed what seemed to be the base of a monument partly obscured through the overhanging branches in the background of the watercolour. 'Avignon, monument' was promptly entered into Google, and up came the Centennial Monument, constructed to mark the year when Avignon finally became part of France during the French Revolution. It has now been re-sited nearer the river, and I got a spectacular view of it as I hurtled towards it in my taxi from the TGV station (a beautiful contemporary structure which gives you the sense of being inside the skeleton of a sinuous snake). Today the monument sits in the centre of a roundabout, unencumbered by surrounding trees and buildings. While Hodgkins faithfully rendered the architectural elements of the base, the leafy branches of the trees saved her from having to deal with the classically clad maidens cavorting around its midriff, and the snarling bronze lion at its base is reduced to a rapid brown swirl of paint.

While the scene is one of reflected light and shade, the elegantly dressed woman passing in front of three mules harnessed to a tram is the real focus of attention. Her pale-pink gown is drawn sinuously around her as she steps forward, her appearance and stance reminiscent of the Japanese geishas that are the focus of many ukiyo-e prints. These were eagerly collected by French modernist artists after they appeared as wrapping for imported fine porcelain in the latter part of the nineteenth century, creating a movement known as Japonisme. Manet, Degas, Monet and Van Gogh were all avid collectors, fascinated by the flat planes of colour in the often elaborately patterned costumes, as well as the artful way space is implied by the careful placing of one or two items in the 'background'.

In Hodgkins' painting the young woman's tartan parasol seems ready

Le vieux Pont d'AVIGNON

H. Poupard fils, Avignon

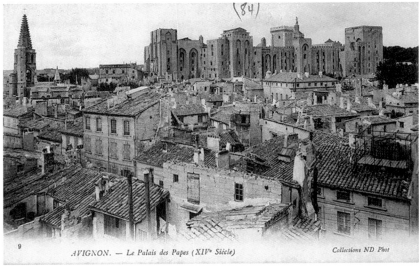

9 *AVIGNON. — Le Palais des Papes (XIV^e Siècle)* Collections ND Phot

ABOVE A postcard showing Pont d'Avignon during the time Hodgkins painted in the town and surrounding area. *E. H. McCormick Research Library, Auckland Art Gallery Toi o Tāmaki, gift of Roger Collins, 2017.*

BELOW A postcard showing Avignon's Palace of the Popes during the same era. *E. H. McCormick Research Library, Auckland Art Gallery Toi o Tāmaki, gift of Roger Collins, 2017.*

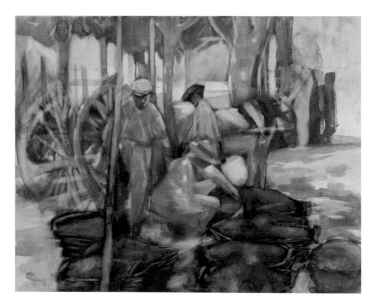

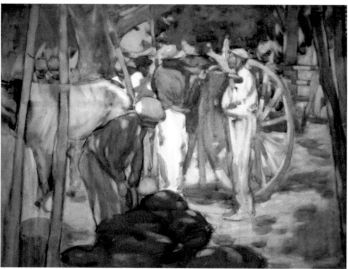

ABOVE **Fig. 26** *Untitled [Checking the Baskets]*, 1906, watercolour and charcoal on paper. *Auckland Art Gallery Toi o Tāmaki, purchased with assistance from the Auckland Decorative & Fine Arts Society 2007.*

BELOW **Fig. 27** *Untitled [Loading the Cart]*, 1906, watercolour and charcoal on paper. *Auckland Art Gallery Toi o Tāmaki, purchased with assistance from Geri and John Herbert, Cyril Wright and Linda Light 2007.*

to be unfurled the minute its owner steps out of the shade, and a delicious black hat, a froth of white cascading from the back, matches the long white stole or collar that curves around and down the front of her jacket. Unaware of the artist, she turns her head slightly in the direction of the tram, accentuating the elegance of her neck, an area of the female body considered especially erotic in Japanese art. Nearer to the monument, men stand underneath a gas lamp with the attentive gaze of people impatient for their own tram to arrive. The young woman, absorbed in her own thoughts, dominates and ties the scene together.

Before the autumn advanced too far, Hodgkins spent as much time as she could in the fields and markets, noting: 'A terrific thunder storm burst over Avignon in the night & today it is raining & very cold & if I were at home I should probably be sitting over a fire with a good book Sissie wld probably be tidying & mending things. Now you know the sort of day.

'. . . The vintage is over & the last grape converted into wine. It has been a plenteous year . . . I have spent many mornings making studies & still life drawings of the grapes for my big picture which is now well on towards completion.

'It was an interesting & primitive scene watching the men, who might easily have belonged to any century, handling the grapes with purple stained hands, weighing them & sending them off in laden lumbring carts generally painted the brightest blue, drawn by white mules already much over burdened by heavy but very picturesque harness in which bells play a part.'[3] Two watercolours acquired in Paris by Auckland Art Gallery in 2007 show men checking cloth-covered baskets and loading them onto carts — possibly the scene Hodgkins describes (*Untitled [Checking the Baskets]*, Fig. 26; *Untitled [Loading the Cart]*, Fig. 27).

One of the high points of Hodgkins' stay in Avignon was a telegram she received from Monsieur Maurice Guillemot, editor of *L'Art et les Artistes*, who had just viewed the watercolours she had on display at the Société Internationale des Aquarellistes at Galerie Georges Petit in Paris. He wrote: 'Mes felicitations! Vous êtes triomphatrice!'[4]

15
Paris
FRANCE

Hodgkins passed through Paris many times on her way to rural locations that gave her the subject matter she sought for her watercolours, but it was only in 1908 that she determined to settle in the city. Sharing first prize with Australian artist Thea Proctor in the Australian Section of Women's Art in the Franco-British Exhibition in London made this financially possible. She travelled across the channel with Theresa Thorp, an amateur painter who had become one of her pupils in Dordrecht, Holland, the year before.

She had spent the year before, from May 1907 to August 1908, in the Netherlands, initially drawn to it as an inexpensive place in which to live and, more importantly, to teach. Her subjects remained familiar — canals, domestic subjects of mothers and children, and the by now ubiquitous market scenes. But her new locale, as she said in interviews in Australasian papers in 1913, gave her access to the work of two major Dutch painters, Anton Mauve, a realist painter, and the Maris brothers, members of the Hague School of painting. She didn't specify which of the three brothers was most influential, only that in their painting she saw how 'colour would be taught to flow, to vibrate, to thrill'.[1] What she learned would influence her own watercolour style from then on.

From the mid-1860s an international revolution in art-making had emerged in Paris. Charles Baudelaire's 1863 essay *Le Peintre de la vie moderne* (*The Painter of Modern Life*) called on artists to celebrate everyday life with the same serious intent with which religious or classical subjects had been approached in the past. Artists must be of their time, whether capturing the light-filled landscapes of the south or the seductive bars and theatres that became central to night life in Baron Haussmann's newly designed city. While artists and writers captured the rural activities found in French fields and villages, and set up artists' colonies in ports such as Pont-Aven and Concarneau, Paris served as the powerhouse of creative thought and action, and remained so until the outbreak of the Second World War, drawing artists and writers from around the world into its ambit.

After arriving in Paris in November 1908, Hodgkins moved into accommodation at 85 rue Vaneau in the 7th arrondissement. She took a cheaper room bathed in sunlight (something she relished) while Theresa Thorp had a more expensive room with the luxury of a fire, in front of which Hodgkins could toast herself in the evening. She also ran into Rosamond Marshall, whom she had first met in Rijsoord in Holland in 1903 and who had become a good friend. Marshall had 'a lovely little flat & is living like a little Princess in the greatest comfort & luxury', and she urged Hodgkins to stay for a month over Christmas. But Hodgkins knew she wouldn't get any work done if she did so. As she told her mother: 'Miss Thorp is a much better mate for me. She is a worker like myself & very serious about art. Rosamond is not . . . I have decided to work in a studio in the morning & paint out-of-doors or out of windows in the afternoons.'[2]

Determined to master painting the nude in oils, in January 1909 she joined a class taught by symbolist painter Pierre Amédée Marcel-Berroneau in his studio. Until recently none of her studies from this period had been identified, but we have now discovered that an oil on cardboard of a still-life subject has a seated nude woman beneath it: this was revealed when the work was X-rayed. Hodgkins obviously believed that she would not find a market for the work, or perhaps was dissatisfied with its execution, and, as was common practice, simply painted over the top of it.

One of Hodgkins' proudest moments occurred in 1910, when she was employed as the first woman watercolour teacher at Académie Colarossi. This was a real endorsement of her progress, but unfortunately no letters describing this period survive. Unlike the traditional École des Beaux Arts, both the Académie Julian in rue du Dragon, where New Zealand artist Charles Goldie studied from 1893 to 1898, and Atelier Colarossi (as it was also known) were progressive art schools open to both male and female artists. Situated in rue de la Grand Chaumière in the Latin Quarter, the atelier had been set up by an Italian sculptor, Filippo Colarossi, to facilitate the creative development of poorer artists.

Fortunately for us, between 1896 and 1898 Australian art student Alice Muskett wrote a series of pieces for the *Sydney Daily Telegraph* about life at the Académie, describing Mr Colarossi as uninspiring in appearance — short and carelessly dressed — but immensely kind. In her day he employed eight professors, and there were about 30 pupils in each class, although some came only when they could afford it. In 1896 men had to pay 300 francs (£12), whereas women paid 100 francs more (£16), for which they could attend two classes every day of the year. Women also had to pay an extra 6 francs to hire an easel and a stool, but they were otherwise treated equally, even if their daytime classes were segregated, the women attending at 16 rue de la Grand Chaumière and the men at number 12.

According to Muskett, some women made themselves ill in their eagerness to learn, attending classes from eight in the morning when the doors opened until 10 in the evening. There was a lot of art gossip before classes began, but once the students settled down in earnest a silence would fall. Hessian was stretched along the walls to protect the surfaces from the male artists who had the habit of wiping their brushes on them despite the signs asking them to refrain from doing do. Among the list of rules on the walls was 'No Bullying'. In winter, especially, light faded in the late afternoon, and so classes would break up until lamps were lit for the evening.[3] In Muskett's day, events were enlivened by Mimi the cat, who minced between the students as they tried to concentrate on their work. She may have gone by the time Hodgkins taught there; given her penchant for felines, she would almost certainly have mentioned Mimi in her letters.

In an interview with Franco-Swiss art critic Pierre Courthion in 1941, Henri Matisse described the evening classes in drawing he had taken briefly at Colarossi. In his day these were conducted to the accompaniment of a pianist who played Chopin or Beethoven. At that time students paid 50 centimes for the privilege, and once the class was finished they would adjourn to the Petit Casino in the Passage de l'Opéra, avidly sketching the

CLOCKWISE FROM TOP LEFT Paris scenes: The hostel in which Hodgkins exhibited after she arrived in Paris; Prunier restaurant; the courtyard of avenue du Maine, where Hodgkins established a teaching studio in 1911.

clientele while their most recent instructions were fresh in their minds. After the curtain went up, they turned their attention to the performers, hoping to set down both their actions and expressions, aided by a 50-centime glass of beer or brandy with cherry syrup. On other occasions they focused on people walking by in the street, drawing rapidly from the shelter of adjacent doorways. Cyclists were also sought as subjects because of the increased speed with which the students had to capture their movements.

As well as Hodgkins, Henri Matisse, Albert Marquet and Georges Rouault also studied under Marcel-Berroneau. Just as Braque and Picasso would discuss their struggles inventing what became known as cubism, each rushing back to the studio to produce works they could then competitively analyse, so Matisse would stand across the street from his friend Albert Marquet, seeing who could complete their drawing the most rapidly. But while Picasso and Braque were fracturing then reconstructing forms as a series of planes, cubes and cones, Matisse was searching for rhythms, the constant movement of bodies and what he described as the 'exactness and lack of it', so that the sketch 'was like a moment in the individual's life. Marrying these two things was my goal.'[4]

Matisse later summed up what this kind of activity meant to an artist: '[T]here has to be opposition and struggle . . . You come out by your own means. The essential thing is to come out, to express that sense of falling head over heels for the thing; the artist's job is not to transpose something he's seen but to express the impact the object made on him, on his constitution, the shock of it and the original reaction.'[5] These same sentiments can be sensed in Hodgkins' ongoing approach to her work.

In 1911, Hodgkins had set up her own atelier in Paris at 21 avenue du Maine, a set of studios made famous by Marie Vassillieff, who set up her own academy there the same year. At different times Guillaume Apollinaire, Maurice Utrillo, Constantin Brâncuşi, Amedeo Modigliani,

Pablo Picasso, Georges Braque, Jean Cocteau and Henri Matisse were among those who worked in the cul-de-sac of studios, which today are partly obscured by vines and creepers that provide a refreshing coolness in the heights of a Parisian summer.

The influence of this period in Paris is evident in Hodgkins' work. Claude Monet seems to have been the inspiration for a pair of watercolours produced sometime in 1908–09. Both *April* (Fig. 28) and *The Hilltop* (Fig. 29) show groups of women and children at the top of a hill, their figures standing out against the sky. In Monet's pair of paintings — *Study of a Woman En Plein Air: Woman with an Umbrella Turning to the Right* and *Study of a Figure En Plein Air: Woman with an Umbrella Turning to the Left* (both 1886, and now in the Musée d'Orsay in Paris) — the model is silhouetted against the sky, clutching an umbrella which casts her face into shadow. The young woman is passive, the artist focusing on her billowing scarf, the cloud-patterned sky and the movements of the model's skirt mirrored in the green and yellow blades of grass.

In Hodgkins' two works the focus is on the movement of the young women. In *April*, one, dressed in black, grips the hand of a younger girl, a smaller child on the left holding up one arm to shield her eyes from the sun. Another young woman on the right looks away, following the gaze of a little girl pointing out of the picture frame. In the foreground, a beautifully rendered hound glances at the artist, completing a circular effect as our eye is led from figure to figure and back again, as if they are dancing in the wind. In *The Hilltop*, a single figure stands out against the sky, gazing into the distance, while her companions are relaxing on the grass, away from the wind's buffets. Only one small girl is included, firmly clasping her sunhat to her head. We sense the individuality of each figure: the two paintings are a terrific example of how an artist's imagination might be sparked by something they have seen, and yet they make their own composition completely individual rather than imitative.

Her figure subjects are now closer to the picture plane, allowing a greater sense of individual character and purpose. In an impressionistic

ABOVE **Fig. 28** *April*, 1908–09,
watercolour on paper.
Private collection.

BELOW **Fig. 29** *The Hilltop*,
c.1908, watercolour on
paper. *Museum of New Zealand
Te Papa Tongarewa, purchased by
public subscription 1913.*

work, *Untitled [Woman in a Sunhat]* (Fig. 30), an elegantly dressed young woman appears to be seated in the stern of a boat, her upper figure and sunhat-covered head silhouetted against sea and sky. The hat is tied under her chin by a scarf, but she holds the brim as if it might fly off at any moment, and a sensation of wind is suggested by the rapid brushstrokes that sweep around her white dress and the dash and dazzle of the reflections on the sea behind her. Related poses can be seen in the works of Renoir, Manet, Berthe Morisot and Mary Cassatt.

New Zealand art student Cora Wilding took lessons from Hodgkins in Paris in 1912. 'I remember my first lesson,' she recalled in 1961, when interviewed for radio: 'She pounced upon my paint box and said . . . look you've only got red and yellow and blue and you should change those colours and have bright viridian, she was very keen about viridian. And more chromes too, brighter colours, she didn't like the French blue and yellow ochre, she thought those earth colours dead and liked the brighter colours. I remember the way she seized a paint brush, put a tremendous lot of paint on it, it was watercolour she was working with and a great big swirl right from the shoulder to get the line, the expressive line, she was very keen about lines.

'I remember she gave me very good advice when I arrived in Paris, she said, yes, it's good to study the old masters, you should go to the Louvre always on Sundays or the Luxembourg, they are always open, but you ought to go and very seriously study the modern people . . . There are about 20 private galleries in Paris on the other side of the river from the Quartier Latin where Miss Hodgkins was living and where the centre of the art students were. And she said it's the modern people, that we live in modern times and we have got to express modern times and that is why she . . . broke away from the Impressionists completely.'[6]

Wilding also recalled going to a meal in Hodgkins' studio just after she had arrived in Paris. Hodgkins had sent her an invitation, writing that she would be interested to hear about New Zealand friends. Christchurch-born Owen Merton, who had helped Hodgkins set up the atelier, painting

Fig. 30 *Untitled [Woman in a Sunhat]*, c.1910, watercolour on paper. *Auckland Art Gallery Toi o Tāmaki, The Ilene and Laurence Dakin Bequest, purchased 2007.*

the walls white, with a bright yellow dado to add a dash of colour, was also invited. Wilding concluded: 'Miss Hodgkins always loved having young people about. I think that was what kept her so very youthful in spirit always ready to try anything and give anything a go. As a hostess she was wonderful. I'll never forget that first meal we had. Owen said you know she is a very good cook she is quite famous. We started off with crabs in little scallop shells . . . and I can remember the delicious coffee she made . . . she certainly was very hospitable.'[7]

From 1908 to 1914, the Breton fishing town of Concarneau became the focus of Hodgkins' summers, as Paris was too hot and expensive, and her students preferred the Breton seaside atmosphere and the range of subjects on which they could practise their en plein *air* techniques. A photograph of Hodgkins painting in Concarneau (possibly taken by one of her students) shows her white-clad figure topped by a large impractical hat. She is right on the edge of the breakwater, leaning forward over a sheet of drawing paper pinned to a board on a tripod easel.

Over her shoulder we can see the fishing fleet moored in serried rows, some with white sails, others with a much-favoured rusty red ochre. This colour, used by fishing boats all over the Mediterranean and in parts of Britain, was applied as a kind of waterproofing, and was traditionally made from a mixture of red ochre, cod oil, urine and seawater, and must have had a quite pungent smell.[8]

The fishing boats were famous for their use of blue nets, the annual summer festival to celebrate them commencing just prior to Hodgkins' first visit to the town. To the far right of the photograph, hidden behind the sails, you can just make out the walls of the Ville Close (Walled City) in the middle of the harbour, which can be reached either by bridge or boat.

In a sketch of a middle-aged fisherman bent over the sail he is mending,

OPPOSITE **Fig. 31** *Untitled [Fisherman Sewing a Sail]*, c.1911, watercolour and charcoal on paper. Canadian artist Emily Carr described how Hodgkins took her students to a fisherman's loft to sketch in Concarneau in 1911. *Auckland Art Gallery Toi o Tāmaki, purchased 2007.*

Untitled [Fisherman Sewing a Sail] (Fig. 31), Hodgkins confidently captures the volumes of his body beneath his pinkish-purple shirt and brown vest. For half the foreground the white paper is left plain, apart from a few pale dashes to suggest the density and weight of the fabric; the tools of his trade line the wall in the background, creating a tonal contrast.

Elizabeth Rhind was one of the young New Zealand artists who made the pilgrimage to study under Hodgkins in Concarneau, spending a month there in the summer of 1911. In 1969, the centenary of Hodgkins' birth, a recording was made of her and others' memories of the time. Rhind commented: 'She allowed her pupils a lot of freedom. They could do just what they liked and they [could be] almost impressionist if they wanted to be. She didn't worry very much about drawing and of course in my case I didn't worry either if she didn't mind. As long as you got the effect and light and a pleasing impression.

'She always taught in watercolours and oil brushes, the coarse hog ones which gave rather a good effect on paper and that is the way she always painted. It was great joy learning from her but I think that perhaps she allowed her pupils a bit too much freedom. She just walked round amongst her pupils and gave a lesson each day. She was always rather quaintly dressed. She always had a smart hat and high heels. She kept herself very much to herself she didn't mix with her pupils a great deal. I can understand people being a little bit in awe of her because she had a little edge to her tongue and a very humorous gleam in her eye.'

Rhind was not overawed by Hodgkins because she leavened any criticism with a great deal of humour and was always kind. She also recalled Hodgkins' great affection for New Zealanders, as well as for the country. Rhind felt that 'although art had to come first, art didn't really compensate her for all she had lost. It was always a struggle between art and affections.'[9]

Hodgkins painted a number of watercolours in which hotel dining rooms and salons provide the setting, demonstrating similarities in composition to Berthe Morisot, not least Morisot's *Cottage Interior*

(Cottage in Jersey) (1860), which shows a young girl holding a doll at a window, with a circular table laid for déjeuner, and a view of a garden and then sea in the background. A similar circular table laid for lunch appears in Hodgkins' undated *Rosamond* (Fig. 32) and *Déjeuner au Renard d'Or* (c.1909). The handling in each is different and experimental, but the outlining of the plates, jugs and glasses on the table is treated in a similar delicate manner to that of Morisot. In Monet's *Lunch: Decorative Cloth* the table is laid in a garden, providing a contrast between the dappled shade that falls on the circular table in the foreground and the beds of colourful flowers in bright sunlight.

Hodgkins' family continued to press for her to return to New Zealand, but after a successful exhibition in 1910 at the International Society of Watercolourists, she wrote to her mother: 'It has been a week of excitement for me — each post has brought me in some good news from Paris about my pictures — flattering press notices — kind letters — requests for lessons etc & I am feeling a little happier than usual. I enclosed for your edification M. Guillemots kind letter — translation on t'other side for those of the family who don't know French. Girlie of course is a scholar & will read it off easily. It's nice isn't it dear? Arent you willing I should stay & follow it up? Don't you want me to find myself permanently & definitely in an established niche in the Art World. I wish you were as terribly ambitious for me as I am for myself.'[10]

Chloe Steer, longtime friend and gallery volunteer, joined me in Paris for part of my journey. We had booked an Airbnb in rue des Petits-Champs which looked suitably romantic online and was ideally situated in the 2nd arrondissement. We had arrived at our destination in the late afternoon, exhausted after having sat in the dark in a tunnel somewhere in a Paris banlieu for several hours before our train was shunted free by another engine, and then crawling our way slowly into the city. We looked without success in the metal letterbox for the promised

Fig. 32 *Rosamond*, 1909, watercolour on paper. *The University of Melbourne Art Collection, gift of Dr Samuel Arthur Ewing, 1938. Photo by Lee McRae.*

key: without it there was no way of entering the narrow courtyard behind the building, which turned out to face a street both front and back.

Only the timely appearance of a très charmant young baker from the famous bread shop below saved us. He not only let us through the gates, past the open back door of the bakery and the tiny atelier that created handmade shoes for men, then through the locked door at the bottom of the set of stairs, but also helped us up the three flights to our door and located the key under the door mat. Our absent host had obviously forgotten that we were coming; her things were scattered throughout the flat, and the only available set of bedding was folded, washed and wet on a clothes rack. Chloe settled herself on the sofa facing the kitchen and I took the bedroom. We were highly amused by a sudden fanfare and the arrival of hundreds of men and women clad in white (with just the odd dash of black) carrying everything needed for a picnic in the Petit Palais gardens behind our building. We had arrived in time for White Night, and after refreshing ourselves we walked out to view them setting up.

I returned to Paris in July 2016 with Catherine Hammond, my co-researcher on the Hodgkins project, and as always it was lovely to be back. Catherine had booked us an apartment in the Place des Vosges in the Marais, close to the library at the Pompidou Centre. The pitch-black entranceway, illuminated only by the door to the street, led to a narrow, curved, wooden staircase — the dim light revealing that the riser of each step had failed long ago and you could see what appeared to be rubble packed behind them. The apartment itself was fine — a lovely large room facing the street, with floor-to-ceiling French windows.

Health and safety is unknown in Paris, and only a low black cast-iron railing stopped us from tumbling into the street. A kitchen bench and a stove filled most of one wall, and high cupboards above held most of the equipment for preparing a meal. A table for two was tucked into a corner, a banquette providing the necessary seating, while on the other side of a partial dividing wall was a pull-down sofa, with a mezzanine bed above it. It could be described as petite bijou or just plain tiny, but it

was saved by the high ceiling and, more importantly, the locale.

The patisserie across the road sold delicious bread and pastries, and on the next corner there was an exorbitantly expensive little grocery store for urgent provisions until we located a supermarket several streets away. Our bags crammed with olives, cheeses, finely sliced hams and other necessaries, we climbed 'our' winding stairs and made our first Parisian dinner. The owner of the apartment had demonstrated how to use the air-conditioning unit, which involved opening one of the French windows, stuffing a fat plastic hose through the gap, then closing the curtains to try to keep the cool air in. As this plunged the apartment into darkness, we resolved to do without and to enjoy the view of the tiles and chimneys of the rooftops opposite, accompanied by the roar of cars, motorcycles and Gallic chatter from the street below.

Blandine Massiet du Biest, a Parisian now living part of the year in New Zealand, kindly agreed to meet us outside the Musée d'Orsay on our first morning of research. We were grateful for her assistance, for we would never have negotiated the vagaries of the museum's library system, its baleful gatekeepers so intent on keeping any riff-raff out that even Blandine was forced to roll her eyes. The 'working end' of institutions are often more proletarian in appearance than their public faces, and this was no exception. The entrance led off one of the galleries packed with nineteenth-century art, but once inside the space was very utilitarian and drab, although the library itself was more charming, with tiny windows looking out over the Parisian rooftops.

Catherine and I had gone to the Bibliothèque Musée d'Orsay to check their catalogues of the different exhibitions, including those for the salons in which Hodgkins had been included: a single work in the salon held on 1 May 1910, the winter salon 1909 (five works); the Salon de l'École Française (five works); and one work in each of the Salons de la Société Nationale des Beaux-Arts of 1911 and 1912. I was also interested in *Le futurisme à Paris: Une avant-garde explosive*, which was shown at the Pompidou Centre between October 2008 and January 2009, in light

of the extremely entertaining interviews that Hodgkins gave, first in Australia and then in Dunedin, in which she described her attendance at the Futurist Symposium in Paris in 1912.[11]

This symposium was held in January at Galerie Bernheim-Jeune, which Hodgkins said had been 'attended by a dense crowd of journalists, dealers, beaux-arts students, beautiful models — with a sprinkling of the Parisian haut monde and plutocratic Americans'. She described the founder of the movement, Filippo Tommaso Marinetti, as 'a short, thick-set man', looking more like an irascible cavalry officer than a poet: 'He was fiery and combative; and his first words were like a flame in a factory audience — with the audience for soot! He proclaimed himself a destroying angel, an apostle of destruction! . . . He wanted to wipe out imprisoning traditions, clear away all the masterpieces and destroy the museums and galleries, particularly in his native Italy . . . Art schools, academies of all kinds — they must go! (Howls from the students!) Models must go! (Shrieks from the models!) . . . Paint ideas, not appearances. When you paint a horse running, what matter its legs? You wish to paint the speed. Four legs! Twenty-four legs! No matter, if the horse runs.'

Marinetti had then declared that all art would eventually become abstract, something Hodgkins told the journalist she could never embrace entirely: 'Does it seem foolish to you? It didn't seem all foolish at the time. Marinetti and his audience were so much in earnest. And the excitement! And the uproar! Well, that's Paris. Whether it agrees or not, it wants to hear, to learn to discuss. It's receptive, however combative. It gives everyone a chance. London doesn't give novelty a chance. It presents a cold wall of indifference — and then, years after, you see the light struggling through the chinks.'[12]

Her interviewer finished by describing the works Hodgkins currently had on display in Sydney: '[T]he process of Miss Hodgkins' artistic education is seen in the work of different dates and styles; the latest is the best. Her interpretation of colour — not hard and brilliant but rich, soft, flowing — is her best gift. Her feeling for the medium — with a touch

fluid and caressing, as if the colour had run of itself just where she wants it — is her best acquirement . . . She is a painter's painter.'[13]

Many of the works either sent back to New Zealand or acquired by its galleries after Hodgkins' death had a marked effect on burgeoning New Zealand artists. Writing about his own early influences in 'Beginnings', an article published in *Landfall* in 1966, Colin McCahon created his own poetic response to *Summer*, a watercolour painted in Concarneau in 1912 which he saw on display at the Dunedin Public Art Gallery: 'There was one painting . . . I loved above all else, Frances Hodgkins' *Summer*. It sang from the wall, warm and beautiful, beautiful faces beaming from summer blossoms. It was strong and kind and lovely.'[14]

After the First World War Hodgkins never lived in Paris again (almost certainly for reasons of economy), although she continued to visit or pass through on her way to Brittany, or the south, keeping up with exhibitions and meeting old friends. In 1930 she had lunch at Prunier, the famous Parisian restaurant that specialises in seafood of all kinds. She described her meal to her dealer at St George's, Arthur Howell: 'I stayed in Paris long enough to eat a perfect dejeuner chez Prunier oysters, langoustine, foie gras — seated on high stools at a Marble Bar — oh Heaven — all very soulful & concentrated.'

Her letter also describes the exhibitions she has seen, including 'a very exciting show of Picasso, Braque, Matisse etc & met some exciting looking people — 1 Princess, 1 Ambassador, who being a Diplomat enjoyed talking. I enjoyed listening to him explaining what Picasso really meant. The Princess tapped him on the arm & said "You know an artist never explains". I murmured that I thought Leger was only an inspired plumber — un plombier inspire — and that mot went round the room — my little moment . . .'[15]

Unaware that there were two establishments, Catherine and I booked at the more upmarket restaurant Prunier on the corner of rue de Traktir

rather than the oyster bar. It was an extravagance but worth every euro. The outside is iridescent turquoise, with a design of interlocking circles that would have been just as much at home in Swinging London in the 1960s, and is an art deco delight. Inside, the dotted white circular motif is interspersed with vertical lines on shiny dark-brown walls, and the etched glass windows have abstract sea and shore patterns.

White tablecloths add touches of light, and on the ceiling larger art deco lamps are enhanced by smaller lamps around the edges. Mirrors bounce further light off all the reflective surfaces, and beaten copper panels showing sea creatures advertise comestibles, oysters and crustaceans. At odds with his opulent surroundings, a bronze bust of a resolute fisherman in a sou'wester peers out at the end of the bar, a reminder to those who dine on langoustines and oysters of the labour involved in providing such glistening delicacies, and the weatherbeaten lot of the fishermen who risk their lives at sea.

While Hodgkins would have taken as much pleasure from sitting in one of the little fish cafés in the narrow streets of Martigues or Cadaqués, the offer of a lunch at Prunier, no doubt paid for by Maurice Garnier, was too good an opportunity to be missed. Her letters reveal her delight at treats like this, not least because they occurred rarely, and therefore every moment was to be savoured. We couldn't have agreed more.

16

Penzance and St Ives

ENGLAND

Hodgkins first visited Penzance, in Cornwall, in 1902, making brief forays to St Ives, where she was later to stay for the duration of the First World War. Chloe and I arrived in Penzance from London late on a warm afternoon. At the car-hire office on the harbour edge I was dismayed to view the enormous silver-grey Audi we had been allocated — it was Chloe's natural form of transport but far too grand and large, even with the seat pushed forward as far as it would go, for the likes of me.

We set off on the short journey to Newlyn, where I had booked us into Trereife House, a rather splendid eighteenth-century Queen Anne stone farmhouse that's been home to seven generations of the Le Grice family and is now a bed and breakfast. We admired the gardens when we arrived, but once shown to my room I was distracted by a wasp nest the size of a small armchair that was hanging off the gutter opposite the window, surrounded by a cloud of angry creatures. (I had once stepped on a German wasp nest and didn't want to repeat the experience.) I was rather relieved when we set off to walk the narrow footpath that winds from the house around to Newlyn itself, reasoning that the wasps would be asleep by the time we returned.

Although it is a small fishing village with a big history, we could find few traces of the art colony that thrived in Newlyn from the 1880s to the outbreak of the Second World War. It has a particular affinity with Brittany, where many British artists painted from the latter part of the nineteenth century onwards. Traditionally both depended on fishing, with farming in the hinterland; and after the railway opened up, Cornwall provided artists a more relaxed and collegial environment in which to work than London with its crowds and exorbitant prices.

Like the impressionists in France, artists of the Newlyn school found their subject matter in the daily activities of the local fishing villages as well as in the nooks and crannies of the surrounding farmland. While many paintings were on a domestic scale, the colony also produced much larger works, such as *For of Such Is the Kingdom of Heaven* by Frank Bramley (Fig. 33), still the most popular work in Auckland Art Gallery's collection,

Fig. 33 Frank Bramley, *For of Such Is the Kingdom of Heaven*, 1891, oil on canvas. *Mackelvie Trust Collection, Auckland Art Gallery Toi o Tāmaki, purchased 1913.*

not just with members of the public but also with painters, who are drawn to its masterly brushwork. The painting shows the funeral of a child from a middle-class family whose little white coffin is carried by young women in matching white, symbolising the infant's innocence and their own state of unmarried purity. Clad in traditional black, the parents of the child walk behind the group, bent in their grief, while fisherfolk look on from the wings, the adults at one in their understanding of loss. Their simply dressed children, their faces ruddy with good health, are more curious about the elaborate white dresses of the girls leading the procession and the bunches of costly funerary chrysanthemums favoured by those wealthy enough to afford them.

I was seven when my mother took me to the Art Gallery for the first time to see it, and artists still make the pilgrimage today because it is a supreme example of the beginnings of modernism, a study of white as much as light, the costumes of the figures painted in broad brushstrokes creating an impastoed surface rather than the smooth glazes loved by the Academicians. Close up, the white dissolves into the subtlest shades of pink, the palest yellow ochre, blue and a whitish grey. Although it is based on a narrative, a compositional device that was erased within modernism, I believe Hodgkins would have loved it. The Penlee House Museum and Gallery in Penzance has a good representation of works by the Newlyn school, but unfortunately it was closed while we were visiting.

When Hodgkins was staying in Penzance, Norman Garstin introduced her to some of the leading artists in the community. Hodgkins felt an easy camaraderie with Garstin and his wife, Louisa, more commonly known as Dochie, having worked alongside them in France the year before. Of the works she viewed in Newlyn, Hodgkins particularly warmed to that of Elizabeth Forbes, who was 10 years her senior. She wrote to her sister Isabel in New Zealand: 'I went down in the morning with Mr Garstin and was introduced to Mr & Mrs S Forbes, W. Langley Rheam R.I., Lamorna Birch & several others, it was all very nice & interesting. Mrs Stanhope has asked me to go & see her & I am to go this Saturday & Miss Courtney is

going to drive me there. I am at Mrs Forbes feet — she wins one with her strength of color & design — tho' I don't want to be influenced by her — merely seeing her work helps one . . .

'The next day was <u>our</u> show — that is Newlyn. <u>We</u> have a gallery of <u>our</u> own & are very proud of it. It is a brave show & the Stanhope Forbes work raised it to a much higher level. Her work was magnificent — much better than her husband's. They were mostly Shakespearian, mediaeval things — but they simply sang with color & light & brilliancy — no one could touch her — she is head and shoulders above them all down here or in fact in England. I think she is pretty generally regarded as the first woman artist in England — she together with Mrs Adrian Stokes.'[1]

While her letters record a continuation of the interminable teas and ritual leaving of calling cards that she had grumbled about before departing New Zealand, they also indicate her early awareness that she had to make her own way, to look and learn from the painterly skills of others, but not be lured into imitation. Like a number of Hodgkins' letters home in her first decade away from New Zealand, this one to Isabel was extremely long; she was eager to share everything with her, proudly listing the works she was having exhibited, knowing that her family would be pleased, but also validating her decision to come to the other side of the world: 'I had 5 things on the walls 3 for the Academy & 2 for N.E.A.C. & they all said nice nice things about them & seemed to think I painted like Arthur Melville, which is rubbish — or if it is it is quite unconscious . . . I had a try for the Academy tho' it is quite hopeless I am sure. It is not the place for water colors in the first place — but they all thought I should send something & try my luck — I am looking for a room for a studio. In the meantime I am working in the afternoon at the studio where Mr Garstin's pupils work. They are seldom there in the afternoon & I have it to myself.'[2]

When Chloe and I strolled into Newlyn in the early evening, we walked along the breakwater depicted in Bramley's painting, which stretches its protective arm around the moored fishing boats. We dipped in and out of the narrow lanes between the cottages, their walls clad either in the soft local grey-brown stone or whitewashed, with bright blue sills and doors. Newlyn today in some ways resembles Martigues of 1921, which Hodgkins had mocked as a grubby little fishing village when she first arrived. The residents have a strong sense of independence, and when a merger with Penzance was mooted several years back they refused, although the two are only a mile or so apart. As a result, although it still maintains a very active fish, crab and shellfish industry, the village shows signs of neglect caused by a lack of regional funding.

The drifts of green slime that hung beneath the surface of the water added to the sense of decay. Staff in what appeared to be a quaint waterside pub roundly ignored us, proving the adage that you should never judge by appearances. The dinner menu didn't look inviting either, so we retreated, walking disconsolately back to the tiny local supermarket, thinking perhaps we might have to resort to rustling up some sort of dinner in my apartment, which had a reasonably set-up kitchen. However, Lady Luck drew us on to discover another hotel overlooking the water on the opposite side of the breakwater. Here we were warmly welcomed and plied with delicious food that could have graced any good London restaurant; Chloe discovered her favourite sherry, and suddenly all was right with the world and our opinion of Newlyn much improved.

The next morning, following in Hodgkins' footsteps, we met at the front of the house to go on to St Ives. We drove as far as Hayle, then discovered that it was one thing to *know* that you should park the car and take the little train into St Ives but quite another thing to find just where to do it. We had followed the directions provided by our host, but we seemed to have inadvertently driven into an old people's home, its neat little cottages crammed tightly either side of an extremely narrow

driveway. Assuming we had taken a wrong turn, we headed further away along the shoreline until it became evident that there was no sign of a railway for miles around. I did a risky U-turn and we retraced our journey.

Sure enough, the pensioners' driveway opened out into a field and a large car park, and there was our train. It still runs because there is very little parking in St Ives itself and it takes only 15 minutes to trundle gently along the coast. On a fine day the turquoise sea sparkles and the white sands gleam, but unfortunately clouds descended, and for most of the day seemed to threaten the storms that are a constant feature of maritime environments.

H odgkins had made two day trips to St Ives, the first in the hope of seeing Moffat Lindner and his wife (it turned out they were away), and the second to visit New Zealand artist Margaret Stoddard. Although Hodgkins was delighted to see an old friend, she secretly thought that Stoddard had become too absorbed with tone over form, although she kept her opinion to herself. In a letter to her sister she paints a humorous portrait of her first impression of their outing to visit Open Day in March 1902: 'On the 24th we went over again to St Ives — it was a dreadful day — raining in sheets & wretchedly cold but nothing daunted we set out, for we had 15 studios to visit before dark. It was show day, the great day of the year & it wld never do to miss it. Of the 15 studios occupied by 32 artists I don't think I saw more than 10 good pictures.

'Arnsby Brown & Julius Olson were the best, their work was splendid especially the latters. Louis Grier was good I believe but unfortunately by the time we reached his studio it was shut. It was great fun going round — the Studios were hidden in the queerest places. Down dark subterranean passages up chicken ladders — in old boat houses, up sail lofts — any where where they could get a white-washed wall & a top light. Finally we wound up at a Mr Boschreiz for tea. He is really a most talented man but no one looked at his pictures, we were all too much taken with

getting as much tea & cake as we could. If his pictures were as good as his tea he deserved the best place the Academy can give him. There were still a few more studios to see before our train left, but such a glut of pictures had left us worn out so we decided to do the Ocean Wave Studio & then go home. However, on reaching the O.W. we were informed that the proprietor was unfortunately <u>drunk</u> & there was in consequence no view of the pictures. One artist excused his pictures on the ground that he had been playing golf & had had no time, and afterwards I heard that golf threatened to be the undoing of the St Ives men. They played golf for their living & painted for amusement, it pays better they say.'[3]

There is a Dickensian flavour to her description, one that disappeared when she went back to St Ives at the end of 1914 and stayed for the duration of the war. She had to make the best of it then, and the air of frivolity evaporated. Today, when you're pushing your way through the crowds on a weekend in St Ives, it is hard to imagine what it must have been like for those living there in 1915, when artists were forbidden to paint out of doors in case they were suspected as enemy spies passing on details of the coastline and defensive sites to the enemy.

Hodgkins was horrified when the edict forbidding all sketching in Cornwall came through 'like a thunder bolt, scattering my pupils & placing me in the novel position of wondering what I would do next. A fine of £40 if one is caught with an easel or a camera.' She complained to her mother: 'It is so tantalizing to be within sight of so many beautiful things to paint, rocks pools skies paddling children & bits of coast — I tried my best blandishments on the Sergeant from time to time promising not an inch of coast line to be included but he is adamant & threatens to confiscate my painting gear if I don't look out.'[4]

Hodgkins wrote an amusing description of a fellow artist's near-brush with the law: 'Laura Knight, the Newlyn painter & her husband are here painting, she is painting nude children bathing, with all of St Ives looking on, the horrified & the un- together & even the Sergeant himself not knowing whether to interfere in the interests of public morality or

CLOCKWISE FROM TOP Cornish scenes: Porthgwidden Beach, over the hill from Porthmeor, St Ives; Hodgkins' studio in St Ives, No. 7; Porthmeor Studios, as they are today.

not. The mother of "Frankie" who was being painted together with 11 others told me "Lor Miss to see 'er painting the parting in the boys' 'ed & down his back would frighten yer." Next day she went a step further — tapping Mrs Knight on the shoulder she told her, fair & square if she didn't instantly put bathing drawers on all the 13 boys in her picture she would go for the Sergeant. Mrs Knight realising the situation & anxious to avoid trouble gave 2/- to the biggest youth & told him to clear off & buy pants but whether she altered her picture or not is doubtful. Mrs Painter, the mother of Frankie however went home well pleased with her day.'[5]

O ur sights were now set on Porthmeor Studios, where Hodgkins lived and worked for much of her time in St Ives. Initially she was given the use of Studio No. 4, as Moffat Lindner, who usually painted there, was away. On his return he arranged for her to move into No. 7 Porthmeor Studio rent-free; she worked here from 17 June 1915 to 14 April 1916. She enjoyed having the older artist nearby, having caught up with the Lindners by chance in Caudebec-en-Caux in July the previous year. They had also come across one another in Dordrecht in 1907, though the coincidence is less surprising when so many artists visited locations that were well known, much discussed and relatively comfortable to visit.

They trusted each other's opinions, Hodgkins recording how Lindner would come into her studio of an evening to discuss their respective day's progress, each giving a critique of the other's work when invited to do so.[6] Lindner worked on and off in Studio No. 4 from 1899 to 1947. By the late 1920s he had become director of the St Ives Society of Artists (STISA), making him one of the old identities of the village, and in 1929 he acquired the studios rather than have them sold out from under him.

Lindner became a firm advocate of Hodgkins during her time there, inviting her to tea with his staunchly feminist wife, Augusta, affectionately known as Gussie. Augusta Lindner organised the committee that was responsible for bringing to St Ives a large group of

refugees from war-torn Belgium. Nearly a hundred of them, almost all elderly, or mothers and children, arrived with just the clothes on their backs, and local families generously took them in, despite the widespread food shortages. Seeing them around the town in their ill-fitting clothing, Hodgkins observed: 'One smiles at these things in order not to weep for the tragedy is heart breaking.'[7] Sensitive to their plight, she paid several of the families to sit for her, capturing the strained expressions of the older women and the forlorn faraway looks of bewildered children who understood little of what was said to them, let alone why they were there.

Maurice Minkowski, another artist staying in St Ives, who had fled Poland in 1905 to escape the Jewish pogrom, also recorded the refugees' plight. His paintings have some similarities with those of Frank Bramley, often showing a broader view, with larger numbers of people in each scene, including the old men and women who accompanied the younger refugees. While Hodgkins empathetically recorded the bond between mothers and children, Minkowski personally shared their sense of dispossession.

From a technical point of view, Hodgkins was gradually becoming more experimental and expressive, not least in her combinations of patterns and brilliant flashes of colour that showed affinities with the post-impressionist French artists Pierre Bonnard and Édouard Vuillard. Inevitably her thoughts often turned to the exhilarating period she had spent in France before the war, not least when she began experimenting with much larger canvases painted in oil, the medium she had struggled with in Paris. Some of these portraits proved particularly successful. She painted the Lindners and their daughter Hope (a much-adored and long-awaited addition to the family) in front of what may be the open studio window at No. 4, using thinned-down paint which allowed her to manipulate oil as if it was watercolour.

Lindner and Hodgkins had certain things in common, for Lindner had also started his career in watercolours, and his technique was not dissimilar in its use of shimmering washes. He particularly favoured rivers and harbours at times of day when the sun or moon cast long rays

over water. Hodgkins would be drawn to the same effects when working in Bodinnick in Fowey in 1932, but she may have also recollected Van Gogh's painting, *Starry Night Over the Rhône* (1888), where lights on the far side of the river reflect in more impastoed yellow lines across its dark water.

Another couple who were generous to Hodgkins were Edgar and Edith Skinner, who went on to help Bernard Leach set up his famous pottery in the town in 1920.[8] Hodgkins painted the Skinners' portrait at their home, Salubrious House, named not for its atmosphere but because of the street in which it was located. The house is large, with a handsome captain's lookout on the roof. (When Leach moved to St Ives, the Skinners sold Salubrious and moved to another house closer to his studio.) Hodgkins would have enjoyed their company, for Edgar Skinner spoke fluent Italian and the couple were keen devotees of the arts, even if he only painted watercolours for enjoyment and Edith's poetry was sentimental in tone. When the painting was completed, Hodgkins had every right to stand back and feel she had finally succeeded in oils. *The Edwardians* (Fig. 34), on a larger format similar to *Mr and Mrs Moffat Lindner and Hope*, demonstrates her reconnection with memories of Paris.

Almost every surface of the painting is densely patterned and brightly coloured, but saved from being overwhelming by passages in black — the maid's skirt, Edith Skinner's jacket and Edgar Skinner's black dress suit. Standing with a severe expression beside his wife on the right-hand side of the painting, his face is broken up by smudges and overpainting, its effect balanced by the mass of his black top hat. Mrs Skinner's face is treated in a starkly different manner that would become familiar in Hodgkins' oeuvre in the 1920s, being almost sculptural, with a blue outline, white highlights that amplify her plump cheeks, and lilac shadows around her eyes and glancing across her cheekbone, topped off by a black toque perched jauntily over her forehead. Her armchair, while clearly outlined, is a mélange of different fabrics and fantastical colours, and yet somehow it works. The maid is shown entering on the left, carrying a decanter of red wine and glasses, her figure upright, not at all subservient.

Fig. 34 *The Edwardians*, c.1918, oil on canvas. *Auckland Art Gallery Toi o Tāmaki, gift of Lucy Carrington Wertheim 1969.*

This device was also used in the Lindner portrait, where Mrs Lindner faces 'into the canvas', as if she and the artist have come upon father and daughter by chance. Another similarity in composition is the window in the background, which serves as a surface on which to bounce light, creating a curious inside/outside feel, not least because the Skinners are obviously dressed for a formal occasion rather than sitting at ease as would be expected when at home. First exhibited as *The Victorians,* the title was changed to *The Edwardians* when it was acquired by Lucy Wertheim at the end of the 1920s.

A further large-scale work, *Loveday and Ann: Two Women with a Basket of Flowers* (Fig. 35), shows two fishermen's daughters, who were no doubt happy to pose as an alternative to their everyday work, but may have been alarmed at the highly creative and unnatural manner in which they were depicted, for their faces are painted in brilliant fauvist green and orange. This portrait was first exhibited in 1916 at the National Portrait Society's exhibition at the Grosvenor Gallery in London, along with *Mr and Mrs Moffat Lindner and Hope.*

There is a psychological tension between the two girls, which is articulated in a poem written in 1993 by Grace Nichols for an exhibition at Tate Gallery about *Loveday and Ann:* 'One has rolled away — / unwinding in the waves of her private blue ocean, / knowing how right she is. / The beauty of her smugness — / Not lost on the other who sees / the pleasure of her crabbing-hand / but chooses to stay land-locked, / sulking on the sands of her own / small hurt, while flowers bear witness — / Even in the alcove of friendship / there are distances.'[9]

The grey stone building at Porthmeor where Hodgkins had her studio sits on the sea wall at the top of the old slipway leading down to the beach. Its vast bay windows and slanting ceiling panes provide sweeping vistas of the beach and flood the inner spaces with the light so essential to artists, although they were fewer in number in

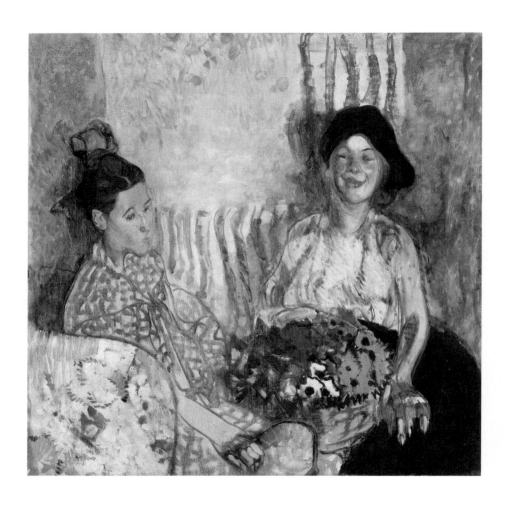

Fig. 35 *Loveday and Ann: Two Women with a Basket of Flowers*, 1915, oil on canvas.
Tate St Ives, purchased 1944.

Hodgkins' day. Although we hadn't made an appointment, the director of Porthmeor very kindly gave Chloe and me a tour of the studios, which today are reached by a balcony-cum-passageway stretching along the leeward side of the building, each bright blue door marked with its number. Moffat Lindner's studio at No. 4 is relatively small and must have seemed quite cramped when filled with canvases and other artists' equipment, but the director then took us to the end of the passageway to the much larger Studio No. 7 into which Hodgkins later moved. It stretches from the front of the building almost to the street behind. Today it is painted bright white, and has a cast-iron stove similar to the one we saw in the first studio. Its current occupants were the artist couple Iain Robertson and Clare Wardman, who greeted us warmly, having had a residency in New Zealand in 2010.

Before the building was taken over as artists' studios, some of which became the home of the St Ives School of Painting, these spaces were part of a series of working buildings stretching along Porthmeor's sea wall, protected from the worst of the weather. They were used to service the pilchard industry, the lower floor providing shelter for sorting the fish, a job which was mainly done by women, who were skilled at packing them into barrels among layers of salt, tails pointing neatly inwards. You can only imagine the raw state of their hands at the end of a day's work. Whole families were involved, and in summer the place would have been smelly and fly-blown, though undoubtedly a nirvana for stray cats.

Eventually the cold and the rats got too much for Hodgkins and she moved across to Wharf Studio beside the harbour, forsaking the ever-changing views of the whirling clouds and pounding waves for the more mundane boating activities that took place within the shelter of the breakwater. At low tide the mud flats may have proved rather depressing, but Hodgkins had little time to brood; deprived of the fishing, harbour and canal scenes that had been among her staple themes in France, she had become extremely busy with portraits of families and babies. In spite of her refusal to flatter, doting mothers were happy to acquire these

watercolours, a medium best suited to quickly capturing subjects who were prone to move when awake. In many of these works the infant is sleeping — an altogether easier task.

Throughout the war Hodgkins inevitably felt a much stronger pull to her remaining family in New Zealand. Reading her letters, you become highly attuned to her moods — sometimes tinged with despair, sometimes en fête. Along with the efforts to retain some form of social normality, the letters reveal her anxieties, her heightened sense of familial bonds, and her physical needs in moments of extremity. Most of us never expect our personal letters to become public property: we would construct them differently otherwise. But it is perhaps inevitable that you share your feelings with family — the personal discomforts, the grumbles, the thoughtless comments written down in haste and then regretted at leisure, as well as the day-to-day observations that help to give relatives a sense of your milieu. For Hodgkins, a renewed sense of family affections and loyalty came to the fore.

On her last trip to Australia and New Zealand, when Hodgkins had her highly successful exhibitions in Sydney, Melbourne and Adelaide in 1913, George Edward Rich, a newly appointed judge to the High Court of Australia, became a major supporter. His wife, formerly Betha Bowker, was a cousin of Frances's mother, Rachel. Bowker's daughter Lydia had gone to New Zealand in 1886, when Hodgkins made a profile portrait sketch of her, and Hodgkins had stayed with the family in Sydney in 1901 on her first journey to England.

Although she warmed to the Richs and their cousins, the Hoopers, to whom she was also related, she privately thought the Bowkers self-centred and obsessed with the fripperies of modern life, describing Betha's manner as cool, suave and soothing as a suede glove, and noting her preference for window shopping over almost all other activities.[10] Their house, however, was immensely comfortable, with three servants to attend

to everyone's needs, and it must have been very pleasant to be taken out on the harbour in the family's motor launch in the afternoons.[11] In 1913 Rich had just been appointed a judge (he later received a knighthood for his services), and Hodgkins arrived in time for the celebrations. Justice Rich took an immediate interest in her work, arranging for her to have an exhibition at Hordern's Department Store.

At the time of her successful exhibitions in Australia earlier that year, Hodgkins had painted an informal watercolour portrait of members of the younger generation of Richs (almost certainly at their home, Belton, in Mona Road, Darling Point), which she called *The Quiet Hour*. Lydia Tempest Rich is shown reclining on the sofa with a cousin, Phyllis Lydia Rolin, while her brother Jack Stanser Rich is perched on the arm of the chair, looking solemn. Hodgkins captured the carefree atmosphere of the time, although she was almost certainly referring to Lydia and her friends when she wrote, 'But oh! The Australian flapper — she is a perfect horror', whereas she viewed Jack as the flower of the flock: 'a bright boy with a charm of manner'.[12]

When Jack volunteered at the beginning of the war, his distraught mother sailed with him to England to delay the moment when they would have to part. On leave from his training at Aldershot, Jack visited Hodgkins in St Ives in January 1915, and they had a marvellous time together. Money was no object, and Jack hired a car. They drove in the biting cold from Land's End, at the western tip of Cornwall, to the Lizard Peninsula, wrapped in rugs, hot bottles and cushions, with bottles of wine and stout to keep their spirits up. Hodgkins described the views to her mother: 'The sea calmed down & was a vivid green & blue — no boats in sight save one little tin pot steamer carrying guns & puffing up & down. The Coastguardsman told us she had secured a German grain boat the week before & towed her in to Falmouth. We scrambled about the rocks & took some photos & then on to the Lizzard for lunch.

'The lighthouse still shows but the village & Hotel lights are all blacked out at night. From here we drove inland over the icy moors & fetched

up about 6 half frozen at Launceston, still in Cornwall where we dined & spent the night at the White Hart. Next morning the country was white with frost & it took some courage to start — the roads were like iron & ice every where. We had to abandon the moors & take another route up & down the red Devon coombes, the ploughed lands silvery white & the trees crystalled & cracking like pistol shots under the weight of frost.'

She added that Jack paid for them to stay in a 'swanky hotel', where they dined on pheasant and gradually thawed out from the cold so that their faces lost 'that hatchetty look & the world seemed a better & brighter place after our good meal'. He'd paid a fortune for the car hire, but before they went their separate ways he said, 'When I come home wounded we'll have another motor trip.'[13]

Jack and his fellow soldiers sailed from Liverpool to the front sometime in February 1915. After Hodgkins failed to hear news of his whereabouts, she became a veritable lioness trying to track down her missing cub, storming up to London to speak to military officials, writing chiding letters into the void in the desperate hope that he was still alive in some muddy trench somewhere, and bombarding the errant mail service by posting every food delicacy she could lay her hands on in a time of deep rationing. The food sent to her by family and friends was forwarded immediately to the front, but for the most part her packages ended up who knows where — soldiers were moved on, died, or, once broken, were sent home, and the gifts appeared doomed to circle endlessly in space like Dante's fourteenth-century lovers Paola and Francesca, unless someone more fortunate took the opportunity to claim them for their own. In times of such adversity, who could blame them.

Jack was injured during fighting and died from his wounds in May 1915. Judge Rich wrote to Hodgkins informing her of his death. According to Jack's regimental commanding officer, he had 'behaved with the utmost gallantry on all occasions': little solace when you have lost the son you persuaded hard not to serve because of his youth. [14]

Heartbroken, the judge asked Hodgkins if she would paint Jack's portrait

from a photograph. It must have been a difficult task, because Hodgkins didn't finish the watercolour until the following year. She almost certainly used one of the photos they had taken when on their motoring trip; it shows the bare-headed young soldier looking serious and determined against an anonymous studio background.

In the portrait (*Lt J S Rich*, Fig. 36), Hodgkins has positioned Jack very close to the picture plane, looking directly out at us, a slight, comforting smile on his lips. His head in its officer's cap stands out beside a rain-washed cloudy sky, while sparse green and purple lines of watercolour suggest a vast flat plain and a river winding far into the background. There is a curious 'present, yet not present' atmosphere to the work, as if Jack is gazing from a long distance while also being very near. The painting hangs in pride of place in a family member's home in Melbourne today.

Some of Hodgkins' other friends were also being touched by tragedy, among them Rosamond Marshall, with whom Hodgkins had had such a gay time in France, who lost her brother in August 1915.

In 1917 Hodgkins' nephew Geoffrey Field, her sister Isabel's oldest son, arrived in England as a member of the New Zealand Expeditionary Force, and as soon as he got leave he headed west to St Ives. He had last seen Hodgkins on her brief visit to Wellington in 1913. In a recorded interview made by friends and family in 1961, he recalled his visit: 'My aunt met me at the station and escorted me with much pride to her studio and then she regaled me with a sumptuous repast of cakes and things which I enjoyed very much after the pretty rough tucker at the camp and then she told me she had arranged with two old ladies to board me or lodge me in St Ives and took me around to them and introduced me to them and I found myself in a comfortable very old fashioned bedroom in a very old fashioned house in St Ives and I was very impressed by what she had done for me.'

Fig. 36 *Lt J S Rich*, 1916, charcoal and wash on paper. *Private collection.*

He was very touched at her pride in him, and how she showed him off to her own friends and supporters, ensuring that he was well fed wherever they went. He also became aware of how much she was loved and respected in the little St Ives community. After he was posted to France she wrote constantly, if not entirely legibly — he felt she wrote very fast, as if 'her pen was engaged in a race with her thoughts. Her writing was just the same as her speech. She could write just in the same manner as she talked. Very witty and interesting and full of life.'[15]

When Geoffrey's sister Lydia visited England in 1919, Hodgkins joined her in London to go to Buckingham Palace where her husband, Captain Will Pharazyn, received his war decorations. Lydia then returned with Hodgkins to St Ives, where she was sometimes perplexed by the esoteric conversations around her. But she also was impressed: Hodgkins 'was adored by all the young artists down there they really sat at her feet and it was quite a new picture of her that I got being worshipped by this world of young artists . . . You could see she basked in it and it was very stimulating to her to find that the younger generation thought so much of her. I remember how clever she was.

'The same thing there with her studio she'd go to a sale and buy up for a few shillings all sorts of interesting bits of furniture. They weren't antiques — they were just nice bits of wood that had a good shape and she would paint them all in different colours and she would do the walls of her studio in primrose and do things that everyone is doing now but was considered then most unusual and most dashing and advanced and it all bewildered me a little bit. In fact I was rather shocked by it all (laughs) it was so unconventional. But she was a very kind person. She was a person who understood other people's difficulties. She had a most amazing assortment of friends, some of them very unusual and bohemian people. I remember once when I said I would run up to see a friend of hers, a woman who lived nearby and she said "oh don't go in the morning dear she will be dying her hair" which I thought was very understanding . . .

'She was a wonderful person and really very witty and with a great sense of humour. If she had had money I know she would never have kept it she'd have been keeping all her friends. I often would have to make her be sensible and practical. If she sold a picture, it was all gone, the proceeds were gone in a flash. But she was like that, she would say "oh but they have helped me before" she was so good in that way.'[16] Lydia Pharazyn also reflected on Hodgkins' sensitivity, not least her despair when work wasn't going as well as she wanted, but equally how she was elated when things did go well. It is useful to read these perceptions of Hodgkins, given that many writers have been aware only of her own poverty and reliance on the generosity of others.

Just as artists such as Moffat Lindner and Norman Garstin offered support and advice to Hodgkins when she was finding her way, so Hodgkins assumed this mantle with younger artists, many of whom started out as students but became life-long friends. She had a particular gift for building up confidence in the young people around her, and she was such a lively and witty observer of life they appeared not to notice her age. She kept a keen eye on the social, creative and political environment and, most important of all, she was able to critique their work in such a manner that they were buoyed into trying even harder.

In spite of everyone's straitened circumstances, pupils continued to seek her out, especially in the summer months. Hannah Ritchie and Dorothy (Jane) Saunders first met Hodgkins in France before the war; later, Hannah came to St Ives, as did Amy Krauss, who went on to focus on ceramics rather than painting. At the war's end Hodgkins went up to London before returning briefly to St Ives, where she met up with fellow artists Cedric Morris and Arthur Lett-Haines. She painted a striking portrait of Lett, as he preferred to be called, whereas his charcoal sketch of her could not be called flattering.[17]

As yet, Hodgkins hadn't made the acquaintance of Ben Nicholson, who became a major influence on the younger generation of English modernists and who worked in St Ives at the end of the 1920s, exhibiting

ABOVE **Fig. 37** Alfred Wallis, *The Steamer*, 1920–40, ships oil paint on cardboard. *Auckland Art Gallery Toi o Tāmaki, gift of Lucy Carrington Wertheim 1948.*

BELOW St Ives scenes, from left: The Godrevy Lighthouse; Alfred Wallis's tomb, the tiles of which were produced by famous potter Bernard Leach.

alongside Hodgkins at the Seven & Five Society. Nicholson and his first wife, Winifred, also painted at Porthmeor Studios along with Christopher Wood. Walking along the road from the studios one day, the two men happened to glance inside the open door of a tiny cottage and were able to make out some remarkable paintings balanced on the mantelpiece. They were the works of a naïve painter, Alfred Wallis, who had worked as a fisherman, then as a rag-and-bone merchant and ship's chandler, and who only started painting after his wife had died in 1922.

His simple, sometimes tiny paintings, often done on cardboard from torn-up boxes (Lucy Wertheim later said he was particularly fond of Quaker Oats) using leftover paints from his shop, were to have an important influence on a number of later British modernists. Many of his paintings of ships were from memory but, significantly, he wasn't bothered whether he painted the prow of a ship in two dimensions and moved into three dimensions at the stern, and nor was he aware of the rules of perspective in painting deep space (*The Steamer*, Fig. 37). A favoured motif was the Godrevy lighthouse at the entrance to St Ives Bay, the subject of one of Virginia Woolf's most successful novels. Wallis's fresh approach was liberating, allowing the young painters who discovered him to throw aside the formal constraints taught in art school and to call on their imaginations and memories to paint what might be called the 'essence' of a subject rather than its literal form.[18]

Chloe and I would have loved to have stayed on in St Ives, but after walking in the blustery wind along the beach below Porthmeor and then calling in briefly to Tate St Ives, it was back in the car again. We were travel-weary, but hoped the next day to have some luck at Dartington Hall, which was listed as owning several of Hodgkins' works. I hadn't had a response from the curator, but we decided to take a punt and I had booked us into a rather grand hotel on the outskirts of Plymouth. Having driven around the same roundabout several times, we finally

made it to our lodgings, which certainly lived up to their reputation, with suits of armour standing guard in the corners, palatial grounds and a much newer accommodation wing adjoining the historic main building.

Alas, there was no time to enjoy our surroundings, as we needed to dash into Plymouth before the art gallery closed to view its oil portrait of Mrs Hellyer (Fig. 38), one of Hodgkins' patrons from St Ives. (The museum also houses a display of porcelain, all produced from the kaolin clay that is still gathered upriver from Bodinnick, where we would stay the following evening.) Hodgkins described the finished work: 'I have made the lady really beautiful, tho' she is strictly not so, but no one quarrels with you for making the faulty faultless. She is really rather the Patrick Campbell type of brunette with short curly hair sticking out all round — very jolly, & wears priceless clothes.'[19]

We were fortunate that the portrait was on display — although it was hung rather high on the wall — and I was thrilled to see it, for it showed a marked difference from Hodgkins' larger group portraits or the popular watercolour studies of babies which had become a staple at the time. Mrs Hellyer, her hair cut in a bob, arms outspread, is every inch a modern woman, even if she has slipped slightly in her frame. The work is important, because it also demonstrates how modern Hodgkins could be in her treatment of a subject, provided the sitter was amenable.

Hodgkins also made a series of lively, brightly coloured watercolour studies of the Hellyer children when she stayed with the family at Carbis Bay, and, as she added in her letter to her mother, she now had a commission to paint an oil of all the family for which she was to be paid £100 — a considerable sum that would keep her happily for months without the need for students.[20]

The next morning we set off early to Dartington Hall, in Totnes, Devon, only to discover that the curator was in hospital and there was no chance of seeing what, if anything, remained in the school's

Fig. 38 *Mrs Hellyer*, c.1916, oil on canvas. © *The Box Plymouth City Council (Arts and Heritage).*

collection. Dartington was one of a number of liberal schools that acquired works by Hodgkins, and not all of them have been retained.

Dartington was set up in 1926 by Dorothy Whitney, a fabulously wealthy American philanthropist, and her second husband, Englishman Leonard Elmhirst. Its founding principle was that boys and girls would learn from involvement in the estate's activities and there was to be 'no corporal punishment, indeed no punishment at all; no prefects; no uniforms; no Officers' Training Corps; no segregation of the sexes; no compulsory games, compulsory religion or compulsory anything else, no more Latin, no more Greek; no competition; no jingoism'.[21] When they bought Dartington it was more or less in ruins, but once restored it proved to be a centre for all the arts, not least music, and major artists of all kinds would come to work alongside amateurs, as well as philosophers and writers. Eardley Knollys, who acquired a number of Hodgkins' paintings before selling them on at his Storran Gallery, had obviously shown her work to the Elmhirsts, and they made a visit to her studio in Corfe, Dorset, in October 1945.

Hodgkins would have been only too aware how poor and bleak her studio was, but there seems to have been a steady stream of collectors prepared to put up with an afternoon's discomfort to be in her presence. On that particular afternoon she had already had a visit from the evolutionary biologist Professor Julian Huxley, whom she liked very much, but her state of mind is evident in her next comment to Eardley Knollys: 'Then followed the man from Dartington Hall thirsting for my Soul or at least his wife was. So it goes on!'[22] In January the following year she complained: 'I have very nearly been kidnapped to Dartington Hall which shattered me.' There had obviously been an invitation to come and stay. Knollys thought she may have turned down the invitation because of the difficulty of getting there, but when he offered to drive her, she retorted: 'It is awfully good of you to say you will motor me to Dartington. Don't waste your time. I do not intend to go there.'[23] In spite of her resistance, the Elmhirsts acquired at least three of Hodgkins' paintings, including

a still-life flower study, a watercolour from her time in St Jeannet and a gouache of an abandoned cottage in Cerne Abbas.

Thwarted in our attempt to view the extent of Dartington Hall's collection, Chloe and I had to satisfy ourselves with a walk around the beautiful walled gardens, their deep flower beds full of blooms and buzzing bees, which in fact Hodgkins would have loved, had she visited.

17

Bodinnick

ENGLAND

It was a fine early summer afternoon when Chloe and I approached Bodinnick, a tiny village clinging to a hillside on the side of the Fowey River in south Cornwall. The drive from Dartington had gone smoothly, and I recognised from an earlier visit the narrow road that led down to the wharf on the Fowey side to catch the car ferry across to Bodinnick. To my barely concealed horror, we were the first in the queue, so I inched the Audi to the open prow of the boat, convinced that the vehicle was panting to throw itself into the river.

We could see the Old Ferry Inn opposite, not far from the water's edge, but once I had manoeuvred the car off the ferry and onto the concrete ramp we were forced to make a sharp left (almost perpendicular) turn and wind our way up the narrow one-way lane and round the top of the hill, carefully avoiding a tractor wending its way towards us. We then inched our way down to the hotel, only to discover that we couldn't park there and I had to back up the vertiginous lane to safe haven. I achieved this feat using the wing mirrors, as I could see nothing over the steeply pitched boot of the car.

We had booked rooms at the Old Ferry Inn because it was the only accommodation available, but with its white exterior and finely constructed metal ship above the sign that hung over the doorway, it looked everything we needed after a day's driving. We were shown up a narrow set of stairs that seemed to lead in several directions at once to rooms that, while spacious, had very low ceilings, as befitted the wee Cornish folk for whom they were built — even I could touch the ceiling! For once I insisted on taking the room facing the water, as it gave me the view I was seeking: the short distance down to the river, and across to the former boatbuilders' yard tight against the hill to the left of the concrete ramp I had just negotiated in the car. I was also curious to discover whether the deep bay windows facing the water might have been the setting from which Hodgkins painted some of her works when she stayed in Bodinnick over the winter of 1931-32.

The Old Ferry Inn in its current form was built some time in the

seventeenth century to provide accommodation for travellers, as the river crossing was an essential part of the main route from the West Country to the towns and cities spread across the south coast of England. Shortly after her arrival in Cornwall in December 1931, Hodgkins wrote to Dorothy Selby: 'I forget if I have written since I came down here. I stayed some days with my friend Gertrude Crompton at her house built on an exposed & very steep cliff. Her Folly I call it — so bleak — winter — no trees — no flowers — no grass will grow. Why do very practical minded people with great souls loving all humanity build houses on remote & isolated windswept rocks? The storms are too awful all windows are sealed. Do you remember you & Barling falling into a rocky Hotel by mistake — near Treboul. Well this is mild compared to it.

'So I searched round & found Bodinnick up a creek, over several ferries & quite ungetatable after dark — & here I am. The Nook is neither of the "Rookery" or the "Cosy" sort but suits my needs. No other fool could stand it. Besides which the colour is so dark & sodden with damp. Bracken is bright red — black ships on the river . . .'¹ Writing to Lucy Wertheim a few days later, she referred to her 'anchorite's life' in Bodinnick, yet the solitude and lack of distraction were essential to her work.

Neither Chloe nor I wished to emulate the life of an anchorite, so once we'd unpacked we descended to the bar for something restorative. Pleasantly rotund, as befits his calling, the barman, Pascal (of French origin but recently from the Isle of Skye), listened attentively when I explained that we were searching for 'The Nook' and also the vantage point from which Hodgkins painted several of her works, but he was unable to help, although he had collected a lot of historical material about the village. However, when we showed the paintings on my iPad to the local 'art historical consultants' propping up the bar, they insisted that mine was the only room from which one of Hodgkins' watercolours could have been done.

The bay window on the third floor was ruled out, as it had been added long after Hodgkins had stayed in Bodinnick, while the room beneath

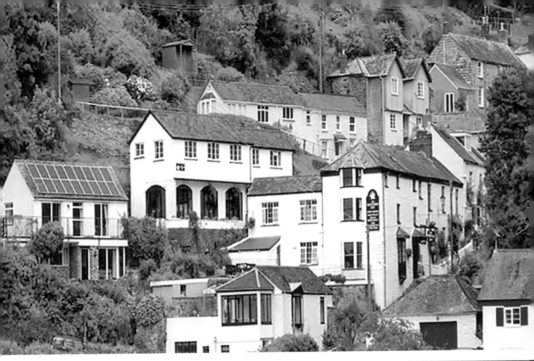

CLOCKWISE FROM TOP Bodinnick scenes: A view towards the Old Ferry Inn. The third floor bay window was added years after Hodgkins stayed there; the du Maurier home, Ferryside; the view of Ferryside from my room (see Fig. 39, page 202).

mine had always been a public lounge. There were two cottages below the inn, but one had been altered and provided the wrong vantage point, while the tinier cottage directly below had narrow-silled multi-paned windows which would have fragmented any view of the river.

It was only on my return to New Zealand that a clue was eventually found in a reference in one of Hodgkins' letters to the budding writer Daphne du Maurier, who had stayed at The Nook from October to Christmas 1929, having been permitted to remain in Bodinnick by her father, the actor and theatrical entrepreneur Sir Gerald du Maurier, so long as she was under the tender care of Miss Roberts, her landlady at The Nook. The family had recently bought a rambling building that for years had been part of a boatbuilding yard on the water's edge. While Swiss Cottage — which the du Mauriers renamed Ferryside once they had moved in — was being made habitable, Daphne du Maurier was allowed access to her bedroom, and it was there that she worked on her first novel, *The Loving Spirit*, during daylight hours.

Arriving in a new destination in the dead of winter had its trials. Years later in her autobiography, du Maurier described how her immediate response to The Nook in the winter of 1930 was similar to that of Hodgkins'. She rued having to 'crouch in my little hip-bath of a morning, and to creep up the garden to the outside sanitation', not least when 'it never stops raining, hailing, blowing, sleeting and snowing'.[2] The kindly Miss Roberts had struggled upstairs with a can of hot water to fill the hip bath for her lodger's daily ablutions, and would continue to do so for Hodgkins. Jolly and open-minded 'Miss Roberts, who never looked askance at my shorts, or trousers, or muddy seaboots . . . and whose pleasant tittle-tattle of village gossip, invariably without malice, proved so entertaining.'[3]

When du Maurier returned to The Nook in the evenings, Miss Roberts would cook her supper before retiring up the steep little stairs to bed while the budding writer remained on the upright sofa in the sitting room, reading her book by lamplight and candles. At one point she left

for a spell with her family in Hampstead, departing on 'a wet dismal day, the trees dank and lifeless: even Miss Roberts' macaw Rob, perched as usual on the sea-wall, sat with his fine head humped between bedraggled feathers'.[4]

Du Maurier was ensconced full-time at Ferryside by the time Hodgkins moved in with Miss Roberts. Hodgkins wrote a Christmas letter to her friend Dorothy Selby, describing the present she was sending to her: 'a picture of The "Nook" which is my temporary home. The large white house on the right belongs to Sir Gerald du Maurier which he uses as a stage setting only in the summer — But his rather beautiful son-daughter lives here, Daphne, & is [a] rather disturbing feature in the extremely homely little village. She *will* wear male attire — very attractive but theatrical — wh. she is *not*, I believe, only literary. In my boredom I try to read her Cornish local books.'[5]

The current whereabouts of the sketch she gave Dorothy Selby is unknown, but Hodgkins must have done it from the Fowey side of the river, given that she describes Ferryside as on the right. In another watercolour, *Bodinnick Cornwall* (Fig. 39), done from a different vantage point, she captures Ferryside tight up against the hill. Behind the house she has included two large red and black ships at anchor before moving up-river to pick up their loads of kaolin clay. Immediately in front of the window in the drawing, tight into the corner of the road down to the ferry ramp and the steep lane leading back up on the left, is an irregular picket gate that can be seen (admittedly with a magnifying glass) in an earlier black and white photograph of the landing which I found online.

The gate, as indicated by du Maurier, was a favoured perch of Rob the parrot, who wove his way into Hodgkins' letters and paintings. He appears in the highly decorative drawing that became the basis for Tate Britain's *Wings over Water* (Fig. 40), looking back over his wing towards the cottage, the village of Fowey downriver in the distance. Every inch of the original drawing is filled with objects: a cushion perched on the broad window ledge supports a collection of shells, while two vases of

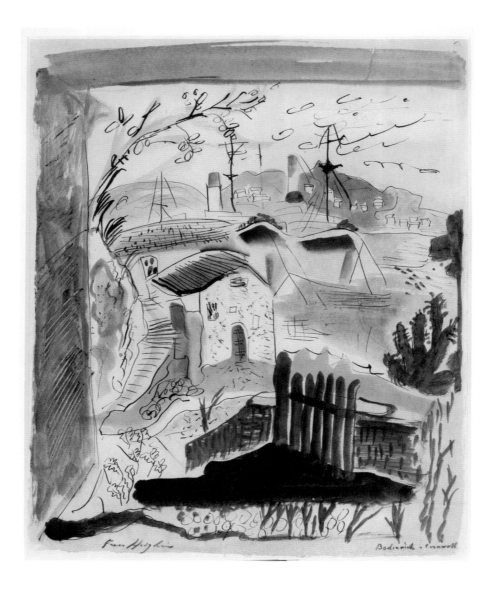

Fig. 39 *Bodinnick Cornwall*, 1931–32, watercolour on paper. *Private collection.*

flowers and leaves stand sentinel against a patterned wallpaper on the left, a taller arrangement on the right.

In the Tate painting, almost certainly produced slightly later (as was typical of Hodgkins' practice), the focus on pattern has been eliminated, the wall on the right is painted a plain smoky pink apart from shadows, and the three vases are more clearly defined by colour than by line. But Hodgkins has turned the perspective, moving the hillside to the right so that Fowey itself is hidden from sight and the vase of flowers on the left blocks any view of Ferryside. Now the parrot perches on a more substantial fence, its plumage standing out against the water. The tones of the painting overall suggest this has become a nocturne.

Like a magician, Hodgkins transforms the black-and-white photographs of the time — our only record of what each place she worked in really looked like — into colour, from the whitewashed walls of the buildings to the collections of still-life objects that she draws. The patterned curtain in the sketch has become the side section of a bay window, suggesting that rather than spend her evenings in The Nook, Hodgkins followed her old pattern of retiring to the inn, where she might enjoy a glass of wine, a cigarette and convivial company, or, as her work suggests, sit in the bay window of the lounge and observe the views.

In the second version of the work, also sometimes called *Wings over Water* (Fig. 41), the artist has returned to her view of Ferryside and the kaolin clay ships, but the window itself has disappeared. Instead a ledge supports an uptilted bowl, its inner base decorated with flowers, beside a cherry-festooned jug, both possibly products from the kaolin clay that had made the region wealthy. Below, Ferryside stands slightly away from the bare hill beside it, while Rob the parrot is perched on a slender twig to the right, leaning down to pick berries on the bush below, his brilliant red feathers a foil for the masses of greens surrounding him. Hodgkins is mining her pile of drawings, selecting favoured elements for the composition, and leaving others to take their turn at a later date.

She wrote again to Dorothy Selby expressing her irritation at having

Fig. 40 *Wings over Water*, c.1932, oil on canvas. *Tate Britain, presented by Geoffrey, Peter and Richard Gorer in memory of Ree Alice Gorer, 1954.© Tate, London, 2018.*

Fig. 41 *Wings over Water* (also known as *Wings on Water*), 1931–32, oil on canvas. *Leeds Art Gallery, Leeds Museums and Galleries, gift from the Contemporary Art Society, 1940. Photo © Leeds Museum and Galleries (Leeds Art Gallery) U.K. / Bridgeman Images.*

to wait for her possible summer students 'to make up their b—y minds if you'll forgive me the word — which I catch from the parrot whose language is shocking'.[6] Hodgkins had an affection for animals of all kinds, and a retinue of cats, mostly stray, wove their way into her life in many of the places she stayed in Europe and England. Parrots were no exception, and her letters are peppered with references to them.

Daphne du Maurier was to spend many happy years in Cornwall, writing some of her most popular books there, but, ever restless, Hodgkins moved on once she had worked through the subjects that appealed to her. Yet the memory of Rob the parrot stayed with her, and years later, when the Second World War made it difficult to work out of doors and her eyesight was fading, a similar bird made a guest appearance in *Parrot and Poppy* (1945), although without the shining red feathers that might have clashed with the rosiness of the poppy in the centre of the composition.

H odgkins went up to London from Bodinnick at some point in January 1932 to complete a contractual agreement with Alex Reid and Lefevre, staying on for the exhibition of the Seven & Five Society, in which she had six works. By 6 March she was back in Cornwall, where the weather was much improved, often allowing her to spend up to six hours a day sketching in the woods. Then in mid-April she moved to Pendower, further along the coast, hoping that friends might join her for some sketching.

We didn't have time to visit Pendower, but were determined to cover as many of the places Hodgkins had mentioned in her Bodinnick letters as possible. I persuaded Chloe to do the four-mile Hall Walk that skirts around an estuary past Lanteglos, where we climbed the steep muddy path up through the woods to the late-medieval church of St Wyllow, with its unusual wagon roofs (presumably because their rounded beams look like covered wagons). Then we went on to Polruan, where Hodgkins had stayed with Gertrude Crompton that stormy Christmas.

A couple we chatted to on the walk had said we should go out to Headlands, a garden clinging to the cliffs that is owned by an 80-year-old who opens it to the public every Thursday to raise money for the local lifeboats. The suggestion of a cream tea was enough to make Chloe struggle on, up steep lanes and past charming little houses crammed together as if to protect them from winter winds. It had developed into an exquisite sparkling blue day, and the garden was spectacular, for you could see right up the coast. For a moment you could persuade yourself that it was somewhere on the Mediterranean, except just a tad colder, until you found a niche amongst the rocks where it was very tempting to lie down, for a long, long time.

Once back in the harbour, where we were very taken with one of the large lifeboats pulled up on the seaweed-covered slip for barnacle-scraping, a little orange boat ferried us back across to Fowey itself. The ferryman had one of those weatherbeaten faces, craggy beyond belief, that looked as if it had been old from birth. He was extremely courteous, and demonstrably anxious that one of the infants, dogs, barely clad teenagers or ancients such as ourselves might plummet into the river instead of scrambling up the landing on the other side. We walked back through Fowey (where Chloe finally got her cream tea, rather than the sachet of dry biscuits and a paper cup of tea that we had been offered at Headlands), and then crossed back again to Bodinnick on the car ferry. A visit to the bar revived us, and we had dinner in the excellent restaurant that has been added on to the side of the inn.

18

Leeds, Manchester and Liverpool
ENGLAND

By the time I got to the Midlands, where Frances Hodgkins lived from 1925 to 1927, summer was advancing and several curators I wanted to see were getting ready to take their annual leave, which left me little time to spare. I stayed with the family of a very old friend in Leeds, which, like many other Midlands towns and cities, still displays evidence of the wealth created in the nineteenth century by manufacturing and the philanthropy of newly wealthy middle classes who wanted the best for their local communities.

Leeds Art Gallery, for example, is, at its core, a wonderfully exuberant Victorian edifice, with glazed decorative tiles adorning pillars, walls and stairs, and with more modern spaces added over time. I had a great time looking at its two Frances Hodgkins works in storage (I'd found only one on the website) and I earned my keep by pointing out that the house outlined in the background was Willy Lott's cottage at Flatford Mill (*River Garden*, Fig. 42), from Hodgkins' time in Suffolk in 1930.

It was a remarkably hot day, so rather than stay in the city my hosts drove me out to the countryside for the afternoon, something Hodgkins did herself when she could get away from Manchester. We visited Saltaire, a town built by Titus Salt as a model village for his mill workers in the mid-nineteenth century. Salt's Mill is a huge stone building nestled between the canal and the railway line, perfect for transporting raw wool in and woollen goods out of the village. It fell into disrepair until a contemporary philanthropist restored it in the 1990s, and one floor became a museum devoted to David Hockney, the region's most famous local painter.

Mr Salt believed he must provide for the physical, spiritual and moral needs of his employees and their families. Accordingly, he built a handsome circular church surrounded by a colonnade, topped with an impressive lantern in the form of a smaller circular temple supporting a domed roof. Its handsome blue clock above the drum kept parishioners on time for church as well as work: it was a fitting building in which to reinforce his ideas concerning appropriate morals and beliefs. On the day we were there,

Fig. 42 *River Garden*, c.1930, watercolour on paper. *Leeds Art Gallery, Leeds Museums and Galleries, photo © Leeds Museum and Galleries (Leeds Art Gallery) U.K. / Bridgeman Images.*

the long drive leading up to the church was lined with red, white and blue bunting, but somehow I sensed it wasn't for our benefit. Salt was a fervent teetotaller, and demanded strict adherence to his beliefs. Autre moeurs, autre temps: Saltaire now boasts a very smart-looking bar called, fittingly, Don't Tell Titus. To finish our day, we climbed up to the Cow and Calf on Otley Moor — a massive outcrops of rock set among clumps of bracken and dotted with wild foxgloves. If she had visited, Hodgkins would have liked the rocks. But she would have preferred the flowers in a vase so that she could paint one of her famous landscapes/still lifes.

The next morning, I took the train to Manchester, which proved a very different kettle of architectural fish — handsome nineteenth-century red brick for the most part, although much of the centre was bombed in the First World War and has been rebuilt. I walked my suitcase from the station to the Manchester Art Gallery, a grand stone affair that opened free to the public in 1835. I had an appointment to view the Hodgkins in its collection, but was disappointed to find that a number of the works historically listed had in fact been on long- term loan from Mrs Hewit, mother of Forrest Hewit, chairman of the Manchester Calico Company, who had been instrumental in getting Hodgkins a job as a textile designer in 1925. The works had since been taken back by the family and sold, leaving the gallery's Hodgkins collection depleted. However, the staff were extremely helpful, getting out their records for me to photograph, and providing useful information for the catalogue raisonné, but it meant I would need to seek information further afield for the location of the Hewit paintings.

By the time I had trundled my suitcase to my hotel, it was an outrageous 31 degrees. Half the streets were being dug up, or so it seemed, and the noise was mind numbing. And then there was the hotel, a relatively new pale-brick complex, which proved to be another Fawlty Towers. (Never trust a hotel that has a deep-purple foyer the size of a broom cupboard.) I had chosen the place because it was reasonably priced and handy to

the different galleries I needed to visit, while providing the possibility of cooking for myself. The apartment looked very contemporary, with a feature wall in black; white and silver wallpaper; black furniture and imitation clear plastic 'Philippe Starck' chairs; and a bijou table in the kitchen set for an intimate supper for two.

However, I was less than thrilled to discover that all the windows were permanently sealed, and there was no air conditioning — Manchester, after all, is more famous for perpetual (and, in Hodgkins' day, sooty) rain than heatwaves. It was hotter inside than outdoors, and so I took my tired self down to the front desk, stamped my tiny foot and requested a portable air-conditioning unit. Rather alarmed by this diminutive madwoman resembling a ripe cherry, a staff member trundled an air conditioner up to my room forthwith.

Venturing out again at around six o'clock, I asked a young woman where I could buy some food, and was directed to the local shops, which were about to close. She warned me that the area wasn't entirely safe after dark, so I made my way with some speed to the nearest grocer's, which was so tiny you could have been forgiven for thinking it was a tobacconist. Its staff had already pulled the blinds down over the produce display units, so I asked one of the women if they would pull them up long enough for me to purchase some provender. She responded reluctantly, irritated at the inconvenience.

On my return 'home', I foolishly put some washing into the machine under the kitchen bench (supposing it a luxury after two months' washing everything by hand), and then struggled for the next two hours to retrieve it. When assistance finally arrived — the same man who had brought me the air conditioner wrestled the door open — my black clothes looked as if they had mated with a white sheep, foreclosing any chance of sartorial elegance the following day. Thunder began to rumble ominously overhead, so I withdrew to my hermetic bedroom to try to get some sleep. All the doors were self-closing, so I requisitioned the plastic chairs as doorstops to allow some air circulation, and fled to the arms of Morpheus.

odgkins first went to Manchester at the behest of her friends Hannah Ritchie and Dorothy (Jane) Saunders, who lived a train ride away from the city centre. Manchester was a thriving city between the wars, and the arts played a dynamic role at many levels. With three major art galleries producing exhibitions, and London's many galleries and museums often sending their exhibitions on tour, there was never a shortage of stimulation. Hodgkins noted after a very happy visit in November 1922 that she had seen an impressive show of theatre designs and models, and had returned only reluctantly to Burford, where she would have to face the rigours and isolation of another winter. If Ritchie and Saunders helped keep Hodgkins' spirits up by sending her delicious little treats, she in turn reported to them on the latest exhibitions in London in case they got the opportunity to go themselves.

Ritchie had studied under Hodgkins in 1911 at her summer school at Concarneau, and came again the following year with Dorothy Saunders to work under Hodgkins at St Valery-sur-Somme. (Dorothy only later took the name Jane, which Hodgkins doesn't use until about 1930, which can be confusing when you first read her letters.) They had also hoped to join Hodgkins at Burford in 1917, but after a brief visit Hodgkins realised that Burford wouldn't do: the war had had a depressing impact on the countryside, and a lot of farming had been put on hold. Two years later, in a celebration of the gradual returning to normality, she took a class at Park Farm, Great Barrington, producing larger-scale watercolours that celebrated the first harvest after the war. In the farmyard was a great black traction engine, its belt used to drive the elevator carrying the hay up to the top of the ricks as they were being formed. The watercolours show a hive of activity, men standing on top of the new ricks three or four metres above ground. But what the works can only imply is the dust and smoke and the roar of the engine. Farmyards were to become a continuing source of inspiration for Hodgkins, culminating in the sophisticated, abstracted gouaches done during the Second World War.

Ritchie and Saunders joined Hodgkins again for a fortnight in

Frances Hodgkins (centre) with Hannah Ritchie (left) and Jane Saunders (right) on Whitsunday weekend in the Lake District in May 1925.

E. H. McCormick Papers, E. H. McCormick Research Library, Auckland Art Gallery Toi o Tāmaki, gift of Linda Gill, 2015.

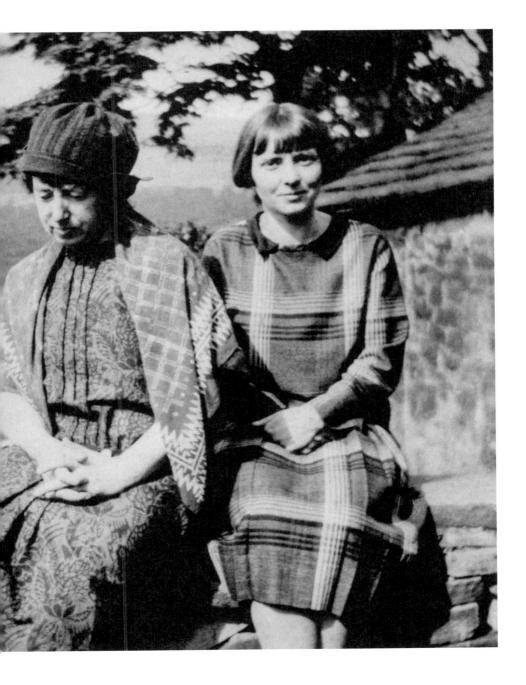

Burford in 1922, although they were forced to work indoors because of rain. On their return to Manchester they sent sent her a pamphlet on Roger Fry, as well a text on vegetarianism. Hodgkins thanked them for the texts: 'They are the Law & the Prophets of Diet & Art & both speak with deepest conviction & a touch of righteous fanaticism.'[1] There had obviously been much discussion about developments in modernism, Hodgkins recommending that Ritchie see Vanessa Bell's solo exhibition at the Independent Gallery when she went up to London.

This didn't eventuate, although a couple of Hodgkins' other students took the train for that purpose, but Hodgkins was pleased to hear that her friend had seen an exhibition at the Tate, as it was a good place to get an overview of 'the moderns'. She had also read an article they had sent her by the art critic Reginald H. Wilenski, an art history lecturer at the University of Manchester who wrote contemporary art criticism for *The Athenaeum* before being superseded by Fry. Hodgkins preferred his approach to that of the avant-garde, describing him as 'far and away a more enfranchised critic' than Roger Fry, whom she found quite prescriptive.

Typically, Hodgkins' letter leavened serious comment with humour, describing how she had once met Wilenski, 'a turbulent young Jew who was both an independent and an iconoclast', and who made polite comments about her work and two very rude ones about her hat.[2] Knowing her penchant for rather outlandish millinery, this is no surprise. Hodgkins was evidently abreast of current developments in England, and although often forced for reasons of survival to paint more conservative works for sale, she had already determined her own experimental path.

Having spent some time in London, Hodgkins accepted the train fare from Richie and went to Manchester in November 1922 to give a series of demonstration lessons at the girls' high school where Ritchie and Saunders both taught art. The two women had first invited Hodgkins to come to instruct a group of six for a month in 1917 over the summer break, but Hodgkins was at that time finding plenty of commissions as a portraitist in St Ives and decided not to leave while things were going well.

The 1920s, however, were to prove difficult years for Hodgkins, who felt that during the war she had lost the momentum she had worked so hard to achieve. Postwar economic difficulties also meant there were fewer collectors or art lovers with money to acquire works. In the early part of the decade teaching was her primary means of support. When she did travel she produced some magnificent works, but these were tempered by many smaller, less adventurous sketches that she hoped would sell more readily. Adding to her woes, she continued to be dogged by ill health.[3]

Her luck changed during a visit to Manchester in 1925, carefully orchestrated by Ritchie and Saunders, who brought her to the attention of Forrest Hewit. The two younger women had gone to a lecture by Walter Sickert, whom Hodgkins had met on a number of occasions, and they brought Hewit home with them afterwards. Hodgkins was persuaded to show him some of her work, to which he immediately responded, perceiving elements in them that would reproduce well on fabric. He invited her to work as a designer for the Association, an amalgamation of a number of smaller fabric-printing companies that dated back to 1899. By 1925 its head office was in the rather magnificent Edwardian baroque St James Building in Oxford Street, Manchester.

The company agreed to pay Hodgkins the princely sum of £500 a year, and she wrote with relief to her mother: 'I am now settling down to my new work & slowly getting used to the long hours & unusual restrictions, rather tedious after going my own sweet way for so long. But for security's sake one has to pay a high price. I can hardly believe that the terror of these past distracted years has passed & that life has eased for me just when I had given up all hope & felt at the bottom of the pit. I shall stick to this post as long as I can — long enough to put my savings into an annuity for my old age.'[4]

The company also sent her to Paris to view the very latest in decorative designs at the Exposition Internationale des Arts Décoratifs et Industriels Modernes, held in a huge glass and iron pavilion beside the Grand Palais that had originally been built for the 1900 Paris Exposition.

The grand entrances to the Exposition Internationale des Arts Décoratifs et Industriels Modernes held in Paris in 1925.

The title of the 1925 exposition evolved into the evocative and now ubiquitous term, art deco. Like the Venice Art Biennale today, leading countries designed their own pavilions in which to show off the best of their nations' designs: Russia's strongly constructivist, while the Dutch building was expressionist, and the Belgian art nouveau. It is possible that Le Corbusier's Pavillon de l'Ésprit Nouveau, one of several French pavilions, a modular construction with clean lines and pared-back interior decoration, allowing the architectural volumes and furnishings to have equal weight with the artworks on the walls, had the most lasting influence on Hodgkins' later work, not least when she went to Spain in the 1930s.[5]

One critic described the experience: 'The first impression of the Exposition is startling. Passing through the silver obelisklike towers of the Porte d'Honneur one comes at once upon a cubist dream city or the projection of a possible city in Mars, arisen over night in the heart of Paris.'[6]

The pavilions housed the latest developments in design, whether furniture, fashion or ephemera. Some of the thousands of examples of modern decorative art shown there are now held in the Musée des Beaux-Arts in Paris, which I visited when in the city. The range of styles was almost overwhelming. One screen — in which simplified figures painted bright pink and red, with their hands raised, rise out of stylised foliage in bright and dark green, while in the upper part of the central panel a wreath of bay leaves encircles a bright pink parrot — has a distinctly Polynesian feel.

Another is monochromatic, with stylised horses that might have stepped off the pediment on the Parthenon, while a third combines a range of chevrons flowing like waves across the surface or creating concentric circles similar to those carved on the prows of Māori canoes as navigational devices or representing the heavens in Renaissance scientific art. They encapsulate the two extremes of the Exposition, one highly coloured, the other muted; abstract pattern versus the abundance

of nature. The exuberance of both would have been anathema to Le Corbusier, who thought that decorative art was in the process of dying out, to be replaced with 'machine-made, mass produced objects'.[7]

Hodgkins responded to the air of excitement and the range of works on display, writing exuberantly to her sister Isabel: 'I am just back from 3 weeks in Paris. Paris under new conditions. None of the old "Me" none of the old Paris. I lived like a real lady for once — taxis everywhere — even so I was leg-weary looking for the things I was supposed to see. I was sent over on purpose to see the wonderful Exposition Arts Decoratif, an ultra-modern Show of European & British Industrial Art — all marvellously well done & displayed. That is all except the British Section, which quite failed to express itself in modern terms & as a consequence looked old fashioned & dingy beside the faultless order & taste of France — which was beautiful & ingenious & tasteful to the nth degree.

'French psychology expressed itself — its love & glorification of feminine beauty & grace. The Pavilion of Elegancy was supremely well done. 200 above life size gold and silver mannequins, clothed in ravishing frocks in exquisite colour schemes. What there was of the dresses was delicious. They had no backs — very little front, up to the knees & no sleeves — but long tails or trains or wings like fire flies. The tailor mades & more ordinary frocks were, of course, more discreet. Many high French artists are now designing fabrics — many of the fabrics were groups & arranged in artificially lighted cases (like shop windows) in front of back cloths painted & signed by some of the biggest artists of the day. So art comes at last to serve commerce — and raise & beautify it — even if it's only the label for a bottle of relish.

'When I returned to Manchester I had to report to my Managers & chiefs. I think they were not displeased. Anyway the immediate material result was that I was given a room of my own — which is now my Studio & I am hard at work on the ideas and impressions gathered in Paris. In a fortnight's time I submit my designs to the Managers. I receive neither praise nor blame. If my designs are accepted & passed I shall be proud.

Fig. 43 *Untitled [Textile Design no. V]* (top) *and Untitled [Textile Design no. III]*, c.1925, gouache on paper. The Exposition Internationale des Arts Décoratifs et Industriels Modernes had a major influence on Hodgkins' textile designs for the Calico Association.

The work is neither monotonous nor repetition work — and it brings me sweet security — at long last!'[8] Enclosed with the letter was a batik scarf of the kind produced by 'the firm' for the African market. It may have been designed by her artist friend Karl Hagedorn, who was employed by the company for this purpose.

Earlier in the week Hodgkins had written to Hannah Ritchie and Jane Saunders, who were on holiday abroad, describing how she had made a theatrical entrance to her employers on her return from Paris, flinging over a chair 'the jolly cubistic scarf of many colours . . . colour was much discussed . . .'. She confessed that after her employers expressed approval of her research, and granted her her own space in which to work, she handed out cigarettes the next morning to the workers with whom she had previously shared the space to ensure no hard feelings.[9]

She then set to, producing a series of finished designs which were then placed in the 'design library' for the printers to draw on. In retrospect, her artist friend Arthur Lett-Haines felt that Hodgkins had always been an expert in pattern, and that she was largely influenced by antipodean and Polynesian art. This is not immediately apparent in her painting, although her love of portraying Māori remained constant. Curiously, in Cedric Morris's portrait of Hodgkins (Fig. 44), a curtain behind the armchair in which she sits has some similarities with both tāniko weaving and tapa cloth.

The reason for Hodgkins' departure from the Calico Printers Association is unknown, but the contract was not renewed in 1927, and Hodgkins had to fall back on painting sales and teaching to support herself. In an interview with Eric McCormick when he was researching his book *Portrait of Frances Hodgkins,* her close friend Elsie Barling recalled that Hodgkins had confided in her that her position at the Association was like being 'a race-horse shut in a stable', with no time left for her own work.[10] Very little is known of what became of her designs apart from a small group acquired by Te Papa, not least because she had no control of them once they were placed in the company's design library.[11]

ABOVE **Fig. 44** Cedric Morris, *Portrait of Frances Hodgkins*, 1928, oil on canvas. *Auckland Art Gallery Toi o Tāmaki, purchased with funds from the William James Jobson Trust, 1954.*

BELOW Cedric Morris (left) and Arthur Lett-Haines with Rubio the Macaw. *Tate Archive.*

On the second day of my stay in Manchester, I set off early to Salford, a brief train ride away. A city in its own right since 1926, Salford is separated from Manchester by the Irwell River, which in parts is not much larger than the canals that criss-cross Manchester and that were a vital part of its industrial success before the introduction of the railways. The Manchester Ship Canal is the largest, stretching from the city all the way to the Irish Sea. The Salford Museum and Art Gallery is an extremely handsome building that is part of a Victorian brick enclave of civic buildings surrounding a tree-lined square. As happened at all the public institutions I visited, I was greeted with enthusiasm by the registrar, who because of the economic climate also serves as curator, and we descended into the basement to look at the works in storage. Many of those in Manchester collections were acquired from exhibitions held locally during Hodgkins' lifetime, so I felt there was a real connection with her time in the city.

The main entrance to the Salford museum has a large display area, and my attention was caught by an exhibition of life in Salford during the First World War. It showed a packed crowd of women queueing for food outside shops with names such as the Home and Colonial Store and the Novelty Stores and Book Exchange. Some carried handbags and wore hats, but the majority were poorer, their shoulders covered with shawls that in some instances were also draped over their heads, like the beautiful mother in Hodgkins' *Lancashire Family* (Fig. 45). After her friend and dealer Eardley Knollys tracked down the location of *Lancashire Family* in 1944, Hodgkins recalled the pleasure she had taken in painting these women, and wrote: 'I remember about that period I had artistic yearnings to paint Lancashire Mill Girls: some of them were raging beauties. I loved painting piled in family groups.'[12]

Although many of the studies she did were sketches or watercolours, *Lancashire Family*, which depicts a mother sitting with her two sons, is painted in oil. The shawl draped over her head gives her the appearance of a Madonna. None of the sitters looks at the artist, the mother gazing

ABOVE **Fig. 45**
Lancashire Family,
c. 1927, oil on
canvas. *Auckland Art
Gallery Toi o Tāmaki,
purchased 1963.*

RIGHT A 1917
photograph of local
women queuing for
food in Salford. *Salford
Local History Library.*

to her right, while the two boys have their eyes fixed on something to the left of the artist's head. The mother's left hand, fingers cupped, gestures towards us. The smaller boy holds a toy yacht — possibly one of Hodgkins' props, as it also appears in other works. They both wear mufflers tied firmly around their necks, whereas the mother wears a simple shift with shoulder straps, as if she alone is dressed for summer. Her shawl floats across behind the boys in a protective manner. Each figure is sculptural, their solid forms accentuated, in the case of the boy on the left, with a bright emerald green, as though reversing the traditional manner of painting paler tones on the uppermost surface of an object to indicate the fall of light. The painting has faint elements of cubism — the smaller boy's clothing is monochromatic and his body, while moulded across his chest in three dimensions, becomes two dimensional in his lower torso. Broad white highlights model the faces, adding to the sculptural effect, and the overall mood is one of great calm. Hodgkins almost certainly would have paid the family to sit for her, a practice she refers to constantly throughout her letters.

A number of artists she admired, such as Mary Cassatt, had produced similarly structured compositions. Yet Hodgkins' years in France and Italy would also have familiarised her with the church paintings of the feminine trinity of St Anne, the Virgin Mary and the infant Christ child, who are traditionally depicted in a similar hierarchical construction, the grandmother behind and above her daughter, who holds her child in her arms.

When her mother Rachel died in April 1926, Hodgkins inevitably felt the tug of home, writing to her sister Isabel on hearing the news: 'On the night of the 22nd one of my large Water Colours which is on exhibition in a Manchester Gallery fell off the wall & smashed the glass. I was leaving the Gallery at the time & heard a crash. There seemed no sort of reason for it — except the usual reason that applies to about 1000 other pictures that fall annually off the wall — it just happened. I said to the Secretary "That's a family premonition — death always follows".

Sure enough the first post in the morning brought me the cable — I was — and am alone in the house for this week & one is prone to dwell on these matters and wonder!'[13] She mourned her mother deeply, but gradually the burden of guilt was lifted from her, and her reflections on the mother-daughter relationship were almost certainly an underlying influence on the series of paintings on this theme that emerged in the following year.

M anchester was an advanced cultural centre in the 1920s, and Hodgkins relished the access to exhibitions, theatre, lectures and film of which she had been starved while living in Burford. One of the city's natural forces was Lucy Wertheim, daughter of a successful Manchester merchant, whom Hodgkins met through her student Agnes Drey and her brother, the art and music critic Raymond Drey. Agnes had joined Hodgkins' summer classes in France in the early 1920s. Hodgkins wrote to Hannah Ritchie in 1924: 'Agnes Drey is a really sweet unselfish character so good tempered & kind but a child not yet grown up very much under her parents' hands — but unwilling & incapable of acting or thinking for her self which makes her rather a tiring companion for long "close up" quarters. Her experience of life is "nil". Her world has been lived among books & in romance of the school room. I feel rather doubtful about her future in art. She has not progressed so much as I hoped, or she promised. Oils defeat her — she has no form sense. She draws better on the whole. She works hard but heedlessly — I am all the time nagging her for her dirty untidy ways — filthy palette etc instead of getting on to the more interesting side of her work. The Irish girl is doing better. She left another Class to come to me which was hopeful & has firmly attached herself to me. She has adopted Miss Drey being of a masterful nature & liking the child as well she might for her merry ways & companionableness.'[14]

Raymond Drey was married to Anne Estelle Rice, who painted the

Fig. 46 Anne Estelle Rice, *Portrait of Katherine Mansfield*, 1918, oil on canvas. *Museum of New Zealand Te Papa Tongarewa, purchased with T. G. Macarthy Trust funds, 1940.*

famous portrait of Katherine Mansfield (Fig. 46) when they were both in Looe in Cornwall in 1918. Rice's career in many ways mirrored that of Hodgkins. American by birth, she had studied in Paris at a similar time, developing a fauvist style of painting, as demonstrated in the bold colours in Mansfield's portrait. On the rebound from a relationship with the Scottish painter John Duncan Fergusson, she married Raymond Drey in 1913.

Hodgkins and Wertheim were introduced over afternoon tea at the Drey home at Withington House in Manchester in 1926. Years later, in her book *Adventure in Art*, Wertheim recalled: 'I remember the immediate sympathie between us; her wit, the charm of her warm voice, her felicity of expression. I felt I had made a friend.'[15] Wertheim was a young untrained enthusiast who responded emotionally to people and art, and was solicitous in her attentions to those with creative talent struggling to succeed. Hodgkins welcomed this after the recent loss of her mother, although she ultimately found the attention smothering.

Wertheim took an immediate interest in Hodgkins' work, and would show it for some years at the Wertheim Gallery, which Hodgkins had encouraged her to open. Wertheim described how Frances had exclaimed to her husband, Paul: '"Your wife should open a gallery for us poor artists: her enthusiasm would make it a success!" Those words, however spoken more than half in jest, sowed a seed in my mind that was to bear fruit later.'[16] Wertheim herself admitted that she had grown up with more traditional art on the walls — Géricault, Zoffany and John Sell Cotman alongside Sickert, Henry Lamb and others — and she recalled ruefully that her cousin-in-law Fanny, who was married to the artist Edward Bawden, had looked around and exclaimed with faint disdain, 'Lucy, have you never heard of Picasso?'[17] Wertheim was determined, nonetheless, and with Hodgkins' ongoing support and advice finally opened her London gallery in 1930.

Hodgkins moved away from Manchester in mid-1927, taking up again her peripatetic lifestyle, and by the middle of the following year demonstrated a much more confident sense of her direction within modernism and a refusal to compromise. She wrote to Wertheim from Martigues in February: 'I preferred not to show at all rather than exhibit with the older traditional set with whom I have nothing in common . . . I am wayward — what artist worth his salt is not? I have changed & evolved & experimented, but am none the worse for that.'[18]

She continued to return to Manchester for visits, and in November 1928 had an exhibition of paintings at 2 Mount Street. Raymond Drey wrote an introductory catalogue essay for the show in which he discussed the degree of abstraction in her paintings, and concluded: '[S]he makes each stroke of her brush instinct with life. And in this her genius is akin to that of the great Chinese masters of calligraphy.'[19] The exhibition was a great success, but when the curator at Manchester City Art Gallery, who was writing a thesis on art, asked her what went on inside her when she painted a picture, all Hodgkins could reply was: 'I painted a picture much as a hen lays an egg — that it was inevitable — which seemed to please him . . . Artists are too engaged "doing it" to analyse their emotions.'[20]

Jane Saunders, as one of Hodgkins' former students, was a keen observer of her way of working: 'Something happens to everything that you make into a picture. Whatever you see . . . you must do something to it before you can create a picture. It goes into your mind and comes out again transformed. Frances could transmute everything into an interesting object . . . Everything she touched could become a beautiful picture.'[21]

Walter Sickert, whom Hodgkins knew and admired, was also to show works in some of Wertheim's exhibitions. The two had met on a train, Sickert drawn to Wertheim's Renoir-esque prettiness and proportions. He was pleasantly surprised when Wertheim turned up at the lecture he was giving at the Manchester Art Gallery titled 'Straws from Cumberland' and they became friends.[22] Wertheim later recounted to Hodgkins how when Sickert was visiting once, her young daughter came in from a walk with

her nurse wearing a brown velvet hat made in Paris, which sported a long pheasant's feather. 'Sickert rose to his feet, and gravely shook hands with her remarking as he did so "I see you are wearing Louis XI's hat."' Frances Hodgkins, a collector of elaborate millinery,[23] exclaimed, "'Very clever — how like Sickert to note the resemblance."'[24]

In the next couple of years Wertheim made the acquaintance of other modernists, including Henry Moore, Cedric Morris, Arthur Lett-Haines, and John Skeaping and his wife, Barbara Hepworth. Hodgkins may have been the conduit to some of these associations, for most of them found it almost impossible to sell their works in the 1920s, and they would have relished Wertheim's enthusiasm for their work. To progress the opening of her gallery, and give herself access to local artists, Wertheim used as her weekday base her pied à terre at Regent's Park, the walls of which she decorated with modernist paintings, some from young artist Christopher Wood, a friend of artist Ben Nicholson. Alongside Wood's *Purple Crocus* and another painting of Dieppe, she hung Hodgkins' *The Birdcage*, with its luminous turquoise blues, and *Djerba No 2* by Cedric Morris (Fig. 47).

There were also sculptures by Henry Moore and Eric Gill. These were just the beginnings of her collection, and Wertheim continued to buy from exhibitions of Hodgkins' work in other galleries until the mid-1930s. Some of these she sold on, and others she kept. Wertheim also allowed a number of artists to use the apartment in London when it was unoccupied. Hodgkins was one of those who benefited from its decor and comfort.

Wertheim often took on a motherly role with some of her artists. She loved Christopher Wood's naïve way of painting, but she also adored him, not only acquiring a number of his paintings but also supplying him with money whenever he needed it, in spite of his not turning up to the dinners she arranged for him, to which she would often invite guests who might help him further his career. She was apparently unaware of the opium addiction that was to overcome him in France at the end of the 1920s. She attributed his laying his head on her shoulder in a state of trance at a dinner attended by her children as an act of

ABOVE **Fig. 47** Cedric Morris, *Djerba No 2*, 1926, oil on canvas. *Auckland Art Gallery Toi o Tāmaki, gift of Lucy Carrington Wertheim, 1948.*

BELOW Christopher Wood and Winifred Nicholson, c.1925–30. *Tate Archive, M00958.*

clairvoyance — his friendship with her was going to make him great![25]

When she visited Wood in Paris on the pretext of acquiring works from his Georges Bernheim exhibition (she was almost the only person to do so), it finally became apparent to her that all was not well. Having decided to open her gallery with a solo show of Wood's paintings, she visited him again in Paris in July 1930 to select a range of his latest works, not all of which she was drawn to, as his palette had become muddied. On a later visit that year she refused his sudden demand that she should give him £1200 annually or he would shoot himself, and was horrified to hear in August that he had thrown himself under a train at Salisbury Station. Her one solace, apart from spending time with Wood's parents, was the show, which opened as part of a group exhibition of artists among whom were Matthew Smith, Walter Sickert, Cedric Morris and Frances Hodgkins.[26]

Shortly before Wood's death, Hodgkins begged Lucy Wertheim to reconsider the name she was planning to give the gallery. Wertheim had been to visit Hodgkins in Suffolk, where she was spending the summer painting, sometimes in the company of Lett-Haines and Morris, who were living at The Pound in nearby Higham. The day after Wertheim returned to London, Hodgkins wrote: '[W]e sat in the Tea Garden and talked about your Gallery — particularly the naming of it — which we regard of the first importance. To avoid giving the cynical critics a handle to lay hold on is a great point. We unanimously agreed to ask you as a great favour to reconsider the name of "Young Masters" & call yr gallery simply The Wertheim Gallery.

'To begin with yr main planks & supports (say Cedric — Matthew Smith Kit Wood — A Robinson Sickert & myself specially myself are mature in art as in years. How can I pass as a young master? See how the critics will get you. Think of Wilenski touching it off in his biting way. It will kill the gallery — as it killed "Young Painters" by ridicule. Whereas "Wertheim" is a great name in the world of affairs & wealth. It implies wealthy backing & patronage & strength. It is a name that talks.'[27]

Soon after, when Hodgkins heard of Wertheim's overwhelming distress at Christopher Wood's death, she wrote her a stern letter: 'Of course you are shocked & sorry — who isn't? But what <u>can</u> be said in defence or justification? Don't you think he has let you all down? His Mother, his Art, his Group, his Dealer? His friends and you? Who backed him. Life was jolly nice to Kit. He had no troubles but of his own making . . . Drugs are beastly & abominable & lead to <u>depths</u> of degradation — physical & spiritual. He has not had the strength or staying power so his Doom & Destiny have descended on him prematurely. No, go ahead with his Show & do <u>your best out of it.</u> It is a great opportunity for Showmanship but <u>No Sentiment</u> for God's sake in yr Gallery. Keep it on hard business basis of merit & worth. Art will go on just the same without Kit's help but it is a pity he has gone & left us.'[28]

On my own final day in Manchester, I was woken at 5.30 by a drunken Mancunian trying to find in which of the 50 apartments his Jenny was staying by screaming her name as loudly as he could, alternating a cajoling tone with bellows that sounded deeply threatening.

In the afternoon I had an appointment at the Whitworth Gallery, which was a good distance away, but I was determined to walk in spite of the drizzle. Oxford Street, where the Whitworth is located on the edge of a large park, is lined with major buildings, many of which are part of the University of Manchester. After I had spent the afternoon looking at the gallery's collection of Hodgkins' artworks in the beautiful new library, I was invited to join the staff to celebrate the gallery's Building of the Year prize in the Royal Institute of British Architects North West Regional Award. The extension illustrates a Japanese aesthetic, its glass walls looking out onto an extensive green sward dotted with mature trees. I had inadvertently timed my visit well, for the Whitworth had only just reopened, and it was extremely pleasant to share a glass of champagne in its contemporary gallery, the soft rain falling outside.

My next very brief stop was Birmingham and, in spite of the fact that most of New Street was being dug up, I really liked the energy of the place and rather wished I could have spent more time there. The sunshine also helped. Birmingham Museum and Art Gallery has a very large Hodgkins gouache of the fishing village of Solva, in excellent condition, and I was reminded once more that you can never get the full nuances of Hodgkins' painted surfaces from looking at a reproduction. The kindly curator took me on a quick tour of an Edward Burne-Jones and Andy Warhol exhibition before dashing off to begin her summer holiday, while I returned to the station and went on to Liverpool. Three cities in a day was to prove my record on the trip.

Before I arrived in Birmingham in the early evening, I had gone online and cancelled my first hotel booking, as I didn't have the strength to carry my suitcase up two flights of stairs. I relocated to a large Victorian hotel in the centre of town and a room festooned with red velvet, black-and-white striped curtains, and plush grey carpet. I was impressed with the large-scale paintings that mingled on the grand staircase with mounted deer's heads replete with magnificent sets of antlers. One of the paintings showed a group of nine women clad in crinolines, at their ease in a bower, while another was of a group of conscientious objectors who spent time in Walton Gaol, each face painted from life, and with one or two clutching what looked to be violins. The work was more naïve in style but far more powerful.

The Walker Art Gallery in Liverpool has a Hodgkins watercolour, *The French Innkeeper*, also known as *François*, of a portly man with a clipped black moustache and a cap jammed over his black curls. Of equal interest is the watercolour sketch on the verso of a group of figures leaping into water, beneath which is a faint drawing of an elaborate urn that appears in a couple of her paintings made when she was staying at Flatford Mill in Suffolk in 1930. Written in pencil at right angles is 'River Garden',

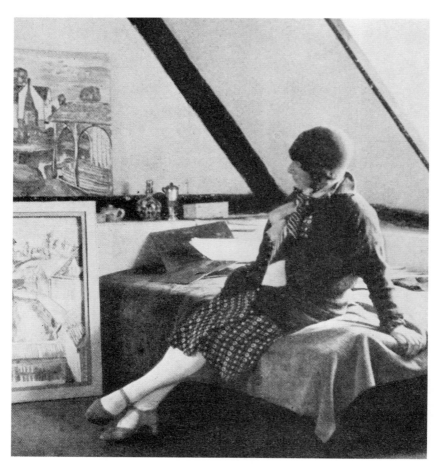

ABOVE Frances Hodgkins in her studio at Flatford Mill, Suffolk, 1930, at the time of her exhibition at St George's Gallery, London. *E. H. McCormick Papers, E. H. McCormick Research Library, Auckland Art Gallery Toi o Tāmaki, gift of Linda Gill, 2015.*

RIGHT Flatford Mill today (see Fig. 42, page 210).

the title of the watercolour I had seen two days before (see Fig. 42, page 210) in Leeds. Hodgkins sold *François* directly to the Liverpool gallery; a letter in her hand dated 10 December 1932 asks them to put the money into her bank account in Threadneedle Street, London. The Walker Art Gallery file has a document of indenture drawn up between the 'Lord Mayor, Aldermen, and Citizens of the City of Liverpool' outlining the sale of the work for the price of 15 guineas and in which Hodgkins signs the copyright for the painting over to the city in perpetuity.

Her generosity may have stemmed from the fact that her father was born in Liverpool. The gallery's archives hold a copy of his baptism certificate dated 23 September 1833. His infancy was spent in the dockland slums, but William Matthew Hodgkins, like James Tannock Mackelvie, who was born in similar circumstances, became a self-made man, thanks to educational opportunities and a determination of spirit. Both emigrated to New Zealand, William Hodgkins becoming a prominent solicitor, amateur watercolourist and ardent promotor of the arts, and Mackelvie, who remained in New Zealand for only six years, becoming a major benefactor of the Auckland Art Gallery. I felt an immediate affection for the city.

In the nineteenth century its white stone buildings would have been stained with soot from the port, but today everything sparkles, not least on a sunny day, and the docks are a thriving hub of the arts, boasting the Tate Liverpool among the venues of note. I spent the latter part of my afternoon visiting Tate, and then the International Slavery Museum, located in part of a vast red-brick warehouse. Many Liverpudlians got rich on the backs of slaves; in the second half of the eighteenth century the city played a major role in the transport of humans, who shared their accommodation with wool and cotton from the Lancashire mills. Chastened after my visit, only an excellent meal was able to restore my spirits until I climbed the hill and returned to my hotel room.

19

Ibiza
SPAIN

Standing high up on the farthest end of Dalt Vila on Ibiza, I watched a low silver ship gliding slowly out of the port in the early morning light, followed closely by another. I was informed by a local that a sheikh was sailing on the first craft, while the second contained his harem. Ibiza's reputation today can be one of sybaritic excess, the rich and famous basking on their superyachts alongside scantily dressed partygoers out to destroy their livers with overdoses of sangria or the plethora of drugs readily available in the enormous nightclubs just outside Eivissa (Ibiza) township. But if the main port can be the equivalent of Dante's third layer of hell, Ibiza remains the prettiest of islands once you get off the beaten track, and there can be much to impress and charm in the town itself.

I was first invited to visit the island in 2014 by Antoni Ribas Tur, an Ibizan arts reviewer living in Barcelona, who had come across one of Hodgkins' paintings while idly surfing the internet one evening. He was astounded to discover that this marvellous artist had spent the winter of 1932 and the spring of the following year on the island, and yet he knew nothing of her. He contacted Auckland Art Gallery and we started corresponding. After a preliminary meeting with Antoni later that year when I was passing briefly through Barcelona, I outlined the research I needed to undertake, and he kindly offered to take leave for a few days to escort me — a piece of good fortune, given that my Spanish is limited and my Catalan non-existent.

True to his word, when I returned to Barcelona in 2015, Antoni collected me from my hotel at the crack of dawn and we flew to the island. His charming older brother, Vincent, had also arranged to take time off from work in the afternoons, seeing it as an opportunity both to assist me and to practise his English. He offered to drive us to the smaller villages where Hodgkins had stayed, and where I hoped to identify the locations and subject matter of her Ibizan landscapes.

Antoni was staying with his family on the island. I had done my own booking online, but — as seems so often the case — the charming hotel overlooking the harbour that I had viewed on the website was not quite what it had seemed. I knew I was in trouble when the woman behind the

CLOCKWISE FROM TOP LEFT Ibiza scenes: Windmill on Puig des Molins today, sadly without its sails; the bastion at Dalt Vila; view from the bastion (photo by Martin Davies); a typical traditional Ibizan house.

desk rightly identified me as Methuselah, saying that if I wanted a quiet room it would cost me an extra €38 a night. What she meant was that the nightclub beneath my window would close at 3 a.m., as opposed to the club at the back of the building which closed two hours later. My nicely appointed room had traditional French windows that overlooked the port, but its charm was marred by the mural above the bed of a red-clad superhero whom I was, of course, unable to identify. I was definitely in foreign territory, and my first instinct was to run, but on discovering that the extra payment was non-refundable I decided to warm to the decor and the flickering neon of the hotel sign outside the window, and put it down once again to experience.

The area I was staying in is known as La Marina, and is not greatly changed since the 1930s if you take away the bars and tourists. In those days, La Marina and Sa Penya were the domain of Ibiza's fishermen and their families. Writer and journalist Miguel Ángel González evocatively described the random stacked cubes of houses with their windows picked out in the red, blue and green paint that remained after the fishermen had painted their boats; the sets of stairs without rails leading to upper floors; and the glass balls used by fishermen as floats which serve a purely decorative function today. In Hodgkins' day, nets would have been strung between the balconies, and longlines would have curled in woven baskets at the doorways. González described how water would be delivered to households in saddlebags borne by donkeys that had to keep their footing on the uneven cobblestones. Stray cats had free access to the houses, their owners happy for them to hunt the huge rats that thrived in an area where sewage often flooded the streets after heavy rain. Hens were also given free rein, but their chicks were protected by large open terracotta pots, because cats are no respecters of the difference between food and vermin.[1]

Like every fishing village, there would have been olfactory overlays of drying fish and the aforementioned drains, as well as the rising and falling sounds of the community, none of which could be captured in a painting or photograph. No wonder Hodgkins fell in love with the place.

Tucked under the wall of the massive citadel known as Dalt Vila is Mercat Vell (The Old Market), a classical loggia with a cast-iron water fountain at one end, its stalls filling with fresh fruit and vegetables, packets of herbs, and containers of dried figs and other delicacies on market days. Hodgkins' letters suggest the fare was much plainer in the winter months.

From the cool shade of the market you can walk up a steep ramp known as the Rastrillo before passing through the historic stone Portal de Ses Taules, its raised drawbridge and rusticated entry guarded by two headless statues of Roman centurions. Over the door the vast coat of arms of Felipe II supports a coronet, and a lengthy inscription below notes the fortification's completion date of 1585. Once inside, you pass through a former armoury before entering a complex pattern of winding paths, interweaving stone steps, lethally slippery alleyways and narrow, labyrinthine whitewashed streets dripping in bougainvillea. Its strident colour might seem harsh in softer lights, but in the brilliant Mediterranean sunshine it appears translucent, like a string of jewels against the paleness of flesh.

Dalt Vila, the seat of local and church government, seems little changed by time, tradition and history. Displays of local and international contemporary art are housed in a vast, elegantly restored warehouse, Museu d'Art Contemporani d'Eivissa, and there are more traditional displays nearby in the Puget Museum, named after its former residents. Hodgkins made several visits to a tiny building that served as the archaeological museum. Photos from the period show lines of clay Tanit goddess figures lined up on shelves. The building had few windows, and the displays were quite static; they appear in the photos through a crepuscular haze.

Now a purpose-built museum stands as part of the great necropolis for which the pre-Christian island was famous, only part of which had been excavated in the 1930s. Founded by the Carthaginians in 465 BCE, the town of Ibiza became *the* place to die in, hence the vast size of its burial sites. Now professionally lit, those remarkable Tanit figures, equivalents of the moon goddess Astarte, take pride of place in state-of-the-art displays.

When Hodgkins came to Ibiza at the very end of 1932 the town had

ABOVE View of Puig des Molins on the left, stretching to the necropolis and Ibiza's new archaeological museum to its right.

BELOW One of the Tanit goddesses on display at the archaeological museum.

already begun to sprawl across the bay. She stayed at the newly opened Hotel Balear, and although she initially complained about the cold and the lack of food, gradually the town and its inhabitants captured her imagination, not least when the spring and early summer months added colour and warmth to her environment. By the time she left the island, she had produced a prodigious number of drawings and watercolours, some of which were then worked up in oils. Her watercolours are lyrical both in their colouring and in their delineation of the bold architectural forms visible at every turn.

Hodgkins may have travelled to Ibiza on the recommendation of her friend Maurice Garnier, whom she had met when staying in St Jeannet three years earlier.[2] If so, his enthusiasm for the island was mirrored by Manchester artist and fabric designer Karl Hagedorn and his wife, who had recently visited and fallen under the island's spell. Hodgkins and the Hagedorns had become friends while she was in Manchester in the 1920s. The Hagedorns were certain that Hodgkins would find the subject matter she was seeking from a creative perspective; as her letters and paintings demonstrate, she was at her happiest when observing those who continued to feel a strong link to the land and its rhythms, just as she was stimulated by meeting new people with whom she could discuss creative ideas. And yet she was apprehensive about the journey. Hagedorn later recalled that Hodgkins had dined with them in London on the eve of her departure but she was reluctant to leave, returning twice to their house before they finally put her on the last boat train at midnight.

She arrived on the island in the company of former student and fellow artist Gwen Knight, and by the end of January had three friends in tow. She complained that they only thought about sunbathing (although this would provide a good subject for her drawing, while she had to focus on producing works for her next exhibition in London. Finding space to work was also problematic, rooms being expensive to rent, and she found it impossible to find a studio. She was forced to paint in her bedroom, which was small and had poor light.

May Smith, a young Anglo-Indian artist who had grown up in New Zealand, arrived at Hotel Balear a couple of weeks after Hodgkins. She recalled: 'She invited me to come and see some of her paintings and in the bedroom the bed was very soon strewn with a great pile of the watercolours which she had been working on while she had been staying there. I was, of course, quite amazed to see and most intrigued to see what she made of landscape that I was struggling with too at the time. My main trouble had been light because of the soft light of England [and] to be suddenly landed into the brilliant light of Spain was very confusing and my first efforts had been completely without colour completely flat and that was the obliterating effect of bright sun. She then told me that she never worked after half past eight in the morning but sometimes she rose at 5 in order to get two or three hours in before the sun rose high and began its obliterating effect. And then after that she stayed indoors and went out sketching not before 4 in the evening. Those were the two periods in which she studied outside out of doors.'³

Hodgkins' early letters are laced with references to the number of Germans staying in the town, many of whom had fled the rise of fascism at home. Also staying at Hotel Balear was Dolf Rieser, a South African-born artist who had studied in Germany and Paris. He described how they became acquainted: 'The pensione was adequate, inhabited by a number of Europeans whom I slowly got to know. I met a Dutch civil servant, married to a charming Indonesian girl. There were also a number of English middle-class ladies, ardently occupied in painting pink sunsets. One evening, however, a very interesting lady turned up with a female companion. Later I got to know her very well indeed.

'At first, I took her to be one of the sunset painters whom you always met in the Mediterranean. However, on one of the first days of her appearance I was walking along a goat path, right above the built-up town, when I suddenly caught sight of the woman in question. There was no escape, as she was established right across the path and I had to look at her daubs. When I got nearer, however, I stopped thunderstruck. There on

her easel was a most beautiful, almost abstract, translucent watercolour of the port. I stopped and congratulated her and she said, "Well, I'm Frances Hodgkins: quite well known nowadays" and smiled rather delightfully.

'After that we became very good friends and had many talks in the pensione. I admired her skill, ability and potential very much. She had been given a lot of beautiful paper; intended for the English £5 notes, and on this paper she painted her watercolours. She also painted in oils and did a portrait of the Indonesian. At a later stage, Frances gave me one of her watercolours, which she swapped for a black and white drawing of mine.[4] At that stage I was starting to draw in very precise lines with pointed matchsticks dipped in Indian ink.'[5]

The goat path described by Rieser meanders along the ridge of Puig des Molins (Hill of the Windmills) that leads out from the far side of Dalt Vila. Today it is quite built-up, but there is still a spectacular view of the harbour to the left and the Bay of Figueretas to the right. Only five windmills remain, all of which have lost their wooden sails.

In January 1933 Hodgkins described to Karl Hagedorn how intensely she responded to the Balearic Islands: '[I]n this clear ivory light every common object looks important & significant . . . things appear in stark simplicity minus all detail — nothing corked up (bouchée) or hidden as in grey, or brown light of the north. Of course, later on, this intense sun light will convert colour & form into absolute negation but at the moment there is complete livlieness. The pale coloured flat roofed houses without windows give a blind restful feeling, of immense space.'[6]

If Hodgkins loved the architecture, the limited diet available in winter was less appealing. She wrote to Dorothy Selby, thanking her for a bright yellow handkerchief that had arrived for Christmas, but was unable to resist complaining about the food: 'You will think I think a lot about eating — we all do — it gets on ones nerves — the feeling of being undernourished is very depressing — Luckily there is a Dutchman who catches fish & shares it out

with us — it is good & wholesome but like most Mediterranean fish quite tasteless — This we eke out with cheese & Danish butter wh we have to buy. A favourite & frequent dish is Tortillas, a sort of tough omelette mixed with maize — incredibly dull & a never failing dish is octopus — a revolting sight.'[7] Fortunately, as warmer weather approached, more crops became available and anxiety eased, although she continued to worry about money: the exchange rate was poor, and she was still paying the lease on her Marylebone studio in London, a contract which she very much regretted having signed.

But there were other compensations, in addition to the rich vein of subject matter for her work. From early on in her European career one of her pleasures had been to spend an evening in a local bar, enjoying the warmth and escaping the confines of her hotel room.

By the end of a dark winter's day, the four walls would have seemed to close in, and the warmth, light and chatter of a bar was greatly preferable. A glass of local wine was an excellent way to ease the spirits. She often complained of having a wretched cold or influenza, so the smoky atmosphere possibly didn't do her any good. But Hodgkins had been a smoker, and the fug of tobacco would have settled around her unnoticed.

Hodgkins could engage in lively chat if she felt so inclined, and the early language lessons from her trip back from New Zealand in 1906 would have allowed her to converse to a degree with the Spaniards. But when she went to Ibiza and then to Tossa de Mar in the 1930s the Catalan dialect almost certainly confounded her. When she criticised the constant chatter of German coming from the resident émigrés, the frustration must have partly arisen from her inability to converse at any depth with those she encountered.

One of those living in Ibiza in 1933 was Austrian-born artist and architect Raoul Hausmann, whose Dada practice in Berlin had made him and other 'degenerative' artists a target of the authorities. He moved to Ibiza with his wife and lover in 1933, eventually shifting from Ibiza township to a house in San José (Sant Josep), a tiny village further west. In those days there was only one bar/café there, located adjacent to the

church, so it is very possible that Hodgkins' and Hausmann's paths crossed. On the day of our visit a funeral was being held at the church, so we retired to the same bar for a cold drink. The space was narrow, and had dark-brown painted doors on two sides. There was hardly any room for sitting inside, but a cool wind had sprung up so we decided against moving to the wooden chairs and tables crammed into the outside loggia.

Armed with a camera, Hausmann set about recording the local people — the graceful young women with their black hair parted in the middle and drawn back into a long, single plait, their voluminous garments embellished by the paisley shawls worn on special occasions — but he was equally drawn to the modular nature of the local architecture. Many peasant fincas (farmers' houses) were constructed around a large central room, often empty except for traditional, locally made rush-covered chairs that might be stacked up or else placed in an arrangement pleasing to the owner's eye.

Traditional Ibizan peoples had an innate sense of aesthetics that seemed to Hausmann to have grown as naturally as the prickly pears outside the windows, representing a way of life that he and many others felt was lost to more sophisticated European societies. Hausmann was influenced by Matisse, who was quoted in the 1935 issue of *The Studio*, published in England: 'For me, the subject of a picture and its background have the same value while the picture is formed by the surfaces, differently coloured, which results in the creation of an "expression".'[8] The local houses, their walls and arches, niches and simple furniture, created a series of planes interspersed with shadow that Hausmann felt reflected Matisse's dictum, no single element standing out over another, creating a harmonising whole. The same could be said of Hodgkins' late paintings in the 1940s, in which a focus disappears in favour of a range of sometimes disparate objects that she wove into a pleasing ensemble.

Hausmann's photographs are particularly telling in relation to Hodgkins' Ibizan paintings, as they both capture similar subject matter — the windmills on Puig des Molins, the gateways leading into Dalt Vila, and, most importantly, the whitewashed houses so reminiscent of what

Hodgkins had seen in Morocco 30 years earlier. Their arched porches reflected a Moorish influence, and many had simple loggias constructed with pruned vine branches to provide shade from the blasting summer heat and a support for training figs or vines. Hausmann's photographs of San José demonstrate the moodiness of the village in early spring — in the foreground of one, the almond blossoms wreathe the fields round about while dark storm clouds cluster above the village, threatening to drench the fields and strip the trees of their floral display.

Hodgkins didn't visit San José until May, when the weather was much more enticing. On the back of a postcard showing a group of smiling farm workers, written to Dorothy Selby, she described the village as 'very good country — A Fonda with 2 rooms — v. primitive — clean — 4 pesetas a day — I shall rest & sun bathe — Wish you were here. There is such a tribe of Picts & Scots swarming every where.'[9] Her painting of its monolithic church, *Church of San Jose* (1933), shows it towering over the three-arched porch facing the street in front. In reality the church has two tiers of windows, three vertical rectangles immediately about the porch, with a further two higher up either side of an oval window. To one side there is a set of yellow shutters, which Hodgkins has moved centre stage to give her composition a greater sense of balance.

While staying in San José she acquired a black-and-white postcard, now held in the Alexander Turnbull Library in Wellington, which shows the façade of the village church from a slightly different vantage point: the narrow, stony path opposite that leads up and around to the house where Hausmann had taken up residence. She also picked out the jaunty red roof of the bell tower above a side chapel, the view of which is now partly hidden, as the porch has been extended and runs in front of it.

According to the locals, the leaves of the olive trees are a softer green in spring, the clouds of white almond blossom brightening the fields before the leaves are fully out. Almond trees begin to flower in February, and

ABOVE A postcard showing the church at Sant Josep, Ibiza. Hodgkins painted a watercolour sketch of the façade at close quarters. *E. H. McCormick Papers, E. H. McCormick Research Library, Auckland Art Gallery Toi o Tāmaki, gift of Linda Gill, 2015.*

BELOW A postcard of Ibiza sent by Hodgkins to Hannah Ritchie. *E. H. McCormick Papers, E. H. McCormick Research Library, Auckland Art Gallery Toi o Tāmaki, gift of Linda Gill, 2015.*

unless the storms are particularly fierce the blossom stays on the branches for about five weeks — a useful fact when dating Hodgkins' paintings of this time. Great brown furrows (which she captures in *Phoenician Pottery and Gourds*) stand proud where early ploughing has been done in preparation for sowing, and in spring a soft mist often bathes the valleys, while inland the temperatures give a hint of the warmth of summer to come.

The island's rural villages are dominated by remarkable churches, each different in structure but composed of the kind of block-like forms that were the delight of a modernist's eye. According to a local guide, these whitewashed façades almost always face east, turning their backs to the sea, whereas the rest of the walls are massed brown stone, their surfaces fading into the landscape and therefore unlikely to catch the eye of passing pirates. Antoni had already identified the massive rear of the church of San Miguel as the setting for one of Hodgkins' more complex paintings, *Almond Tree* (Fig. 48). We scrambled around to the back of the building, but the precipitous drop below its walls made it impossible to find the vantage point Hodgkins had used. The valley below is peppered with almond trees, but Hodgkins took a single tree and made it tower over the church like a frothy pink umbrella. To my heathen eye, the brown mounds to the right of the painting looked like a file of fat self-important priests departing from the site of an inquisition.

As we travelled across the island, armed with digital images of possible Ibizan paintings that Antoni and I had put together over the past year, I asked all and sundry if they could help identify the locations. Happily, the generally reserved locals became fascinated with my project. After we had returned from San Miguel, the charming older waiter in the bar beside the quay where I had breakfast each morning put me on to a chain-smoking photographer in via Punica who had collected massive digital files of early Ibizan photographs and postcards. Nearly expiring from the heat and cigarette fumes, I sat beside him as he patiently trawled through images on a large computer screen, allowing us to see details we might otherwise have missed.

He brought up a photograph that showed almost precisely the same

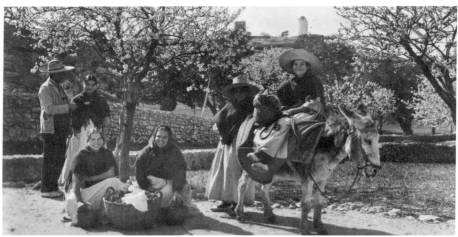

ABOVE **Fig. 48** *Almond Tree*, 1933, gouache on paper. *Private collection.*

BELOW A postcard from the time Hodgkins was in Ibiza, showing a group of peasants among the almond blossom at Puig des Molins. The photograph was taken by Domingo Viñets in the early 1930s. Postcards had just started being published when Hodgkins stayed in Ibiza, and she sent a number of them to friends and family.

scene as Hodgkins' *Almond Tree*, but taken from a more distant vantage point. As a photographer, he understood immediately what Hodgkins had done, in effect compressing depth and zooming in for a close-up. But he also identified my supposed troop of priests as paller (in Spanish, pajer), the clumped haystacks created by packing bundles of straw or hay around a central supporting stick of bamboo.[10] (Fortunately I had refrained from sharing my earlier impression.)

Two depictions of the monastery complex at San Miguel suggest Hodgkins spent time in the vicinity rather than merely visiting for the day. In *Spring in the Ravine*, the church buildings perch on the hilltop, angled away from the viewer as if sliding down the other side of the hill. A stony road appears briefly centre stage, and there are no almonds in sight. Instead the landscape is scattered with taller trees, their bent branches rising upwards. Some have clumps of leaves behind the branches rather than around them, a conscious compositional device. Painted in pinks and blues, the surrounding land undulates in differing directions, the background dominated by stylised mountains above which float round puffs of clouds.

The third work, a watercolour titled *Road to the Hills, Ibiza* (1933) (Fig. 49), reproduced on the cover of this book, appeared to look side-on at the church and, though rapidly executed, was evidently produced for exhibition rather than as a preliminary sketch. On my return visit to San Miguel, our guide pored over *Road to the Hills*, declaring that it was not, as Antoni and I had assumed, another view of the church. Instead the artist has turned her back and painted the view across the valley.

But what excited her more were the slashes of blue to the right of the watercolour, indicating that a stream had flowed freely there in Hodgkins' day. Today, apart from the reduced river that passes close to Santa Eulalia, Ibizans depend on aquifers and desalination plants for their water, and our guide exclaimed indignantly that in very dry periods large tankers have to bring water from Barcelona because the local council continues to grant permits for new hotels with swimming pools to meet the expectations of tourists.

Sa Talaia, the table-top mountain near Sant Josep, is the highest point on the island. Hodgkins painted a watercolour of the mountain that she allowed to be printed as a silk scarf in 1941. She wasn't alone in being drawn to its attractions. The Jewish philosopher and writer Walter Benjamin, who stayed on Ibiza at the same time as Hodgkins, also preferred the hinterland to the bustle of Ibiza township. He wrote of the pleasure to be had in walking to the summit of Sa Talaia by moonlight, accompanied by a young Scandinavian man, or in talking to the fisherman who provided langoustines to the villages. He met Paul René Gauguin, grandson of his more famous namesake, who sometimes visited the island on fishing trips, looking for subjects that he could turn into woodcuts. A close observer of social ritual, Benjamin also described the tragic scene of a young man whom he had befriended carrying the tiny white body of a baby to the church, followed by weeping women clad in black.[11] Even today, you cannot remain long in island cultures like Ibiza or my own Paros without witnessing the rites of passage that mark everyday life.

On my last day in Ibiza, the friendly archivist in the Ibiza library suggested that I meet an English writer and publisher, Martin Davies, who turned out to have New Zealand connections. He invited Antoni and me to visit him immediately, as he had to teach later in the afternoon. When we arrived, Martin had already laid out his own archive of catalogues and books about Hodgkins, although he hadn't been aware that she had spent time on the island. When he looked over three watercolours done from what seemed to be the same vantage point, he insisted on taking me to meet Rosa, who had lived in that area all her life. Antoni returned to his family for lunch, so was unable to join us. Rosa worked in a large hotel, and on passing through the lobby Martin and I wended our way down among an array of muscle-rippling men, their torsos glistening with oil, who were sunbathing around the pool

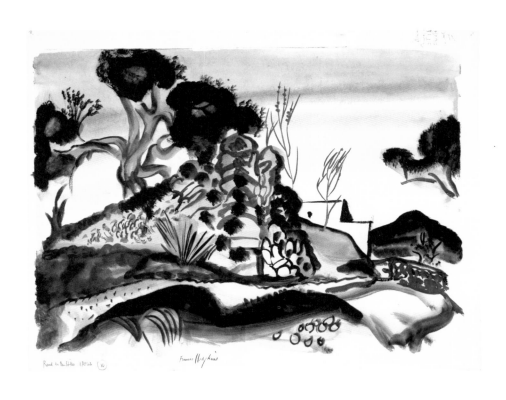

BELOW Fig. 49 *Road to the Hills, Ibiza*, 1933, watercolour on paper. *Museum of New Zealand Te Papa Tongarewa, purchased 1975.*

or stretched on sunbeds, straining to read their digital devices in the brilliant sunshine. They barely gave a glance in our direction.

At one end of the pool a blue, white and yellow tiled loggia served as bar and restaurant, providing a spectacular view of the bay beneath us. Two charming middle-aged waiters, looking like pirates in their blue and white spotted scarves, were busy behind the bar, and we were promptly joined by Lola, an ancient yellow terrier with a diamante-studded collar who sat patiently under my table until I shared my ham and cheese with her. When offered scraps of bread she delicately moved them aside with her nose and continued to wait for the next protein morsel. Martin went off in search of Rosa, who was busy in the laundry, while I went up to the bar to pay. I was amused to see a large carved wooden penis standing proud beside a plastic pig dressed in a nurse's costume embellished with pink tail feathers. The pirate fed the tip I gave him into the pig, which lit up and rumbled, 'Ooh that felt good, baby.'

Fortunately by the time Rosa finally arrived I had composed my features. She was tiny and lean, her face marked with the deep lines of a lifetime of sun and cigarette smoke. It transpired that she owned the hotel. She immediately identified the location of the watercolours we were trying to place, directing us to a steep set of stairs, towards Puig des Molins and above Figueretas, which led down to the water. The area is now heavily built-up, and Martin and I would never have located them without her help.

Just as Hodgkins had made several watercolours of the windmills standing like sentinels along Puig des Molins, so the stepped houses with their terrace walls tight up against the stairs obviously appealed compositionally, and were the closest she got to capturing domestic life. In one watercolour the front terrace of the house has a birdcage sitting on the wall, which is replaced in the second version by a contented cat curled up in the sun. The third takes a more sideways view, focusing on the stepped walls themselves; these, unusually, have squat columns rising up at intervals.

Rosa was also able to unravel a puzzle regarding the oil painting

Monastery Steps (1933-35) (Fig. 50), the location of which was proving elusive. First exhibited at the Leicester Galleries in London in 1935, it produced an immediate reaction when I showed it to Ibizans. On my first morning Antoni had taken me up to the monastery, which stands out near the cathedral at the top of Dalt Vila, nestled behind a line of houses which drop away precipitously on the left, and approached by a broad set of stone steps. But it was immediately apparent that what Hodgkins had painted was different from what we saw before us. Rosa identified the right-hand part of the painting as drawn from a vantage point on the opposite side of Dalt Vila, showing the winding path (now a sealed road) that leads between sturdy walls along from Puig des Molins.

It became evident that while Hodgkins' watercolours responded more directly to particular locations, these later oils, worked up after she returned to England, often interwove elements that were plucked from several locations — a complex and sophisticated approach of which we had previously been unaware. Yet the clues are there in her letters, for she writes to her dealer Duncan Macdonald in May 1936, after her second Spanish interlude in Tossa de Mar on the Costa Brava: 'I am looking for a quiet corner where I can settle down and chrystallize the after glow of my Spanish memories — before they grow dim.'[12]

Monastery Steps accentuates blocks of colour, carefully considered curves and individual architectural forms, tied together by a series of strong verticals. The paths and buildings first catch our attention, but you gradually become aware of the dark bands that 'frame' the composition either side and stand in stark contrast to the brilliant colours within the work. A pine tree soars up in front of the monastery wall, its pointed tip creating a secondary cross beside the crucifix on the highest point of the building.

Hodgkins had thought very carefully about how she wanted colour to work in this painting, for in reality it is the monastery that is ochre-coloured, while the left-hand building is painted the blinding white used for most traditional buildings. The rich emerald green is a colour

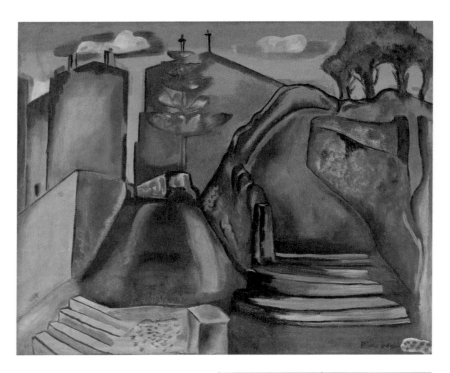

ABOVE **Fig. 50** *Monastery Steps*,
1933–35, oil on canvas. *Private collection.*

BELOW An old photograph showing the
steps in Dalt Vila. *todocoleccion.net.*

CLOCKWISE FROM TOP Ibiza scenes: Raoul Hausmann's house in Sant Josep today; three of the stations of the cross outside the church of Sant Agustí des Vedrà; view of the back of the church of San Miguel.

entirely of her own imagination. Therefore, while *Monastery Steps* refers to places that Hodgkins observed first-hand, the final painting is a telling demonstration of how an artist transforms the literal into a creative refinement that is entirely her own.

Not that she didn't continue to make topographical paintings as well. Now bitten by the Hodgkins bug, Martin continued to correspond with me, and he made another discovery about the vantage point from which Hodgkins had painted while he was on a guided tour of Dalt Vila at a time when visitors were allowed inside the Santa Lúcia bastion behind the cathedral apse, an area normally off-limits today. As he noted in one email, from that vantage point the angle at which the breakwater juts out into Ibiza Bay corresponds with Hodgkins' treatment of the subject.

Later in the afternoon, after I had recovered from my highly informative hotel visit, Vincent drove us to Sant Agustí des Vedrà, my favourite Ibizan church. Built without a porch, its rectangular façade is pierced by a central arched doorway, above which is a small circular window crowned by a bell tower. To the right of the door are three tightly grouped, white curved tablets like tombstones, each bearing a black cross that marks three of the Stations of the Cross that you normally see inside Roman Catholic churches. It was like discovering a Colin McCahon painting in the Ibizan countryside.

Another painting that was to be our focus for much of my visit is *Spanish Shrine* (1933–35) (Fig. 51), again painted on Hodgkins' return to England and not shown until her major exhibition at the Leicester Galleries in February 1935. Antoni had made an appointment with a local official to open up the Cova de Santa Agnès, a grotto outside the town of Sant Antoni de Portmany, which had been closed for some time because of staffing issues. The official arrived wearing open-toed sandals and was mortified to find that beer and wine bottles had been tossed through the grille that closed off the entrance to the cave. We gingerly made our way down the steep stairs, picking between shards of broken glass, before the space opened out into a large brown stone chamber of ancient lineage.

ABOVE **Fig. 51** *Spanish Shrine*, 1933–35, oil on canvas. *Auckland Art Gallery Toi o Tāmaki, purchased 1954.*

BELOW The restored statue of the Immaculada in the Cathedral of Ibiza; barrels for wine and water in the Ethnographic Museum, Santa Eulalia.

At the far end stood the benign figure of Santa Agnès, towering over a crucified Christ on her left, a vase of tired artificial flowers sitting on a stone shelf to the right. In front was a very simple white marble altar resting on a base of neatly stacked stones.

Antoni had wondered whether Hodgkins had visited the grotto, using it as the rock formation in the background of *Spanish Shrine*, but it was hard to see a correlation between the curving roof of the cave and the irregular mass of what looks to be a cliff that serves as a backdrop to the central figure in the painting. Set into this mass Hodgkins includes a rectilinear shape pierced by the plain curved doorway Portal Nou (New Gateway), which was constructed in the sixteenth century to provide an alternative entry to the citadel. Tucked in behind the woman on the left is a jug which Hodgkins also included in *Phoenician Pottery and Gourds*, while opposite a lily pokes out at a jaunty angle. This flower is found in many of Hodgkins' paintings, no doubt because she liked its folding petal and contrasting bold yellow stamen, but she may also have been aware of its symbolic association with fertility.

With that and other paintings in mind, early on our second morning Antoni and I took the bus to Santa Eulalia (Santa Eulària des Riu), where Hodgkins had also spent some time. Antoni pointed out the famous well which had been the envy of others, providing agricultural riches to its owner, Don Ignacio Riquer, who owned all the land south of the Eulalia River at the time. According to the American writer Elliot Paul, who lived in Santa Eulalia, the inexhaustible hidden spring that fed the well was Don Ignacio's greatest pride, 'a mark of God's special favour'.[13] Hodgkins made a small watercolour sketch of the wheel, which was operated by a blindfolded mule harnessed to the long wooden bar attached to the central divot. The poor beast spent its days walking in eternal circles, drawing water up from the aquifer deep below the ground.

We alighted from the bus slightly outside the town, and wandered through a restored farmlet, now part of a tiny museum, its fields thriving thanks to the water that courses through the only river in the entire

Balearic Island complex. We climbed the hill to the church of Santa Eulalia, originally a Moorish construction and famous for its arched porch, the subject of one of Hodgkins' watercolours (*Porch, Santa Eulalia*, Fig. 52). During services it is mainly the women who sit inside the churches; the men stand on the threshold, mulling quietly over recent events. Gendered roles on the island often diverge from perceived tradition: in Ibiza, young women carry the statues of the Madonna out of the churches and through the streets on saints' days, whereas in countries like Italy and in other parts of Spain men carry out the task.

Overlooking the town to one side of the church complex is Can Ros, the local ethnological museum situated within a traditional house. As a lover of kitchens, I gazed longingly at the array of terracotta jugs and urns used for storing wine and olive oil, and the simple hearth where the indoor cooking took place — these appear in Raoul Hausmann's photographs, demonstrating that they were still in use in the late 1930s. One room contains an olive-oil press, and in wall apertures there are wooden barrels and baskets, an important find, as they bear direct relevance to *Spanish Shrine*.

The central figure in this painting, with her long hair and hands clasped in a traditional gesture of prayer, has frequently been interpreted as a fusion of a pre-Christian goddess and the Virgin Mary. Long before I went to Ibiza, Antoni had kindly written to Francesc Xavier Torres Peters, a canon of the Cathedral of Ibiza, and a historian, asking if he recognised the figure. Peters promptly responded with photographs of what remained of the church's much-revered statue of the Immaculada, which had sustained damage from an anarchist attack in the Spanish Civil War. Her outer wooden shell looked anomalous standing at a lean on the sloping pavement outside the church, waiting to be bundled into the boot of a vehicle and delivered to her restorer.

The photographs showed that the entire body beneath the blue cloak was missing. The Immaculada's arms were still intact, but her hands had gone, as had her face, although from behind you could still see her long hair

ABOVE **Fig. 52** *Porch, Santa Eulalia*, 1933, watercolour on paper. *Private collection.*

BELOW The porch of Santa Eulalia, today.

flowing down her back. The church had finally raised the funds to restore her, and by the time of my visit the figure of the Immaculada was back in place on her sliver of moon and billowing clouds. Sadly, compared to Hodgkins' monumental and dignified figure, the new sculpture seems a tad saccharine, its ancient power overlain with contemporary sentimentality.

In Hodgkins' painting the two attendants share her dignity. The figure on the left kneels before a stream of water, with a water barrel similar to the ones seen in the Santa Eulalia museum balanced. The other figure holds a woven basket of fruit on her head, the traditional method for carrying small quantities of crops from the fields and orchards. The same traditions exist throughout the Mediterranean and, as a number of writers have noted, set up resonances with the headdress worn by the Tanit goddesses that we had seen in the archaeological museum in Ibiza township.

Antoni was also curious about *Two Heads* (Fig. 53), a portrait Hodgkins made of two young women while in Santa Eulalia. One was readily identified as Mary Hoover (later Mary Aitken), an American who lived for some time in the town after leaving Madrid, where she had been assisting the Spanish artist Luis Quintanilla paint frescoes at the university. The islands were seen as a safer haven than Spain's large cities in the early 1930s, when political tensions were on the rise as the communists and anarchists sided with the democratic republicans against the conservativism of the nationalists. Antoni wondered if the other young woman might be the Catalan artist Soledad Martínez, who often travelled to Ibiza between 1932 and 1935. Martínez, who knew Hodgkins' friend Maurice Garnier, rented a house in Puig des Molins, a cheaper part of town, where she and her friend Olga Sacharoff worked. The latter would later stay in Tossa de Mar at the same time as Hodgkins, so it is quite possible that they crossed paths. Garnier and Hodgkins met up in Ibiza near the end of her stay in mid-1933, and she accompanied him back to his home in Royan in France, as evidenced by a portrait sketch we found in the Tate Archives in London in which he looks distinctly nautical in a peaked cap against a backdrop of yachts (Fig. 54).

The names of friends and companions weave tantalisingly in and out of the Hodgkins narrative, but as yet we have found no definitive proof that Hodgkins and Martínez did indeed meet. These connections are like pieces of sky in a jigsaw puzzle: links are suggested between the different pieces, but they are not always easy to connect. An exception is in the case of Mary Hoover, who painted a portrait of herself playing cards in a café; behind her is a group of dejected men. Another man, his head resting on his hand, gazes intently at the young woman, whom the painted artist does not see, but at whom the real artist was gazing directly. A photograph of Mary Hoover in front of a large portrait of the Santa Eulalia bartender appeared in *Time* magazine on 29 April 1935.

O n my last evening in Ibiza, Vincent and Antoni drove me out to the famous fish restaurant at Es Cubells at the southwest end of the island. Of all the places we had managed to cram in over three days, this village seemed the most remote and untouched by tourism, and the restaurant's clientele had probably never seen the inside of a discotheque. Antoni and Vincent insisted that I order a fish that turned out to be enormous — absolutely delicious and still smelling of the sea. I was alarmed at the thought of having to consume it all until I discovered help was on its way in the form of several svelte black cats which insinuated themselves under my chair. It seemed fitting, given Hodgkins' lifelong love of felines.

On Ibiza Hodgkins painted portraits and compositions of figures, such as boys playing traditional flutes, but, with the exception of *Spanish Shrine*, mostly shied away from the activities of working people. This contrasts with the focus of her French watercolours before the First World War. She could not, however, resist the cats (Fig. 55) and dogs. *Yudi y Moro* (Fig. 56) are two of the famous Ibizan hunting hounds, indigenous to the islands, whose long legs enable them to leap over scrub in search of prey.

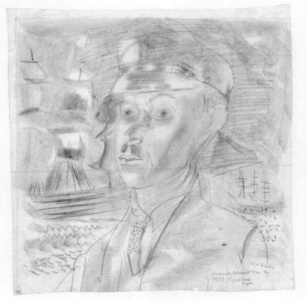

ABOVE **Fig. 56** *Yudi y Moro*, c.1936, watercolour and gouache on paper. *Dunedin Public Art Gallery, purchased with funds from the Dunedin Public Art Gallery Society 1970.*

RIGHT **Fig. 55** *Siamese Cats*, c.1933, gouache on paper. *Private collection.*

On my last day Antoni took me to what he considered to be the best bakery in Ibiza, insisting I buy a traditional cake known as a flaó for my hostess on Menorca.[14] I somehow managed to wrestle this awkward object onto the little plane, and miraculously it arrived in one piece. I had been looking forward to staying with my friend Caroline at her tiny farmhouse, which seemed to be almost unchanged since the 1930s and proved very similar to the Greek cottage we had lived in over those summers in the 1970s — simple rooms with thick stone walls that keep the interiors cool in summer, small windows whose faded dark-green shutters also give welcome shade at the height of the day, and irregular terracotta floor tiles which need to be swept at regular intervals.

The interior of Caroline's kitchen was enchanting — long enough to take a stout wooden table which served as a repository for terracotta jugs full of cooking utensils, half-finished bottles of wine and the odd lump of cheese with a corner taken out; a surface for cutting up vegetables while chatting to your host as she prepared dinner; and a surface to eat if the weather outside turned inclement. A hand-embroidered napkin hung over the enamel shade of the overhead light, casting a delicate tracery of shadow on the walls. The evening was balmy, and we were able to eat outside under the vine-draped loggia in the company of Hamish, a New Zealand artist who has lived on Menorca for many years, and a strikingly elegant artist (also a watercolourist) and her voluble philosopher husband.

I produced the unassuming-looking flaó with some trepidation, but it proved to be absolutely delicious, the crust light and crumbly, the almond-cheesecake filling delicate, with the slightest hint of mint and anise. Odd clattering noises heralded the arrival of a couple of the numerous tortoises that live in the area, and, to add to the perfection of my brief stay, on the last evening we were accompanied by the song of a nightingale.

20
Tossa de Mar
SPAIN

I flew into Barcelona airport from Menorca in time to meet up with Chloe, who was waiting, hot, jet-lagged and exhausted, having just flown from New Zealand. After she reprimanded me for my quizzical expression at the sight of her *two* suitcases, we boarded the bus which she, in her usual efficient way, had already located among the plethora of large, diesel-belching vehicles lined up at an angle to the kerb. Our next port of call was Tossa de Mar, further up the coast of the Costa Brava (Wild Coast) where Hodgkins stayed from September 1935 to around May 1936.

I love riding Spanish buses: they are almost always on time, extremely comfortable, and give you the time to appreciate the changing countryside from a fair height. This is far more relaxing than wrangling with hire cars, incomprehensible maps and malicious one-way systems. On our arrival at the bus terminal on the outskirts of old Tossa, we collected a map from the adjacent tourist agency and made our way down through the main street, bathed in late afternoon sunshine, in time to see its little shops opening after the afternoon siesta.

Our hotel proved to be on one side of Plaça de l'Església, which sounds romantic in Spanish but in English translates prosaically to Church Square. The building in question, dedicated to Sant Vincent, is the largest in the village, the only embellishment in its plain façade of pinkish stone being a niche holding a statue of the saint. The hotel has taken over one corner of the square, as has another opposite, giving a bustling air to what might otherwise have been a deserted space. Several little roads lead off, heading to the sea, the railway station, or Vila Vella, the medieval fortified town at our end of the bay.

Chloe and I collapsed in an exhausted heap on our first night, and would have slept soundly except that the church bell (slightly cracked, perhaps) clanged until 12.30; then at 4 a.m. the local rubbish truck sounded as if it was taking a few walls with it as it spun in a circle in the street outside. In an unforgivable display of disloyalty, Chloe cracked up with laughter when she saw my appearance the next morning. We went down to the reception desk, looking importunate, and were moved to the

ABOVE View of Tossa from the ramparts.

BELOW A view of the town from above Vila Vella.

back of the hotel, where the windows opened onto a tiny (silent) lane, and the abbreviated view was of chimneys and rooftops, rather than the picturesque piazza and its accompanying revelry.

If Ibiza proved a gold mine, Tossa de Mar took more time to reveal some of Hodgkins' secrets. The town is defined by the hills that close in towards the two bays that make up the village, so that most tourist development is captured within them. Today the developed part of Tossa facing the Platja Gran or main beach is crammed with budget hotels, populated during the season with broad-beamed English and Russian tourists determined to scorch themselves senseless on the grainy sands before traipsing back to their hotels, cuffing wailing, overtired children around the ears before settling down to fish and chips or pizzas.

Vila Vella, which rises up at the far end of the bay, could not be more different. You could easily think it had always been stocked with charming brown stone houses — so dark compared to Ibiza's sparkling whiteness — but photographs from the 1930s show that there were terraced fields outside the crumbling wall leading up to the summit, and gaps among the houses inside the fortifications. Today winding lanes and steep flights of stairs sit among the restored houses inside the walls, their irregular stones softened by pots and troughs cascading with flowers, and vines snaking their way up drain pipes. Against one wall a magnificent fig has sprouted from a natural crevice in the stones to provide shade for its owners, its fruits a plump, perfumed gift for those with arms long enough to reach them.

Many visitors take the more obvious route upwards, via the new road that leads from the beach below the walls before looping back and up the hill. As they climb they pass an empty apse — all that is left of what was once the gothic church of Sant Vincent. Those with a modicum of taste avert their eyes from the bronze sculpture of Ava Gardner, whom the locals adored for putting the village on the map when she made the film *Pandora and the Flying Dutchman* here in 1951. The statue resembles a bronze figurehead that has lost its supporting prow, and young men

find it hard to resist having their photo taken beside the statuesque figure whose hair ripples backwards as if in a strong wind.

More often than not, her living companion drapes an arm across her shoulder so that an idle hand can fondle one of her enhanced metallic breasts. Those of more mature years or rotund girth can spare themselves the experience by availing themselves of the brightly painted 'train' that trundles slowly up the paved slopes to the highest point: Es Cars lighthouse, which now houses a charming small museum.

The coastline is dotted with these marvellous structures, warning those at sea of its dangerous, rocky coastline and marking safe haven once ashore. Often standing as lone markers in the wild and isolated landscape, they caught Hodgkins' attention on Ibiza as well as the Costa Brava. Today visitors to Es Cars who baulk at the entrance fee to the museum can content themselves with the adjacent café. Its broad decking offers a panoramic view up and down the coast, and an all-important bathroom is a further attraction, although only those who have ordered food or drink may use it.

Vila Vella is the sole remaining medieval fortification on the Catalan coast, and the intrepid can walk around the restored ramparts, its crenellations offering framed views of the mountains behind the bay and the broad expanse of iridescent sea stretching to the horizon. The circular machicolated towers that rise up like sentinels at intervals around its perimeter proved ideal subject matter for Hodgkins when she took the precarious path above Vila Vella, looking for a suitable location from which to paint. She described the walk as essential for keeping warm in the winter. The vantage point allows a sweeping vista that captures the individuality of Vila Vella itself while skimming beyond the clusters of cottages and winding streets below.

When Chloe and I made the climb, we accessed the path through an aperture cut through the wall, holding our breath in face of the cliff that tumbled down to a rocky cove below. Wire is now strung between metal posts to stop anyone falling, but it probably resembled a goat track when

Hodgkins was there. Higher up the path we took a brief respite from the sun under an overhanging olive tree, from where we could see the vast sprawl of modern Tossa spreading out from the older village below.

odgkins arrived in Tossa on 17 September 1935, when the blazing heat of late summer made the beach impossible to stand on, and didn't leave until the end of spring 1936. The landscape was isolated, wild and rugged, heavy with the scent of hillside pines that stood out against the sky. Even today the innermost stretch of the larger beach of La Pauma (Palma), its line of fishing boats pulled up on the sand, is scooped out by the river that comes tumbling back into play after winter rains. She records this in *Return of the River* (Fig. 57), writing to her friend Ree Gorer that as soon as the water started to flow, women appeared either side to do their washing.

The second beach, Mar Menuda, is a good walk away past a rocky yellow-ochre outcrop, which today has been subsumed beneath hotels and restaurants. Once the weather warmed up, the bay provided sheltered swimming uninterrupted by the coming and going of fishing boats. The famous La Pauma restaurant, its pine trees clinging to the cliffs, divides the two bays. It was quite isolated in the 1930s, and accessible only by walking over the promontory on which it perches. Today a road sweeps around the coast.

Although the village boasted a population of only about 1400 residents in the 1930s, a number of leading modern artists were captured by its isolated charms. Among the French artists who made their way to Tossa in the warmer months was Marc Chagall, who fell in love with the village, calling it a 'blue paradise'. A photograph shows him playing with his daughter in the sea. Painter and photographer Dora Maar captured her companions perched inside a fishing boat on the shore, the men wearing cumbersome knitted one-piece swimsuits, their white limbs awaiting the attentions of the sun. Writers paid tribute to the radiant light and fresh

Fig. 57 *Return of the River*, 1937, gouache on paper. *Christchurch Art Gallery Te Puna o Waiwhetū, purchased with assistance from the Olive Stirrat Bequest 1983.*

air, though a pervasive smell of fish came from the brightly coloured boats that dominated the shore. Photos of the time show fishermen silhouetted against the setting sun, pulling lines in from the sea and straightening and gathering up the nets.

Other visitors to Tossa during the period of Hodgkins' stay included French intellectual and literary polymath Georges Bataille, and artists André Masson, who owned a house in the village, and Albert Gleizes. Hodgkins makes no reference to this 'Parisian presence' among Tossa's visitors in the letters remaining from this time, but some of the works she painted over this period include a distinctive 'surreal' element, arising not from the subconscious but rather in a conscious overlaying of forms and motifs.

Masson and Gleizes would have been present at the 1936 opening of the little museum and art gallery in a restored palazzo inside the furthest stretch of the wall around Vila Vella. The museum also houses some extremely fine artefacts from the early Roman villa of Els Ametllers, discovered in 1914. Some of the villa's grander floors remain in situ, their mosaic designs intact, while finer examples were moved to the museum, along with sculptural fragments, Roman glass and jewellery, and a carved marble lion-headed table leg.

The upper part of the museum houses their collection of modern art, almost all of it gifted, so that the two periods serve as book-ends to the history of Tossa. It is sad that there isn't an example of Hodgkins' work here, the most obvious explanation being that the Lefevre and Leicester galleries were expecting everything she produced, in accordance with their contract. Yet it would have warmed our hearts to have seen her represented in Tossa. Instead, as in Ibiza and so many places where she stayed, there is no record of her sojourn or her own particular interpretation of place in these delightful local art museums.

Why did she come to Tossa? Ree Gorer may have recommended it as a destination to Hodgkins, as it was advertised regularly in the *New English Weekly*: '[T]he beautiful Tossa, Spanish Mediterranean coast, with its mountains and forests, the wonderful sand-beach, its quietness and

Four views of Vila Vella, Tossa.

simplicity, the place for your holidays. Full board in German-Swiss house (running water in all rooms, baths, first-class cooking) Ptas. 12 (6/-) Cheap travel by special arrangement. Information catalogue at Casa Steyer, the Guest-House of Foreigners.'[1]

Writer and pacifist Margaret Storm Jameson also stayed with her husband at Casa Steyer for five weeks from March to April 1935. The hotel, run by a Swiss and a German Jewish exile, was seen as a safe haven for the many refugees who holed up there after fleeing Germany, but Jameson refers to it also being occupied by a group of English female artists, one of whom would have been Hodgkins, and possibly some of her students. While Jameson also grumbled about the tasteless meat, unpalatable bread and coffee made with goat's milk, she warmed to the beauty of Tossa's quiet headland and harbour, the stony soil and the empty streets.

Other visitors were equally enchanted by the scent of herbs and wood smoke, the scorching light that contrasted so vividly with the all-encompassing darkness once the sun had set, and the random chorus of cicadas and frogs. Yet this picturesqueness was inevitably leavened by the underlying tensions brought on by poverty and by the anger felt by many locals faced with the rising threat of fascism. It had a marked effect on Jameson. She would recapture the political tensions in Tossa, as well as her memories of Casa Steyer with its resident English artists and German refugees, in two books: *In the Second Year* (1936) and *The Green Man* (1953).[2]

Hodgkins also grumbled about the number of Germans staying at Casa Steyer, not least because she felt they had had a deleterious effect on the local cuisine — true, perhaps, in regard to pickles, but unfair on the anchovies, which are such an essential part of Spanish cuisine. Perhaps they were pickled, like rollmops, rather than drenched in garlic, olive oil and lemon.

As often happened, she felt out of sorts with the place until she had familiarised herself with its landscape and its mores: 'When I first came the country side did not appeal to me & I collected a lot of notes & sketches, casually, without bothering much about what might come through,' she

wrote to Ree Gorer. 'It is only this last 6 weeks I have settled down to serious work — I have been rather too intense & am feeling tired & like going to bed & keeping warm — for it has become cold, a kind of brooding cold, only warm at midday.' However, she conceded, 'There is plenty of material here to paint. I am working up courage to start on figures — The life of the village is rich & dramatic. The little shops at night, enchanting like Dutch interiors gone Spanish — and the gilded altars in the village churches, vulgar & gaudy, but in the dim light, like a Rembrandt.'[3] She wrote about her delight in the sight of the 'fishing boats lit by huge lamps, setting out after dark — their phantom shapes splashed in silver & blue like the fish they are going to dazzle'.[4]

Chloe and I were having no luck in locating Casa Steyer, so on the advice of the information office we visited the local council archivist, Rosa Maria. She was extremely friendly and tried to help in every way, though she spoke no English at all. With a lot of arm-waving, she indicated that they didn't have any hotel records from the mid-1930s, but she directed me to a photographer's studio where we were able to sift through excellent large black-and-white photographs of the period. At some point the photographer had discovered his mother-in-law's album, and had re-photographed everything that was relevant to the history of Tossa. I bought a copy of a large photograph of young, handsome fishermen working with their boats on the foreshore, but once again came up blank in regard to Casa Steyer.

In 2018, however, I came across a reference to an unpublished essay that paints a further picture of Hodgkins' stay in Tossa. This had been written by New Zealand expatriate Greville Texidor for Hodgkins scholar Eric McCormick, who, for some unknown reason, hadn't included it in his writings on Frances Hodgkins. Texidor was the daughter of New Zealander Editha Greville Prideaux and her British husband, William Foster. After dancing for a period with the legendary Bluebell Girls troupe

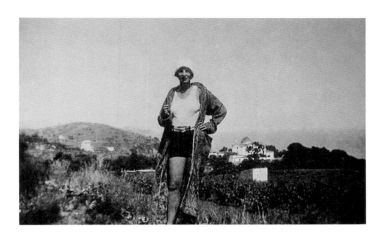

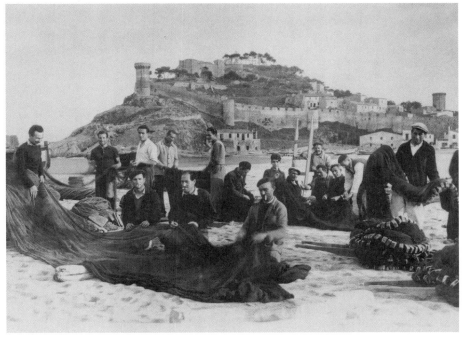

ABOVE Greville Texidor photographed at Tossa de Mar in the 1930s.

BELOW Fishermen on the beach at Tossa in the 1930s. *Jordi Ferre Fotograph, Tossa de Mar.*

in Paris, Greville travelled widely, marrying Spanish-born Manuel Maria Texidor i Catasus, who had set up a cork factory in Buenos Aires. They moved to Barcelona before settling in Tossa in 1933, but the marriage ended after she met German émigré Werner Droescher, who was working as a tutor, the following year. Both Texidor and Droescher were fiercely left wing and were to fight for the anarchists in the Spanish Civil War.[5]

Hodgkins and Texidor met after Hodgkins had made a gift of one of her paintings to Herr Steyer, her host at the hotel. According to Texidor, Steyer (his full name was Luis Steyer Weber) was immensely proud of it, hanging it in pride of place in his newly decorated salon with its red velvet chairs and whitewashed walls. He renamed the space his 'lounge', feeling it added a modern touch to the establishment. Casa Steyer had formerly been some sort of warehouse, and Texidor described the inner courtyard lined with open arches 'like a cloister', and an upturned boat which the hotel gardener had filled with flowers. This man was the font of all local gossip, and it was he who informed Texidor of Hodgkins' arrival in Tossa. She in turn passed on the news to her own guest, former Slade student Marjorie Hodgkinson, now wife of the British artist Mark Gertler. Hodgkinson's immediate response was 'Here she is again!' She was an admirer of Hodgkins' work, and their paths must have crossed at one or more of the other locations in which Hodgkins had painted.

Texidor couldn't remember whether she had first met Hodgkins 'on the beach or at the Marcus snack bar where they played Bach and had such good Welsh rarebit', but she and her older acquaintance got on immediately and took many walks together in the months ahead, sometimes through the old town to the fortifications, or through the remains of the Roman villa. One of their favourite destinations was the lighthouse, which Texidor described as presiding over the village, 'white against blue, like a guardian angel'.[6]

Texidor would have given Hodgkins an insight into the complicated local politics. Beneath Tossa's agreeable surface there was considerable division between the church, which sided with the conservative state,

and many of the poorer citizens, who supported either the anarchists or communists, or both, hoping for a better standard of living. As a result of these factions Tossa was to be bombed heavily by Franco during the civil war.

Texidor was also able to observe how a painter worked at close quarters, for while she kept pointing out what she thought were suitable subjects, Hodgkins would suddenly 'alight on what she was going to paint, often some insignificant rock or shrub'.[7] When Texidor took her to visit Can Kars, the handsome house in which she lived above the river, Hodgkins admitted that she had been there already on her walks, although she had viewed it only from the outside. It is from this vantage point that she must have been able to see the snow on the Pyrénées that she mentions in a letter.

What becomes apparent in Texidor's account is that although Hodgkins had described Tossa in an early letter to Ree Gorer as 'a sad little colony in winter, and that even Teufel, the hotel's fox terrier, looked like an introvert if you can use so big a word for so small a dog', she gradually became involved with the goings-on at Casa Steyer, developing a fierce loyalty to her host.[8] She settled into a rhythm: 'I paint during the morning — dividing my time inside & outside the Studio — this is the very charming part of a place like Tossa. So small & simple one can step into the old streets and have a look round — make a quick sketch & back to the Studio repeating this little stunt perhaps 2-3 times during the morning — no fatigue — no complications —I am mildly happy here as regards work — Subjects have come slowly . . . only very so-so for landscape — but a good deal better now that the River has come down from the mountains & is slowly filling up the dry riverbed groups of washing women are now washing clothes on the banks — Three quarters of the rivers in Spain dry up in the Summer.'[9]

At one point Hodgkins asked if it would be possible for her to stay at Can Kars. They finalised plans on one of their walks, during which Texidor showed her the local workers involved in charcoal burning, a speciality

which stretched as far as France, where poverty-stricken Spaniards could eke out a living when in extremis. On the flat land either side of the dry riverbed were summer huertas or vegetable gardens, whose soils were enriched in winter when the river came down from the mountains again. Texidor recalled how Hodgkins was irritated by field after field of cabbages, too repetitive for an artist to paint and probably reminiscent of the massed greens of the English countryside that so irked her.

Texidor painted her own description of the huertas when viewed from a distance and at some height. They spread across the valley 'like tapestry, the ground deep as moss pattered by irrigation ditches and orange coloured walls linked by half hidden shapes of old cisterns and sheds. As I saw it that day its easy luxuriance put me rather in mind of Miss Hodgkins painting. As she saw it was simply a nuisance. "Why does such a nice village have to be <u>completely</u> surrounded by greens? That cabbage patch! You can't go anywhere without seeing it."'[10]

Yet Hodgkins does allude to them in two of her gouaches, albeit in modified form. In the foreground of *Spanish Landscape in Orange, Brown and Green* (Fig. 58), for example, there are stooks of hay, with two or more poles crossing near the top. Similar in construction if not in form, these *pajera* have the hay packed around them as if they were wigwams, unlike the rounder Ibizan *pajer* with only a single supporting central stick.

When Hodgkins was in Tossa the whitewashed walls of a brand-new hotel, Casa Johnstone, stood out in stark isolation on the steep hillside above the beach. Its inclusion in the gouache created the favourite 'white note' that she had used since her early days in France, although its stepped form is slightly disguised behind the haystacks. You wonder, given her grumbling about the food at Casa Steyer, whether she secretly wished she could have stayed at Casa Johnstone, and yet you also sense her reticence: in spite of longing for a variation in diet, Hodgkins knew how distracting stimulating company could be.

Casa Johnstone was built by Archie and Nancy Johnstone to attract former colleagues in Fleet Street, where Archie had worked as a journalist.

Chloe and I searched for it in vain among the squat, ugly tourist hotels that now cluster on the hillside opposite Vila Vella.

On our return to the hotel on our last evening, Chloe happened to hear the receptionist mention that there would be a Corpus Christi procession at the church next door. We had noticed that people were drawing stencilled outlines in the lanes, and by 5 p.m. the streets were full of quite remarkable flower patterns. They were mainly abstract, and every part of various types of flower, as well as grass clippings, coffee grounds and sawdust, had been used as blocks of colour to fill in the designs. Outside the church, a group of men in shiny black suits were clutching musical instruments and dragging on cigarettes as if their lives depended on it — everyone smokes in Tossa, even the dogs.

We went into the church and observed the end of the Mass, then drums sounded, cigarettes were extinguished, tiny children quickly changed into white dresses and boys into little suits, and, clutching bunches of white flowers, emerged from the church. Older boys carried long dripping tapers of candle wax, the band broke into what vaguely resembled a tune, and the procession launched itself into the lanes. They were followed by the elderly priest, plus another bearing the monstrance that carries the wine and wafer symbolising the blood and body of Christ. They tromped through all the flowers around and around the town until not a single design remained and every building, human and animal considered themselves blessed. Two hours later, the streets were spotless.

It was only when I returned to Tossa the following year, and an obliging guide asked questions on my behalf, that I discovered that Casa Johnstone still exists, much as it looks in those early photographs but surrounded by the tennis court and swimming-pool complex of the sprawling Don Juan Hotel. Thinking that they would hardly doubt a sweet little silver-haired art historian with only a shaky grasp of Spanish, I asked for permission to visit at the front desk, and the kindly but rather

Fig. 58 *Spanish Landscape in Orange, Brown and Green,* c.1936, gouache on paper.
Private collection.

CLOCKWISE FROM TOP Tossa scenes: The band waits for the start of the Corpus Christi procession; a street decorated for Corpus Christi; Casa Johnstone, which Hodgkins included as 'that white note' in *Spanish Landscape in Orange, Brown and Green* (Fig. 58).

bored gentleman waved me towards a set of escalators that whisked me out of the hotel and up the hill, and there it was.

Wearing my most confident face, I walked briskly inside as if I had forgotten my towel or tennis racquet, and discovered that the interior also appears unchanged. The hotel was built on three floors at the back, but with only two facing the bay, creating the stepped effect seen in *Spanish Landscape in Orange, Brown and Green*. The rooms are not large, so perhaps they accommodate those who can't afford the opulence below. The main door, beneath the first-floor terrace, is reached across sandstone crazy-paving, the bank with its date palms and prickly pears rising sharply to one side. Hanging on the wall is a black-and-white photograph taken from that vantage point in 1936 and showing a line of fishermen's sheds along the beach.

H odgkins' move to Can Kars never eventuated. Sometime in January 1936 she was collected by her good friend Ree Gorer in her car, and for the next fortnight they drove up through the wild region north of Tossa known as L'Empordà.

Ree, born Rachel Alice Cohen, had married Edgar Gorer at Hampstead Synagogue in 1902, and had studied sculpture at the Slade School of Art, which had accepted both male and female students from the time it opened in 1871. While it would seem that Ree gave up active work as a sculptor at the time of her marriage, she maintained an exceptionally keen interest in contemporary art throughout her life, and was patron to a number of artists, including Hodgkins, whose works she acquired from 1930 onwards. Ree's husband, Edgar, had been an antiques dealer in both London and New York and died tragically when the Germans torpedoed the *Lusitania* as he was making his way back to London in 1915. The Gorers' three sons, Geoffrey, Peter and Richard, all made their mark in the fields of science, medicine and horticulture, but tragedy struck again when Peter, a brilliant immunologist, died young of cancer. Geoffrey became

Ree Gorer's sons Geoffrey, Richard and Peter photographed in 1950 at Abbey Lodge, London, where their mother lived until her death in 1954. Behind Geoffrey's head is the lower portion of Frances Hodgkins' *Private Bathing* (Fig. 59, page 296), which they owned until 2003.

a writer and social anthropologist, and Richard wrote and edited books on gardening. Each, in their own way, were loyal supporters of Hodgkins.

There is only one reference to the trip through L'Empordà in Hodgkins' extant letters. In this she describes stopping in the elegant little city of Girona to post off nine gouaches to her dealer, Duncan Macdonald. Today Girona has expanded rapidly, serving as a hub for the villages scattered along the coast as well as for trains and the nearby airport. A little off the tourist track, the city centre is delightful, the colourful buildings rising up over the river that runs through it. Their colours are stronger than the rosy pinks and greys of Venice, with glassed balconies allowing shelter while allowing residents to enjoy the comings and goings on the river.

You still get a sense of old Spain here, and the shops are of the sort that have long disappeared in larger cities. We found one, dedicated to thousands of different types of hair clips, ribbons, miniature toys and other haberdashery items, which proved irresistible. The streets in the historic quarter are lined with broad arcades that protect the townspeople from sun and rain; the area retains its high walls, and it has an outstanding cathedral and stately gothic ruins containing the wooden frame from a cathedral rose window, standing like a sculpture in the empty nave. Although Hodgkins painted a work about the journey, *Road to Girona*, cities were not her favoured subject matter. Once her works were posted back to England, she and Ree Gorer returned to the coast and its rugged mountains.

The morning after the celebration of Corpus Christi, Chloe and I set off for Cadaqués, a small town on the coast. Hodgkins' only mention of Cadaqués was in 1933, when she recommended a simple local hotel, Fonda Marine, to an unidentified friend of Dorothy Selby: 'It is just over the Frontier — from pt Vendre & a very good place for painting — & cheap from 7 pesetas — good for Easter and the

ABOVE View of cypresses from Girona's ancient city wall.

BELOW The romanesque cloister of the Cathedral of Saint Mary of Girona.

summer months — I have a friend there now — She loves it — But she is a bather before a painter & that counts in that blistering sun — I have heard the heat in Ibiza now described as African torture.'[11] A number of the gouaches deriving from her holiday with Ree Gorer contain clues that, once unravelled, gave us a clear idea of where they visited.

As a respite from hotels, I had booked for Chloe and me what looked to be a new apartment. However, try as we might, we couldn't find it, and no one, including the local policeman and policewoman, eager to help though they were, knew where it might be. We were finally sent off around the left arm of the bay, lugging our suitcases in the 31-degree heat, and eventually a barman pointed up a very steep, narrow lane, known locally as a rastell. At this point I thought Chloe might throw herself in the harbour, but fortunately our accommodation proved to be halfway up, rather than at the top of the incline, and we were immensely relieved to find ourselves in a modern, well-appointed space with everything we needed for a three-day stay. I gave Chloe the master bedroom, although she was disappointed that the view of the sea was blocked by the building opposite. I took the bunk in the back room, reasoning that if *I* managed to tangle my hair in the wire wove above me when I sat upright, given her height she could be trapped for eternity.

I fell in love with Cadaqués, not least because of the way it nestled into the bay, with the church rising up above the cluster of white buildings below. During the Spanish Civil War about a third of the inhabitants fled to Cuba, but returned with enough wealth to build a number of quirky houses. Casa Blava (Blue House) is perhaps the most eccentric, with its mismatching turrets either end and every window and door edged with pale-blue tiles. In fact tiles are a feature of the town, each old street marked with a maiolica depiction of a saint to protect its inhabitants. And there is a sophisticated edge to the place, with very good restaurants tucked in among those selling simpler fare.

Cadaqués had been the childhood holiday home of Salvador Dalí (Pablo Picasso and many other luminaries also stayed in the town). Dalí

CLOCKWISE FROM TOP Cadaqués scenes: Cadaqués viewed from the bottom of our rastrell; returning from the supermarket; the giant plaster egg on the roof of Salvador Dalí's summer house at Port Lligat.

moved over the hill to Port Lligat, buying a tiny barraca, or fisherman's cottage, on the right-hand side of the bay for himself and his wife, Gala, only after his father, who didn't approve of the match, made it clear that he was no longer welcome. While Dalí grieved for his beloved home — the rock formations of the coast are included in a number of his paintings — his father must have been irked to know that his errant son was only 25 minutes away in the next bay. Over the next 40 years Dalí acquired a cluster of tiny cottages, combining them into the curious, higgledy-piggledy house that you can visit today.

Walking over the hill, Chloe and I paused at the simple fishermen's chapel containing two modern primitive metal saints resembling works by Giacometti, and a crucifix shaped out of a long bow. We were pleasantly surprised at how endearing and domestic Dalí's house was. We both noted the tiny wire cage in his bedroom in which he kept a cricket so that he could listen to it chirping during the night; no doubt when it finally expired there were plenty of others to take its place. The house is a paen to surrealism, overlaid with exotic feminine interventions introduced by Gala. The twin iron beds have tailored cerise and blue bedspreads, with a large matching padiglione, or canopy, draped above them.

The house stands on the wrong side of the bay for the morning sun, so Dalí had a large mirror set up on the wall opposite so that he could study the changing light at sunrise, glancing across the glassy sea from the comfort of his bed. Paintings are hung among ephemera — a stuffed bear leans at an angle at the bottom of a set of stairs, and the artist's favourite (stuffed) swans stand on a bookcase over the fireplace, their wings spread is if about to take flight. The books are bound in plain paper of different tones, creating a soothing effect.

The garden is intriguing. A great stone figure made of found materials lies among the olive trees, and frothy masses of the palest pink geraniums tumble over a whitewashed wall. The place was completely liveable, although what the locals thought of its giant egg sculptures and the

theatrical goings-on for which Dalí was famous can only be surmised. As surreal as his artworks, Dalí loved dressing up and having characters parade through the garden in fancy dress.

On our way to Cadaqués Chloe and I had had to change buses at Figueras, where we visited the rather hideous, egotistical Dalí Museum. We pushed through the mass of tourists to the tiny room at the top which includes Dalí's own little collection of Old Masters, the museum's saving grace. I much preferred the private to the public Dalí. Hodgkins didn't approve of the surrealists, possibly finding them too self-indulgent, and while some of her later paintings have certain surreal qualities, they stem from her rearrangement of motifs rather than from her subconscious. Yet you have to admire an artist who so determinedly followed his own desires. A bronze figure of Dalí leaning insouciantly on his cane stands on the pebbly beach, gazing back at the town in Cadaqués. You can't help wondering if his father was still alive when it was installed . . .

The changing palette of Hodgkins' depictions of this region maps the terrain she encountered as she and Ree Gorer were driven further north: the dusty, dry, pink and lilac tones, with sudden blushes of soft blues and browns found in the scrubby bushes known locally as maquis — including erica, some sort of heather, and broom in the vegetation clinging amid terraces of olive trees and great clumps of prickly pears.

Two gouaches — *Ruins, Cadaqués* and *Private Bathing* (Fig. 59), in which a series of arches linking two promontories of land is viewed from some height over a sea of prickly pears — were the key to our search. Hodgkins showed the sea beyond dotted with islands, a squat lighthouse visible as a whitish smudge on the island furthest to the left. Her chauffeur must have stopped briefly at a high vantage point before winding down to Cadaqués; once the car engine had been turned off, the only sounds would have been the wind and the cries of birds, or perhaps the bleating of wild goats, a welcome change from the bustle and gossip of Tossa de Mar, and just the tonic Hodgkins needed to lift the spirits and sharpen her visual acuity.

I had wondered whether the arches were those excavated at the Greek

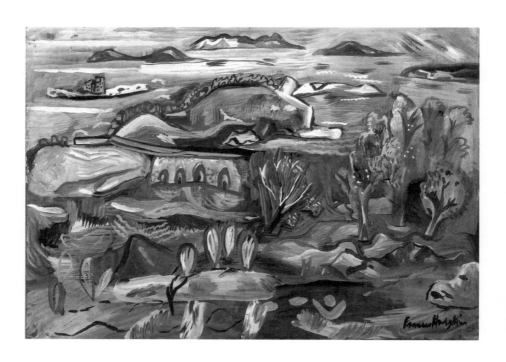

Fig. 59 *Private Bathing*, c.1935–36, gouache on paper. *Private collection.*

(later Roman) ruins of Empúries, south of Cadaqués, so Chloe and I got up early in the morning and took the bus over the hill to Roses and on to L'Escala, before walking the brief distance to the site. Certainly the arches were similar in shape to those Hodgkins had painted, but they were Romanesque rather than gothic in shape, and set deep within a wall, so the perspective was completely different from what she had depicted. However, the next day, when I showed my images to the young woman selling tickets for boat trips from a booth on the beach, she once again 'got it', saying that it was Cadaqués' very own Roman bridge that linked the mainland to a small island. We would see it if we walked around to the far side of the bay on the right.

Both *Ruins, Cadaqués* and *Private Bathing* are examples of Hodgkins' composed painting rather than a topographical view: the islands known as the Illes Medes are no longer anchored out from Estartit, but have been floated along the surface of the sea to rest opposite the nearest bay to Cadaqués. *Ruins, Cadaqués* was almost certainly the first of the two, given that the sea in part is a startling emerald green and the arches of the bridge more curved. In *Private Bathing* the road leading off the bridge is painted with much greater firmness and clarity, and the palette is in the softer tones of *Hill Landscape* (Fig. 60). The four arches of the Roman bridge, however, can be viewed only from within the bay of Cadaqués itself, not from the hills behind. Hodgkins has woven the motifs together to create a memoir, so pleasing and much richer than a postcard or a photograph that captures only a single place in a single moment.

One of the reasons I made a return visit to Europe in 2016 was that I had ascertained in the meantime that Hodgkins had continued travelling up the coast, and that *Hill Landscape* was painted further north, on the far side of Cap de Creus, one of the national parks of outstanding wild beauty on the coast. The drive is still precipitous in parts, winding down to Port de la Selva, another fishing village in a

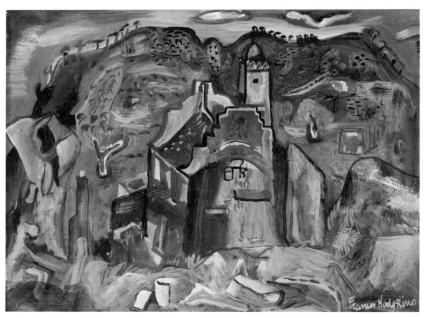

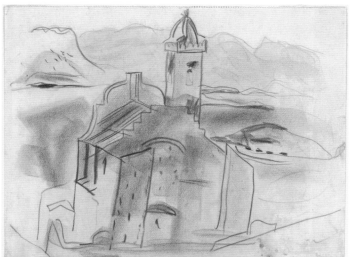

ABOVE **Fig. 60** *Hill Landscape*, 1936, gouache on paper. *Private collection.*

BELOW **Fig. 61** *Untitled [Santa Maria de la Neus] [Sketch for Hill Landscape]*, c.1935–36, graphite on paper. *Museum of New Zealand Te Papa Tongarewa, purchased 1998 with New Zealand Lottery Grants Board funds, FH1112.*

broad bay, beneath the towering Monastery of Sant Pere de Rodes at the top of the mountain. The monastery stood in ruins in 1936, but is now beautifully restored and worth the drive up the mountain, provided you have a steady hand on the steering wheel and you're not afraid of heights.

Below in Port de la Selva, the church, Santa Maria de la Neus (Our Lady of the Snows), rises up above the surrounding houses in the village. Its façade is graced with a curving baroque gable, and an immediately identifiable square bell tower topped by a visor-like dome. Much of the village is tucked up against the hill, and as I wandered its narrow lanes searching for the same vantage point that Hodgkins used, the nearby bulk of the church, its walls radiating heat, provided a comforting feel.

I discovered that once again the finished gouache differs greatly from an initial sketch made by Hodgkins on the spot, which captures the outline of the church against the broad sweep of the bay and the mountain beyond (Fig. 61). In the painting, Hodgkins plays with the composition, turning the church away from the bay so that it faces the hill behind. I had been perplexed by the rear façade of the church in her composition, because it shares a version of the stepped gable rising above the roof line beside the bell tower. Today the building looks very different from behind but, as Antoni discovered, it has only recently gained a contemporary brick structure that replaces the parts of the rear that were blown off the back of the church during the civil war.

A further work, *Private Bathing Beach*, is a rapid gouache sketch in a brighter palette, suggesting it was done in situ, compared to the softer tones of the larger finished gouaches that needed time to complete. On her return to Tossa, Hodgkins wrote to her dealer: 'I scribbled a line to you from Gerona when sending off my paintings. Now I am back again in Tossa finishing a second lot ready to follow in a few days' time. This will complete my winter's work. There will be a few I hope that will appeal to you. May I suggest that you await to see the full set, series, suite before making up your mind about them. You will see that I have put a large amount of Frances Hodgkins into them, even into the joyless marrows,

and I do hope that you will not say this woman's work is not worth a penny a day to me. I am sure you will realise that I have had to adapt myself to local conditions & do the best I can. I defy any one to paint lovingly & buoyantly through a Spanish winter, or be incited to imaginative heights.

'The Water Colours I intend for you, are still in embryo, and may remain so for some long time yet if this cold weather continues. I have just returned from a few days motor trip & feel very fit & fresh & rested and almost recovered from the shock of the malicious abhorrent & hateful woman's [Lucy Wertheim] (you wrote of) Show of my early work. She is a d-d nuisance. It leaves me with a blank outlook as regards my real show with you for I suppose it wont do to have another one, at any rate till the Autumn. What do you feel about it? It must have annoyed you.'[12]

She added, 'I shall be moving on from here at the end of the month on the long trail homewards. Quite happy to leave Spain feeling as I do all the time that my spirit is out of place. There is a nice Spanish Proverb which says "If you desire to bring back the wealth of the Indies you must take with you the wealth of the Indies" — in other words nothing for nothing. I was lucky to see a Picasso Show in Barcelona (good) a most purifying experience. All my energy was torn from me — (Bad).'[13]

On my first visit to Barcelona to meet Antoni, I had been fortunate to see an archival exhibition of the show to which Hodgkins' letter refers at the Museu Picasso. Picasso had been determined not to exhibit his works in the city of his youth until such time as its citizens would appreciate his painting. None of the paintings he selected from Paris to go in the show were included in the exhibition I saw, but the catalogue included reproductions of them all.[14] The majority were from his cubist period in Paris, with only a small selection from the early 1930s. Hodgkins would have been transported back to her own heady days there, when cubism first made its mark on the avant-garde.

Sometime after leaving Tossa, Hodgkins stopped for two days in

Hyères in the south of France, before moving on to Bormes-les-Mimosas, east of Marseilles, to see an optician. She noted in a further letter to Duncan Macdonald that she had tried going back to Spain, but when she did she found the 'dazzle beastly & the winds more so, so after one good long look to right & to left I decided I had had enough'.[15] She was now in her mid-sixties, and time was starting to take its toll on her eyesight, yet her painter's eye had never been stronger. One of the gouaches from her time in Tossa that she showed at the Lefevre Gallery, *The Road to Barcelona* (Fig. 62), was described by the *Sunday Times* critic Eric Newton on 17 December 1939 as one of the highlights of an outstanding exhibition. In particular he praised its 'colour which made everything else in the room look pedestrian and tentative'.

Hodgkins' early departure from the Costa Brava meant she missed the British Royal Navy destroyer that pulled into the bay in Tossa to evacuate English residents prior to the outbreak of civil war on 17 July 1936. The war turned friend against friend, family against family, and destroyed much with which Hodgkins had been familiar. Many foreigners fled. Archie and Nancy Johnstone refused to leave, turning their home into a refuge for Spanish children and then walking them over the Pyrénées to France, where they were placed in refugee camps.

The writer Robert Graves and his partner Laura Riding were among those driven from Majorca when the fascists rose up against the left, taking control of the Balearic Islands and 12 other provinces of Spain in just four days. According to Graves' nephew Richard Graves, all the radio stations were closed down, creating a sense of isolation and fear; no one knew what was happening outside their immediate locale. In early August 1936, Graves and Riding were picked up by the same British destroyer that called into several of the Balearic and Costa Brava ports to collect those who had been advised to leave.

Graves and Riding eventually returned to London, where they were put up by Katharine (Kitty) West, one of Hodgkins' friends and supporters, who lent them her apartment at 32 York Terrace in Regent's Park. Having

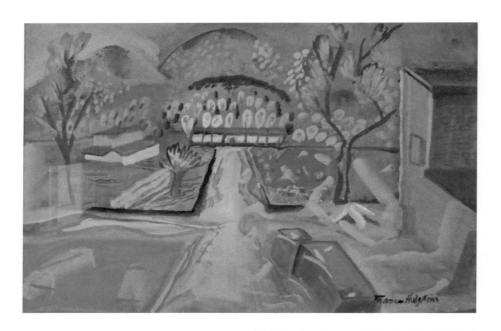

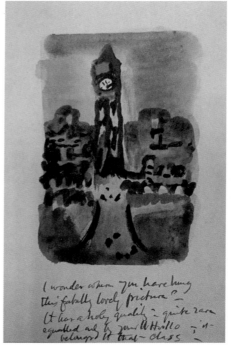

ABOVE **Fig. 62** *The Road to Barcelona*, c.1936, gouache on paper. *Private collection.*

RIGHT A hand-painted postcard sent to Ree Gorer by Frances Hodgkins from Cadaqués, influenced by a painting by Utrillo called *Road to Emmaus*. Hodgkins went on to paint *The Road to Barcelona*, casting a secular take on a religious subject, having recently seen an inspiring exhibition by Picasso in that city. The text reads: 'I wonder where you have hung this fatally lovely picture? It has a holy quality and is quite rare, equalled only by your Utrillo — it belongs in that class'.
University of Sussex Library.

lived for so long in a Spanish village that was stimulating and exhilarating, yet also relatively primitive, Graves marvelled at the palatial environment in which he now found himself, with its hot baths, maidservants and the ability to make a telephone call at will. He would not have seen works by Hodgkins in the apartment; West didn't acquire her still-life painting or the double portrait of her and her husband, Anthony West, until 1937.[16]

But we know that Hodgkins did have contact of a sort with Robert Graves: in 1942 she stayed for a fortnight in the house in Brixham, Devon, where he had taken up residence for the duration of the Second World War. Hodgkins wrote later to her friends, the photographer Douglas Glass, who worked for the *Sunday Times* for most of his career, and his wife Jane, who were staying nearby, asking them to thanks Graves for his kindness.

21

London

ENGLAND

ondon was a hub that Frances Hodgkins passed through; she stayed there at various times throughout her life, and exhibited and shared the company of friends and supporters there, yet she never felt quite at home. She had first arrived in London in April 1901, the year that marked the transition from the Victorian to the Edwardian era after the death of the Queen. She missed the state funeral, but there was still a pall of mourning over the city. Years later she credited this experience with her development as a colourist, because you had to get down to black to find colour.[1] The Apollo Theatre and the Whitechapel Gallery had just opened, and the seeds of a modern city were emerging, although it would be many years before London could earn such a title.

The city was smelly (horse-drawn trams were still in use) and the drains most certainly hadn't been modernised, and when the wind failed to blow a soot-stained complexion was all too common for those who could not afford private transport. Also evident were the class divisions between rich and poor, even as the striving middle class, which had emerged in the mid-nineteenth century with the expansion of industrialisation, cut a swathe in between.

Hodgkins' ideas about the city had been formed by the novels and London newspapers she read at home in New Zealand, and from the 1889 New Zealand and South Seas Exhibition in Dunedin, where she would have seen a display of British art. Some of it was acquired for the Dunedin Public Art Gallery, which her father had helped establish in 1884.

Her first arrival in the city was not propitious. As she described to her mother: '[N]o wonder one's first impressions of London are disappointing, it was a thick yellow fog and pouring in torrents as we steamed up the Thames and we threaded our way slowing thro' all kinds of craft, the bright brown sails of the barges making ripping pictures against the pea soup back ground. Then the long weary wait at the Docks and the long train journey up to London thro' forests of houses and chimney pots with peeps of very sordid humanity.'[2]

London could be formidable for women travelling on their own, not

least because of its size, but if you had the money or introductions to the right people there were certain havens of comfort, and she was lucky to be scooped up by the Spences, old family friends from Dunedin, and put to bed for a week, as she was very frail. Effie Spence had decorated her bedroom so it would look cheerful when she arrived, and once Hodgkins was on her feet she took her around some of the galleries. Hodgkins was, however, rather disappointed by what she saw: '[T]he New English Art Club in Piccadilly — such daubs . . . the R.B. Artists . . . better tho' I was much surprised at the average standard of work . . . Most of the modern watercolors are tremendously worked up, miniature work seems to have influenced the style and it is quite a relief to see crisp unworried looking canvases.

'Some work I saw by a man called Proctor I was tremendously taken with and I asked the Sec. about him & if he took pupils, it was beautiful work, figure in landscape and just what I wanted both color and style but alas he didn't. Here was a little side room quite like our own Chamber of horrors at the O.A.S. [Otago Art Society] with some dreadful potboiling atrocities altogether, I came away not particularly impressed with the R.B.A.'s [Royal Society of British Artists].'[3] Ernest Proctor was an impressionist painter who had studied in France, so her comments suggest a sense of the direction she was determined to follow, even at that early stage.

In 1902 she returned to London from Penzance, where she had visited Newlyn and St Ives. It was the coronation of King Edward VII and accommodation was at a premium. Before she left Cornwall she wrote in high spirits to her mother: 'I am going to share Miss Robertson's doll's house flat with her in Chelsea for such time as I am in town. It will be a bit of a squeeze but women can always manage when there are no men around. There is only one bedroom & that Miss M. Cargill inhabits Miss R. therefore sleeps in or under the kitchen table — I am to be coyly & chastely tucked away behind a curtain in the drawing room — said curtain during the day cunningly converted in to an armchair or a bath or a coal box or

something I forget which, anyhow we are going to manage somehow & all that is expected of me is to tread carefully — bring as little luggage as possible clean my own boots, have my breakfast in bed (so called) & the rest of my meals where I can get 'em — & (this is a point of honor) leave Miss R's armchair in the right hand corner alone which Miss R. claims for herself by virtue of being an old maid . . . Miss Robertson like other London landladys is making the most of her opportunities in Coronation week, but I fancy she is rather over crowding her rooms! However I will be very little there. I merely want headquarters & a safe harbourage for my luggage.'[4]

Arriving to a rain-sodden London, its decorations wilted and stained, she found the crowds overwhelming, although she enjoyed doing the rounds of the New Zealand community, either resident or visiting for the occasion. She was forced, however, to refuse some of the more formal invitations, as she didn't have smart enough clothes and couldn't afford to buy more at London prices — a familiar circumstance for much of her life. Hodgkins was relieved when she eventually left for France.

Hodgkins was to pass through London many times on the way to the Continent, visiting friends and viewing exhibitions. At the end of the First World War, in December 1918, she took a lease on a studio at Eldon Road in Kensington — a risky thing to do when finances were very tight. She confided to her mother: 'I long for something nice to eat. You can't think how stodgy & tasteless every thing shoppy is, you simply loathe it all & it causes such indigestion & nausea. I have had no milk nor butter since coming to London, I prefer the 5 ounces of margarine to the 1 oz of horrible butter, nor can I get my clothes washed no laundry will look at a new customer, so dear, I have been very over worked & weary . . . washing, cooking, charring, painting, teaching & going out to tea & dinner . . . In between the acts I get some painting done, but very little — you can't get any help at all. Women ask £1 a week just to light yr

fire — the coal question is fierce. I have struggled along with a smoking stove & insufficient coal till I am desperate now I have decided to make a clean sweep of the stove & get a gas one instead & make my landlady go halves . . .

'One gets so tired at times & the spirit flags & fails & the thought of "going west" has no longer any dread for one, only a promise of rest & deep peace which this earth does not give. I try to believe in Success & have nothing to do with Despondency but it is not so easy as it sounds . . . The crowds in the trains & buses are so great it takes nerve to face them. I have already had my handbag & ration book & purse stolen & I can tell you it is no joke losing yr ration book these days. I am for ever coming or going to & from the Town Hall in Kensington getting emergency cards, what time I recover my book — wh I <u>never</u> shall. Finally I shall get a new book but only when about 900 slips & counter foils & yellow green & pink pages are forthcoming testifying to my identity & honesty.'[5]

Hodgkins' paintings had sold well at an exhibition at Anthony Horden's gallery in Sydney in October 1918, but having borrowed money from her old friend Judge Rich to cover the usual costs of freight and framing, she now had to settle her debts and she was anxious about the reviews in the Australian papers, which friends sent her clippings of: 'I wish the papers wouldn't make me out a sort of freak artist. I am really a very sober minded thoughtful sort of person with nothing slapdash or offhand about my work. Every stroke I put down comes from real conviction & is a sincere <u>aspect</u> of truth — if not the whole truth. If I can only live long enough the world will have to acknowledge me — I am horribly stubborn & I haven't lived these long years of privation & hard work for nothing.'[6]

In January she was snowed-in and the frozen pipes burst (a common enough occurrence in English winters), and though her studio was warmed by the newly installed gas fire, her bedroom was unheated. Hodgkins needed a warm studio for her pupils, but when the new gas appliance failed she had to eat humble pie and ask the man who had

taken it out to reconnect the coal fire. Things were rather bleak. She wrote to her mother: 'I went out to supper on Sunday night, the fog got thick, buses stopped & lined up, miles of them, & I was 2 hours getting home — groping my way. Talk of a foggy situation!'[7]

After developing influenza and bronchitis she threw in the towel and rented out the studio for six months to Cedric Morris and Arthur Lett-Haines before returning to Cornwall. The Spanish flu epidemic that struck Europe at the end of the war was partly spread by men coming back from the front by rail; as they fanned out from hubs like London onto regional rail they carried the influenza with them. Soldiers returning to countries like New Zealand were infected in the same way, so that parents who had sighed with relief that their sons had managed to survive until Armistice Day on 11 November 1918 might very well lose them anyway. Few parts of the world were immune, and the epidemic resulted in more deaths than by plague in the fourteenth century.[8] Because of her often cold and damp living environments, Hodgkins continued to suffer from bronchitis and influenza for much of her life, but fortunately for her (and for us) she escaped the Spanish flu.

Hodgkins exhibited works in group shows at a number of venues in London during her European career, some only once, and at others several times, including at the International Society of Sculptors, Painters and Gravers, which held its exhibitions at the Grosvenor Gallery, the International Society, the Royal Institute of Painters and the Royal Academy — where she had works included five times between 1903 and 1916. Although conservative, the Academy's cachet meant she got wider exposure than at some of the lesser venues. She had crowed to her mother in 1903: 'I know you will all rejoice over the joyful news that I am on the Line at the R.A. Tra-la-la-la-la! I enclose official statement in case you don't believe me . . . also had a 2nd one accepted but not hung — they accept about 1000 more than they can find room for. The one on the line

is a ¾ length of an arab girl more elaborate & more highly finished than my usual work. Mr Stanhope Forbes wired to Mr Garstin & he sent the news on to me. The latter, poor man, is out himself, at which he is very sad . . . We are going to the R.A. tomorrow, the first day. I did not get a ticket for the private view but I believe I shall get one for the Soirée later on.'[9]

It was a struggle, however, as exhibitions didn't necessarily equate with sales. Hodgkins was elected an Associate of the Society of Women Artists in 1908, and exhibited with them four times between 1912 and 1940, but her first one-person show was not until 1920, at the Hampstead Art Gallery. Professionally it was a success, but it did nothing to fill her empty coffers. Although she spent nine months in London that year, no works by her have the city as its subject matter, unlike the works done in rural and seaside environments. It wasn't until 1927 that she considered trying to reclaim a footing in the metropolis, having an oil portrait of two girls and a watercolour included in the New English Art Club. Even so, she knew she couldn't survive a London winter unless forced to, and she was back in Martigues by January 1928, in spite of having had the luxury of staying in Lucy Wertheim's elegant flat before leaving for the south.

A turning point was in sight. Arthur Howell at the St George's Gallery wrote to her asking for two watercolours for an exhibition. He showed four of her works in January 1928 while she was in Martigues, and she was now working frantically towards a solo exhibition of 48 works at Claridge Gallery in Brook Street that opened in May. It heralded a watershed in her career. She would have been particularly pleased by a review in *The Times*, whose critic wrote, 'In her own way she, too, like Cézanne, is engaged in trying to make of Impressionism something like the old masters', and praised her use of colour, among other things.[10]

And there were some amusing social occasions that were good not only for her spirits but also for her networks. These included 'an "End of the World" Party on Wed: positively Judgement Day dress', after Cedric Morris had had a hugely successful show and when Arthur Lett-Haines was about to leave for Paris. Morris and Lett-Haines had been enormously

supportive of Hodgkins when she was extremely hard up, and it was Morris who put her name forward in 1929 for the Seven & Five Society, which despite its conservative beginnings was now emerging as the face of the avant-garde. The society reformed itself every year, and Hodgkins showed five works in that first exhibition, bringing her into the ambit of fellow New Zealander Len Lye, as well as other emerging modernists, including Henry Moore, Ben Nicholson and his wife, Winifred, and Paul Nash. Barbara Hepworth first exhibited in 1933. All of these artists became the leading faces of modernism in England.

H odgkins spent five months in a studio flat at 34 Fitzroy Street in Marylebone from the middle of August 1928, and from there wrote to congratulate her brother Bert on his appointment as an electoral officer. As she noted, they had both been in the news. She sent him a cutting, commenting: 'It is about time they realise I exist and am doing something a little more significant than the usual ruck of artists who come to Europe — even if it is unpopular now people will in time grow used to the strangeness of my technique, a "handwriting" unfamiliar to them and therefore 'eave a brick at its 'ead! That is the present irritating attitude of the public towards my work. I have won my difficult way by sincerity it is the only test. The foe, of course, is debt, starvation etc and I have had the rottenest of times during the long struggle but I hope to survive.

'I have now got a Studio in London. It is in a Mews — mostly garages & 1 blacksmith, 1 vet: 2 artists beside myself — poor & very poor people in the neighbouring streets, mostly Jews & Italians, & a big sprinkling of Germans — I have never seen so many fat boys. The next big street is the sort of London Latin Quarter, a rival to Chelsea & Bloomsbury. One time the Rents were very low — now soaring to fancy prices. I give £80 for one room which does not exude comfort — indeed I doubt if I shall be able to winter in it. I can buy all my food in the little shops round about —

you can get anything from stewed eels to kippers! & lovely fruit off the barrows — but nothing is really cheap (nor as nice) as in France.'[11]

In November that year she became very ill with the 'internal ulceration' that had been the bane of her life since her first journey to England, but she was extremely fortunate to be treated by a doctor whom she described as 'a famous person on the Staff of the Women's Cancer Clinic & who has attended me for nothing. Naturally my earning powers have suffered . . . I have been too down on my luck to do any work and now winter has closed in & the days are so short & dark & sunless. One gets little chance with the brush. I am doing some textiles to make some money — not easy money and I am doing a design for the B.B.C. . . . for a book on textiles they are bringing out — no cash — only kudos.'[12]

Shortly afterwards she was able to report to her brother: 'I am having a little whiff of luck, even fame. I can even dare hope that the tide has at last turned in my favour. It appears an eminent art critic has been praising my work & has even asked if he may come & see me. And all because he is reported to have said that he considers me one of the great European Water Colourists (hope he was sober). I have sold: 1 oil 20 gns 1 water colour 7 gns 1 Drawing 5 gns and 4 different people have enquired after Water Colours and wish to buy. Friends are advising their friends to buy now while I am (comparatively) cheap — next year —!

'It is very cheering I can do with a bit of luck. I have had a rough time & my illness has been brought about by hard work & anxiety the struggle for bread has been formidable. I have had wonderful friends who have never lost faith in me. I have travelled far from the Academic tradition which fetters England & recognises no possibility of further revelation. There is now a growing increase of interest in the newer outlook & a change of attitude. I believe if you saw my present work you would find it very simple to understand. It has grown more & more simple & sincere.'[13]

The year 1930 proved eventful for Hodgkins. She had four works included in Lucy Wertheim's inaugural group show, which opened on 7 October at the Wertheim Gallery at Burlington Gardens — an important

milestone for Wertheim but one slightly overshadowed for Hodgkins by the opening two days later of her one-person show at St George's Gallery in George Street, less than 20 minutes' walk away. But Arthur Howell was less adventurous than Wertheim, and at first was prepared to show only Hodgkins' watercolours, as specified in her contract. She asked him to lend her oils to the group show, as he already had them in stock. Howell, realising he might be missing out, changed his mind and included some oils in his own exhibition as well.

He now presented her with another contract, in which he guaranteed to buy a certain number of her works every year but only at the price of £10 each. To be fair to him, this was a leap of faith, as Hodgkins was by no means the success she would become; even so, the watercolours were being sold at between £12 and £15, while the oils ranged from £30 to £45. It was hardly a good deal for Hodgkins. After fretting about the contract for some time, Hodgkins eventually signed it and pre-sold all the works in the show. Arthur Lett-Haines and Cedric Morris were absolutely furious on her behalf.

Geoffrey Gorer felt similarly about the later contract she signed with the Lefevre and Leicester galleries; once she had paid all her expenses, she had very little left to live on. On paper it looked rather grand — Lefevre gave her £200 a year in return for 48 watercolours and gouaches — but again the gallery reserved the right to choose those they liked, and if it didn't match her quota she had to turn around and produce more. This caused her much distress.[14]

On my first Hodgkins research trip to London in 2015, I went to visit Toby Clark, a young relative of Maude Burge, with whom Hodgkins had painted in St Tropez and Ibiza. He lives a block away from 40 Belsize Park Road, where Hodgkins stayed in 1932 after returning from Bodinnick in Cornwall. She wrote to Dorothy Selby: 'This is a marvel Flatlet, the whole house is electrically run — seems sur-charged

Frances Hodgkins (right) and Dorothy Selby photographed in the garden of Geoffrey Gorer's home The Croft in Bradford-on-Tone in the 1930s. *E. H. McCormick Papers, E. H. McCormick Research Library, Auckland Art Gallery Toi o Tāmaki, gift of Linda Gill, 2015.*

with power — very high power. I feel rather un-canny. Kettle boils as you put the plug in — bath ditto. Everything bright clean & labour saving but of the food — poisonous!'[15] The next morning, before sending the letter off, she added: 'Monday morning. Feel a wreck & unfit for work. Ben & Barbara came in last night 9-45 — stayed till midnight — too much joy for me. Winifred going to Paris to see Picasso Show. Ben returns to Cornwall & mind the babies.'[16]

Separated from Winifred Nicholson but still involved in raising their children, Ben Nicholson was now working with his new partner, Barbara Hepworth, in adjoining studios in Lawn Street, very close to where Toby Clark lives today. While in Bodinnick, Hodgkins and Winifred had spent time together discussing personal matters. Inevitably Winifred felt spurned by her husband, and this may have opened old wounds for Hodgkins, given her own failed engagement so many years before. Ben Nicholson never knew that she was critical of his new arrangements.[17]

Hepworth may have been more aware of it, though. In the June Opie recordings made at the centenary of Hodgkins' birth in 1969, Hepworth intimated that they had only met once or twice: this doesn't appear to be quite accurate. In 1933, when Hodgkins returned from Ibiza to Lambolle Road, a street running parallel to her earlier address in Belsize Park Gardens, she noted in a letter to Dorothy Selby: 'I am all alone in my Studio that is with 2 deserted cats who share my fishbones — absolute stillness: I have really got down to work & have finished the bulk of it. I have not seen a soul for days — Barbara stole softly to the door this morning to ask me to supper tonight to meet Herbert Read Poet . . . Ben is with Winifred. On his return he & Barbara go to Dieppe there to meet Bracque [sic] & persuade him to have a Show in London.'[18]

You sense that Hodgkins wouldn't have disapproved of the relationship on moral grounds but rather that she empathised with Winifred, who was determined to make her way as an artist even though she had family responsibilities. Hodgkins' friend Douglas Glass felt she had an admirable ability to make friendships with younger people in particular. In 1969

June Opie described him as a dynamic man, rooted in rebellion, a man of intellectual vitality and passion: 'Frances,' he said, leaning forward, emphasising her name, was 'one of the persons in the world I'd say I love, in the deepest . . . deepest sense possible. In some funny way, perhaps, I could say I loved her more than my wife in another category — in another department of love. But she had that capacity to . . . give a terrible lot, without appearing to give. She said, "Douglas — just don't be afraid," because I was afraid, you see. I used to lie like stink about everything. It was the only way I could tackle life, really. And it was people like Frances — she was earlier than my wife — who somehow, by their own conduct the very way they lived, showed me that . . . there's nothing to be afraid of. There's, really, nothing to be afraid of. And shortly — you know, after a time, you feel safe in that area with this person. And affection grows out of that. She never moralized at all. And having been brought up in a moralizing atmosphere this is very precious to me.'[19]

Toby very kindly walked me around the neighbourhood, so I could get a sense of distance between the streets in which they had all lived. I was thrilled to see the Isokon building, which was under construction over the fence at the time Nicholson and Hepworth were working in their studios in Lawn Road. Its white exterior, each floor dominated by a heavy balcony wall running the length of the building before rising up to the next floor, was considered a perfect example of minimalist living, and the building had the great advantage of having a bar on site, one that was frequented by Nicholson and Hepworth, as well as Henry Moore, until he severed contact with Nicholson after an art quarrel. It was a shining beacon of modernism in Victorian and Edwardian London, and in its early years its residents included the Bauhaus architects and designers Walter Gropius, Marcel Breuer and László Moholy-Nagy, as well as the crime writer Agatha Christie, among others.[20]

odgkins continued to move to and from London, never settling although inevitably drawn to the city for her own exhibitions and to view those of friends and fellow artists. She wrote to Dorothy Selby from Worth Matravers in Dorset in 1938, exhorting her to see the exhibition of Picasso's *Guernica* and related studies which were displayed first at the New Burlington Galleries in October and afterwards at Whitechapel Gallery: '— you may hate it — but at least go & see it.'[21]

In the latter part of the 1930s she almost invariably stayed with Ree Gorer in her home The Elms in Highgate, near Hampstead Heath, rather than in paid accommodation, but even then only for relatively brief periods. Gorer's extremely comfortable home was a haven for artists and intellectuals, and proved a welcome respite from work. Ree Gorer's son Geoffrey probably met Hodgkins for the first time in 1929 at a party in London given by Cedric Morris and Arthur Lett-Haines. He and his brother Richard gifted *Wings over Water* (Fig. 40, see page 204) to the Tate in memory of their mother in 1954. And of course Geoffrey provided a refuge for Hodgkins at The Croft, the cottage he acquired at Bradford-on-Tone in Dorset, not far from Corfe Castle.

One place Hodgkins would have looked (and possibly felt) quite at home was the Sesame and Imperial Club for Women in Grosvenor Street. She first recorded lunching at the Sesame (as it was generally known) in October 1902 with Miss March Phillips, who showed Hodgkins her sketches. Phillips had joined Hodgkins' group the month before at Dinan, at a time when fellow students were fleeing the ever-pouring rain that prevented them from working out of doors. On that occasion Hodgkins was more impressed by the fact that Phillips' brother had had extracts of his book on the South African War published in the *Spectator*.

Phillips was much taken with Hodgkins' work, and suggested they share an exhibition together in London, with Phillips covering all the costs. Hodgkins was tempted, even if she thought that Phillips' watercolours were distinctly inferior, but she was wary of being trotted out as the New Zealander with talent, as if she was 'a pink eyed albino or a double jointed

negress — or something that will prove attractive and draw crowds'.[22]

Phillips also invited her to travel to Sicily — the one place guaranteed to be warm enough for a comfortable winter stay — but Hodgkins, who never held back in her acidic comments about people she didn't entirely like or trust, was dubious about whether she could cope with being with such a non-artistic person for so long, though Phillips was a good friend to her and 'a most capable business like woman'.[23]

The Sesame Club was invaluable for single women wishing to host soirées on neutral territory. Poet, novelist and journalist Hubert Nicholson described it at the time as having 'a dark red narrow frontage with black marble pillars, but inside was large, rambling and old-fashioned with windows that looked out on an enclosed court with flowers, a statue and a fountain . . . its corridors haunted by dowdy peculiar ladies with inquisitive eyes, wandering about clutching glasses of sherry'.[24]

One of the club's long-term residents was poet and critic Edith Sitwell, with whom Hodgkins had friends in common. After meeting Sitwell at Ree Gorer's house in 1938, Hodgkins wrote to Dorothy Selby: 'The presence of Edith Sitwell is always rather discomfiting. She can be so black & sinister looking.'[25] How I wish there existed a painting of the two of them, Hodgkins with her striking outfits which happily combined various colours and patterns, rather like her paintings, and the elegantly severe Sitwell hovering over her like some kind of ravenous bird. Hodgkins and Sitwell would meet up again. After the opening of what was to be a very successful solo show at Lefevre's in April 1940, Hodgkins and a group of friends retired to 'Edith Sitwell's club', where they drank White Ladies, a potent cocktail of gin, triple sec and lemon. No sherry for them! Hodgkins described the evening to her brother William: 'Very entertaining. Plenty of . . . people to talk to & some very pretty dancers from the R. Ballet. Prim & almost unrecognisable in their ordinary day clothes, definitely of another world.'[26]

The young writer Denton Welch was summoned to lunch at the Sesame with Sitwell in April 1943. In his journal, he described how he

had arrived in vague terror that he might not recognise her, but need not have worried: 'Then the tall figure dressed all in black, black trilby, Spanish witch's hat, black cloak, black satin dress to the ankles and two huge aquamarine rings. Wonderful rings on powder-white hands, and face so powder-pearly, nacreous white, almost not to be believed in, with the pinkened mouth, the thin, delicate swordlike nose and tender-curling nostrils. No hair, I remember no hair at first. The rings, the glistening satin, and the kid-white skin.'[27]

Other friends and supporters that Hodgkins and Sitwell had in common included National Gallery director Kenneth Clark, who owned three of Hodgkins' gouaches; composer William Walton; Henry Moore and his wife, Irina Radetsky; and the artist John Piper and his young wife, writer Myfanwy Evans. The Pipers eventually brought their friendship with Sitwell to an end when in 1955 she committed the unforgivable sin (as staunch Anglicans saw it) of converting to Catholicism. Sitwell had asked novelist Evelyn Waugh to serve as her godfather and they kept up a correspondence, Waugh writing the same year: 'I know I am awful. But how much more awful I should be without the Faith . . . I heard a rousing sermon on Sunday against the dangers of immodest bathing-dresses, and thought that you and I were innocent of that offence at least.'[28]

Another friend described how in a stage performance in New York, Sitwell glided across the room like a high altar, rich fabrics and jewels gleaming — somehow fitting for someone who abandoned the modest embellishments of the Anglican Church for the glowing altarpieces, embroidered chasubles and incense censors that are an essential part of Catholic ritual.

In 1939 Hodgkins was invited to send a work to the World's Fair in New York. She refused to select this herself, insisting to Dr Honeyman, one of the dealers at Lefevre Gallery, that she would 'very much appreciate the courteous suggestion of Sir Kenneth Clark, and, of course, yourself

in suggesting that I should indicate a choice but I would rather leave it to you, if I may, as I distrust my judgement when it comes to giving an opinion of my own work. Pictures, once painted, are forgotten or, at least, cease to interest me much and I am all for the latest newly conceived which I invariably consider my life's greatest masterpiece.'[29]

Hodgkins had left the Seven & Five Society in 1935 after they voted to become purely abstract, and it is revealing that in the *London Bulletin* of January–February 1939 Henry Moore was described as a surrealist, Oskar Kokoschka as an expressionist, Piet Mondrian — who Winifred Nicholson brought to London that year — as constructivist, John Tunnard as an abstract artist (in fact he also fits in the surrealist camp), and Frances Hodgkins as an independent, an accurate description.

Other English modernists were constantly battling over the right 'ism' to follow, but Hodgkins kept her head down and followed her own path, sometimes weaving certain surrealist elements into a partially abstracted tapestry of motifs. John Piper wanted to place her among the neo-romantics, an approach to which he became dedicated after rejecting the move to abstraction by Nicholson, Hepworth and others. But even then Hodgkins doesn't quite fit the bill, as it is hard to place her domestic barnyard detritus and collapsing sheds in the same category as Piper's ruined cathedrals.

Meanwhile, Hodgkins continued to attract the support of some of the leading figures in the art world. She wrote to her brother William in 1941 about her financial situation: 'I haven't anything to worry about as it is all being done for me by a young group of friends, writers & painters backed by Sir Kenneth Clark, director Nat. Gallery who thinks I must have a Civil List Pension (for no other reason I can see than that they like my painting & don't like the idea of my being in want during the time I am forced to put aside my work).'[30]

But her most important accolade was the invitation to be one of the artists to represent Britain at the Venice Biennale in 1940. She wrote to Dorothy Selby from Corfe in the depths of winter, after Lefevre had cancelled her contract because of the threat of war: '[T]hey have

honoured me with a Room at the Venice International (a Biennial Show) in the Spring, no desperate hurry, but pictures have to be got together. Reid Lefevre are very pleased that I have been asked to represent Britain, one of the artists that is & mean if possible to run a London Show of my Water Colours & Gouaches conjointly.'[31]

In an impressive review in *The Sunday Times*, Eric Newton had described her as a genius, and this had assisted sales. She added sardonically to Selby that no doubt her dealers were regretting having stopped her contracts; they now wanted her to go up to London and discuss the situation. In the end she was able to negotiate a less punitive agreement, and all sides were contented.

When the Venice exhibition was cancelled because of the war, the British Council held it in May 1940 instead, at Hertford House, now the home of the Wallace Collection in London. Twenty-six of Hodgkins' paintings were displayed, including *Spanish Shrine*, *Almond Tree* and *Methodist Chapel* (Fig. 69, see page 346). The show was a huge success. Other artists in the exhibition, each of whom had their own room, included her friend Duncan Grant, Frank Dobson, Glyn Philpot, Edward Wadsworth, Alfred Munnings and Gertrude Hermes. It was an interesting mixture: Munnings was primarily a painter of horses, albeit with impressionist overtones, and he loathed modernism with a vengeance.

Meifod, Bridgnorth, Ludlow and Clun

WALES AND ENGLAND

M̲eifod is a little village in Powys, Wales, where our family spent two winters in the 1970s, following our summers in Greece. David found work repairing dilapidated stone cottages, with appropriate names like Starving Castle, located up mountains and tucked into valleys, and in exchange for rent I cleaned Penylan, the Georgian hall owned by our hosts, Simon and Sophie Meade.

We were first introduced to the family by English friends in New Zealand, and when we arrived Sophie and Simon swept us up into their daily lives, as they did all the other New Zealanders who came their way over the years. Marcus was the same age as two of their children and went with them to the local school. In the evenings and on weekends they drove us around the country to opera, plays or the movies. Simon (who is well over six foot tall) walked me in to one performance in Bangor inside his floor-length Russian bearskin coat. We had found our winter paradise and, more importantly, we experienced the generosity and kindness of people who were more interested in ideas — art, politics, music, literature, history, philosophy — than in social mores and the English class system.

Minutes after we first arrived at the hall, we became involved in a frantic search for Steasel (he was so tiny when they found him, they couldn't tell if he was a stoat or a weasel), who had gone missing. The freshly hatched chickens in their bed of straw inside the main hallway were at risk. He was eventually found inside the grand piano, demolishing a rabbit's head, and we knew that we were going to have a remarkable time here. The hall was enormous and rambling, and as I gradually cleaned and polished the collection of antique furniture, the delicate traceries of European porcelain, enamels, and other family treasures now sporting the odd bantam feather or piece of straw that had wandered away from the hall, I often pondered on the skills and dedication of craftspeople all over the world who create objects of great beauty for others. As do painters themselves.

My research into Hodgkins has involved some of the places I became

ABOVE **Fig. 63** *Landscape [Ludlow Castle]*, c.1916, watercolour on paper. *Auckland Art Gallery Toi o Tāmaki, gift of Sir Ernest Davis, 1937.*

RIGHT Ludlow Bridge over the River Teme.

familiar with over those winters, so after my visit to Liverpool I headed back to Wales, where Sophie and Simon kindly bundled me into their vehicle and drove me to Bridgnorth, Ludlow and Clun for the day.

B oth Bridgnorth and the handsome market town of Ludlow, with its black-and-white timber-frame houses, are in the county of Shropshire. Hodgkins had stayed in both places with her students in June 1926, producing a landscape painted from the vantage point of the curved bridge that crosses the river Teme, allowing a sweeping curve on the right-hand side of the paper that rises up to Ludlow Castle on the hilltop, partly obscured by trees (*Landscape [Ludlow Castle]*, Fig. 63). This compositional line curves protectively over the cluster of warehouses and domestic dwellings, creating vertical rhythms, their zigzagging roofs adding a kind of syncopation. You can almost hear Hodgkins pointing out their merits before her students put brush to paper. Hodgkins' own work is painted wet on wet, the soft masses of trees drawn upward to the billowing sky.

Hodgkins returned to Bridgnorth in the summer of 1932. She wrote to Dorothy Selby that she promised to find rooms for everyone in one place in town near the river, and not to put her up a hill on her own, as she had done last time, when Selby was forced to stay in Bridgnorth itself while the rest of Hodgkins' pupils had an idyllic time on a local farm.[1] Her painting style had changed radically in the six years since she was last there, but again Hodgkins' favoured vantage point was on the opposite side of the Severn River, which divides the upper town and castle from the fertile flat river plain below. Sophie and Simon went in search of lunch while I walked up and down the river bank, searching not just for the right view up and over the narrow line of former warehouses on the river bank opposite, but also for a particular building on the near side, aspects of which appear in a number of Hodgkins' watercolours.

I had a copy of a postcard of the period which showed pleasure boats

Fig. 64 *The Lake*, 1930–35, gouache on paper. *Tate Britain, presented by the Contemporary Art Society, 1940.*

tied up at their moorings, but also a precarious white urn at an angle on the steep bank leading down to the water. Today a paved towpath stretches along to the curve of the bridge that takes you back across the river, so finding the exact location of Hodgkins' vantage point wasn't easy.

On a hunch I accosted a woman in a high-vis vest who was approaching in a determined manner along the towpath. Some days the gods are more munificent than others, and it turned out she worked for the water board and was carrying a map of the area as it was in the 1930s. I asked her if any of the houses nearby could possibly have been inns at the time, and she pointed to one. Like a number of the places Hodgkins visited, it wasn't available for accommodation, but you could spend the day painting in its garden so long as you purchased the establishment's food and beverages. The building, now privately owned, is contained within a neat white picket fence, and there is no longer any sign of the scallop-edged awning that undulates across some of Hodgkins' watercolours, but I knew I had struck gold.

In the neatly paved courtyard at the front was a cluster of white concrete urns, resplendent with flowers. One in particular was identical to that seen in the postcard and in Hodgkins' watercolour, *The Lake* (Fig. 64) which is now in Tate's collection. In Hodgkins' day there was evidently an unusual sculpture of two women, which she included in several works; this was nowhere to be seen. It is quite possible that the sculpture had been carved in wood, rather than stone or cement fondant, and has long since rotted away, but it may also be nestled in that back garden to this day.

I was unable to find anyone at home to throw light on this, but took several photos of the urns before rejoining Sophie and Simon in a state of high excitement. A white urn also appears in a number of other works, not just in Bridgnorth but also from the time two years earlier, when she was staying at Flatford Mill in Suffolk. Their sinuous, decorative forms, with their resonances of Italian or French gardening history, clearly appealed to her, and they also created that 'white note' that was her preferred focal point within a composition.

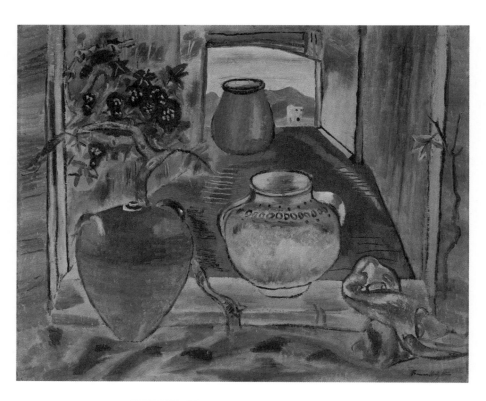

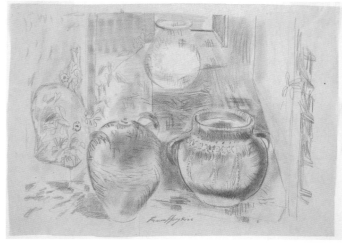

Highly satisfied with our day's work, we wended our way back to Bron Fedw, the cottage we had rented high on the hill above Meifod, where Sophie and Simon are now living. We drove via Clun, where Hodgkins lost her painting kit while staying there briefly in 1941. The second triumph of the day occurred on our return to Bron Fedw. We were discussing how Sophie had run an art gallery years ago, first in Newtown and then in Welshpool, where works by Hodgkins had been included in a couple of exhibitions. She was a little hazy on the details, but she suddenly turned and said, 'Simon, Simon, didn't Tinkles have a Hodgkins on Skye?' Five minutes and a phone call later, I had discovered a previously unknown oil painting that had been included in her major exhibition at the Leicester Galleries in 1935.[2]

The works in that exhibition spoke powerfully of the locations she had been to and the subjects that were important to her. Spanish and French watercolours and oils predominated, including *Phoenician Pottery and Gourds*, *Peasant Pottery*, *Citrons*, *The Red Jug*, *Vine and Melon*, *Spring in the Ravine, Ibiza*, *Spanish Shrine*, *Monastery Steps*, *The Cloisters*, *St. Eulalia, Ibiza*, and *Old Mill, Les Andelys*. But Bridgnorth was also represented with *Sabrina's Garden* (Sabrina is the water nymph who lives in the river Severn) and *Houseboat, Severn*. I was able to view *Spanish Jars* (Fig. 65) in London the following year, and recognised its importance immediately, because we already had the preparatory drawing — finished rather than a brief sketch (Fig. 66). It is an excellent example of her working practice at the time, with the stripes in the sky that can only just be glimpsed through the deep-set window, indicating that the work had begun during Hodgkins' visit to St Tropez in 1931 but not finished until much later, when her visit to Ibiza was fresher in her mind: hence the title.

23

Ponterwyd, Llangurig and Dolaucothi

WALES

The following day, I was very kindly driven to Ceredigion, Montgomeryshire and Carmarthenshire by Laura, the partner of Jasper, current residents of Penylan, and their daughter, Molly, who were both curious to understand what had drawn Hodgkins to Wales. We went first to Ponterwyd, Llangurig and Dolaucothi, before driving home via Aberystwyth on the coast. My visits were not in the same order as Hodgkins', but then she had months or years between them: I only had one day.

Hodgkins had a holiday at Ponterwyd in 1935 before setting off for the Costa Brava, initially staying at the George Borrow Hotel. Nestled up against the Cambrian mountains in central Wales, Ponterwyd is a little stone village divided by the eighteenth-century Yr Hen Bont (Old Bridge). Once across, there is a chapel, a cluster of shops and houses, and a crossroads. There is a smaller, possibly even older bridge tucked behind trees about a hundred metres further on from Yr Hen Bont, which may well have been more visible in Hodgkins' day.

My main interest was the now-defunct mill house below the bridge. We fought our way down through the undergrowth so that I could stand by the river beneath it, trying to sense where Hodgkins would have sat to paint the view of the mill. I took a photograph of the boarded-up windows, including a green-framed glasshouse that had since been built up against the stone wall, its ripe tomatoes thriving from the retained heat of the stones. I had already climbed on the broad stone wall on the bridge, much to the consternation of my fellow travellers who expected me to tumble over at any moment, but once down by the river I realised that in fact she had painted the mill from the road above. The lower extension was on the right in her work, but in a photograph of the time it is clearly on the left. Not that this matters in an artwork; it's the composition that counts.

Hodgkins noted in her one letter written from Ponterwyd to Ree Gorer: 'Since coming here it has rained pretty well every day & all day — with brilliant intervals when we can gaze around on the lovely hills Pumlumon [Fawr] the highest & nearest within everyone's walking distance but mine

ABOVE View of Mill House, Ponterwyd, from the wall of the bridge.

BELOW Clochfaen Hall in Llangurig, Montgomeryshire, today, where Hodgkins stayed briefly in 1945.

own! I have sat about in damp fields, under dripping bridges & arches, hay stacks even pig sties, sheltering from the weather — and the trippers who come in their hundreds — dreadfully spoiling the place — They actually drove me away from the Hotel so noisy & rowdy was it — and now I have a room in the village, which is quieter & less populous — but dreary.' She added that she had met up with Cedric Morris, who had been staying with friends in their castle near Cardiff, and she felt he looked 'thin & sad — He has been painting in one of the distressed areas, a mining valley, where he says things are tragically bad — the miners all but starving & worse hopeless.'[1] She was determined to stay on until she had enough material, adding that she felt completely revived in the marvellous air of the area: 'There is a white mist over the valley — I shall take the bus down to Aberystwyth & see Art Exhn of Welsh Contemporary work, got together by Cedric & Augustus John . . . a fine collection of Innes' work, from private collectors.'[2]

Hodgkins returned to Wales in September 1942 and stayed at the Dolaucothi Arms Hotel, Llanwrda, in Carmarthenshire, where she was surprised to bump into Storran Gallery owner and friend Eardley Knollys.

Although she painted out of doors when possible, the Welsh weather was fickle, so she produced several gouaches of the bits and pieces lined up on the kitchen dresser of her host Mr Morgan, and later gifted one of the works (*China Shoe*, Fig. 67) to Knollys. The random assortment of objects on dressers and mantelpieces, including in this instance the pink china shoe that sits in the foreground of the composition, particularly appealed to her.

A visit to Clochfaen Hall in Llangurig, Montgomeryshire, only 20 minutes away from Ponterwyd, on the recommendation of Knollys in 1945 proved less pleasing, for in spite of the sunshine and an abundance of cream and good food, Clochfaen's location on the flat river plane of the Wye held nothing that attracted her artist's eye, it being a place better suited to what she described as the 'Fishing Aristocracy or walkers and climbers'.[3] In this company, she may also have lacked the mental stimulation she needed for her work.

Fig. 67 *China Shoe*, 1942, gouache on paper. *Private collection.*

We pulled up at the front door of Clochfaen Hall and knocked loudly, but the building seemed deserted apart from the distant barking of a dog. Clochfaen is a long, two-storeyed black-and-white timber arts and crafts house built in the early twentieth century and with what look to be additions either side. It still functions as a bed and breakfast, and I would have liked to ask if there was a guest register from the period. Alas, time was of the essence and, like Hodgkins, we moved on.

24

Solva, Middle Mill, Abereiddi and Porthgain

WALES

On her return from a fortnight's stay in the fishing village of Solva, in Wales, Hodgkins wrote to her dealer Duncan Macdonald that she had been 'working moderately hard, moderately successful in a landscape of steep valleys speedy rivers & castles looking like their own mountains but it takes a long long time to acquire a little idiom & rhythm in paint — if ever. Such nice gentle people I was among at Solva, mostly bird watchers & all such terribly poor.' The Redfern Gallery had requested some of her works for an exhibition, and Hodgkins asked Macdonald if he could supply them from what he had in stock.[1]

The years following on from her return from the Costa Brava until the outbreak of war were a particularly felicitous period for Hodgkins as finally she gained the standing she deserved in the avant-garde art world. In 1938 she wrote to Dorothy Selby, reminding her of their stay at the Cambrian Hotel in 'Solva of blessed memory', where they had been intrigued to find a work by a younger modernist, Graham Sutherland.[2] Hodgkins had thought it to be a crib from Cedric Morris, who had also stayed in the village. In spite of this criticism, she recommended Selby go to the current exhibition of Sutherland's work at the Bruton Street Gallery in London, as 'he is in the making — coming on fast'.[3]

Sutherland had returned to Wales in 1936 after visiting Pembrokeshire two years earlier, and described it as the place where he 'began to learn painting'. He recalled being fascinated by 'twisted gorse on the cliff edge . . . the flowers and damp hollows . . . the deep green valleys and the rounded hills and the whole structure, simple and complex'. He discovered in Pembrokeshire a landscape of 'exultant strangeness' but also felt that he was 'as much part of the earth as my features were part of me'. The landscape inspired him to create surreal, organic landscapes of the Pembrokeshire coast, helping him secure his reputation as a leading British modern artist.[4] And that is how Pembrokeshire remains today, a little like New Zealand, far to the west in Britain, with a wildness and freshness that is balm to the soul.

CLOCKWISE FROM TOP Solva scenes: View of the next bay from the hill above Solva; the lime kilns; the village of Solva.

When Catherine Hammond and I went to Pembrokeshire in 2015, accommodation was unforthcoming in Solva itself, so we settled for a charming pub below the main hill of Haverfordwest, half an hour's drive away. The hotel boasts of having opened in 1675, and you could see that this might be so. I drove there early in the day, while Catherine would come by train in the evening, after her librarians' conference had finished in Cardiff. It was a bright sunny day, and my spirits lifted as I drove over empty roads in a landscape similar to the Yorkshire moors before dropping down into Solva. The pebbly beach is now mainly reclaimed as the car park, and on the far side is a line of lime kilns, which I would have thought a perfect motif for Hodgkins, though I have not identified them in any of her extant works. The single road that winds up through the village is lined with brightly painted stores, cafés and houses. An old-fashioned tea shoppe advertised crab sandwiches, always a tug at the heart, but I foreswore, promising myself a treat once my research was done. (By the time I returned, they had sold out.)

Crossing over the bridge above the shore, I walked to the top of the hill to the left to look down into the next bay: I was looking for a particular promontory with a line of eroded rocks running into the sea. From the cliff you can see little bays scooping in and out, many of them filled with boats. This is a walker's and sailor's paradise. The hills were still purple with heather, and the ground was soft underfoot. The cheery man in the car park expressed concern that I might plummet to my death; you'd certainly want shoes with a good grip if you were walking there in the rain. The wind was exhausting, and I thought of Hodgkins working out of doors, her paper in danger of flying off at any minute.

From Solva the narrow road leads two kilometres up the valley to Middle Mill, where Hodgkins did most of her paintings and sketches during the two weeks she spent in the area, possibly because there were fewer holidaymakers but also because it is sheltered and full of the motifs she loved. Beside the narrow river on the far side of the bridge there were two mills, one for wool and one for corn, each with their wooden wheel.

Hodgkins' wheels would have received a tick of approval from Leonardo da Vinci because she could paint a semi-circle, a circle and an ellipse without her hand trembling: according to the Renaissance master, the mark of a skilled artist.

Unlike the woollen mill, the corn mill and its lodge no longer function, but they are available for rent if you ever fancy a holiday there. Outside the woollen mill I could see a line of old square wicker baskets, used to store the fleeces before they were spun, and a tempting display of wares inside. Channelling Hodgkins' colour palette, I bought a pair of apple-green fingerless mittens, telling myself I would use them for typing this book on cold winter days. I later discovered that the pub nearest the water in Solva has a great array of early photographs of the village, invaluable when you are trying to get a sense of what it might have looked like so many years ago. I was particularly taken with one showing a couple of men wrestling with two indignant sheep being washed in the nearby river before being shorn and the wool spun. In the photographs the building behind, which became Hodgkins' favourite motif in her Middle Mill paintings, appears to lean at an angle.

In reality Middle Mill is tiny, but Hodgkins expands the landscape in those of her paintings produced on her return to her studio in Corfe, sometimes floating this favourite building up the hill, though in fact it nestles directly opposite the bridge. Today white- and purple-flowering vines intertwine above the doorway of the cottage — a picture of early summer prettiness. As I knocked on the door I noticed the sign, Llanunwas Arms, carved in slate and set in the wall.

Judy, the friendly and helpful present owner, told me that when she and her husband acquired the building, which had long since stopped functioning as an inn, they removed the two little sloping-roofed bothies at either end (used for storage), and they had also taken off the glassed front porch, which were distinguishing features in Hodgkins' paintings. An extension with a garage has been built onto the left-hand side of the house, painted white so that it doesn't compete with the older stone of

CLOCKWISE FROM TOP Middle Mill scenes: Llanunwas Arms; the wooden wheel at the wool mill; wool baskets at the mill.

Llanunwas. Today the hillside behind is dense with trees, but apparently it was much clearer in the 1930s, and crops were grown on the slope.

Hodgkins' paintings of Middle Mill are readily identifiable, but I have long pondered another gouache, *Ruins* (Fig. 68), which has been linked to Ibiza or Tossa de Mar, not least because of its rich palette of turquoise blues and greys. However, the ruined arch that can be seen in the foreground has a lintel of brick, which I now knew wasn't used anywhere in Ibiza or Tossa, although the line of rocks in the background is treated similarly to works done in Spain. Just as wild as the Costa Brava, Pembrokeshire seemed a much more likely place for bricks to be used in this way.

I had shared my morning coffee at a very good little café down on the wharf with 65-year-old lobster fisherman Nicholas (with whom I was tempted to abscond until he told me he was retired). He advised me to make enquiries about the work at the bookshop in the village. On showing one of the women working there a reproduction of *Ruins*, she rushed me up two flights of stairs to the children's and travel section, where she plucked out a copy of an illustrated story set in the area. In it were views of two harbours north of the cathedral town of St David's, just a little way along the coast. She told me I must first go to Abereiddi, and I would find part of my painting there.

Having driven past St David's and up the coast, I entered a maze of narrow lanes devoid of any road signs to indicate which one of them led down to the sea. Miraculously, like a homing pigeon, I managed to find it. Abereiddi (Abereiddy in English) was, like many of the bays along this coast, the site of slate and tin mines, but today only a few inhabited cottages remain. I parked the car and walked up the far hillside, followed by a group of tiny cream and black cows curious to see what I was up to. I was heading for a small cluster of ruined dwellings, only black-slate fragments of their walls remaining.

Once there I could see on the next promontory the ruins of a spectacular three-storey mine. When it was closed down a channel was blasted through to the sea, creating an unsettling deep-green lagoon.

ᴀʙᴏᴠᴇ **Fig. 68** *Ruins*, 1937, gouache on paper. *Museum of New Zealand Te Papa Tongarewa, gift of Mrs Joshua Shields in memory of her husband, 1940.*

ᴀʙᴏᴠᴇ The former slate mine at Abereiddy.

A group of intrepid men were leaping in turn from the top of the windswept hill into the water below, their wetsuits making them seem like a colony of frightened seals. The suits would have been little protection had they hit the walls on the way down.

Of more interest to me were the ruined cottages. Their lintels had collapsed, but those still intact in the bay below had the same vertical brick design that can be seen in *Ruins*. That solved one part of the puzzle. Hodgkins also accurately captured the sweep of the bay below. The rocks in the distance didn't fit, however, being not dissimilar, in miniature, to the faraglioni she had seen on Capri in 1914. When Nicholas the fisherman looked at the painting, he thought they might well be Dinas Fach at Porthmynawyd, an eroded promontory southwest of St David's, but equally they could be at Ceibwr, further north.

But there was one aspect of Hodgkins' painting yet to solve, and I was determined to return the next day, after spending the evening with Catherine at Haverfordwest. As it happened, no restaurants were open by the time we met, so we wandered rather forlornly around Haverfordwest's crumbling graveyards (where at least there was soft unmown grass to walk on) and then had dinner in the hotel. They needed a tea trolley to bring it in — plates groaning with meat and swimming in gravy all prepared lovingly some time earlier, with extra dishes of vegetables which had been put on to cook at the same time.

I didn't eat the Yorkshire pudding (maternal adage: don't eat anything bigger than your head) and so my plate was returned to the kitchen looking very similar to when it came out. But the beautiful, curvaceous 50-year-old who served behind the bar when she wasn't at the front desk took no offence. Her delightful lilting Welsh voice was a joy to listen to, and it took me back to our winters in the 1970s in our little cottage in Wales.

efore delivering our hire car to Fishguard, from where we were to catch the train back to London, I drove back to Solva, eager to show Catherine what I had discovered the day before. Hodgkins had stayed at the Cambrian Inn, opposite the bridge as you enter the village, at the junction of Main Street and Middle Mill Lane. When we visited the hotel it looked rather sad: centuries of dilapidated plaster was being scraped from its façade in readiness for restoration. Later it was painted a lovely sage green, a colour of which Hodgkins would have heartily approved. Like everyone we spoke to, the owners were very friendly, allowing us to take photos in the bar, though the restoration work made it hard to imagine what it might have looked like in Hodgkins' day. The hotel is next door to the deconsecrated Methodist chapel which Hodgkins also painted (Fig. 69), now a brightly decorated Cuban café.

We walked in the morning sunshine to Middle Mill and knocked again on Judy's door. She was expecting us, and had got out some photocopies of Hodgkins' paintings that had been sent to her the year before by none other than Roger Parsons, whose extensive bookshop had been part of Auckland Art Gallery for so many years before moving to bigger premises down the road. He had introduced himself to Judy, no doubt knowing Hodgkins' links to the village through the books that had passed through his hands, and my visit the day before had triggered her memory. We also met her neighbour, Matthew, whose father had written what proved an invaluable booklet on the history of Solva and Middle Mill.

There was a forge and a smithy in Solva in the 1930s, and the rich-green water meadow on the near side of the bridge provided grazing for the cows that were walked up from the village after milking each morning. The booklet describes how Linda the Milk walked them back again in the evening and the process was repeated. (I expected Dylan Thomas to appear at any moment.) Hodgkins loved these cows, initially painting them quite naturalistically but gradually turning them into pantomime creatures that obviously appealed to her sense of humour. One of the photographs of her studio in Corfe taken by Felix Man for *Vogue* magazine shows a toy

ABOVE **Fig. 69** *Methodist Chapel*, c.1937, gouache on paper. *Private collection.*

BELOW Solva's Methodist chapel today.

cow on a wooden stand on the mantelpiece. I recognised it immediately: I had bought one for my son Marcus when we lived in Meifod. Hodgkins may have bought hers as a reminder of her holiday in Solva, and gradually it stole its way into her paintings.

After saying our farewells, Catherine and I drove to Abereiddi to see the stone ruins and the lagoon, and then made our way to our last port of call. Porthgain, a harbour slightly further north, once had vast factories manufacturing first slate, then brick, then stone, which was exported around the country by sea. Today it is an idyllic fishing port and tourist destination, with the industrial ruins mouldering romantically into the landscape. We had very little time, but fortunately what we had come for was clear to see on the hill at the mouth of the tiny harbour: one of the two white-painted stone obelisks marking the harbour entrance that rises on the far right of Hodgkins' painting. I almost wept with pleasure at solving another of the creative puzzles Hodgkins had set us.

Pembrokeshire feels like a very old country with ancient traditions, some of which I have since tried to research to give me a better understanding of the place. I was fascinated to discover that two years before Hodgkins visited Solva, an article was published about eighteenth- and nineteenth-century burial rites in the village. The body covered in a white cloth would be laid on a bench with its feet facing the fire, a tin pan on its breast with a candle on it. Each mourner who entered would place another candle in the pan, and throughout the evening the mourners sang and told stories to keep the corpse company.

Towards midnight two strong men would climb up on to the roof of the house and let a rope down the chimney, then shout 'Chwerwyn gwd' (no translation provided). Someone would take the rope and tie it to the feet of the corpse, and shout 'Chwarae'n barod' (The play is ready), then those on the roof would pull the body feet first up the chimney, before letting it down again, and it was put back to rest on the table.[5] You wouldn't want to die there . . .

25

Worth Matravers, Swanage and Kimmeridge

ENGLAND

odgkins stayed on and off with Amy Krauss at Corfe Castle in Dorset after her return from Tossa de Mar in 1936 and into the following year. She went up to London at one point, staying at Conduit Street in Mayfair, but after she contracted laryngitis she was taken to Highgate and spent three weeks in bed being nursed by Gorer Gorer. Her return to Corfe was unpropitious, for while driving her home Ree wrote her car off — exactly how is not described. The occupants, fortunately, were less injured than the vehicle, but Hodgkins recollected that she came back to Corfe 'in bits and pieces'.[1]

In September she moved to Worth Matravers, Dorset, which she described to her brother William as 'a little lost village' perched on the limestone clifftop near the coastal town of Swanage. She had begun to worry about her itinerant lifestyle, and although the village didn't immediately present itself as a subject for her work, travelling to France seemed dangerous now there was the threat of another war. She wrote to Gorer: 'I have taken two rooms at a Farmhouse where I shall stay as long as it suits me — It is close to the sea, that is 1 mile down & 5 miles up . . . I mean to stay quiet & wait for the impulse.'[2] Unless you count the pub clinging to a triangle of land on the steep and narrow road into the village, Worth's most striking architectural feature, even today, is a large D-shaped pond attached to the village green.

Hodgkins initially took two rooms at Sea View, a former vicarage attached to a farm, comprising a studio shed in the garden and a room to sleep in. Apart from brief forays to Brittany that summer, a motoring holiday with Gorer to Tréboul and St Tropez the following year, and weekends away staying with friends, she was to remain at Worth until April 1939.

As so often happened when she first arrived in a place, things were unsettled — this time because the farmer was working to turn more of the house into a three-room apartment for her. She expressed the hope that after she was settled, and when Ree and her son Geoffrey were staying at The Croft, they would make the short journey to Worth. She lamented

ABOVE The Pond at Worth Matravers.

BELOW The main street in Worth Matravers.

that she couldn't start on anything new because she had to address what her dealers felt were flaws in her latest gouaches and prepare them for her exhibition.[3] Duncan Macdonald had expressed a lack of confidence in some of the works she originally posted to him, and so she scraped them back and painted them afresh.[4] A letter from Duncan Grant arrived, inviting her to join him and Vanessa Bell at the summer show at Agnew's, along with '15 other artists of highest calibre', and this galvanised her anew.[5]

Overlooking the English Channel, her new abode was rather stark, but as she told Ree: 'The mornings are very lovely & I want to paint even before I have finished breakfast. Sunsets splashed yellow & black. Not very exciting landscape ...' While in Worth she produced a number of paintings of a house and dairy farm, but she visited several friends with farms during her stay in the area, so it is difficult to identify which farmyard is depicted.

When the Macdonalds and Reids arrived unexpectedly not long after she had moved to Worth Matravers, Hodgkins apologised for the lack of seating or food of any kind. However, once settled in her rooms, she worked to create an amenable living environment, so essential for both comfort and creativity. She was good at cutting patterns for furniture, having re-covered a chair with the help of a local upholsterer in St Ives in 1919, for example. Later, in Manchester, she had brightened up her studio by covering a chair, making curtains and painting the walls bright colours to compensate for the never-ending rain.[6]

Some-time in the 1930s she had acquired an armchair that was to remain her main piece of furniture. It had to be looked after by friends when she went on her travels, which can't always have been convenient. After she had settled into her new accommodation in Worth, she wrote thanking Ree Gorer, who had had the chair re-uphostered: '[T]he great Chair has come timed to perfection for Christmas Eve. Towards 10 o'c by Southern Railway, just as I was off to bed. Thick fog outside. I opened the door to see what looked like a box as large as a cottage attempting to get into my Cottage & finding it the very deuce of a job ... Today I unpacked

it — no Her — my dearly loved Cinderella has turned into a beauteous Princess clad in dove coloured velvet.

'Like the Prince I was transfixed & have remained so all day. In fact we have spent almost the entire day together in each other's arms so to say in front of the fire. It is a chair in which to dream. Oh! Much more than that. A support, a tonic, a prop, a very real succour which cuts down through everything to ones very soul. Say — like a good picture. It has magic qualities. It makes one think, for instance, that some of my worst duds may be finished pictures one day. Best of all it has raised me to a level of feeling well & happy. It is the most completely satisfying gift I have ever had & when I am sick of the sight of everything else I shall love my chair which will be warm & comfortable even if it stands in an icy draught. It looks good & right & dignified in this little room where not so long ago the small window was lit with oil candles & a horn lantern.'[7]

This letter proves my theory that when the weather was inclement Hodgkins used not just a kitchen chair, as a number of modernist artists did, but also an armchair as a prop (that all-important word) to create some of her still lifes. *Still Life with Fruit Dishes* (Fig. 70) in Dunedin Public Art Gallery's collection is the earliest obvious example. She has placed a range of still-life objects in the confines of an armchair, rather than on a table or window ledge. She plays with reality because the slices of melon in the foreground defy gravity by floating in front of the upholstery rather than balancing on it, as does the jug with lilies on the right. The work includes the same twisted cloth that can be seen in her St Tropez paintings, as well as a jug lying on its side. This may have been consciously placed there or it may have been the happy result of its refusal to stay upright on the padded seat.

A horizontal vase is also seen in her radical *Self Portrait: Still Life* (Fig. 71). It contains what looks to be a large dahlia, but this time Hodgkins floats it up to the top of the armchair rather than across its seat. Once alerted, you can make out the shape of the armchair beneath her favourite scarves and pieces of fabric, on which lie a hat, the vase, a twisted belt and

that stylish pink shoe with its ruched upright band of black velvet. In both examples she 'frames' the chair with paint, but whereas in *Still Life with Fruit Dishes* the wooden floor beneath is still evident, in her self-portrait she has encased the chair and its objects within a border of soft green, only the 'shadow' cast on the wall giving any sense of depth.

An extremely contemporary work, it prefigures post-modernism in its selection of parts to stand for a whole, while also linking to one of the precepts of cubism. However, rather than the pieces having to be converted by the mind's eye for the viewer to see a glass or jug or mandolin, here we have to take a different conceptual approach, setting aside what we know of Hodgkins' physical being and 'reading' her instead by her favourite objects.

When Picasso painted his portrait of expatriate American writer Gertrude Stein between 1905 and 1906, he is said to have needed more than 80 sittings before he felt he had achieved the effect he wanted, and then only after visiting the Trocadero's collection of ethnographic art, inspiring him to turn her face into a form of African mask. It took Stein some time to reconcile herself to his manner of depiction, although she had already cut her teeth in coming to terms with a nude, her brother's first acquisition of his work. When his portrait was criticised for not resembling Stein, Picasso responded that in the end she would manage to look just like it.[8]

So, too, with Hodgkins — we know what she physically looked like, but encompassed in her self-portrait are aspects of everything that was important to her: objects she loved and which held particular symbolism for her, her favourite scarves reflecting her love of pattern and design, and her ability to construct a work rather than simply paint what was in front of her. It states clearly: judge me by what I do and what I believe, not by how I look.

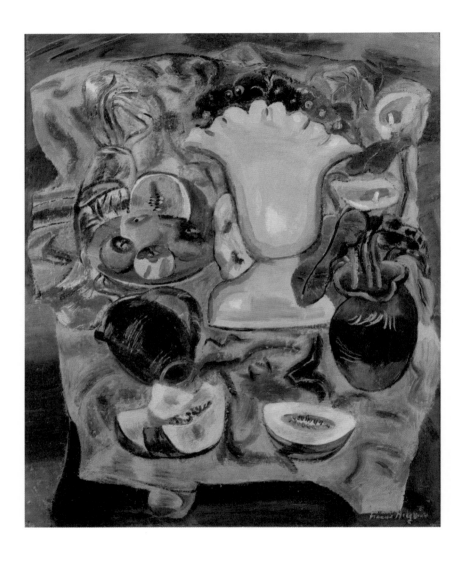

Fig. 70 *Still Life with Fruit Dishes*, c.1937, oil on canvas laid on hardboard. *Dunedin Public Art Gallery, given by a group of anonymous donors, 1949.*

Fig. 71 *Self Portrait: Still Life*, c.1934–35, oil on cardboard. *Auckland Art Gallery Toi o Tāmaki, purchased 1963.*

odgkins writes quite fondly of Swanage. When she felt trapped in Worth Matravers, which after all was only a tiny village where you could meet the entire population in 10 minutes if so desired, she could catch the bus into Swanage and go to the cinema, always a favourite pastime.

Chloe and I arrived there in the early evening. It was going to be our base for the next two nights, and we planned to venture out during the day to Worth Matravers and Corfe Castle. I had booked rooms in a large hotel perched up on the cliff in Burlington Road, looking out to sea. Mine turned out to be recently refurbished and very smart, but so small I could touch both walls, more or less, from my single bed. And if I was feeling lonely I could lean out the window and pat the bonnet of our car. While Chloe was given a slightly larger room on the first floor, she was denied proximity to the car of which she had become rather fond, not least because I was not driving it anymore.

Too tired to venture down the hill into town, we braved the large dining room, painted a shade of apricot-pink, where waiters were doing their best to provide silver service. We had only just sat down when two elderly women entered and hissed, 'That's our table', and we retreated abjectly, finding a remote corner in which to eat our meal. It was evident that many of the guests had been coming to this hotel for their summer holiday year after year. An elegant young couple, who looked as if they were down from London, walked in, did an about-turn and headed immediately for the car park, whereas I was overcome by a desire to do cartwheels across the lounge. The next evening, after our trip to Worth and Corfe, we ate in town at an extremely good contemporary restaurant with excellent service, and my faith in Swanage was restored.

immeridge Bay, which is very close to both Corfe and Worth Matravers, is a curving stretch of beach backed by rolling hills. The village itself is further inland, but it was the shore that Hodgkins

preferred. She could tuck herself into the sheltered side of the bay out of the wind to make preliminary sketches, which she could then work up in her studio back in Worth. Verdant in summer but windswept in the winter, there is a certain wildness to this part of the Dorset coast. Today a couple of fishermen's cottages remain, the ground littered with old lobster pots, nets, the upturned hull of a boat and other detritus from the fishing industry.

When Lefevre Gallery's Alex Reid expressed a desire to put on another watercolour show in 1942, Hodgkins was anxious that she didn't have enough material to hand, because once again she was waiting for new spectacles. She promised him a set of almost a dozen 'baby' gouaches that she had in her portfolio, suggesting she had produced them over time rather than during a single day-visit. Although she doesn't mention going to Kimmeridge again, it is walking distance from both Worth and Corfe, so she could have travelled there at any time. Many of the works from this period were more landscape in nature than still life, but the detritus at Kimmeridge was too attractive to resist and it took centre stage in the series created from her visit. She described the gouaches as 'Flotsam & Jetsom on Kimmeridge Beach' that she had kept in reserve with the intention of working them up in oils. She wanted them to be shown as a set but Reid could select those he preferred.[9]

In 1937, in reaction to Ben Nicholson and Barbara Hepworth's move to abstraction, John Piper had called for artists to return to nature as a source of inspiration, stating, '[I]t will be a good thing to get back to the tree in the field.'[10] Once war set in, this consciously emotive neo-romantic response to ruined buildings and abandoned objects became particularly poignant: countryside and cities that had been a constant were now threatened with destruction.

Paul Nash, a former fellow member of the Seven & Five, was also drawn to Dorset, particularly the individual rocks, bones and fossils scattered in the landscape. These suggested an ancient history, but for Nash they were also full of surrealist overtones, becoming 'the pyramids

Fig. 72 *Kimmeridge Foreshore*, c.1938, oil on canvas. *Victoria University of Wellington Staff Club collection.*

of his small world'.[11] In certain of Hodgkins' works they take on a similar aspect, their place in the composition suggesting a scale that plays with reality. In *Kimmeridge Foreshore* (Fig. 72) she paints from an extremely low perspective, as though the scene is viewed at ground level, and the dominating curve of the bay is minimised. In other gouaches and watercolours, it is as if the water tanks and boats and buoys are players, and the landscape merely a stage.

As the war progressed, many people in the area were uprooted. Hodgkins expressed her sadness at the way lives were disrupted, writing to her friend David Brynley: 'Your heart would bleed if you could hear the sad stories of the poor old people being turned out this week end from Kimmeridge to make room for the billions of Canadians pouring in to this part of England.'[12] By that time the bay had become a rifle range — and a major target for German bombers — and was off-limits to civilians. In these circumstances, Hodgkins' paintings of flotsam and jetsam became a form of vanitas, suggesting both presence and loss.

Reluctantly, Hodgkins was forced to leave Worth and return to Corfe at the beginning of April 1939. Her landlady, Mrs Bridle, died, and Mr Bridle, not wishing to carry on, put the farm up for sale.

26

Cerne
Abbas

ENGLAND

Much as it is pleasant to have a welcoming party, Chloe and I were surprised when we drove into the village of Cerne Abbas to see a man step in front of our car, wave his arms and direct us into a field, not least because we proved to be the only vehicle there. We had inadvertently arrived on Cerne Abbas's Garden Open Day, and the director of traffic told us that presently the field would be crammed with eager visitors. So, we thought, would the café. Instead of setting off on our search, we settled for a coffee while we could. We were immediately drawn to the front room of the Royal Oak Inn (thought to have been built around 1540), its pale-blue bay window leaning out into the street and the rest of the façade so weighed down by ivy that it looked as if the whole lot could topple at any moment. The counter was groaning with baking of every kind; there must have been many members of the Women's Institute slaving over a hot oven the previous evening.

Cerne Abbas is one of those lovely villages described in *The Dorset Magazine* as curled like a dormouse under the bare chalk downs. The cottages have pitched roofs with square chimneys either end, the kind you see in many places along the south coast of England and up into Pembrokeshire in Wales. The main street, where the grander houses are located, is dissected at one point by the Cerne River (more a stream for most of the year), with the Piddle to the east and Sydling Water to the west. The streets leading off are lined with pretty cottages, their miniature stone courtyards festooned in early summer with every kind of flowering vine, shades of ivy and tumbling roses, set off by their supporting stone walls — my kind of garden, not too smart around the edges.

The history of the village is a rich one. According to *The Dorset Magazine*, the second half of its name is owed to the Benedictine abbey to the north of the village, which can be dated back to 987. Narratives as to how the abbey developed vary, one claiming that it was founded by St Augustine, who, on converting the locals, needed water to baptise them and caused water to spring from the ground at what is known as St Augustine's well.[1] Others say that it was founded by Athelmær the Stout, brother of the King

CLOCKWISE FROM TOP Cerne Abbas scenes: The New Inn, where Hodgkins stayed in 1943; Chloe walking up Mill Lane; the Royal Oak Inn, weighed down by its cloak of ivy.

of East Anglia. According to Wikipedia, people flocked early on to Cerne to venerate a hermit, St Edwold of Cerne, who lived in the hills beyond the village by St Augustine's well. Whatever its origins, the abbey served as a centre of learning and manuscript production until Henry VIII dissolved the monasteries in 1539.

Attached to the abbey was a tithe barn, where the faithful would bring the share of their crops owed to the church at the end of each harvest. After the dissolution, when the land around the abbey passed from church to private hands, Cerne maintained similar agricultural patterns, its weekly market stalls laden with vegetables, poultry and other local products. By the late eighteenth century the village also contributed to the ever-burgeoning fashion industry, producing fine gloves and shoes, and supporting silk-winding and tanning businesses.

But it was really beer that made the village wealthy. Brewing had become a major industry in the eighteenth century, and Cerne Abbas's liquid amber was highly praised by the travel writer Richard Pocock, famed for his writings on Europe, Egypt and the Orient. Like Hodgkins, he seemed unable to settle, and when he became too old to make further journeys abroad, he travelled the length and breadth of Britain and Ireland (where he became a bishop), writing detailed descriptions of each place he visited, for which future researchers remain grateful.[2]

All good things come to an end, however, and Cerne, along with many agricultural centres, fell into decline. Perhaps if the railway west had been closer, prosperity might have lasted, but by 1906 the village was described as decaying and strangely silent, its streets and doorways sprouting grass, the boarded-up windows of houses and the doors of empty barns hanging off their hinges.[3] By then it was part of the vast estate of the grandly named General Augustus Lane-Fox Pitt-Rivers (can a name ever have too many hyphens?). At his demise the village of Cerne Abbas, along with others, had to be sold off to pay death duties, which proved of benefit to his many tenants, who took the opportunity to buy the houses they had formerly rented.[4]

By the time Hodgkins and Dorothy Selby went to stay there in September 1943, prosperity of a kind had returned to much of the village. Hodgkins had hoped to visit slightly earlier, as she had been through a trying time after the roof of her studio in Corfe collapsed and she had no proper space in which to work. She had saved all her painting equipment and moved what she could into her tiny accommodation next door, but the rest had to be stacked against the wall and covered with a tarpaulin; it was impossible to get anything repaired with the war on. However, because of Cerne's popularity as a holiday destination, all rooms were taken in the summer months and she and Selby had to wait until some were free.

They lodged at the New Inn on Long Street, a large barn-like building constructed in bands of horizontal flint and red brick, their uneven divisions suggesting that the building had at some time undergone considerable repairs. Its two floors contained a series of mullioned windows, punctuated by an arch wide enough to allow the entrance of horse-drawn carriage or cart, and leading through to a large courtyard at the back, lined with stables and other outbuildings. Hodgkins and Selby spent their time there sketching and accumulating assorted motifs and landforms that could be worked up into finished paintings once they returned to Corfe. True to form, Hodgkins was drawn to the back alleys (bearing names such as Piddle, The Folly and Duck Lane), where a number of the buildings remained in a state of romantic disorder, rather than to the houses and shops lining the main street.

She also spent time working along the channel of water that wound back towards the village, providing the power source for its corn mill. The narrow lane has stone walls either side, so there would not have been much room to manoeuvre. Chloe and I happily noted that the stream takes exactly the dog-leg bend that Hodgkins included in two works: *The Millers House* and *The Watermill (Water Wheel)* (Fig. 73). She chose to depict the end of the miller's house that has a plain plaster façade, rather than its opposite which has a weatherboard addition over a ground-floor extension.

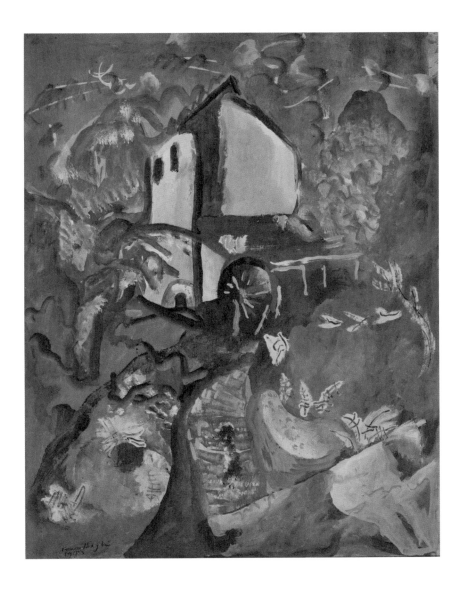

Fig. 73 *The Watermill (Water Wheel)*, 1943, gouache on paper. *Private collection.*

The subject of another work, *Abandoned Cottage No 1* (she also exhibited a second version which has not yet been located), proved elusive, but a black-and-white photograph of a dilapidated cottage from 1943 recently placed on the internet demonstrates certain similarities. Either way, the cottage has been demolished or restored beyond recognition since Hodgkins' time. Her initial sketches, like so many of her preparatory sketches, have not been traced, but they were the source of some very fine gouaches. It has helped future researchers that she included the name of the village in several of their titles, but locating their specific location has proved challenging.

A letter to her nephew Peter Field in New Zealand painted an idyllic picture of a 'darling little village with a few haughty houses & lovely gardens — the perfect English scene — over all there broods a mysterious Giant Cut in the chalk hill by the Romans & still quite alarming. They could draw in those days! It is a tremendously vital giant — really the god of fertility — and looks it — So goes the legend.'5 She refers to the giant's genitalia, as erect as the knobbed club he waves in one hand. Some wags recently turned the club into a badminton racket in the dead of night, drawing both shrieks of horror and furtive smirks from the public, before it was rapidly returned to its original form. It has been suggested that the figure might have once held a head in his left hand, as there is a small relief carving depicting that detail on a local church; it might also depict the Graeco-Roman figure of Herakles/Hercules (no doubt because of the club). Either way, he is very impressive.

H aving satisfied ourselves in regard to this location, we set off in the opposite direction, in search of the tithe barn mentioned in the title of two of Hodgkins' gouaches from that time. Now in private hands, the barn sits on the far side of a broad meadow on the outskirts of the village, and is approached down a narrow path running beside the stream. With its gothic windows and steep pitched roof, it is

one of the most handsome examples in the area. Early twentieth-century photographs show it dilapidated, its two adjacent porches sagging under the weight of ivy, but today all additions have been removed and the one older porch stands in pride of place.

Magnificent though it is, the barn didn't seem to match what Hodgkins had painted in her gouache. We were confused, because behind the village leading to Mill Lane there is an ancient Saxon barn dating from the eighth century, now named Beauvoir Court after the field behind it, which also served as a tithe barn, and which shares the same single window and ogee-arched door at one end. According to local historian Christina Juppe, it pre-dates the Benedictine abbey, and records talk of another barn being part of the complex.[6]

It was fairly derelict for part of the twentieth century until it was restored and turned into a private dwelling (it even served as a veterinary clinic for a time). It seemed a more likely candidate for the building depicted by Hodgkins, until Jonathan Gooderham, another Hodgkins researcher, collector and dealer, was lucky enough to find the owners of the first tithe barn at home. Once viewed from the rear, Hodgkins' painting falls into place.

The nearby village of Nether Cerne also has a tithe barn, magnificent in size but looking less like a church than the one in Cerne. Saxon churches in this area have square towers divided by jutting horizontal bricks that make them look like three boxes sitting on top of one another. Hodgkins included one of these in her gouache *Cerne Abbas*.

True to form, Hodgkins' opinion of Cerne changed according to whom she was writing. On her return to her studio in Corfe at the beginning of October, she followed her usual habit of working from her drawings 'before I forget that cosy little village which we wrung dry in our search after subjects'.[7] But by December she was referring to her three weeks in Cerne as rather uninteresting; it was overrun with tourists and guest houses, and greedy speculators eager to buy up cheap houses in order to make a profit after the war.

ABOVE The former tithe barn, now a private home, in Cerne Abbas.

RIGHT Mill House, Cerne Abbas.

Her friend Kitty West's mother had lived in Cerne, and in a letter to Kitty, Hodgkins described their former house as sumptuously restored, as far as she could tell from peering through the gate, but that it now had a bus stop directly outside and she couldn't imagine Kitty's mother strap-hanging. More tellingly, she reported that she was finding her drawings rather dull, which probably says more for her state of mind as winter set in and she faced the usual battle to keep warm. But Hodgkins was never still for long, noting in a letter posted from Cerne to her nephew Peter Field that she was already planning her next port of call: 'I am on the track of 2 ex New Zealand ladies who run a guest house somewhere in mid Wales — and run it well.'[8]

The plant sale was in full swing when Chloe and I, both avid gardeners, paused there on our way back through the village. People's enthusiasm for the array of shrubs and cottage-garden flowers piled on wooden trestle tables or lined up against the vine-laden wall was infectious, and we were reluctant to leave.

27

Corfe
ENGLAND

Corfe is a picture-postcard village on the Isle of Purbeck, a misnomer but earned because of the proximity of water on three of its sides: the English Channel, the river Frome and Poole Harbour. Not much has changed in the region since Hodgkins' first visited Corfe in December 1934. The village wraps round the sides of a large common, the ruins of Corfe Castle rising in the distance. John Piper introduced his essay on Hodgkins in *Horizon* magazine with a suitably romantic picture of Corfe's castle poking its 'silver-grey ruined walls into the thinning mist'.[1] A less familiar aerial view shown on the Corfe Castle Town Trust Museum's website, a view which Hodgkins certainly would have painted had a vantage point been accessible, shows the castle side-on, its shattered ramparts tumbling down the hill towards the village, which stretches out to the right like a stony ribbon, the hills and fields rolling away into the distance.

Hodgkins' initial reason for visiting was to spend Christmas with her friend and former pupil Amy Krauss, whom she probably first met in Paris when Krauss was studying at Académie Colarossi at the time Hodgkins was teaching there. They had resumed their friendship when Amy — often simply referred to in later letters as 'Krauss' — came to St Ives for lessons in 1915 with her friend May Wilson.[2] In a simple watercolour sketch called *The Potters*, historically thought to have been done by Hodgkins at St Ives around 1918-19, she depicts two young women, one of whom may be Krauss, seated among a display of pots.

However, although this work seems to fit the period stylistically, the young women's dresses reach only to their knees, and their short sleeves are hardly fitting for a winter in St Ives. Therefore, it is more likely that it was painted when Krauss went to Burford in the late summer of 1923. Hodgkins had found her a shop to rent so she could show off the crate of pottery she would bring with her to sell, and by the time she arrived Krauss had already sourced a ready, free supply of suitable clay as well as a site to build a field-kiln. Hodgkins was deeply impressed by her 'shrewd business brain'.[3] As well as working at her wheel, Krauss took

further lessons with Hodgkins. For a time her watercolours were heavily influenced by Hodgkins' style, so that when they both painted a scene of the village from the same vantage point it was at first glance hard to tell them apart.

Eventually Krauss settled in Corfe, first staying at Highlands in West Street, before acquiring a small stone barn in East Street that became her studio while she built two cottages next door, one for herself and one to let, providing an all-important income. She sold her wares by opening the windows of the barn that faced the street, advertised by a sky-blue sign simply reading 'Pottery'.[4] After returning from Tossa de Mar at the end of April 1936, Hodgkins went back to stay at the now-finished Red Lane Cottage with Krauss, having promised her dealer that she would finish her Spanish works while they were fresh in her memory, refining and gradually abstracting her paintings until pared back to a symbolic recollection of form and feature. She spent the summer months first in Wareham, and then in Llangennith and Solva in Wales, but by mid-November she had established herself in The Studio, West Street, at Corfe, just a five-minute walk away from Krauss's barn.

Amy Krauss's former studio still has a single stone, low in the wall, that says 'Barn' (lest we forget), and the bus stop outside is known as Potter's Barn. Chloe and I discovered this only when we asked an elderly man who was mowing his daisies if he knew where the studio might have been. He chuckled in a Dorset kind of way, proudly claiming ownership of the barn, now his house, and took us around the side to show us the aforesaid stone. He was glad of company and invited us in, telling us that he used to go into his loft to get away from his wife but that sadly she had passed away a number of years ago — he obviously missed the opportunity.

We examined two of Amy Krauss's prints of buildings in the village, while he pulled down a ladder in the tiny sitting room and withdrew to the loft, from where he produced an example of her pottery for us to examine. It was rather solid in shape and glazed a dark, rather depressing green that was no doubt the height of fashion at the time of its production.

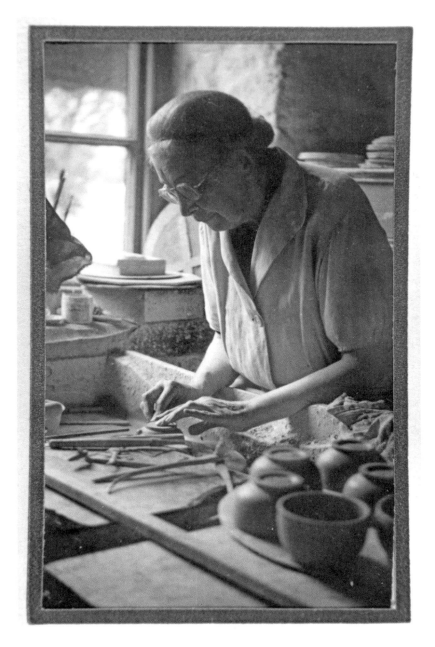

Amy Krauss working in her studio in Corfe c.1940. *E. H. McCormick Papers, E. H. McCormick Research Library, Auckland Art Gallery Toi o Tāmaki, gift of Linda Gill, 2015.*

Hodgkins wasn't alone in sometimes being frustrated with her medium. After Katharine Church had sent some provisions, Hodgkins offered as a thank-you one or two casserole dishes from Amy's next firing, although she warned that the lids weren't always perfect.

It had taken Hodgkins some time to find an appropriate place in which to work. She had first been given the use of the studio in 1934 when she was staying at Highlands. Owned by the elderly artist Francis Newbery, it was a former Wesleyan chapel and had excellent light, although Hodgkins found it disconcerting to be in the company of paintings from an earlier period, as if their outmoded sentiments might steal into her own works if she wasn't alert. She wrote wryly to Mr Reid at Lefevre: 'The high walls are hung with canvasses of a long past Academic School — not so convenient. A quaint galere to find myself in!'[5]

The present owner of the barn kindly drew Chloe and me a little map of the quickest way to get to the West Street studio. The route took us across the road and through to the large common that runs behind the houses on the other side, past another chapel — its façade stark apart from its three rounded windows overlooking the common — and then to the narrow path at the castle end, which led to Hodgkins' studio. She was giving this as her address by the end of 1936, although she didn't stay long, going to Solva and then the following year to Worth Matravers, before, in 1940, settling in the studio in Corfe for the duration of the war.

In a letter to her brother William, Hodgkins described the one-up, one-down cottage next to the studio that became her home, and for which she paid £8 a week: '2 small rooms — very primitive — electric light & heater, a yellow cat, armchair, table & not much else. I go to Swanage by train weekly to change my book & do shopping. Alas it is in a nasty mess after a recent raid & many shops no longer there.'[6] As the war progressed, Eardley Knollys tried to acquire the building to give her some financial security, but it came to nothing.

Hodgkins first met Amy Krauss's friends David Brynley and Norman Notley briefly in 1935, when the men took them to see a film in Swanage. They had a cottage in East Street, although London remained home. The extremely handsome Brynley was considerably younger than Notley, and for part of the 1930s both were members of The New English Singers, which specialised in English madrigals, as well as pieces by Peter Piers and Ralph Vaughan Williams. As they spent more time in Corfe and got to know Hodgkins better, they became close friends.

In August 1941 Hodgkins sent David Brynley a postcard of a Picasso still life that she had acquired in Barcelona in 1936, thanking him for a load of books he had lent her. She was an ardent reader, but because of her peripatetic existence she tended to rely on borrowing. She was particularly interested in evolutionary biologist Julian Huxley's *The Uniqueness of Man*, which she had borrowed and read so many times that in the end she asked Brynley if she might keep it.

Huxley argued that humanity had lost its connection with animals, particularly with the development of Christianity. Traditionally in the Western world this concept was seen as a natural structure, with humans answerable to God, and the natural world placed by degrees beneath them. It was only with Darwin's studies into human origins, and the understanding that human evolution should be viewed on a spectrum that evolves alongside that of other animals, that the pendulum started to swing in favour of the natural world once more. Hodgkins was fascinated by Huxley's writing, her passionate concern for animals and an appreciation of their company being a recurring element in her letters for most of her life.

When she wrote to ask Brynley to ask forgiveness for having forgotten to return it, she said: 'There is no apology abject enough from me to you which could explain and throw light on the mystery of my long silence regarding the handsome gift — or loan — of a signed copy of that rare and daring book I like so much — The Uniqueness of Man — weeks and weeks ago. I must have got embedded in work and forgotten how time was

flying. Do be your own gracious self David and say this incident is now closed and forgive this sinner. I am tremendously proud of my copy. The author's signature adds to its lustre.

'Give him this message that I hope next time he and Mrs Huxley pass this way, they will knock at my studio door. I should be enchanted — if happily I am there. He belongs to the World. I heard a cosmic voice on the air the other night say, that she "loved Julian Huxley because of his accuracy"! — so nice and abstract I thought.'[7] When Brynley informed Huxley of his loss, the author sent him another copy, inscribed: 'Cast your bread upon the waters, and it shall be returned to you, if not buttered, at least autographed'.[8]

Huxley was so impressed by Hodgkins' interest that he made a special visit to meet her when he was lecturing in Bournemouth. This proved a red-letter day for her, having never met Huxley or his wife in person. The Huxleys eventually acquired *Still Life* (*Spanish Still Life and Landscape*), another painting begun in St Tropez but possibly finished later. It shares the twisted cloth, tall white houses and decorated jug (now painted blue) of *Red Jug*.

During the Second World War, the studio proved what she described in a letter to Jane Saunders as an 'old white elephant incubus', not least after its roof collapsed. Her place next door was small and damp, but her main problem was loneliness. She had lost the domestic skills she had demonstrated years ago in Paris, and at her age longed for someone to bring her a cup of tea in the mornings rather than always having to make one herself.[9] Saunders told her she needed to find a 'kind body' to look after her but, as Hodgkins admitted, her neighbour 'puts in an hour tidying up & is always there in case I need her — my midday meal at the Inn for which I pay 3/- a time'.[10] Thanks to Eardley Knollys, Hodgkins started receiving a state pension in 1941 — a timely benefit, as it was very difficult to sell paintings in wartime.

In spite of her trials and hardships, Hodgkins produced some extremely strong works during the years she spent at Corfe. The castle

Frances Hodgkins and David Brynley at Corfe Castle in the 1940s. *E. H. McCormick Papers,*
E. H. McCormick Research Library, Auckland Art Gallery Toi o Tāmaki, gift of Linda Gill, 2015. Photo by Celia Keating.

looms romantically in a number of her compositions, but she could also create a powerful work from the tiny courtyard between the studio, her little abode and Mrs Newbery's cottage next door. Today in summer the courtyard is full of flowers, and is immensely pretty, but in the dead of winter, when it might be dark by 3 p.m., it would have been impossible to work if your eyes were failing, and there would have been no pleasure to be had in her surroundings.

After Hodgkins' 1941 exhibition at the Leicester Gallery, which ran from September to October, John Piper, her old friend from her Seven & Five days, wrote a review of the show in *The Spectator*, published on 17 October: 'There is in result, no sign of the effort that has gone to the creation of these works; no sign of the years of toil that have allowed this . . . apparently songlike expression to have its full effect. Her vision is primarily a vision of colour, yet as every painting here shows (and the final clue is given by three or four drawings in black and white) she draws with originality and power.' Hodgkins wrote to thank him for an important and inspiring piece of writing. 'How beautifully you say what I'm groping after & your phrase of the song does please me very specially.'[11]

Piper's wife, Myfanwy Evans, was writing the Penguin book on Hodgkins that was published after Hodgkins' death, and found her uncooperative in relation to photography. At one point she arranged for a *Vogue* photographer to come to Corfe, but Hodgkins refused to see him and had to write a letter of apology to Evans, who was merely trying to promote her and the forthcoming publication. Hodgkins had been delighted to get the first four Penguin editions, on Henry Moore, Duncan Grant, Paul Nash and Matthew Smith, that had already been released — they were an important development in promoting modern art — but she was also slightly miffed that she wasn't among them. She finished her letter to Evans: 'You will bear in mind what I feel about Vogue without

being abject I would like them to know I am penitent. I must rid of these little Sins that betray me so awkwardly.'[12]

When Duncan Macdonald had previously tried to broach the subject she had tried to fend him off: 'Of course I see the considerable publicity value of a Vogue article (illustrated). Before considering I shall have to find out what restrictions there are about photographing in this ultra restricted area 1st line & all that implies. Supposing you allow me a few days to make enquiries.

'There is nothing glamorous about my poor old chapel Studio. It is strictly precautionary — Anderson Shelter just given me — we live in zone of abortive raids & expect any day to be pushed back. It is not ideal for happy painting.'[13]

She wrote to him again on 5 July: 'I hope that you wont do anything so unjust and so unkind as to send the Editor of Vogue or her assistant to take shots at me against the background of this Studio under its present conditions. Nothing will induce me to consent — the whole idea is repugnant to me & artistically speaking it is a mistake — more, a <u>crime</u>.

'I am going away till the Studio is restored and made safe meanwhile it is locked ... Psychologically — or perhaps pathologically I have an intense aversion to being photographed now — it is too late.'[14] It was two years before she relented, conceding: 'I am writing this while waiting arrival of photographer & fittings. It is a lovely hazy warm day — ideal for outdoor work. I have booked lunch at the Inn for them — they should enjoy their outing. I hope they will. I'll help all I can even to Smiling.'[15]

Hodgkins' appearance mattered a great deal to her, and when she could afford it, or when others had been generous, she got great pleasure from wearing good-quality garments, even if others sometimes found her combinations of patterns and colours rather bohemian. Douglas Glass, for example, described her as looking like one of her own paintings: 'sometimes the most incredible colours put together. In her dress she looked like the "with it" people of today — all these mad colours put together. They weren't those psychedelic colours that they had but they

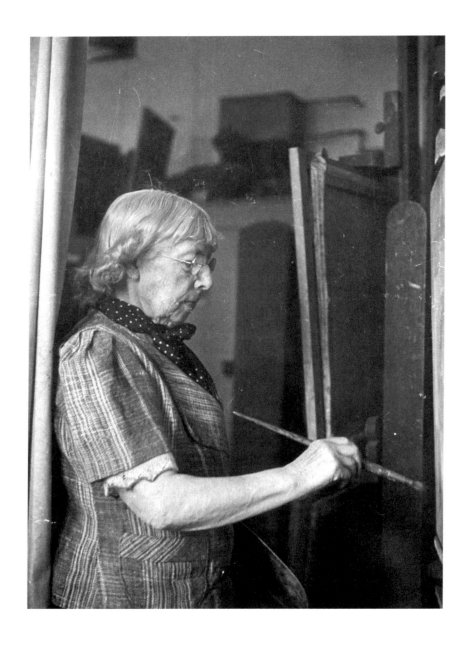

Frances Hodgkins photographed by Felix Man for *Vogue* in her studio in Corfe Castle in July 1945. *Alexander Turnbull Library, ref 35mm-00333-C-F.*

were very brilliant colours; she used to have mad hats that you'd think your Grandmother wore, you know with birds in them, that sort of thing; really florid.'[16]

For the shoot with the *Vogue* photographer, Hodgkins chose to wear a short-sleeved tweed jacket that was almost certainly the work of Ethel Mairet, a remarkable woman who helped restore English weaving and eventually set up a weaving school in Ditchling in Sussex. Although the photographs were taken in black and white, contemporary websites demonstrate that Mairet often dyed her threads tones ranging from pink to dark claret, colours Hodgkins loved.

Mairet was included in a 1943 exhibition of painters, sculptors and weavers in Lewes, Sussex, which also included works by modernist painters such as John Piper, Ivon Hitchens, John Tunnard and Graham Sutherland, all of them showing works that could be used in collaboration to enhance theatre. In 1936 Hodgkins had sent her sister Isabel a postcard showing Gauguin's *Horseback at the Seaside*, accompanied by a scarf. The note on the other side said: 'The scarf is by Mrs Mairet the best English hand weaver & the brooch is from Paris — will you wear them?'[17]

28

Bradford-
on-Tone
ENGLAND

When things became too stressful for Hodgkins in Corfe, not least when gunfire rattled the windows of her studio, she often escaped to The Croft in Bradford-on-Tone, Somerset, the cottage acquired by the Gorers in 1930 as a country retreat. It was almost two hours away and Hodgkins had to go by bus, unless driven there by Ree Gorer, whereas Chloe and I had the luxury of our car, but even so the journey was frustrating.

Once there we easily found the path beside the river that takes you along to the weir. (Hodgkins was often drawn to water in her later works, fascinated by the ripples created as shallow streams passed over stones, only to gain momentum tumbling and foaming down weirs.) However, finding The Croft itself proved an impossible task. In desperation we went into the White Horse Inn, where the two young men, hoping for their first customers of the day, looked disappointed when they realised we weren't there to order anything. But they examined my iPad with interest as I showed them a selection of works done by Hodgkins in the village, and after initially failing to recognise anything, one of them suddenly said of the weir paintings, 'Oh, that's our farm!' It's easy to forget when you spend your life looking at paintings that modern, vaguely abstract works can be quite difficult to 'read' at first glance.

Although Geoffrey Gorer later claimed that Hodgkins hadn't stayed in Bradford-on-Tone for any length of time until 1934, one of the paintings displayed in her first group show at Lucy Wertheim's new gallery in Burlington Gardens in 1930 had been one of two versions of *Farmer's Daughter*, a portrait of Annie Coggan, who lived on the farm nearby and took on the role of caring for guests of the Gorers.

The first version (Fig. 74) is looser in treatment, showing the sitter with her right arm bent, her hand behind her head as if she is letting down her hair. In both works she wears a white sleeveless top with a deep-pink floral brooch. A brick building on the left opens out to a view of the river Tone flowing by in the background. In the second version (Fig. 75), Annie holds the clump of hair hanging down over her breast in both paw-like

hands, as if tying it in a knot, and the pink flower has been moved lower, creating a different rhythm to the composition. And whereas the line of the river provides a light interlude in the first version, in the second there is a radiance to the sitter's face, created by lighter tones on the contours of her cheeks and neck offsetting her rosy cheeks, while the sky behind her head is a soft golden yellow. In the first version, the mood is more contemplative, while in the second, which was gifted by Hodgkins to Coggan, who passed it on in turn to her daughter Nancy Moore, a gentle smile plays across her lips. The background also differs, houses and barns melding with the landscape

Coggan became a close friend of Hodgkins, posing with her for a photograph in the garden of The Croft, accompanied by the inevitable cat that Hodgkins used to feed titbits on the table. After Hodgkins' death David Brynley commented on how much she had loved nature, constantly searching for poetry in the landscape. He described how they often discussed poetry, sharing a particular admiration of William Barnes, a rural Dorset poet: 'to see the quiet-feeding herds, and hear the singing the birds, do still my spirits more than words'. Another poem includes the passage: 'An' all the farmers' housen show'd / Their daughters at the door; / You'd cry to bachelors at hwome— / "Here come: 'ithin an hour / You'll vind ten maidens to your mind, / In Blackmwore by the Stour.'[1] This gives a further resonance to the title, *Farmer's Daughter*, and is surely not coincidental. Brynley felt that Hodgkins shared Barnes' quiet philosophy, and her great talent was to translate these feelings in terms of pictorial colour.

The young men in the pub sent us off in the direction of Tone Green, where we completely failed to find anything resembling The Croft. It was only recently that the father of one of our librarians at Auckland Art Gallery, who lives nearby, drove over to do some sleuthing, and discovered that the house has been renamed Willow Cottage. Photographs show that the house, 20 minutes' walk from the White Horse Inn, has retained the same pitched roof over the front porch, but the mullioned windows have

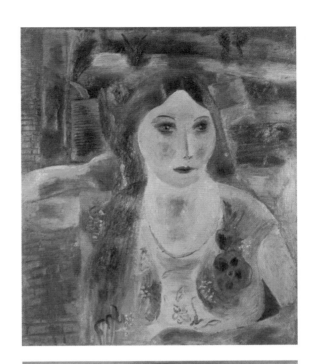

ABOVE **Fig. 74** *Farmer's Daughter (Portrait of Annie Coggan)*, c.1931, oil on canvas. *Collection of the Ravenscar Trust, Christchurch.*

BELOW **Fig. 75** *The Farmer's Daughter (Portrait of Annie Coggan)*, 1929–1930, oil on canvas laid onto board. *Dunedin Public Art Gallery, purchased with funds from the Dunedin City Council, the I M Richdale Trust and the Dunedin Public Art Gallery Society, 2010.*

been replaced. The trees overhanging the front path near the gate have long gone, and today the hedge above the front wall has been neatly trimmed. A side view shows the same profile seen in *Bradford-on-Tone, Geoffrey Gorer's Cottage* (Fig. 76), painted during the war.

The foreground in the work is highly abstracted, with patterns of parallel dashes painted into blocks of colour that wriggle and writhe across the land, laid on in thick impasto, then scratched back with the end of the brush handle. The brick building on the left, possibly the same seen painted in a more literal style in one of her portraits of Annie Coggan, is implied by broad brushstrokes of ochre and deep purplish brown, with sections of crosshatching suggesting the bricks. The Croft is the fulcrum between the two barns, and the trees swirl up like explosions, possibly reflecting the terror Hodgkins felt when bombers flew overhead.

The English landscape took on a new resonance during the war, when the destruction of not just humans but also a way of life seemed imminent. Hodgkins painted a large number of farmyard scenes, particularly one near Fawley Bottom, the home of John and Myfanwy Piper, where she was transfixed by the piles of broken machinery which created random and fascinating patterns and mass. Piper felt she saw them as symbolic of the war, in the same way as the neo-romantic artists argued that they served as metaphors for the emotional and physical damage inflicted on the populace. Picasso argued a similar point in Paris, creating a series of small still-life paintings in the days leading up to the liberation of the city, each dated. As he famously stated, '[E]ven a casserole can scream!'[2]

Annie Coggan claimed that *Zipp* (Fig. 77), one of the 'night' paintings from the period, was derived from an incident when refugees who had been moved into The Croft were thought to have stolen some of Hodgkins' possessions. While its conception may have begun with this event, the painting, like so many of Hodgkins' works, took a long time to germinate, as it can be seen with several others lined up in the background of the photographs taken by Felix Man for *Vogue* magazine in 1945. Hodgkins often laid out groups of work, moving from one to another as inspiration

ABOVE Annie Coggan at The Croft, Bradford-on-Tone, 1930s. *Dr Eric Hall McCormick papers, Alexander Turnbull Library, Wellington.*

BELOW The Croft, now Willow Cottage, today.

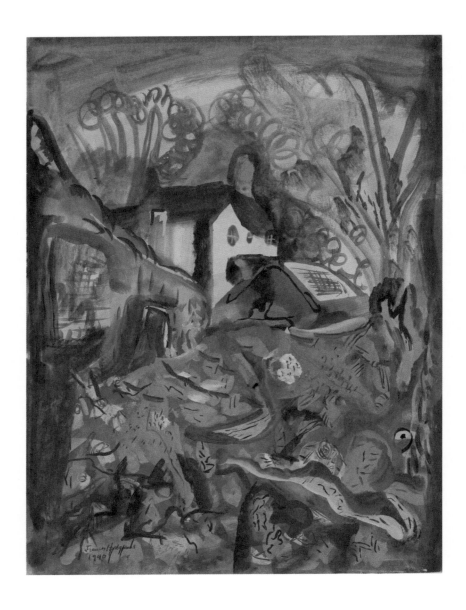

Fig. 76 *Bradford-on-Tone, Geoffrey Gorer's Cottage*, 1940, gouache on paper.
Auckland Art Gallery Toi o Tāmaki, purchased 1970.

took her, and *Zipp* was no exception. Like *Spanish Well, Purbeck, Zipp* is composed of deep tones, individual items such as the dancing zips, shoe and bottle emerging out of the gloom.

But even during the war Hodgkins is addressing 'the modern question', this time in relation to fashion as much as form. In a 2018 article in the *London Review of Books*, 'What does she think she looks like?', Rosemary Hill writes about the ways in which women have made statements through their attire, not least Virginia Woolf and E. M. Delafield, who wrote a column for the feminist magazine *Time and Tide* titled 'The Diary of a Provincial Lady'.[3] Both writers made reference to the ways women of all ages and classes in England defined themselves through innovations in fabrics, styles and tones created with new chemical dyes.

But the greatest revolution was the introduction of new kinds of fasteners. For the first time in centuries a woman could actually dress herself. Rather than having to be winched into stays or stand patiently while a servant painstakingly did up myriad tiny buttons, she could zip herself up instead. Apparently in 1917 Gideon Sundback patented the 'separable fastener', a term that was never going to catch on; within six years it had become the 'zipper' in the United States and the 'zip' in Britain. While Sundback had the military in mind, no doubt concerned that men could throw on their clothing more rapidly before going into battle, women's clothing manufacturers saw the opportunity, thereby changing women's experience with the flash of a hand. Rather than adding an 's', Hodgkins wittily doubles the last consonant, and 'zip' becomes 'zipp'.

W̲hen Hodgkins' nephew Peter Field visited Corfe while on leave during the war in 1943, he was immediately impressed by his aunt's alertness of mind, recalling, in the recordings of family and friends made in 1961 'her perception of everything that was taking place. Her power of observation was completely unimpaired

Fig. 77 *Zipp*, 1945, oil on canvas. *Christchurch Art Gallery Te Puna o Waiwhetū, purchased 1979.*

and everything that she saw you could see that she was registering and forming an opinion. Even things such as the ivy growing on Corfe Castle she objected to because she thought it was hiding the beauty of the stonework. The simplicity with which she analysed objects, I think was one of her greatest assets in her painting. Whatever she saw she was capable of observing analytically with a view to, not actually to putting it on paper, but the whole thing seemed to convey something to her and she seemed to be able to convey it to whoever she was talking to.'

He spent a number of days in her company, finding her a stimulating companion, but on their walks together he also noticed how physically frail she was becoming: '[W]e had to go very slowly and sit down and rest and take it very quietly. She was feeling her age and she was feeling the war too, the effect of rationing and the general strain of the war . . . She could talk very well and she was well versed on a wide variety of subjects. I remember we discussed things like radar which were pretty new in those days and she was interested and she seemed to be able to grasp the fundamentals of it and the importance of it.' Most importantly, Field felt her sense of urgency, of how little time she had left to do the work she wanted to do, because creatively she was still at the height of her powers. He finished: 'She knew she was a great artist and always felt that she could be a credit to New Zealand and was hurt because she hadn't been recognised more by her own countrymen.'[3]

Field never saw his aunt again, although they continued to write to one another, and of course he returned to New Zealand once the war was over. But his assessment of Hodgkins was correct, and she lived to bask in the accolades heaped on her as a result of her retrospective exhibition at Lefevre's in November 1944. Comprised of 79 drawings, watercolours, gouaches and oil paintings, their range stands as a synopsis of her peripatetic life, from a watercolour of the Dogana (customs house) in Venice to the Belgian refugees in St Ives; works representing Concarneau,

Cassis, St Tropez, Tréboul, Ibiza, Dorset and Pembrokeshire . . .

Still lifes, landscapes, animal studies, portraits, farmyards and fishing villages — all demonstrated her ongoing search for new ways to represent everyday things. And the exhibition also indicated the range of people who owned her work. Among them were Forrest Hewit, who had got her the job of fabric designer all those years ago in Manchester; a plethora of friends such as Jane Saunders, Geoffrey Gorer, Dorothy Selby, Kitty and Anthony West; collectors — Lily Macdonald, wife of her dealer; Elizabeth Curtis, radical headmistress and supporter; her dealer Alex Reid and other important figures in British society; the Hon. Sir Jasper Ridley, who became chairman of the Trustees of the Tate Gallery, and a Trustee of the British Museum and of the National Gallery; George Mitchell, who acquired *Spanish Shrine* after the death of Sir Michael Sadler in 1943; and critic Eric Newton, who had so loved the musical qualities of Hodgkins' colour and rhythms. They are a representative selection of those who came to love, admire and respect a woman, a friend, a teacher and an artist who was indomitable almost until the end, which finally came on 13 May 1947.

Frances Hodgkins died in Herrison House, Dorset, an asylum for 'senescent women', for in those days anyone with signs of dementia was placed in such establishments. She had moved into the Greyhound Inn, but gradually her behaviour became more erratic, and Mrs Hobbs, the kindly landlady, could no longer cope; the doctor had her certified on 22 March 1947. Loneliness, the inability to paint anymore, and the experiences she had suffered during the war — all had taken their toll.

At the insistence of Eardley Knollys, Julian Huxley, who was then Director-General of UNESCO, wrote to the director of the hospital, stating that Hodgkins was both a friend and one of the most distinguished modernist painters in England. He requested that she be moved to a private ward. In fact, she was moved to the end of a ward and her bed curtained off. The last time David Brynley saw her, he felt a calmness had 'descended on her like a benediction and in the silence similar to that

which precedes the dawn, I had the feeling that soon she would enter from darkness into Eternal Light'.

He went on: 'I never saw her again. We paid our final homage to her in Weymouth, on a beautiful sunny morning such as she would have loved. Her other friends there were John and Myfanwy Piper, Dorothy Selby, Amy Krauss, Duncan Macdonald, Eardley Knollys and Anthony West. The service was brief, but beautifully spoken. As I watched her flower-covered coffin before it disappeared I recalled some of her wistful remarks: I would have liked a home and children . . . I would have liked to be beautiful . . . A good picture, like murder, will out . . . I have never forgotten New Zealand, one of the most beautiful countries in the world . . . New Zealand is at last beginning to recognise me.'[4]

Afterword

In 1944 Myfanwy Evans interviewed Jane Saunders for the forthcoming Penguin monograph on Frances Hodgkins, and that same day also wrote to Saunders about obtaining a photograph of a Hodgkins work she owned. Saunders replied a day later, having had time to reflect on what she had said in their interview: 'Dear Mrs P . . . It is difficult to say anything exactly true about someone you know & love very well, especially about Frances. Her peculiarities both of temper & physical appearance, & other things which might strike a superficial observer, & which are <u>easy</u> to mention, really don't loom so large in one's knowledge of her. In fact they are so trivial that I never think of them at all. She is unique, and so powerful a spirit that one cannot know her without being changed.

'Actually I sympathise with her cantankerous ways, & in a way that makes them all the more difficult to bear at the time. The words personality & character both seem false applied to Frances. I am not good at describing in words what I feel intensely, but I wish I could convey to you the idea of strength of purpose & integrity of spirit that Frances has always given me. Given is a true word — she has always been a giver. I once said to her when she was saying thank you for some financial aid — that she had given me far more than anything I could possibly give her, which sounds sentimental perhaps, & very young (I <u>was</u> young) but nevertheless reminds me now of the richness of the experience to me then of knowing her. All that has made my life worth living to me, or useful to anyone else, has come from her interest in me.

'I don't think it is possible to understand her without knowing how she

has suffered. I don't mean physically (tho she has), or by reason of poverty, though that too has been a cruel handicap, & a source of real misery, but in her spirit. I understand better nowadays what she was suffering in those Manchester days, & later; the internal conflict, & so terribly alone & without any possibility of help or sympathy; & worse still, unable to accept any help, even if it were forthcoming. It seems to me now that she was becoming terrified lest she should not accomplish her work before she got too old — she knew she had not yet achieved the real aim of her work, & it was perhaps searching rather desperately for the way. The work she has done lately is a triumph of spirit over the infirm flesh — genius defying age & pain.

'Another thing I am sure of, & have always believed is that her inspiration or genius whatever you will was too strong in those critical years of poverty & growth to allow her to compromise & do more popular work to ease her difficulties. It was not [as] though at times her faith in herself may have wavered — she has always had perfect faith in her works.'

Saunders added as a postscript: 'Milton's words fit Frances — both in the obvious meaning & also in the more subtle ideas implicit in the poetry — Fame is the spur that the clear spirit doth raise . . . to scorn delights & live laborious days.'[1]

Shortly after the major memorial exhibition of her work in 1949, *Homage to Frances Hodgkins*, held at St George's in London, some of Hodgkins' paintings were included in a smaller group exhibition. In his review of this exhibition, Neville Wallis encapsulated what many reviewers had said of Hodgkins in her lifetime. He felt her susceptible to influences but enslaved by none, every subject being 'viewed with a hypersensitive eye and recorded with rare refinement', and that what he described as the almost mystical character of her later work occurred because she communed long with nature.[2]

With The Frances Hodgkins Project I have, perhaps, tried to do the impossible: to visit as many as possible of the locations where she worked, but also to try to get inside her head, to see as

she saw. Now, as I look out a window on our land at Kaiwaka, in Northland, I see autumn leaves starting to turn, their reflections shading one side of the pond, long shadows snaking across the dew-covered grass in the mid-morning sunlight. Bushes and shrubs, their various shapes hardly differing, blur into one another, and only the tree trunks stand out as solid forms.

The same occurs when I glance around me as I sit at the kitchen table — a newspaper cast down half read; a yellow-ochre one-handled Spanish jug, spout at the side rather than opposite its handle, squiggly brown lines running around it at intervals. Hodgkins would have liked its simplicity, and I acquired it because it reminded me of her work and I felt it would be useful in the forthcoming exhibition. Another flat brown dish with a lid, splattered with the same tone of brown, accompanies it, and the rest of the table is strewn with magazines, cook books, the computer on which I write, a piece of bright yellow card with a list of things to do, and finally a recently drained coffee cup and a plate with crumbs from toast and homemade marmalade recently consumed.

What, as a modernist, would Hodgkins have done with either view? I think that having at first grumbled that the mass of greens, in all their tones, made it impossible to paint the view out of doors, she would have fixed on the small jetty that runs into the pond, the tree trunks (like those that stand as sentinels in so many of her French and Spanish works of the 1930s) and the upright spears of the flax in the distance — each of these items is clear in form. She would have captured the outline of the pond and perhaps added a few rapid lines to represent the shadows or the movement of light across the water when the wind comes up. She would have eradicated the masses of foliage for the most part, and then, just to confuse us, she would have moved the forms she thought relevant to her composition around until she found the place where they worked best.

And, as was her way, she would have sat, perhaps gazed into space, considered, chosen first one pigment then another, working, overlaying, juxtaposing, using the end of her brush to cut back the layers of paint

in certain areas with calligraphic squiggles, and, after further thought, floated in the jug and the lidded dish at the angles she wanted. It would have taken time, as she worked on several canvases at once, turning from the work on her easel to add a dash or a dab to another composition, stepping back, pausing for thought.

But there is another consideration. From the mid-1930s Hodgkins' letters are scattered with concerns about her eyesight, noting that she wouldn't be able to continue working out of doors unless she got new spectacles. It's quite possible that the softened, misty effect she achieved in what some people have termed her late neo-romantic paintings also owes something to these changes in her vision. If I look out the French doors once more and half-close my eyes so that I am looking through my lashes, something rather wonderful occurs. All that mass of greenery subsides, but the outlines of the jetty and the sharp contrasts of sunlight and shadow stand out as strongly as before.

Hodgkins' constant seeking of different locations was essential, not just for teaching but also for contemplation and reflection, and, most importantly, for inspiration. Her journeys in Europe and Britain brought her in contact with other leading modernists (and the art of the past) as well as new friends and passing acquaintances, who provided company and a conduit for ideas. But most significant of all, her constant journeying from place to place, arduous and tiring though it often was, galvanised her to keep experimenting, to see people, their culture, and the land in which they lived with fresh eyes, which she then translated into the rich and joyous works of art that are her legacy.

Of course no one really 'finds' Frances Hodgkins, because she will never fit comfortably into a single box. But what I hope to have done on this journey is cast some light on how important place became in her search for modernity, and her individuality as an artist, respecting the work of others but always taking her own path.

CLOCKWISE FROM TOP LEFT Frances Hodgkins, 1920; Rosamond Marshall, Dorothy Kate Richmond and Frances Hodgkins in Rijsoord, Holland, 1903; advertisement for Hodgkins' School for Water Colour, 1911; Hodgkins in Mousehole, Cornwall, 1902. *E. H. McCormick Research Library, Auckland Art Gallery Toi o Tāmaki, gift of Linda Gill, 2015.*

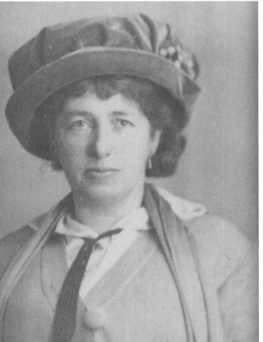

CLOCKWISE FROM TOP Hodgkins photographed by Felix Man for _Vogue_ near Corfe Castle, 1945; a notice for a Seven & Five Society exhibition featuring Hodgkins, 1929; a sketching class at St Valery-sur-Somme, 1912 (with Hodgkins third from right); Hodgkins at St Ives, 1915. _E. H. McCormick Research Library, Auckland Art Gallery Toi o Tāmaki, gift of Linda Gill, 2015._

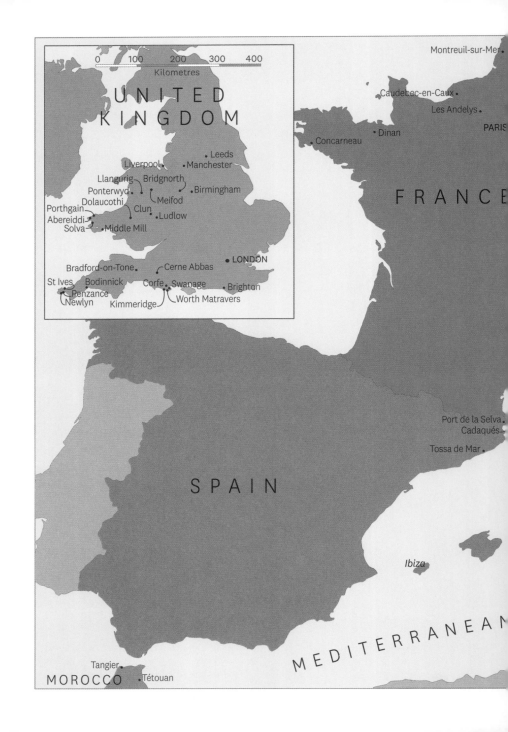

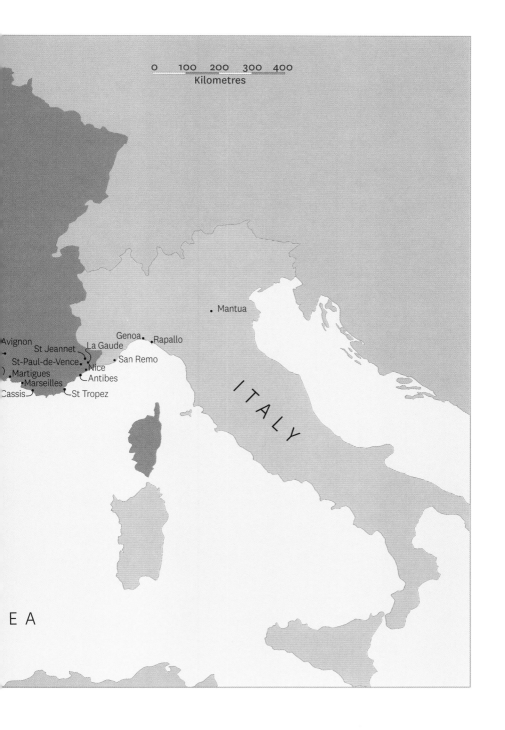

Notes

01 Caudebec-en-Caux

1 Letter to Rachel Hodgkins from Hotel de France, Caudebec-en-Caux, Seine Interieure, 14 July 1901, MS85/10_1, FHLT RC2001/25.
2 Ibid.
3 Ibid.
4 Ibid.
5 Letter to Isabel Field from 21 Avenue de la Grand Armée, Paris, 9 September 1901, MS85/10_5, FHTL RC2001/25.

02 Les Andelys and Dinan

1 Letter to Isabel Field from Rue de l'Apport, Dinan, 30 August 1902. Hodgkins has confused Spenser with Geoffrey Chaucer's Knight in the prologue of *The Canterbury Tales.* The text is often translated as 'a truly perfect, noble knight'. http://www.librarius.com/canttran/genpro/genpro043-078.htm (accessed 5 November 2018).
2 Letter to Rachel Hodgkins from Rue de l'Apport, Dinan, 28 July 1902, MS85/12_6, FHLT RC2001/25.

03 Tangier and Tétouan

1 Letter to D. K. Richmond from Hotel Bristol, Tangier, 3 November 1902, MS85/13_5, FHLT RC2001/25.
2 Ibid.
3 Ibid.
4 Ibid.
5 Ion Perdicaris was kidnapped in 1904 by Mulai Ahmed er Raisuni, known to the English as Raisuli, the year after Hodgkins left. The American government refused to pay the ransom money, sparking a major international incident. Perdicaris ended up respecting his captor, writing later, 'I got so far as to say that I do not regret having been his prisoner for some time . . . He is not a bandit, not a murderer, but a patriot forced into acts of brigandage to save his native soil and his people from the yoke of tyranny.' http://www.capitalcentury.com/1904.html (accessed 24 August 2018).
6 Letter to D. K. Richmond from Hotel Bristol, Tangier, 3 November 1902, MS85/13_5, FHLT RC2001/25.
7 Letter to Rachel Hodgkins from Villa Valentina, 12 January 1903, MS85/13_6, FHLT RC2001/25.
8 Letter to D. K. Richmond from Villa Valentina, 24 January 1903 (no MS no.), FHLT RC2001/25.
9 Ibid.
10 Letter to D. K. Richmond from Villa Valentina, 7 March 1903, MS85/14_1, FHLT RC2001/25.

11 Ibid.
12 Ibid.
13 Ibid.
14 Hermynia Zur Mühlen, *The End and the Beginning: The Book of My Life*, translated, annotated and introduction by Lionel Gossman. Cambridge: Open Book Publishers, 2010.
15 Letter to D. K. Richmond from Hotel Calpe, Tetuán, 23 March 1903, MS85/14_2, FHLT RC2001/25.
16 In the same letter she mentioned that she had been sent a Māori bag on which she had to pay 1s 6d but she was so glad to see the 'little flax friend' that she forgave the donor.
17 Letter to Rachel Hodgkins from Hotel London, Gibraltar, 19 April 1903, MS85/14_6, FHLT RC2001/25.
18 Interview in the *Sydney Morning Herald*, 15 April 1913, 11.

04 Mantua

1 Letter to Isabel Field from Hôtel du Forum, Arles, 6 November 1901, MS85/10_8, FHLT RC2001/25.

05 San Remo

1 Letter to Rachel Hodgkins from Albergo Monte Allegro, Rapallo, 2 December 1901, MS85/11_1, FHLT RC2001/25.
2 Ibid.
3 Ibid.
4 Ibid.
5 Letter to Rachel Hodgkins from Albergo Monte Allegro, Rapallo, 20 December 1901, MS85/11_2, FHTL RC2001/25.
6 Letter to Isabel Field from the Grand Hotel, Oneglia, 20 January 1902, MS85/11_3, FHLT RC2001/25.
7 Ibid.
8 Ibid.
9 Ibid.
10 Letter to Isabel Field from 1 Wellington Terrace, Penzance, 7 March 1902, MS85/11_6, FHLT RC2001/25.
11 Letter to Isabel Field from Patisserie Taffats, Rue de l'Apport, Dinan, 30 September 1902, MS85/12_9, FHLT RC2001/25.

07 St Paul du Var/St-Paul-de-Vence

1 http://folkcostume.blogspot.co.nz/2011/08/joans-provencal-costume.html (accessed 8 July 2017).
2 This information was provided by the tiny tourist office in St Paul. They had only one copy of the brochure so they very kindly photocopied the relevant page.
3 Letter to Rachel Hodgkins from St Paul du Var, 3 December 1923 (no MS no.), FHLT RC2001/25.
4 Letter to Hannah Ritchie and Dorothy (Jane) Saunders from St Paul du Var, *c.*20 December 1923 (no MS no.), FHLT RC2001/25.
5 Letter to Rachel Hodgkins from St Paul, 24 January 1924, FHLT RC2001/25.
6 Photo taken by Baptiste Roussel, https://commons.wikimedia.org/w/index.php?curid=20637287 (accessed 3 May 2016).
7 Hodgkins had experimented with her paint, mixing oil with a water-based medium, causing it to become unstable, and it is only recently that the painting has been restored.
8 Letter to Hannah Ritchie and Dorothy (Jane) Saunders from St Paul, *c.*20 December 1923, FHLT RC2001/25.

08 St Jeannet

1 Letter to Arthur Howell from St Jeannet, 5 December 1929, FHLT RC2001/25.
2 Letter to Arthur Howell from Chez Madame Villa, St Jeannet AM, France, 4 February 1930 (no Ms no.), FHLT RC2001/25.
3 Letter to Arthur Howell, 17 March 1930 (no MS no.), FHLT RC2001/25.
4 Ibid.
5 E. H. McCormick, *Late Attachment: Frances Hodgkins and Maurice Garnier.* Auckland: Auckland City Art Gallery, 1988.
6 Letter to Lucy Wertheim from Pastorale, La Gaude, 26 December 1929 (no MS no.), FHLT RC2001/25.

09 Antibes

1 Letter to Rachel Hodgkins from Hôtel Lion d'Or, St Valery-sur-Seine, 9 September 1906, MS85/17_2, FHLT RC2001/25.
2 Letter to Rachel Hodgkins from Hôtel National D'Alsace, Antibes, 18 November 1906, MS85/17_7, FHLT RC2001/25.
3 Ibid.

10 St Tropez

1 Letter to Rachel Hodgkins from Cassis, 21 December 1920, MS85/38_5, FHLT RC2001/25.
2 Letter to Dorothy Selby from St Tropez, 25 June 1931 (no Ms no.), FHLT RC2001/25.
3 Ibid.

11 Marseilles

1 Rosa Dixon (later Mrs Spencer Bower) travelled to England with Hodgkins. E. H. McCormick, 'Frances Hodgkins — a Pictorial Biography', in Leo Bensemann and Barbara Brooke (eds), *Ascent — A Journal of the Arts in New Zealand,* The Caxton Press in association with the Queen Elizabeth II Arts Council of New Zealand, December 1969, 13.
2 Letter to Rachel Hodgkins written from R.M.S. *Arcadia,* Bay of Biscay, 4 April 1901, MS85/9_5, FHLT RC2001/25.
3 Originally built as an almshouse in the eighteenth century, the Vieille Charité had a chequered history, being used as a refuge for those who lost their homes or livelihoods during the Second World War. It has since been restored.

12 Cassis

1 Letter to Rachel Hodgkins from Cassis, 21 December 1920, MS85/38_5, FHLT RC2001/25.
2 Ibid.
3 E. H. McCormick, *Portrait of Frances Hodgkins,* 2nd edn. Auckland: Auckland University Press, Oxford University Press, 1982, 96.
4 Angelica Garnett, *Deceived with Kindness: A Bloomsbury Childhood.* London: Chatto & Windus/ Hogarth Press, 1984, 68.
5 Ibid, 70.
6 Ibid.
7 Frances Spalding, *Vanessa Bell: Portrait of the Bloomsbury Artist.* London: Tauris Parke Paperbacks, 2016, 217.

13 Martigues

1 Letter to Rachel Hodgkins from Martigues, Bouches-du-Rhône, 4 February 1921, MS85/38_6, FHLT RC2001/25.
2 Letter to Lucy Wertheim from Martigues, 13 February 1928 (no MS no.), FHLT RC2001/25.
3 Letter to William Hodgkins from Martigues, c.28 February 1921, MS83/38_7.
4 Letter to Lucy Wertheim from Martigues, Bouches-du-Rhône, France, 13 February 1928 (no MS no.), FHLT RC2001/25.

14 Avignon

1 Letter to Rachel Hodgkins from Hotel Luxembourg, Avignon, 15 September 1906, MS85/17_3, FHTL RC2001/25.
2 Ibid., 23 October 1906, MS85/17_5, FHLT RC2001/25.
3 Ibid.,10 October 1906, MS85/17_4, FHLT RC2001/25.
4 Reported by A. G. Stephens, 'A Dunedin Girl who Conquered Paris', *Otago Daily Times*, 3 May 1913, 5.

15 Paris

1 A. G. Stephens, 'Frances Hodgkins, a Dunedin Girl who Conquered Paris, Her Exhibitions in Melbourne and Sydney'; and 'An Interview', *Otago Daily Times*, 3 May 1913, 5.
2 Letter to Rachel Hodgkins from 85 rue Vaneau, 24 November 1908, MS85/22_6, FHTL RC2001/25.
3 Alice Muskett, 'A Day at the Atelier Colorossi', *Sydney Daily Telegraph*, 24 February, 2 March, 22 August, 12 September 1896, 27 August 1898. In the 1920s sculptor Henry Moore was one of those who attended, as did many other artists.
4 Henri Matisse with Pierre Courthion, *Chatting with Henri Matisse — The Lost 1941 Interview*, ed. Serge Guilbaut, trans. Chris Miller. Los Angeles: The Getty Research Institute, 2013, 46.
5 Ibid., 50.
6 'Recollections by friends. Patricia A. Sargison. "Wilding, Cora Hilda Blanche"', Dictionary of New Zealand Biography, first published in 1998. *Te Ara — the Encyclopedia of New Zealand*, https://teara.govt.nz/en/biographies/4w17/wilding-cora-hilda-blanche (accessed 3 September 2018).
7 Ibid.
8 https://en.wikipedia.org/wiki/Thames_sailing_barge (accessed 12 April 2018).
9 'Recollections by friends and relatives of New Zealand's internationally acclaimed painter, Frances Hodgkins recorded 19 April 1961', Track 1: 1869–1919, https://teara.govt.nz/en/speech/86/cora-wilding-discussing-frances-hodgkins (accessed 8 February 2016).
10 Letter to Rachel Hodgkins from Grand Hôtel Des Voyageurs, Concarneau, c.15 October 1910, MS85/24_5, FHTL RC2001/25.
11 Stephens, 'A Dunedin Girl who Conquered Paris'.
12 Ibid.
13 Ibid.
14 Colin McCahon, 'Beginnings', *Landfall*, 80, 20, 4 (December 1966), 362.
15 Letter to Arthur Howell from Martigues, 14 February 1931 (no MS no.), FHTL RC2001/25.

16 Penzance and St Ives

1 Letter to Isabel Field, 7 March 1902, ATL 3.2MS85/11_6. Charles Adrian Stokes (1854–1935) and his Austrian wife and fellow artist Marianne Preindlsberger (1855–1927) should not be confused with Adrian Stokes the artist, writer and critic, who with his wife Mellis was instrumental in encouraging British modernists to settle in St Ives before the Second World War.

2 Ibid.

3 Ibid.

4 Letter to Rachel Hodgkins, St Ives, 16 Sept 1915 (no MS no.), FHLT RC2001/25.

5 Letter to Rachel Hodgkins [address cut off; August 1915], MS85/30_10, FHLT RC2001/25.

6 Letter to Rachel Hodgkins from Dordrecht, 12 June 1907 (no MS no.), FHLT RC2001/25.

7 Letter to Rachel Hodgkins from Rock Farm, Beer, Devon, 15 October 1914, MS85/29_1, FHLT RC2001/25.

8 http://www.100firstworldwarstories.co.uk/Edgar-Skinner/story/ (accessed 27 October 2017).

9 Grace Nichol, in Writing on the Wall, Tate Gallery exhibition catalogue. London: Tate, Elspeth Lindner, 1993. Quoted in https://www.independent.co.uk/arts-entertainment/books-writing-on-the-wall-1509939.html (accessed 17 July 2016).

10 Letter to Rachel Hodgkins from the South Australian Hotel, North Terrace, Adelaide, 14 July 1913.

11 Letter to Rachel Hodgkins from Belton, Sydney, 3 April 1913, MS85/26_2, FHLT RC2001/25. Anthony Hordern & Sons was a large Sydney department store that included a very popular exhibition space.

12 Letter to Isabel Field from Sydney, 30 May 1913, FHLT RC2001/25.

13 Letter to Rachel Hodgkins from St Ives, 28 January 1915, MS85/29_9, FHLT RC2001/25. According to his family's website, Jack had obtained a commission in the Australian 26th Regiment before training at Aldersholm, and was attached to the 3rd Battalion King's Liverpool Regiment as 2nd Lieutenant from August 1914. After being injured, he was hospitalised in Rouen (2nd British Red Cross Hospital) in March 1915, and died two months later in Festubert, France, at the age of 19. On 13 March 1918 S. L. Morris of the 4th King's Regiment sent Jack's family this citation which was written by his commanding officer: 'For gallantry and devotion to duty on the 16th and 17th May 1915 at Richebourg in leading his platoon across "no man's land" under very heavy fire and subsequently in a further attack on the Ferme Cour D'Avoue on the 17th, when his platoon was ordered to withdraw from a difficult position, by his coolness and ability he was able to effect this with success and with very few casualties. Lieut J S Rich was exceptionally brave on this occasion running great personal risks to ensure the safety of his men.' He was killed almost at the moment when the operation was concluded. http://www.linleyfh.com/p739.htm (accessed 1 May 2018).

14 Letter to Rachel Hodgkins from St Ives, 16 August 1915, MS85/30_9, FHLT RC2001/25.

15 'Recollections by friends and relatives of New Zealand's internationally acclaimed painter, Frances Hodgkins', recorded 19 April 1961, Track 1: 1869–1919.

16 Ibid.

17 The drawing is now in the National Portrait Gallery, London. https://www.npg.org.uk/collections/search/portrait/mw84917/Frances-Mary-Hodgkins (accessed 4 June 2018).

18 When Lucy Wertheim was taken to visit Wallis in the late 1920s, she described his home as a hovel. She acquired a number of his paintings, paying him a lot more than he asked, and had an exhibition of his works in 1931 at her gallery in London. Lucy Wertheim, Adventure in Art. London: Nicholson & Watson, 1947, 83–84.

19 Letter to Rachel Hodgkins from 7 Porthmeor Studio, St Ives, 17 July [1917], MS85/32_13, FHLT RC2001/25.

20 Ibid.

21 Michael Young, The Elmhirsts of Dartington. London: Routledge & Kegan Paul, 1982, 131.

22 Letter to Eardley Knollys from Corfe Castle, Dorest, 13 October 1945 (no MS no.), FHLT RC2001/25.

23 Letter to Eardley Knollys from Corfe Castle, Dorset, 27 January 1946 (no MS no.), FHLT RC2001/25.

17 Bodinnick

1 Letter to Dorothy Selby from The Nook, 12 December 1931 (no MS no.), FHLT RC2001/25.
2 Cited in Hilary Macaskill, *Daphne du Maurier at Home*. London: Frances Lincoln, 2013, 34.
3 Daphne du Maurier, *Growing Pains — The Shaping of a Writer*. London: Victor Gollancz, 1977, 150.
4 Ibid., 154.
5 Letter to Dorothy Selby from The Nook, Bodinnick-by-Fowey, 21 December 1931 (no MS no.), FHLT RC2001/25.
6 Letter to Dorothy Selby from Bodinnick, Fowey, Cornwall, April 1932 (no MS no.), FHLT RC2001/25.

18 Leeds, Manchester and Liverpool

1 Letter to Hannah Ritchie and Jane Saunders from Burford, *c*.24 June 1922 (no MS no.), FHLT RC2001/25.
2 Ibid., *c*.5 September 1922 (no MS no.), FHLT RC2001/25.
3 Hodgkins had ongoing stomach troubles from her illness during on her first visit to Europe. This was resolved only when she was operated on for a duodenal ulcer in 1941, but she also had chronic bronchitis owing to her living conditions.
4 Letter to Rachel Hodgkins from Platt Abbey, Rusholme, Manchester, 20 June 1925, MS85/42_6, FHLT RC2001/25.
5 The organisers hated Le Corbusier's design, blocking it with a wall until ordered to take it down by the French Minister of Fine Arts. Extract from *Le Corbusier, Oeuvre complète, volume 1, 1910–1929*; http://www.fondationlecorbusier.fr/corbuweb/morpheus.aspx?sysId=13&IrisObjec tId=5061&sysLanguage=en-en&itemPos=44&itemCount=78&sysParentId=64 (accessed 18 May 2018).
6 'Cubist dreams and wings like fireflies: Claire Regnault on the textile designs of Frances Hodgkins', http://arts.tepapa.govt.nz/off-the-wall/5854/cubist-dreams-and-wings-like-fireflies, quoting Helen Appleton Read; quoted in Charlotte Benton, 'The International Exhibition', in C. Benton et al., *Art Deco 1910–1939* . London: V&A Publications, 2003, 143.
7 Eric Knowles, *Art Deco*. London: Bloomsbury, 2014, 25.
8 Letter to Isabel Field from Platt Abbey, 29 August 1925, MS85/42_7, FHLT RC2001/25.
9 Letter to Hannah Ritchie and Jane Saunders, 23 August 1925 (no MS no.), FHLT RC2001/25.
10 Eric McCormick Archives, MS Papers 4126, Alexander Turnbull Library.
11 https://blog.tepapa.govt.nz/2013/11/21/more-than-a-footnote-frances-hodgkins-textile-designs/ (accessed 22 December 2017). For a broader discussion of the Calico Printers Association, see Linda Tyler, 'Fanny's Frocks: Exploring Frances Hodgkins' Fashion Sense', in *Context*, 5 (November 2004/March 2005), 10–15.
12 Letter to Eardley Knollys from Corfe Castle, 6 June 1944 (no MS no.), FHLT RC2001/25.
13 Letter to Isabel Field from 142 Wellington Road, Withington, Manchester, 26 April 1926, MS85/42_10, FHLT RC2001/25.
14 Letter to Hannah Ritchie from Hôtel Belle Vue, Montreuil-sur-Mer, 26 August 1924. As Drey was 34 at the time, she was hardly a child, but Hodgkins' instinct was right, for there are only a few examples of her work extant, and they are amateur sketches. The identity of the 'Irish girl' is as yet unknown.
15 Wertheim, *Adventure in Art*, 2.
16 Ibid.
17 Ibid., 3.
18 Letter to Lucy Wertheim from Hôtel Moderne, Martigues, 13 February 1928 (no MS no.), FHLT RC2001/25.

19 Linda Gill (ed.), *Letters of Frances Hodgkins*. Auckland: Auckland University Press, 1993, 396.

20 Ibid., 397.

21 Jane Saunders in Bensemann and Brooke (eds), *Ascent: A Journal of the Arts in New Zealand: Frances Hodgkins Commemorative Issue*, 52.

22 Wertheim, *Adventure in Art*, 4.

23 Ibid., 6–7.

24 Ibid., 7.

25 Ibid., 11.

26 Ibid., 17–19.

27 Letter to Lucy Wertheim from East Bergholt, Suffolk, *c*.4 August 1930 (no MS no.), FHLT RC2001/25.

28 Letter to Lucy Wertheim from Flatford Mill, Suffolk, 27 August 1930 (no MS no.), FHLT RC2001/25.

19 Ibiza

1 Miguel Ángel González, 'The fishermen's neighborhood', 28 September 2015. https://www.diariodeibiza.es/pitiuses-balears/2015/09/27/barrio-pescadores/795790.html (accessed 25 September 2017).

2 Maurice Garnier, not to be confused with his namesake, the Parisian art dealer, had a naval career during the First World War, but when Hodgkins first met him in St Jeannet in 1930 he had become an experimental sculptor, using found objects. Hodgkins promoted him to her dealer and supporter, Lucy Wertheim, in the hope of securing him an exhibition in England, but nothing seems to have come of it.

3 June Opie interview transcripts of interviews of fellow friends and artists in Britain, MS-Papers-5292-195, Collection: McCormick, Eric Hall (Dr), 1906–1995: Papers, 1969.

4 The location of the work, *Seascape*, which she inscribed 'To Dolf Rieser from Frances Hodgkins 1933', is currently unknown.

5 Unpublished autobiography, https://dolfrieser.com/biography/ (accessed 6 June 2017).

6 Letter to Karl Hagedorn from Ibiza, 29 January 1933 (no MS no.), FHLT RC2001/25.

7 Letter to Dorothy Selby from Hotel Balear, Ibiza, 10 January 1933 (no MS no.), FHLT RC2001/25.

8 Henri Matisse, 'Modernism and Tradition', *The Studio* (January–June 1935), 238. Quoted in Raoul Hausmann, *Raoul Hausmann: Architect, Ibiza 1933–1936*. Brussels: Fondation Pour L'Architecture, AAMd, 1990, 66.

9 Postcard titled 'Grupo Campesino Rural Group to Dorothy Selby', 5 May 1933.

10 Photographer, via Punica 14–16, FOTO RAYMAR.

11 Letter from Walter Benjamin to Gretel Adorno, June 1933, Walter Benjamin: Correspondance 1929–1940. Éditions Aubier Montagne, Paris, 1979, reproduced in *Raoul Hausmann*, 12.

12 Letter to Duncan Macdonald from Red Lane Cottage, Corfe Castle, 25 May 1936 (no MS no.), FHLT RC2001/25.

13 Elliot Paul, *The Life and Death of a Spanish Town*. New York: Random House, 1937, 40.

14 I have since made this myself, which pleased Antoni enormously, saying I was now a true Ibicencan housewife.

20 Tossa de Mar

1 *New English Weekly*, 4, 17 (8 February 1934), 408. Quoted in Jennifer Birkett, *Margaret Storm Jameson: A Life*. Oxford: Oxford University Press, 2009, 135.

2 Birkett, *Margaret Storm Jameson*, 134.

3 Letter to Ree Gorer from Casa Steyer, 7 December 1935 (no MS no.), FHLT RC2001/25.

4 Ibid., 23 September 1935 (no MS no.), FHLT RC2001/25.

5 See https://libcom.org/history/greville-texidor-1902-1964-werner-droescher-1911-1978 (accessed 30 May 2018). Because of Droescher's German heritage, they were forced out of England after they had moved there from Spain, and it was in New Zealand, under Frank Sargeson's wing, that Greville Texidor became a writer.

6 Greville Texidor, unpublished essay on Frances Hodgkins. MSS & Archives A-198, Box 2, Folder 8, UA Special Collections/Kohikohinga Motuhake, University of Auckland.

7 Ibid.

8 Letter to Ree Gorer, 7 December 1935 (no MS no.), FHLT RC2001/25.

9 Letter to Dorothy Selby, November 1935 (no MS no.), FHLT RC2001/25.

10 Greville Texidor, unpublished essay on Frances Hodgkins, MSS & Archives A-198.

11 Letter to Dorothy Selby, 3 September 1933 (no MS no.), FHLT RC2001/25.

12 Although Hodgkins had been enormously grateful for Wertheim's friendship and support at the end of the 1920s, she ultimately found her smothering, and a rift formed between them. Hodgkins didn't like to feel she had been bought, and was offended when Wertheim asked her to do a range of small paintings for little money so she could give them to her friends at Christmas. There was also ill feeling on Wertheim's part after Hodgkins signed a contract with Arthur Howell at St George's Gallery. It was a pity, as they had been very close, but Hodgkins was fiercely (sometimes too fiercely) independent. She never had the kind of equal friendship with Wertheim that she had with her other friends such as Ree Gorer (who was equally beneficent), Amy Krauss and others.

13 Letter to Duncan Macdonald, c.15 February 1936 (no MS no.), FHLT RC2001/25. She was indignant as Lucy Wertheim had included some of her works from the late 1920s and early 1930s in an exhibition, forcing Hodgkins to postpone the show she was planning at the Leicester Galleries until the following year.

14 Picasso 1936, Huellas de una Exposición. Museu Picasso, Ajuntament de Barcelona: Institut de Cultura, 2011.

15 Letter to Duncan Macdonald from Red Lane Cottage, Corfe Castle, 28 May 1936 (no MS no.), FHLT RC2001/25.

16 Katharine West went on to found the Hambledon Gallery in Blandford, Dorset, showing leading artists such as Henry Moore, Elizabeth Frink, Cecil Beaton, Frances Hodgkins, Ivon Hitchens and Lucy Rie.

21 London

1 Douglas Glass, June Opie interview transcripts of interviews of fellow friends and artists in Britain, MS-Papers-5292-195 Collection: McCormick, Eric Hall (Dr), 1906–1995: Papers, 1969.

2 Letter to Rachel Hodgkins from Upper Norwood, London, 19 April 1901, MS85/6, FHLT RC2001/25.

3 Ibid. Ernest Proctor married Doris (Dod) Proctor, and Hodgkins almost certainly met them in either St Ives or Newlyn at a later date.

4 Letter to Rachel Hodgkins from Penzance, 29 May 1902, MS85/12_2, FHTL RC2001/25.

5 Letter to Rachel Hodgkins from The Studio, 1 Eldon Road, London W8, late 1918, MS85/35_9, FHTL RC2001/25.

6 Ibid.

7 Letter to Rachel Hodgkins from Eldon Road, Kensington, 20 October 1919, MS85/37_1, FHTL RC2001/25.

8 https://www.historic-uk.com/HistoryUK/HistoryofBritain/The-Spanish-Flu-pandemic-of-1918/ (accessed 12 May 2018).

9 Letter to Rachel Hodgkins from 52 Lower Sloane Street, London, 1 May 1903, MS85/14_7, FHLT RC2001/25. The watercolour displayed was *Fatima*, from her time in Morocco.

10 Quoted in McCormick, *Portrait of Frances Hodgkins*, 106–7.

11 Letter to Gilbert Hodgkins from London, 15 August 1928, MS85/43_5, FHLT RC2001/25.

12 Letter to William Hodgkins from 34 Fitzroy Street, London, 23 November 1928, MS85/43_7, FHLT RC2001/25. Unfortunately, it hasn't been possible to locate what she created for the BBC.

13 Letter to William Hodgkins from Fitzroy Street, 5 December 1928, MS85/43_8 34, FHLT RC2001/25.

14 Geoffrey Gorer, June Opie interview transcripts of interviews of fellow friends and artists in Britain, MS-Papers-5292-195 Collection: McCormick, Eric Hall (Dr), 1906–1995 : Papers, 1969.

15 Letter to Dorothy Selby from 40 Belsize Park Gardens, sometime in June 1932 (no MS no.), FHLT RC2001/25.

16 Ibid.

17 Noted in Sarah Jane Checkland, *Ben Nicholson: The Vicious Circles of His Life & Art*. London: John Murray, 2000, 106.

18 Letter to Dorothy Selby from Studio 7 Lambolle Road, 3 September 1933 (no MS no.), FHLT RC2001/25.

19 Glass, June Opie transcripts of interviews of fellow friends and artists in Britain.

20 https://en.wikipedia.org/wiki/Isokon_Flats (accessed 7 September 2017).

21 Letter to Dorothy Selby from Worth Matravers, Dorset, 7 October 1938 (no MS no.), FHLT RC2001/25.

22 Letter to Isabel Field from Patisserie Taffats, Rue de l'Apport, Dinan, 30 September 1902, MS85/12_9, FHLT RC2001/25.

23 Letter to Rachel Hodgkins from Venice, *c.*18 July 1906 (no MS no.), FHLT RC2001/25.

24 Hubert Nicholson, 'Glimpses of Edith Sitwell', unpublished memoir, 192. Quoted in Victoria Glendinning, *Edith Sitwell — A Unicorn Among Lions*. London: Weidenfeld & Nicolson, 1981, 192.

25 Letter to Dorothy Selby from Worth Matravers, Dorset, 27 July 1938 (no MS no.), FHLT RC2001/25.

26 Letter to William Hodgkins from Corfe Castle, Dorset, 4 May 1940, MS84/44_9, FHLT RC2001/25.

27 Denton Welch, *The Journals of Denton Welch*, ed. Michael De-la-Noy. New York: E.P. Dutton, 1986, 68.

28 Evelyn Waugh, *The Diaries of Evelyn Waugh*, entry for 9 October 1955, quoted in Victoria Glendinning, *Edith Sitwell*, 318.

29 Letter to Dr Honeyman, Lefevre Gallery, from Worth Matravers, Dorset, 23 January 1930 (no MS no.), FHLT RC2001/25.

30 Letter to William Hodgkins from Corfe Castle, Dorset, 12 September 1941, MS85/45_6, FHLT RC2001/25.

31 Letter to Dorothy Selby, January 1940 (no MS no.), FHLT RC2001/25.

22 Meifod, Bridgnorth, Ludlow and Clun

1 Letter to Dorothy Selby from Lynn, *c.*14 August 1932 (no MS no.), FHLT RC2001/25.

2 After much negotiation and to the satisfaction of all parties, that work has now entered the collection at Auckland Art Gallery thanks to the kind generosity of the former Friends of the Gallery. What pleases me most is that a little bit of Wales has now found itself in New Zealand.

23 Ponterwyd, Llangurig and Dolaucothi

1 Letter to Ree Gorer from Hotel George Barrow, Ponterwyd, 14 August 1935 (no MS no.), FHTL RC2001/25.

2 Ibid. James Dickson Innes (1887–1914) was a British painter whose work had Fauvist overtones,

with a predilection for remote landscape scenes in bright colouring.

3 Letter to Eardley Knollys from Clochfaen Hall, Llangurig, 25 April 1945 (no MS no.), FHTL RC2001/25.

24 Solva, Middle Mill, Abereiddi and Porthgain

1 Letter to Duncan Macdonald from Red Lane Cottage, East Street, Corfe Castle, Dorset, *c.*12 November 1936 (no MS no.), FHLT RC2001/25.

2 Letter to Dorothy Selby from Worth Matravers, Dorset, 7 October 1938 (no MS no.), FHLT RC2001/25.

3 Ibid.

4 https://en.wikipedia.org/wiki/Graham_Sutherland (accessed 27 October 2017).

5 Iowerth C. Peate, 'Pembrokeshire Folk Customs', *Man*, vol. 35 (February 1935): 32. http://www.jstor.org/stable/2791279 (accessed 5 January 2017).

25 Worth Matravers, Swanage and Kimmeridge

1 Letter to Duncan Macdonald from Sea View, Worth Matravers, Dorset, 20 May 1937 (no MS no.), FHLT RC2001/25.

2 Letter to Ree Gorer from Sea View, Worth Matravers, 23 July 1937 (no MS no.), FHLT RC2001/25.

3 Ibid.

4 Letter to Duncan Macdonald, 28 July 1937 (no Ms no.), FHLT RC2001/25.

5 Letter to Ree Gorer from Sea View, Worth Matravers, 21 May 1937 (no MS no.), FHLT RC2001/25.

6 Letter to Rachel Hodgkins from Manchester, 22 January 1926, MS85/42_9, FHLT RC2001/25.

7 Letter to Ree Gorer, Christmas Eve 1937, Worth Matravers, posted Swanage 27 December 1937 (no MS no.), FHLT RC2001/25.

8 https://theculturetrip.com/europe/france/paris/articles/gertrude-stein-pablo-picasso-an-unlikely-friendship/ (accessed 17 July 2018). Stein's evenings at 27 rue de Fleuris became famous, and it was her collection of Picasso paintings, acquired when he was unknown, that helped to promote his career.

9 Letter to Reid from Studio Cottage, West Street, Corfe Castle, Dorset, 15 April 1942 (no MS no.), FHLT RC2001/25.

10 John Piper, in Myfanwy Evans (ed.), 'Lost — A valuable object', *The Painter's Object*. London: Gerald Howe, 1937, 68–73.

11 Paul Nash, *Outline, An Autobiography and Other Writings*. London: Faber & Faber, 1949, 122.

12 Letter to David Brynley from Corfe, 21 December 1943, Allen family archive, Auckland.

26 Cerne Abbas

1 http://www.british-history.ac.uk/vch/dorset/vol2/pp53-58 (accessed 9 December 2017).

2 Sir Frederick Treves, *The Highways and Byways in Dorset*. Quoted in *Dorset Life*, http://www.dorsetlife.co.uk/2012/05cerne-abbas-when-the-village-was-sold-at-auction (accessed 20 December 2015). First published as *The Travels through England of Dr. Richard Pococke, successively Bishop of Meath and of Ossory, During 1750, 1751, and Later Years*. London: Camden Society, 1888, vol. 42.

3 Ibid.

4 Tony Burton-Page, cerneabbashistory.org (accessed 20 December 2015).

5 Letter to Peter Field from the New Inn, Cerne Abbas, 16 September 1943 (no MS no.), FHLT RC2001/25.

6 Christina Juppe, '1400 years of history?', http://www.dorsetlife.co.uk/2011/05/1400-years-of-history (accessed 30 August 2015).

7 Letter to Dorothy Selby from The Studio, Corfe, 16 October [1943], (no MS no.), FHLT RC2001/25.

8 Letter to Peter Field from the New Inn, Cerne Abbas, 16 September 1943, MS85/46_6, FHLT RC2001/25.

27 Corfe

1 John Piper, 'Frances Hodgkins', *Horizon*, 4, 24 (1941), 413–16.

2 May Wilson was one of three sisters, all of whom studied under John Alfred Arnesby Brown. https://cornwallartists.org/directory?page=144 (accessed 16 May 2018).

3 Letter to Hannah Ritchie from Studio, St Lawrence's Street, Burford Oxon, Monday [June? 1923] (no MS no.), FHLT RC2001/25.

4 A. C. Sewter, 'Amy Krauss, Potter and Painter', *Apollo*, 47, 279 (May 1948).

5 Letter to Alex Reid from Highlands, Corfe Castle, Dorset, 20 December 1934 (no MS no.), FHLT RC2001/25.

6 Letter to William Hodgkins from Corfe Castle, 20 June 1942, MS85/46_1, FHLT RC2001/25.

7 Letter to David Brynley from Corfe, Corfe Castle, Allen family archive, Auckland.

8 David Brynley, 'Frances Hodgkins', unpublished memoir, Allen family archive.

9 Letter to Jane Saunders from Corfe Castle, c.1943, Tate Archives 8210.17.

10 Ibid.

11 Letter to John Piper from Corfe Castle, September 1941 (no MS no.), FHLT RC2001/25.

12 Letter to Myfanwy Evans from Corfe Castle, 8 June 1944 (no MS no.), FHLT RC2001/25.

13 Letter to Duncan Macdonald from Corfe Castle, 11 April 1943 (no MS no.), FHLT RC2001/25.

14 Letter to Duncan Macdonald from Corfe Castle, Dorset, 5 July 1943 (no MS no.), FHLT RC2001/25.

15 Letter to Duncan Macdonald from Corfe Castle, Dorset, 25 July 1945 (no MS no.), FHLTRC2001/25.

16 Douglas Glass, Interviews by June Opie: Misc MS 167, Hocken Library,1969, Tape 1, 3.

17 Postcard to Isabel Field from Corfe Castle, 15 July 1936 (no MS no.), FHLT RC2001/25.

28 Bradford-on-Tone

1 'William Barnes — poems'. PoemHunter.com — the World's Poetry Archive. Blackmore Vale is part of the broader Stour Valley in Dorset, and not to be confused with the Stour River that runs through Constable country in Suffolk.

2 https://www.pablopicasso.org/the-charnel-house.jsp (accessed 20 June 2017).

3 Peter Field, 'Recollections by friends and relatives of New Zealand's internationally acclaimed painter, Frances Hodgkins'. Recorded 19 April 1961, Track 2, 1920–1947.

4 Peter Field, 'Recollections by friends and relatives of New Zealand's internationally acclaimed painter, Frances Hodgkins'. Recorded 19 April 1961, Track 2, 1920–1947.

5 Brynley, 'Frances Hodgkins'.

Afterword

1 Letter to Myfanwy Piper, 19 November 1944 (no MS no.), FHLT RC2001/25.

2 Neville Wallis, 'Review', *Journal of the Royal Society of Arts* 97, 4806 (1949), 946. http://www.jstor.org/stable/41364455 (accessed 25 May 2017).

Bibliography

Archives

Alexander Turnbull Library, McCormick, Eric Hall (Dr), 1906–1995: Papers, MS-Group-0380.

Alexander Turnbull Library, June Opie, transcripts of interviews of fellow friends and artists in Britain, MS-Papers-5292-195. Collection: McCormick, Eric Hall (Dr), 1906–1995: Papers, 1969.

Auckland Art Gallery Toi o Tāmaki, Frances Hodgkins' Letters Transcripts, E. H. McCormick Research Library, 1875–1946, RC 2001/25.

Auckland Art Gallery Toi o Tāmaki, E. H. McCormick Papers, E. H. McCormick Research Library, gift of Linda Gill, 2015, RC2015/4.

Hampshire Archives & Socal Studies: Papers of Sesame Club Ref 38M49/E12/19 Hampshire Record Office, Sussex Street, Winchester, Finding number 38M49.

Nga Taonga Sound & Vision, Sound Collection, reference 3950,1969: https://ngataonga.org.nz/collections/catalogue/catalogue-item?record_id=223032.

Books, exhibition catalogues and recordings

7&5: The Seven and Five Society, 1920–1935. London: The Fine Art Society, 2014.

Adventure in Art: Modern British Art Under the Patronage of Lucy Wertheim. Salford: Salford Museum and Art Gallery and the Towner Art Gallery, 1992.

Barton, Christina. The Expatriates: Frances Hodgkins and Barrie Bates. Wellington: Adam Art Gallery, 2005.

Bayly, Janet (ed.). Frances Hodgkins: Kapiti Treasures. Waikanae: Mahara Gallery, 2010.

Bendigo Art Gallery. Wild Colonials: Australian Artists & the Newlyn & St Ives Colonies. Bendigo: Bendigo Art Gallery, 2009.

Bensemann, Leo and Barbara Brooke (eds). Ascent: A Journal of the Arts in New Zealand: Frances Hodgkins Commemorative Issue. Christchurch: Caxton Press in Assoc. with the Queen Elizabeth II Arts Council of New Zealand, 1969.

Blackley, Roger. Goldie. Auckland: Auckland Art Gallery Toi o Tāmaki and David Bateman, 1997.

Bomford, David, Jo Kirby, John Leighton, and Ashok Roy. Art in the Making: Impressionism. London: The National Gallery, in association with Yale University Press, 1990.

Broude, Norma. The Macchiaioli: Italian Painters of the Nineteenth Century. New Haven and London: Yale University Press, 1987.

Buchanan, Iain, Michael Dunn and Elizabeth Eastmond. Frances Hodgkins: Paintings and Drawings. Auckland: Auckland University Press, 2001.

Buchanan, Iain. 'Frances Hodgkins and Neo-Romanticism'. In Writing, a New Country: A Collection of Essays Presented to E. H. McCormick in His 88th Year, edited by James Ross, Linda Gill and Stuart McRae, 155–64. Auckland: J. Ross, 1993.

Carlyle, Leslie. *The Artist's Assistant: Oil Painting Instruction Manuals and Handbooks in Britain 1800–1900 with Reference to Selected Eighteenth-century Sources*. London: Archetype Publications, 2001.

Collins, R. D. J. (ed.). *Hodgkins '97: Papers from the symposium held at the University of Otago, 4–6 April 1997, to mark the 50th anniversary of Frances Hodgkins' death*. Bulletin of New Zealand Art History, Special Series No. 4, 1998. Dunedin: Hocken Library in association with Research Centre for New Zealand Studies, University of Otago, 1998.

Collins, Roger. 'A Long Attachment: Frances Hodgkins in France'. In *Writing, a New Country: A Collection of Essays Presented to E. H. McCormick in His 88th Year*, edited by James Ross, Linda Gill and Stuart McRae, 155–64. Auckland: J. Ross, 1993.

Collins, Roger, and Iain Buchanan. *Frances Hodgkins on Display: Galleries, Dealers & Exhibitions, 1890–1950*. Dunedin: Hocken Library, University of Otago, 2000.

Deepwell, Katy. *Women Artists Between the Wars: A Fair Field and No Favour*. Manchester: Manchester University Press, 2010.

Díaz Jiménez, Manuel. 'Rodríguez Arias, Germà'. *Enciclopèdia d'Eivissa i Formentera*, Consell Insular d'Eivissa i Ajuntament d'Eivissa, Ibiza, 1995–2015. http://www.eeif.es/veus/Rodr%C3%ADguez-Arias-Germ%C3%A0/.

Drayton, Joanne. *Frances Hodgkins: A Private Viewing*. Auckland: Godwit, 2005.

du Maurier, Daphne. *Growing Pains — The Shaping of a Writer*. London: Victor Gollancz, 1977.

—— *Enchanted Cornwall — Her Pictorial Memoir*. Edited by Piers Dudgeon. London: Michael Joseph, 1990.

—— *Vanishing Cornwall*. London: Virago, 2012.

Dunn, Michael. *Nerli: An Italian Painter in the South Pacific*. Auckland: Auckland University Press, 2005.

Evans, Myfanwy. *Frances Hodgkins*. London: Penguin, 1948.

Fairburn, A. R. D. 'The Wertheim Collection'. In *Year Book of the Arts in New Zealand*. Vol. 5, 11–17. Wellington: Harry H. Tombs, 1949.

Frances Hodgkins 1869–1947: A Centenary Exhibition. Foreword by G. C. Docking, essays by David Armitage and Ian Roberts. Auckland: Queen Elizabeth II Arts Council of New Zealand, 1969.

Frances Hodgkins 1869–1947: A Centenary Exhibition. Introduction by Avenal McKinnon. London: Whitford & Hughes, 1990.

Frances Hodgkins and Her Circle. An exhibition arranged by the Auckland City Art Gallery on the occasion of the Auckland Festival of the Arts 1954. Foreword by Eric Westbrook, essay by E. H. McCormick. Auckland: Pelorus Press, 1954.

Frances Hodgkins, Women's Suffrage Exhibition. Introduction by Jill Trevelyan. Wellington: Museum of New Zealand Te Papa Tongarewa, 1993.

Frances Hodgkins: A Modernist Eye. Exhibition curated by Kate Gallager, essay by Kendrah Morgan. Auckland: Auckland Art Gallery Toi o Tāmaki, 2001.

Frances Hodgkins: Forgotten Still Life. Exhibition curated by Sarah Hillary, essays by Genevieve Silvester, Mary Kisler, Catherine Hammond and Sarah Hillary. Auckland: Auckland Art Gallery Toi o Tāmaki, 2015. https://assets.aucklandartgallery.com/assets/media/2015-frances-hodgkins-forgotten-still-life-catalogue.pdf.

Frances Hodgkins: Leitmotif. Exhibition curated by Mary Kisler, Sarah Hillary and Ute Strehle. Auckland: Auckland Art Gallery Toi o Tāmaki, 2005.

Frances Hodgkins: People. Exhibition curated by Pamela Gerrish Nunn. Wellington: New Zealand Portrait Gallery Te Pukenga, 2017.

Frances Hodgkins: Retrospective Exhibition. Foreword by Eric Newton. London: Lefevre Gallery, 1946.

Frances Hodgkins: The Late Work. Foreword by Richard Stokes, introduction by Liz Reintjies, essays by

Rosemary Pawsey and Lindsey Bridget Shaw. Colchester: Minories Art Gallery, 1990.

Frances Hodgkins: The Link with Kapiti: The Field Collection. Exhibition curated by Avenal McKinnon. Waikanae: Mahara Gallery, 2000.

Garnett, Angelica. *Deceived with Kindness: A Bloomsbury Childhood.* London: Chatto & Windus/ Hogarth Press, 1984.

Gill, Linda (ed.). *Letters of Frances Hodgkins.* Auckland: Auckland University Press, 1993.

—— 'Hodgkins, Frances Mary'. Dictionary of New Zealand Biography, Te Ara — the Encyclopedia of New Zealand. https://teara.govt.nz/en/biographies/2h41/hodgkins-frances-mary.

—— *Pastorale: The Pursuit of an Image in Paintings by Frances Hodgkins.* Auckland: Bridgehill Books, c.2015.

Gooding, Janda. *Chasing Shadows: The Art of Kathleen O'Connor.* Perth: Art Gallery of Western Australia, 1996.

Harris, Alexandra. *Romantic Moderns: English Writers, Artists and the Imagination from Virginia Woolf to John Piper.* London: Thames & Hudson, 2010.

Hausmann, Raoul. *Raoul Hausmann: Architect, Ibiza 1933–1936.* Brussels: Fondation Pour l'Architecture, AAMd, 1990.

Howell, Arthur Rowland. *Frances Hodgkins: Four Vital Years.* London: Rockliff, 1951.

Hutchings, Patrick, and Julie Lewis. *Kathleen O'Connor: Artist in Exile.* Fremantle: Fremantle Arts Centre Press, 1987.

Influence and Originality: Landscapes, c1920 to c1950: Ivon Hitchens, Frances Hodgkins, Winifred Nicholson. Nottingham: Djanogly Art Gallery in association with Lund Humphries, c.1996.

Johnston, Alexa. *Frances Hodgkins: Femme du Monde.* Dunedin: Dunedin Public Art Gallery, 2009.

Johnstone, Nancy J. *Hotel in Spain.* London: Faber & Faber, 1937.

Julia, Isabelle. *The Modern Woman: Daughters and Lovers 1850–1918: Drawings from the Musée d'Orsay, Paris.* Brisbane: Queensland Art Gallery, 2012.

King, Annette. 'Ben Nicholson (1894–1982) *1935 (white relief)* 1935'. In *Paint and Purpose: A Study of Technique in British Art,* edited by Stephen Hackney, Rica Jones and Joyce Townsend, 158. London: Tate Gallery, 1999.

Kirker, Anne. *New Zealand Women Artists.* Auckland: Reed Methuen, 1986.

Lesage, Jean-Claude. *Peintres Australiens à Étaples.* Étaples-sur-Mer: A.M.M.E. editions, 2000.

Lewis, Wyndham. *Rude Assignment: Narrative of My Career Up-to-date.* London: Hutchinson & Co., 1950.

McCormick, E. H. *The Expatriate: A Study of Frances Hodgkins.* Wellington: New Zealand University Press, 1954.

—— *Works of Frances Hodgkins in New Zealand.* Auckland: Auckland Art Gallery Toi o Tāmaki, 1954.

—— *Portrait of Frances Hodgkins.* Auckland: Auckland University Press, 1982.

—— *Late Attachment: Frances Hodgkins and Maurice Garnier.* Auckland: Auckland Art Gallery Toi o Tāmaki, 1988.

Memorial Exhibition of the Works of Frances Hodgkins 1869–1947. Introduction by Myfanwy Piper. London: Tate Gallery and The Arts Council of Great Britain, 1952.

Milroy, Sarah, and Ian A. C. Dejardin (eds). *Vanessa Bell.* London: Philip Wilson Publishers, 2017.

Nicola Moorby. 'Her Indoors: Women Artists and Depictions of the Domestic Interior'. In *The Camden Town Group in Context,* edited by Helena Bonett, Ysanne Holt and Jennifer Mundy. London: Tate Research Publication, 2012. https://www.tate.org.uk/art/research-publications/camden-town-group/nicola-moorby-her-indoors-women-artists-and-depictions-of-the-domestic-interior-r1104359.

Paul, Elliot. *The Life and Death of a Spanish Town.* New York: Random House, 1937.

Perry, Gillian. *Women Artists and the Parisian Avant-garde: Modernism and 'Feminine' Art: 1900 to the late 1920s.* Manchester: Manchester University Press, 1995.

Picasso 1936, Huellas de una Exposición. Barcelona: Museu Picasso, Ajuntament de Barcelona: Institut de Cultura, 2011.

Piper, John. *Britain in Pictures: British Romantic Artists*. London: Collins, 1946.

Platts, Una. *The Origins of Frances Hodgkins: An Exhibition of Paintings in the Centennial Year of her Birth*. Dunedin: Hocken Library, University of Otago, 1969.

—— *Nineteenth Century New Zealand Artists: A Guide and Handbook*. Christchurch: Avon Fine Prints, 1980.

Polo, Irene. *La Fascinació del Periodisme. Cròniques (1930–1936)*. Barcelona: Quaderns Crema, 2003.

Rieser, Dolf. 'An Autobiography'. dolfrieser.com/biography/.

Rodríguez, Branchart. *Rosa, La Construcció d'un Mite, Cultura i Franquisme a Eivissa, 1936–1975*. Valencia: Afers, 2014.

Rutter, Frank. *Art in My Time*. London: Rich & Cowan, 1933.

Sentís, Carles. 'Els "descobridors" d'Eivissa" (no som els catalans)'. *Mirador*, 2 November 1933. http://mdc2.cbuc.cat/cdm/compoundobject/collection/mirador29/id/727/rec/15.

Six New Zealand expatriates: Grace Joel, Rhona Haszard, Frances Hodgkins, Francis McCracken, Raymond McIntyre, Owen Merton: The Auckland City Art Gallery, April 1962. Catalogue prepared by Colin McCahon. Auckland: Pelorus Press, 1962.

Spalding, Frances. *British Art Since 1900*. London: Thames & Hudson, 1986, reprinted 1996.

—— *Duncan Grant: A Biography*. London: Pimlico, 1998.

—— *John Piper, Myfanwy Piper: Lives in Art*. Oxford and New York: Oxford University Press, 2009.

—— *Vanessa Bell: Portrait of the Bloomsbury Artist*. London: Tauris Parke Paperbacks, 2016.

Taylor, Elena. *Australian Impressionists in France*. Melbourne: National Gallery of Victoria, 2013.

The Paintings and Drawings by Frances Hodgkins. Foreword by P. A. Tomory, essay by Colin McCahon. Auckland: Auckland Art Gallery Toi o Tāmaki and Pelorus Press, 1959.

Tippett, Maria. *Emily Carr: A Biography*. Ontario: Penguin, 1979.

Torres, Ramon, and Toni Marí Torres. 'Grupo de Arquitectos y Técnicos Españoles para el Progreso de la Arquitectura Contemporánea (GATEPAC)'. *Enciclopèdia d'Eivissa i Formentera*, Consell Insular d'Eivissa i Ajuntament d'Eivissa, Ibiza, 1995–2015. http://www.eeif.es/veus/Grupo-de-Arquitectos-y-T%C3%A9cnicos-Espa%C3%B1oles-para-el-Progreso-de-la-Arquitectura-Contempor%C3%A1nea-GATEPAC/.

Tovey, David. *Creating a Splash: The St Ives Society of Artists: The first twenty-five years (1927–1952)*. Tewkesbury: Wilson Books, 2003.

—— *St Ives (1860–1930): The Artists and the Community: A Social History*. Tewkesbury: Wilson Books, 2009.

Tufnett, Ben. *Cedric Morris and Lett Haines: Teaching Art and Life*. Norwich: Norfolk Museums & Archaeology Service, 2003.

Under the Spell: Frances Hodgkins, Nellie Hutton and Grace Joel; Three Women Artists Influenced in the 1890s by G. P. Nerli. Dunedin: Hocken Library, University of Otago, 1987.

Valero, Vicente. *Viajeros Contemporáneos. Ibiza, Siglo XX*. Valencia: Pre-textos, 2004.

—— 'Mujeres artistas en la Ibiza de los años 30'. *Diario de Ibiza*, 15 January 2010. http://www.diariodeibiza.es/pitiuses-balears/2010/01/15/mujeres-artistas-eivissa-anos-treinta/385177.

—— 'Una gran exposición en Ebusus en 1935', *Diario de Ibiza*, 19 March 2013. http://www.diariodeibiza.es/pitiuses-balears/2013/03/15/gran-exposicion-ebusus-1935/609314.

—— *Experiencia y Pobreza. Walter Benjamin en Ibiza*. Madrid: Periférica, 2017.

Wertheim, Lucy Carrington. *Adventure in Art*. London: Nicholson and Watson, 1947.

Whybrow, Marion. *St Ives 1883–1993: Portrait of an Art Colony*. Woodbridge, Suffolk: The Antique Collector's Club Ltd, 1994.

Wilby, Thomas William. *A Motor Tour through Canada*. London, Toronto and New York: Scholars

Choice, John Lane, The Bodley Head, London; John Lane Co. NY; Bell & Cockburn, Toronto, 1914.

Zur Muhlen, Hermynia. *The End and the Beginning: The Book of my Life*. Translated, annotated and introduction by Lionel Gossman. Cambridge: Open Book Publishers, 2010.

Articles

'Art, Frances Hodgkins'. Supplement to *The Bookfellow*. 1 May 1913, 9.

'A woman painter', *Sydney Morning Herald*, 16 April 1913, 7.

'Modern French Art: Miss Frances Hodgkins's work, Early Years in Paris', *The Mail*, 28 June 1913, 9.

'Art Exhibitions', *The Times*, 24 May 1928, 21.

Boulestin, X M. *Myself, My Two Countries*. London, Toronto, Melbourne and Sydney: Cassell and Co Ltd, 1936.

Brasch, Charles. 'Frances Hodgkins in Auckland'. *Landfall* 31 (September 1954): 209–12.

—— 'Frances Hodgkins at One Hundred'. *Landfall* 92 (1969): 265–76.

Brown, Bernard. 'Cedric Morris at Benton End: A Footnote to Frances Hodgkins'. *Art New Zealand* 25 (Summer 1982–83): 48–50.

Brown, Gordon H. 'The Reputation of Frances Hodgkins'. *Art New Zealand* 16 (Winter 1980): 44–47.

Collins, Roger. 'Frances Hodgkins and a "New" French Connection'. *Journal of New Zealand Art History* 32 (2011): 126–28.

Cooke, Linda R. 'Daphne and Miss Roberts at The Nook in Bodinnick'. July 2016. http://www.dumaurier.org/menu_page.php?id=124.

Davison, Anne-Marie. 'G P Nerli and Frances Hodgkins: the Dunedin Years'. *Art New Zealand* 58 (Autumn 1991): 78–82.

Day, Melvin. 'Frances Hodgkins: 1869–1947'. *Ascent* 1, no. 5 (December 1969): 5–7.

Docking, Shay. 'Frances Hodgkins and a New Tradition'. *Ascent* 1, no. 5 (December 1969): 65–75.

Ensing, Riemke. 'Another Portrait: Frances Hodgkins Everywhere'. *Art New Zealand* 85 (Summer 1997–98): pp 62–67.

Entwisle, Peter. 'Frances Hodgkins at the Dunedin Public Art Gallery: A History of the Collection and a Checklist'. *Bulletin of New Zealand Art History* 14 (1993): 41–70.

—— 'A Portrait of Frances Hodgkins?'. *Journal of New Zealand Art History* 23 (2002): 85–88.

Evans, Myfanwy. 'Frances Hodgkins' *Vogue* (August 1947): 53, 91.

Feeney, Warren. '"The Great Art War": Alan Brassington and Frances Hodgkins' "The Pleasure Garden"'. *Journal of New Zealand Art History* 28 (2007): 97–113.

Fine, Elsa Honig. 'One Point Perspective'. *Woman's Art Journal* 15, no. 2 (1994): 2. http://www.jstor.org/stable/1358596.

'Friends of the Bristol Art Gallery'. *The Burlington Magazine for Connoisseurs* 89, no. 531 (June 1947): 163–64.

Gill, Linda. 'The Letters of Frances Hodgkins'. *Art New Zealand* 68 (Spring 1993): 106–9, 117.

Gorer, Geoffrey. 'The Art of Frances Hodgkins', *Listener* (UK) (17 November 1937): 1082–1083. Reprinted in *Art in New Zealand* (March 1938): 160–63.

—— 'Remembering Frances Hodgkins', *Listener* (UK) (19 June 1947): 968.

Green, Anthony S. 'Reflections on the Hodgkins Exhibition'. *Ascent* 1, no. 5 (December 1969): 29–48.

James, Merlin. 'Influence and Originality. Manchester'. *The Burlington Magazine* 138, no. 1118 (1996): 343–45. http://www.jstor.org/stable/886927.

Jonsson, Julia, Bronwyn Ormsby and Tom Learner. 'Analysis of Frances Hodgkins' Paints'. London: Tate Conservation Analysis Report, 2004.

Kirker, Anne. 'Adoration: A Pencil and Watercolour Drawing by Frances Hodgkins'. *Auckland City Art Gallery Quarterly* 58 (1975): n. p.

—— 'The Drawings of Frances Hodgkins'. *Art New Zealand* 16 (Winter 1980): 40–43.

Knollys, Eardley. 'Obituary for Frances Hodgkins'. *The Burlington Magazine for Connoisseurs* 89, no. 532 (July 1947): 197–99.

—— 'Works of Frances Hodgkins in New Zealand by E. H. McCormick and Frances Hodgkins'. *The Burlington Magazine* 98, no. 638 (May 1956): 173.

Larsen, Ute. 'Primarily a Water Colourist? The Materials and Techniques of Frances Hodgkins' Watercolour and Gouache Works on Paper'. *Journal of the Institute of Conservation* 32, no. 1 (2009): 3–14.

Lonie, Bridie. 'Shifting Signifiers: Fluidity and the Female Body in the Work of Frances Hodgkins'. *Art New Zealand* 78 (Autumn 1996): 80–85.

Macia, Xavier. 'Living the Dream — the story of a British couple on the Costa Brava in the Thirties'. *Metropolitan Barcelona*. https://www.barcelona-metropolitan.com/features/living-the-dream/.

Middleton, M. H. 'Art'. *The Spectator*, 15 November 1946, 512–13.

Mortimer, Raymond. 'Three Methods: John Aldridge and Claude Rogers, at the Leicester Galleries. Frances Hodgkins, at the Lefevre'. *New Statesman and Nation*, 6 April 1940, 460–61.

McCormick, E. H., 'Illustrated by Miss. F. Hodgkins', *Landfall* 18 (1951): 117–121.

—— 'Frances Hodgkins: A Pictorial Biography', *Ascent* 1, no. 5 (December 1969): 8–28.

—— 'Some Recently Acquired Drawings by Frances Hodgkins'. *Auckland City Art Gallery Quarterly* 58 (1975): 1–8.

—— 'Frances Hodgkins: The Path to Impressionism, 1892–1912'. *Art New Zealand* 16 (Winter 1980): 28–35.

—— 'Woman and Child: A Note on a Motif in the Paintings of Frances Hodgkins'. *Art New Zealand* 27 (1983): 18–19.

Newton, Eric. 'Frances Hodgkins: A Painter of Genius'. *Art in New Zealand* (September 1940): 36. Reprinted from the *Sunday Times* (London), 14 September 1940.

—— Review of Frances Hodgkins' Exhibition at Leicester Galleries Oct 1941, *Listener*, 2 October 1941, 473.

Nicholas, Hilda Rix. 'An Artist's Life in Paris'. *The Home* (March 1922): 25.

Nunn, Pamela Gerrish. 'Frances Hodgkins, The "Arrival" in Context'. *Art New Zealand* 56 (1990): 86–89.

Opie, June. 'The Quest for Frances Hodgkins'. *Ascent* 1, no. 5 (December 1969): 49–64.

—— Recording. Nga Taonga Sound & Vision. Reference 3950. ttp://new.ngataonga.org.nz/collections/catalogue/catalogue-item?record_id=223032.

—— Interview by June Opie of English artists and Friends. Nga Taonga Sound & Vision. Reference 3950. https://ngataonga.org.nz/collections/catalogue/catalogue-item?record_id=223032

Piper, John. 'Frances Hodgkins'. *Horizon* 4, no. 24 (1941): 413–16.

Piper, Myfanwy. 'The Life and Art of Frances Hodgkins'. *Listener*, 21 November 1946, 705–06.

Read, Herbert. 'L'Art Contemporain en Angleterre'. *Cahiers d'Art* 1 (1938): 29–42.

Regnault, Claire. 'Cubist Dreams and Wings Like Fireflies: Claire Regnault on the Textile Designs of Frances Hodgkins'. Museum of New Zealand Te Papa Tongarewa. http://arts.tepapa.govt.nz/off-the-wall/5854/cubist-dreams-and-wings-like-fireflies.

Reynolds, Siân. 'Running Away to Paris: Expatriate Women Artists of the 1900 Generation, From Scotland and Points South'. *Women's History Review* 9, no. 2 (2000): 327–44.

Richardson, Mark. 'Canada's first coast-to-coast road trip was no joyride. A snob, a chauffeur, four wheels and a mission: Halifax to Vancouver — or bust'. 4 June 2012. https://www.macleans.ca/news/canada/canadas-first-coast-to-coast-road-trip-was-no-joyride/.

Rutter, Frank. 'The Galleries'. *Sunday Times* (London), 27 May 1928, 5.

Scott, T. H. 'The Frances Hodgkins Controversy'. *Landfall* 12 (1949): 360–74.

—— 'The Pleasure Garden: A Postscript'. *Landfall* 20 (1951): 311–13.

Sheppard, E. A. 'Five Paintings by Frances Hodgkins'. *Art New Zealand* 16 (Winter 1980): 32, 36–39.

Singer, Brian W. 'Investigation of Paint Samples from L1998-20 Refugee Children'. Conservation Report, Northumbria University, Newcastle-upon-Tyne, 2005.

Stead, Oliver. 'A Hodgkins Family Portrait'. *Off the Record* 25 (2017): 25.

Stephens, A. G. 'Frances Hodgkins, a Dunedin Girl who Conquered Paris', 'Her Exibitions in Melbourne and Sydney; and An Interview'. Otago Daily Times, Issue 15754, 3 May 1913, 5.

—— 'Frances Hodgkins, a Dunedin Girl who Conquered Paris'. Otago Witness, 28 May 1913.

Stocker, Mark. *The Burlington Magazine* 148, no. 1243 (2006): 699–700. http://www.jstor.org/stable/20074591.

Stupples, Peter. 'Frances Hodgkins and the "Seven and Five Society"'. In *Hodgkins '97: Papers from the symposium held at the University of Otago, 4–6 April 1997, to mark the 50th anniversary of Frances Hodgkins' death.* Bulletin of New Zealand Art History, Special Series No. 4, 1998, 83.

Townsend, Joyce H., and Sarah Hillary. 'A Lively Parrot: Frances Hodgkins's *Wings over Water*'. *Tate Papers* 5 (Spring 2006) and *Journal of New Zealand Art History* 26 (2005): 40–54. http://www.tate.org.uk/research/publications/tate-papers/05/a-lively-parrot-frances-hodgkins-wings-over-water.

Tyler, Linda. 'Fanny's Frocks: Exploring Frances Hodgkins' Fashion Sense'. *Context* 5 (November 2004–March 2005): 10–15.

Wallis, Nevile. *Journal of the Royal Society of Arts* 97, no. 4806 (1949): 946. http://www.jstor.org/stable/41364455

Warner, Tony. 'Frances Hodgkins'. *Arts Review* 25 (January 1991): 49.

Westbrook, Eric. 'Pupil and Teacher: Some Works by Frances Hodgkins and G. P. Nerli in Melbourne'. *Quarterly Bulletin of the National Gallery of Victoria* 11, no. 1 (1957): 3–5.

Theses

Caughey, Georgina. 'Frances Hodgkins: Journey Toward Modernism'. Master's thesis, Sotheby's Institute, 1998.

Riddle, Maxwell Edith. 'Women and Modernity: The Case of Frances Hodgkins: An Investigation of Her Use and Abandonment of the Image of Women'. Master's thesis, Victoria University of Wellington, 1997.

Schwass, Margot. 'All the Juicy Pastures: Greville Texidor, Frank Sargeson and New Zealand Literary Culture in the 1940s'. Unpublished doctoral thesis, Victoria University of Wellington, 2017.

Acknowledgements

On my journeys I had many adventures of one kind or another, which could not be recorded in a catalogue but which I have been encouraged to share in this informal manner, using Hodgkins' letters as well as her paintings to illuminate my journey.

This book grew out of The Frances Hodgkins Project, which includes an online catalogue raisonné, a touring exhibition and an exhibition catalogue, none of which would have been possible without the national and international support provided by a huge group of people. My special thanks go to the late Rodney Wilson, who started the catalogue raisonné many years ago, assisted by Anne Kirker, and gifted all his material to the E. H. McCormick Library at Auckland Art Gallery, and who gave the project his blessing before he passed away in 2013.

Special thanks go to the Stout Fund, particularly John White of Perpetual Guardian, who administered the Trust when the project began. The Stout's support was supplemented by generous funding from the New Zealand Decorative & Fine Arts Society, led by Jill Huston, and from NZ-UK Link. In particular I have been privileged to have the support of the staff at Auckland Art Gallery who took a leap of faith that the Hodgkins team could pull the project off.

In regard to *Finding Frances Hodgkins*, particular thanks go Catherine Hammond, Caroline McBride, Tamsyn Bayliss, John McIver, Jennifer French, Paul Chapman, Sarah Hillary, Camilla Bascomb, Georgina Whiteley, Rachel Walmsley, Naomi Boult and former director Rhana Devenport.

I also wish to thank the Hodgkins Steering Group members Alexa Johnston, John Gow, Linda Gill, Roger Collins (not least for the use of his wonderful French postcard collection), Linda Tyler and the late Iain Buchanan, for whose knowledge and advice we have been so grateful for.

I would like to acknowledge the descendants of the Hodgkins family, in particular Simon and Kay Brown, for their support for the project. Heartfelt thanks also go to the many private collectors of works by Frances Hodgkins, who have been unfailingly supportive, letting me climb on their sofas, take paintings off walls in spite of not being able to put them back again, and take up their valuable time.

A large number of public institutions have been generous in allowing access to their collections and archives, including: National Gallery of Modern Art, Scotland; Leeds Gallery of Modern Art; Manchester Art Gallery; Whitworth Gallery, Manchester; Salford Museum & Art Gallery; Whitworth Art Gallery, Manchester; Leeds Walker Art Gallery, Liverpool; Welsh National Gallery of Art, Cardiff; Plymouth City Museum and Art Gallery; Royal Academy of Music Collection, London; Victoria & Albert Museum, London; Tate Britain, London; Dulwich Picture Gallery, London; British Council, London; Towner Art Gallery, Eastbourne; Pallant House, Chichester; Brighton and Hove Museums; Pompidou Centre, Paris; Musée d'Orsay, Paris; Art Gallery of South Australia, Adelaide; Queensland Art Gallery, Brisbane; Art Gallery of New South Wales, Sydney; Auckland Art Gallery Toi o Tāmaki; Christchurch Art Gallery Te Puna o Waiwhetū; Waikato Museum Te Whare Taonga o Waikato; Museum of New Zealand Te Papa Tongarewa; Dunedin Public Art Gallery; Sargeant Gallery Te Whare o Rehua; MTG Hawke's Bay; and Mahara Gallery, Waikanae.

The project has also been supported by librarians and archivists Chris Szekely and Sean McMahon at Alexander Turnbull Library, Wellington; Tim Jones, Christchurch Art Gallery Library; Adrian Glew, Tate Library and Archives; Janet Axten, St Ives Archive; Diana Eccles, British Council; and by staff at the British Library; Victoria & Albert Museum; National Gallery Library, London; Bibliothèque Musée D'Orsay; Bibliothèque Kandinsky;

Centre Pompidou, Paris; as well as Steven Miller at the Edmund and Joanna Capon Research Library at the Art Gallery of New South Wales, Sydney.

At Massey University Press, my special thanks go to Nicola Legat and Anna Bowbyes, and to editor Jane Parkin and designers Megan van Staden and Kate Barraclough.

I particularly want to thank the following people for their ongoing friendship and encouragement: Tony Mackle, who is yet to shower me with diamonds and furs; Roger Blackley and David Maskill, who have patiently listened to accounts of my journeys; Chloe Steer, who has worked tirelessly for many years as a wise and loyal friend and unpaid supporter of this project, and painstakingly transcribed all known letters by Frances Hodgkins; Catherine Hammond for her grip of the archives of London and Paris, not to mention her companionship, wit, logic and calm (both Chloe and Catherine have reined me in when drawn to excess, impatience or despair). Thanks also go to my friend and former neighbour, Mary Gee, who kindly accompanied me to the Côte d'Azur and served as my driver to Provençal villages; Antoni and Vincent Ribas Tur for their kindness, companionship and hospitality in Ibiza; and Martin Davies, who has, along with Antoni, continued to follow up leads on my behalf and who showed me a side of Ibiza that I would never had experienced on my own.

In England and Wales I was extremely grateful for the friendship and support received from Sophie and Simon Meade and Toby Clark. Thanks are also due to Norman Coates, Barbara Ewing, John Kisler, Frances Spalding, Liz Prettijohn, Gretchen Albrecht and James Ross for their ongoing hospitality, enthusiasm and support, and to Robert Bayliss for tracking down Willow Cottage in Bradford-on-Tone, and, lastly, to Blandine Massiet du Biest, who acted as our guide in Paris.

And finally I wish to thank David Kisler, who cast a cool eye over the text, and who has remained a staunch if sometimes acerbic supporter of my absences without leave. It really is true that distance makes the heart grow fonder.

Index

Page numbers in **bold** refer to images

Roux, Paul and Baptistine 66
Royal Academy of Arts, London 13, 43, 309–10
Royal Institute of Painters in Watercolour, London 309
Royal Society of British Artists 306
Royan, Aquitaine 265
Royce, Elsie 12–13
Ruins (1937) 342, **343**, 344, 347
Ruins, Cadaqués (c.1936) 295, 297
Rumpelmayer's 92

S

Sabrina's Garden 329
Sacharoff, Olga 265
Sadler, Sir Michael 392
Sale, Molly 21, 24–25
Salford 224, **225**
Salford Museum and Art Gallery 224–26
Salon d'Automne, Paris 67
Salon de la Société Nationale des Beaux-Arts, Paris ('New Salon') 162
Salon de l'École Française 162
Salon des Artistes Français, Paris ('Old Salon') 67, 162
Saltaire 209, 211
San Miguel, Ibiza 253
San José, Ibiza 247–48, 249, 251; *Church of San Jose* (1933) 249, **250**; Raoul Hausmann's house **259**
San Remo 48, 51–52, 55, 56
Santa Eulalia, Ibiza 262–63, **264**, 265, 266; *Porch, Santa Eulalia* (1933) 263, **264**; *St Eulalia, Ibiza* 329
Saunders, Dorothy (Jane) 189, 213, 216, 217, 222, 230, 376, 392, 394–95; Frances Hodgkins with Hannah Ritchie and Jane Saunders, May 1925 [photograph] **214–15**
School for Water Colour, Paris, advertisement for FH's classes **397**
Second World War 17, 111, 206, 213, 303, 359, 364, 374, 376, 379, 386, 391
Selby, Dorothy 108, 109, **314**, 364, 392, 393; letters from FH 98, 99, 198, 201, 203, 206, 246–47, 249, 313, 315, 317, 318, 320–21, 325, 337
Self Portrait: Still Life (c.1934–35) 352–53, **355**
Sesame and Imperial Club for Women, London 317, 318–19
Seven & Five Society 101, 191, 206, 311, 320, 357; private view card, 1929 **397**
Siamese Cats (c.1933) **268**
Sickert, Walter 75, 217, 229, 230–31, 233
Signac, Paul 63, 66, 73, 95, 98, 105, 108
Sitwell, Edith 318–19
Skeaping, John 231
Skinner, Edith and Edgar 177; *The Edwardians* (c.1918) (Hodgkins) 177, **178**, 179
Smith, Matthew 233, 378
Smith, May 245
Société Internationale des Aquarellistes, Paris 145, 159
Society of Women Artists 310
Solva, Pembrokeshire 235, 337, **338**, 339, 340, 345, 347, 372, 374; *Methodist Chapel* (c.1937) 321, 345, **346**
South Kensington Science and Art Department, London 13

Spain 9, 10, 219, 245, 300, 301, **400**; *see also* Barcelona; Cadaqués; Costa Brava; Ibiza; Port de la Selva; Tossa de Mar
Spanish Civil War 282, 283, 292, 301
Spanish Jars (1931–35) **328**, 329
Spanish Landscape in Orange, Brown & Green (c.1936) 284, **286**, 288
Spanish Shrine (1933–35) 101, 260, **261**, 262, 263, 266, 321, 329
Spanish Still Life and Landscape 105, 376
Spence, Effie 306
Spring in the Ravine (1933) 253, 329
St George's Gallery, London 79, 99, 310, 313; FH's contracts 17, 81–82, 99, 313; *Homage to Frances Hodgkins* memorial exhibition, 1949 395
St Ives, Cornwall, FH's residence and visits 136, 167, 171–81, **174**, **182**, 184–85, 186, 188–91, 192, 216, 306, 351, 371; Frances Hodgkins in the Wharf Studio (1918) [photograph] **182**; Godrevy Lighthouse **190**, 191; Porthmeor Studios **174**, 175, 179, 181, 191; ban on outdoor sketching 173; Wharf Studio 181, **182**
St Ives School of Painting 181
St Ives Society of Artists (STISA) 175
St Jeannet, France 63, 79–82, **83**, 84–85, 129, 195, 244; *The Summit [St Jeannet]* (c.1929–30) 79, **80**
St-Paul-de-Vence (St Paul du Var), France 63, **64**, **65**, 66–72, 82; Maeght Foundation 75–76
St Paul du Var (1924) 69, **70**
St Tropez, France 95–109, **96**, **104**, 313, 329, 349, 353; La Hune **104**, 105, 108
St-Valery-sur-Somme, France 213; Frances Hodgkins with two of her pupils at St-Valery-sur-Somme, (1912) [photograph] **23**
Steer, Chloe 10; Bradford-on-Tone 383, 384; Cadaqués 290, 292, 294–95, 297; Cornwall 167, 171–72, 181, 191–93, 195, 197, 198, 206–07; Dorset 356, 361, 364, 366–67, 372; Paris 159, 161; Tossa de Mar 271, 273, 274–75, 279, 285
Stein, Gertrude 353
Steyer, Luis (Luis Steyer Weber) 282
still-life works 67, 72, 98, 145; armchair as prop 352–53; with draped or twisted fabric 105, 352; self-portrait/ still-life compositions 352–53; still-life merging with landscape 211; *see also* titles of individual still-life works
Still Life with Fruit Dishes (c.1937) 352, 353, **354**
Still Life with Vase and Eggs (c.1931) 105, **106**
Stoddard, Margaret 172
Stokes, Mrs Adrian 170
Storran Gallery, London 194
Summer (c.1912) 164
The Summit [St Jeannet] (c.1929–30) 79, **80**
surrealism 320, 357, 359
Sutherland, Graham 337, 381
Swanage, Dorset 356, 375
Sydney 16, 163–64

T

Tangier, Morocco 31–39, 42, 43–44, **45**; Frances Hodgkins painting a young model in Tangier, Morocco

First published in 2019 by Massey University Press
Private Bag 102904, North Shore Mail Centre
Auckland 0745, New Zealand
www.masseypress.ac.nz

Design by Kate Barraclough and Megan van Staden
Jacket image: *Road to the Hills, Ibiza*, 1933
Case images: (front) *Red Jug*, c.1931; (back) *Pastorale*, c.1929–30

A catalogue record for this book is available from the National Library
of New Zealand

Printed and bound in China by Everbest Investment Ltd

ISBN: 978-0-9951029-7-2